Graphis Inc. is committed to celebrating exceptional work in Design, Advertising, Photography & Art/Illustration internationally.

Published by **Graphis** I Publisher & Creative Director: **B. Martin Pedersen** I Design Director: **Hee Ra Kim** I Designer: **Hie Won Sohn**
Editor: **Brittney Feit** I Design Intern: **Erin McGowan** I Editorial Intern: **Zoe Young** I Account/Production: **Leslie Taylor**

Graphis Photography Annual 2019

Published by:
Graphis Inc.
389 Fifth Avenue
New York, NY 10016
Phone: 212 73 9387
www.graphis.com
help@graphis.com

Distributed by:
National Book Networks, Inc.
15200 NBN Way
Blue Ridge Summit, PA 17214
Toll Free (U.S.): 800-462-6420
Toll Free Fax (U.S.): 800-338-4550
Email orders or Inquiries:
customercare@nbnbooks.com

Legal Counsel: John M. Roth
4349 Aldrich Avenue, South
Minneapolis, MN 55409
Phone: 612-360-4054
johnrothattorney@gmail.com

ISBN 13: 978-1-931241-75-5
ISBN 10: 1-931241-75-9

We extend our heartfelt thanks to
the international contributors
who have made it possible to publish
a wide spectrum of the best work
in Design, Advertising, Photography,
and Art / Illustration.
Anyone is welcome to submit
work at www.graphis.com.

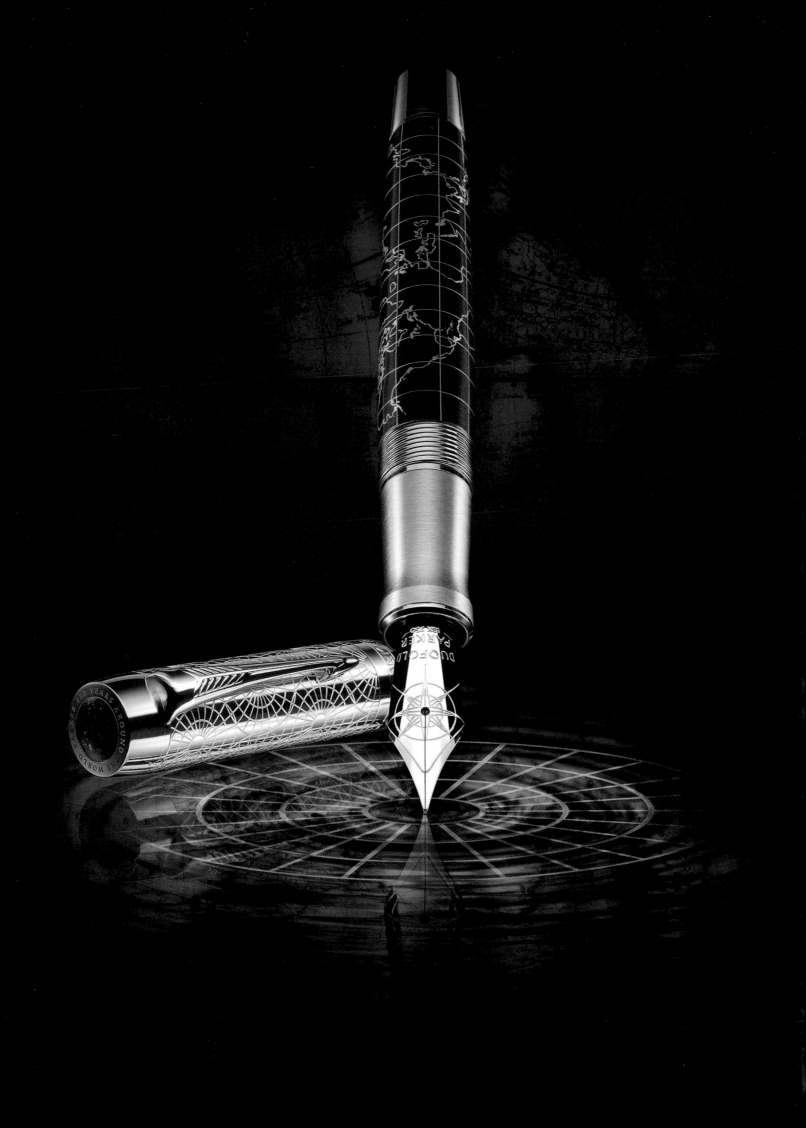

Contents

In Memoriam 6
List of Photography Museums 8
Graphis Photography Masters 10
Competition Judges 16
Platinum Awards 19
Platinum Winners 20
Gold Awards 36
Advertising 37
Animals/Wildlife 55

Architecture 62
Automotive 63
Beauty & Fashion 70
Dance ... 89
Environmental 94
Fine Art ... 95
Food ... 103
Industrial ... 108
Journalism 100

Landscape 110
Nudes .. 118
Portraits ... 120
Sports .. 136
Still-Life ... 137
Transportation 155
Silver Awards 156
Honorable Mention 222
Credits & Commentary 232

Index ... 243
Winners Directory 249
Winners by Country 249
Equipment Choices 250
Graphis Masters 252
Graphis Titles 254

In Memoriam

The Americas

Laura Aguilar
Chicana Photographer
1959-2018

Vivian Cherry
Pioneer Street Photographer
1920-2019

Alan Diaz
Photographer
1947-2018

David Douglas Duncan
Celebrated Combat
Photographer
1916-2018

Marc Hauser
Celebrity Photographer
1952-2018

Seymour "Sy" Kattelson
Street Photographer
1923-2018

Sean King
Hawaiian Photographer
1967-2018

Leighton Mark
Photojournalist
1951-2019

Roger Ressmeyer
Photographer and
Multimedia Producer
1954-2018

Art Shay
Life Photographer
1922-2018

Robert Stinnett
Oakland Tribune Photographer
1924-2018

Henry Wessel
American Photographer
1942-2018

Europe & Africa

Desmond Boylan
AP Photographer
1964-2018

Yannis Behrakis
Photojournalist
1960-2019

David Goldblatt
Chronicler of Apartheid
South African Photographer
1930-2018

Jacqueline Hassink
Dutch Photographer
1966-2018

Erich Lessing
Austrian Photographer
1923-2018

Jeab Mohr
Swiss Photographer
1925-2018

Asia & Oceania

Abas Attar
Magnum Photographer
1944-2018

Ara Guler
Photojournalist
1928-2018

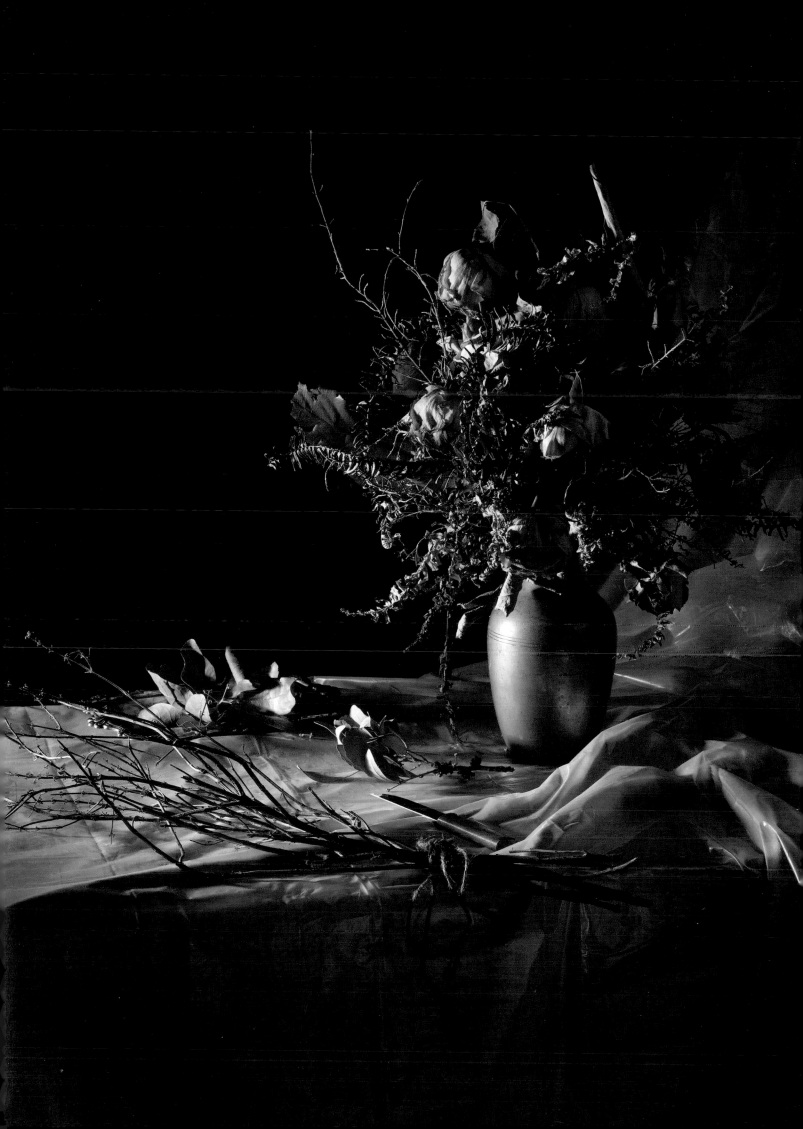

THE AMERICAS

Amon Carter Museum of Art
www.cartermuseum.org
3501 Camp Bowie Blvd.
Fort Worth, TX 76107
United States
Tel +1 817 738 1933

Annenberg Space for Photography
www.annenbergphotospace.org
2000 Avenue of the Stars #10
Los Angeles, CA 90067
United States
Tel +1 213 403 3000

Andrea Meislin Gallery
www.andreameislin.com
819 Madison Ave.
New York, NY 10065
United States
Tel +1 212 627 2552

Aperture Foundation
www.aperture.org
547 W 27th St., 4th Fl,
New York, NY 10001
United States
Tel +1 212 505 5555

Asian Art Museum of San Francisco
www.asianart.org
200 Larkin St.
San Francisco, CA 94102
United States
Tel +1 415 581 3500

Bonni Benrubi Gallery
www.benrubigallery.com
521 W 26th St., 2nd Fl.
New York, NY 10001
United States
Tel +1 212 888 6007

Canadian War Museum
www.warmuseum.ca
1 Vimy Place
Ottawa, Ontario K1A 0M8
Canada
Tel +1 800 555 5621

Center for Creative Photography
www.creativephotography.org
1030 N. Olive Road
Tuscon, AZ 85721
United States
Tel +1 520 621 7968

Danziger Gallery
www.danzigergallery.com
980 Madison Ave., Unit 301
New York, NY 10075
United States
Tel +1 212 629 6778

Florida Museum of Photographic Arts
www.fmopa.org
400 N. Ashley Drive
Tampa, FL 33602
United States
Tel +1 813 221 2222

Fotografiska
www.fotografiska.com/nyc/
281 Park Avenue South
New York, NY 10010
United States

Fraenkel Gallery
www.fraenkelgallery.com
49 Geary St., 4th Fl.
San Francisco, CA 94108
United States
Tel +1 415 981 2661

George Eastman Museum
www.eastman.org
900 East Ave.
Rochester, NY 14607
United States
Tel +1 585 327 4800

Getty Center
www.getty.edu
1200 Getty Center Drive
Los Angeles, CA 90049
United States
Tel +1 310 440 7300

Higher Pictures
www.higherpictures.com
980 Madison Ave.
New York, NY 10075
United States
Tel +1 212 249 6100

Howard Greenberg Gallery
www.howardgreenberg.com
41 East 57th St.
Suite 1406
New York, NY 10022
United States
Tel +1 212.334.0010

International Center of Photography
www.icp.org
1114 Avenue of the Americas
New York, NY 10036
United States
Tel +1 212 857 0000

International Center of Photography at Mana
www.icp.org/facilities/icp-at-mana
888 Newark Ave.
Jersey City, NJ 07306
United States
Tel +1 212 857 9736

International Center of Photography Museum
www.icp.org
250 Bowery
New York, NY 10012
United States
Tel +1 212 857 0000

Jackson Fine Art
www.jacksonfineart.com
3115 E Shadowlawn Ave NE,
Atlanta, GA 30305
United States
Tel (404) 233-3739

Janet Borden Inc.
www.janetbordeninc.com
91 Water St.
Brooklyn, NY 11201
United States
Tel +1 212 431 0166

Jan Kesner Gallery
www.jankesnergallery.com
128 N. Ridgewood Place
Los Angeles, CA 90004
United States
Tel +1 323 938 6834

Laurence Miller Gallery
www.laurencemillergallery.com
521 W 26th St.
New York, NY 10001
United States
Tel +1 212 397 3930

MUMEDI - Museo Mexicano del Diseño
www.mumedi.mx
Avenida Francisco I. Madero 74
Centro, Cuauhtémoc
06000 Ciudad de México, D.F.,
Mexico
Tel +52 55 5510 8609

Museo Archivo de la Fotografía
www.cultura.df.gob.mx
Republic of Guatemala 34
Centro Histórico, Centro, 06010
Mexico City
Mexico
Tel +52 55 2616 7057

Museum of Arts and Design
www.madmuseum.org
Jerome and Simona Chazen Building
2 Columbus Circle
New York, NY 10019
United States
Tel +1 212 299 7777

Museum of Contemporary Photography
www.mocp.org
600 S. Michigan Ave.
Chicago, IL 60605
United States
Tel +1 312 663 5554

Museum of Modern Art
www.moma.org
11 W 53rd St.
New York, NY 10019
United States
Tel +1 212 708 9400

Museum of Photographic Arts
www.mopa.org
1649 El Prado
San Diego, CA 92101
United States
Tel +1 619 238 7559

Pace/MacGill Gallery
www/pacemacgill.com
32 East 57th St., 9th Fl.
New York, NY 10022
United States
Tel +1 212 759 7999

Pier 24 Photography
www.pier24.org
24 Pier
San Francisco, CA 94105
United States
Tel +1 415 512 7424

National Gallery of Art
www.nga.gov/content/ngaweb.html
6th & Constitution Ave. NW
Washington, DC 20565
United States
Tel +1 202 737 4215

National Geographic Museum
www.nationalgeographic.com
1145 17th St. NW
Washington, DC 20036
United States
Tel +1 202 857 7588

Robert Mann Gallery
www.robertmann.com
525 West 26th St. 2nd Fl.
New York, NY 10001
United States
Tel +1 212 989 7600

Smithsonian National Air and Space Museum
www.airandspace.si.edu
600 Independence Ave. SW
Washington, DC 20560
United States
Tel +1 202 633 2214

Soho Photo Gallery
www.sohophoto.com
15 White St.
New York, NY 10013
United States
Tel +1 212 226 8571

Southeast Museum of Photography
www.smponline.org
1200 W International Speedway Blvd.
Daytona Beach, FL 32114
United States
Tel +1 386 506 4475

Staley-Wise Gallery
www.staleywise.com
100 Crosby St #305
New York, NY 10012
United States
Tel +1 212 966 6223

Steven Kasher Gallery
www.stevenkasher.com
515 W 26th St., 2nd Fl.
New York, NY 10001
United States
Tel +1 212 966 3978

The Polygon Gallery
www.thepolygon.ca
101 Carrie Cates Ct.
North Vancouver, BC V7M 3J4
Canada
Tel +1 604 986 1351

Yancey Richardson
www.yanceyrichardson.com
525 W 22nd St.
New York, NY 10011
United States
Tel +1 646 230 9610

Yossi Milo Gallery
www.yossimilo.com
245 10th Ave.
New York, NY 10001
United States
Tel +1 212 414 0370

EUROPE AND AFRICA

Bauhaus Archives (Bauhaus-Archiv)
www.bauhaus.de
Klingelhöferstraße 14
10785 Berlin
Germany
Tel +49 30 2540020

Belfast Exposed
www.belfastexposed.org
The Exchange Place
23 Donegall St.
Belfast BT1 2FF
Ireland
Tel: +44 028 9023 0965

CAMERA WORK Photogallery
www.camerawork.de
Kantstraße 149
10623 Berlin
Germany
Tel +49 30 3100773

Centre for Contemporary Art
www.dox.cz
Poupetova 1
170 00 Praha
Czech Republic
Tel +420 295 568 123

Foam Fotografiemuseum Amsterdam
www.foam.org
Keizersgracht 609
1017 DS, Amsterdam
Tel +31 20 551 6500

FOMU - Fotomuseum Provincie Antwerpen
www.fotomuseum.be
Waalsekaai 47
2000 Antwerpen
Belgium
Tel +32 (0)3 242 93 00

Fotografiska
www.fotografiska.com/london/
10 Whitechapel High St.
London E1 8DX
United Kingdom

Fotografiska
www.fotografiska.com
Stadsgårdshamnen 22
116 45 Stockholm
Sweden
Tel +46 8 509 00500

Fotografisk Center
www.fotografiskcenter.dk
Staldgade 16
1699 Copenhagen V
Denmark
Tel +45 33 93 09 96

Fotomuseum Winterthur
www.fotomuseum.ch
Grüzenstrasse 44
8400 Winterthur
Switzerland
Tel +41 52 234 10 60

Friedrichshain Photo Gallery
www.fotogalerie.berlin
Helsingtorser Platz 1
10243 Berlin
Germany
Tel +49 30 2961684

Galleria Carla Sozzani
www.fondazionesozzani.org
Corso Como, 10
20154 Milano MI
Italy
Tel +39 02 653531

Galerie nationale du Jeu de Paume
www.jeudepaume.org
1 Place de la Concorde
Paris 75008
France
Tel +33 1 47 03 12 50

Gemeentemuseum Den Haag
www.gemeentemuseum.nl
Stadhouderslaan 41
2517 HV Den Haag
The Netherlands
Tel +31 7033 81 111

Helmut Newton Museum
www.helmutnewton.com
Jebensstraße 2
10623 Berlin
Germany
Tel +49 30 31864856

Henri Cartier Bresson Foundation
www.henricartierbresson.org
79 Rue des Archives
75003 Paris
France
Tel +33 1 40 61 50 50

Huis Marseille
www.huismarseille.nl
Keizersgracht 401
1016 EK Amsterdam
Netherlands
Tel +31 20 531 8989

International Festival of Photojournalism
www.visapourlimage.com
4 rue Chapon – Bâtiment B
75003 Paris
France
Tel +33 1 44 78 66 80

Jeu de Paume
www.jeudepaume.org
1 Place de la Concorde
75008 Paris
France
Tel +33 1 47 03 12 50

Josef Sudek Gallery
www.upm.cz
Úvoz 24
118 00 Praha 1
Czech Republic
Tel +420 257 531 489

Kunsthaus Zurich
www.kunsthaus.ch
Heimplatz 1
CH-8001 Zürich
Switzerland
Tel +41 44 253 84 84

La Maison de la Photographie Robert Doisneau
www.maisondoisneau.agglo-valde-bievre.fr
1 General Leclerc Division St.
Gentilly 94250
France
Tel +33 1 55 01 04 86

Latvian Museum of Photography
www.fotomuzejs.lv
Marstalu St. 8, Riga 1050
Latvia
Tel +371 67 222 713

Le Château d'Eau, Toulouse
www.galeriechateaudeau.org
1 Place Laganne
Toulouse 31300
France
Tel +33 5 61 77 09 40

Les Rencontres d'Arles
www.rencontres-arles.com
34 rue du docteur Fanton
13200 Arles
France
Tel +33 (0)4 90 96 76 06

Magnum Photos
www.magnumphotos.com
19 Rue Hégésippe Moreau
75018 Paris
France
Tel +33 1 53 42 50 00

Maison Européenne de la Photographie
www.mep-fr.org
5/7 Rue de Fourcy
75004 Paris
France
Tel +33 1 44 78 75 00

MOTI - Museum of the Image
www.motimuseum.nl
Boschstraat 22
4811 GH Breda
The Netherlands
Tel +31 76 529 9900

MUSAC - Museo de Arte Contemporáneo de Castilla y Léon
www.musac.es
Avenida Reyes Leoneses
24 24008 Léon
Spain
Tel +34 987 09 00 00

Museum Boijmans
www.boijmans.nl
Museumpark 18
3015 CX Rotterdam
The Netherlands
Tel +31 10 441 9400

Museum für Fotografie
www.smb.museum
Jebensstraße 2
10623 Berlin
Germany
Tel +49 30 266424242

Museum of Photography, Thessaloniki
www.thmphoto.gr
Warehouse A', Port of Thessaloniki
3, Navarchou Votsi St.
54624, Thessaloniki
Greece
Tel +30 2310 566 716

National Centre for Contemporary Arts
www.ncca.ru
123242, Moscow
Zoologicheskaya St. 13
Russia
Tel +7 499 254 06 74

National Museum of Photography
1221 Copenhagen
Denmark
Tel +45 33 47 43 08

National Science and Media Museum
www.scienceandmediamuseum.org.uk
Pictureville
Bradford BD1 1NQ
United Kingdom
Tel +44 844 856 3797

Pinakothek Der Moderne
www.pinakothek.de
Barer Straße 29
80333 München
Germany
Tel +49 89 23805360

Portuguese Centre of Photography
www.cpf.pt
Largo Amor de Perdição
4050-008 Porto
Portugal
+351 22 004 6300

Saatchi Gallery
www.saatchigallery.com
Duke of York's HQ
King's Road
London SW3 4RY
United Kingdom
Tel +44 20 7811 3070

Sala Pares
www.salapares.com
Carrer de Petritxol
5, 08002 Barcelona
Spain
Tel +34 933 18 70 20

Tate Modern (London)
www.tate.org.uk
Bankside
London SE1 9TG
United Kingdom
Tel +44 20 7887 8888

The Photographers' Gallery
www.thephotographersgallery.org.uk
16-18 Ramillies St
Soho, London W1F 7LW
United Kingdom
Tel +44 (0) 20 7087 9300

Thessaloniki Museum of Photography
www.thmphoto.gr
Warehouse A', Pier A, Port of
Thessaloniki
3, Navarchou Votsi str.,
54625,Thessaloniki
Greece
Tel +30 231 056 6716

TORCH Gallery
www.torchgallery.com
Lauriergracht 94
1016 RN
Amsterdam
The Netherlands
Tel +31 20 626 02 84

Triennale di Milano
www.triennale.it
Viale Emilio Alemagna
6, 20121 Milano MI
Italy
Tel +39 02 724341

Victoria and Albert Museum
www.vam.ac.uk
Cromwell Rd, Knightsbridge
London SW7 2RL
United Kingdom
Tel +44 (0)20 7942 2000

ASIA AND OCEANIA

Centre for Contemporary Photography
404 George St.
Fitzroy VIC 3065
Australia
Tel +61 3 9417 1549

Irie Taikichi Memorial Museum of Photography Nara City
www.irietaikichi.jp
600-1 Takabatakecho, Nara
Nara Prefecture 630-8301
Japan
Tel +81 742 22 9811

Ken Domon Museum of Photography
www.domonken-kinenkan.jp
2 Chome-13 Iimoriyama, Sakata
Yamagata Prefecture 998-0055
Japan
Tel +81 234 31 0028

Kiyosato Museum of Photographic Arts
3545-1222 Kiyosato, Takane-cho
Hokuto-shi Yamanashi 407-0301
Japan
Tel +81 551 48 5599

Korean Camera Museum
Gwacheon-si
Gyeonggi-do 427-080
South Korea
Tel +82 25024123

Museum of Contemporary Art Australia
www.mca.com.au
140 George St.
The Rocks NSW 2000
Australia
Tel +61 2 9245 2400

Museum of Photography, Seoul
www.photomuseum.or.kr
45 Bangi-dong, Songpa-gu, Seoul
South Korea
Tel +82 2 418 1315

Silk Road Gallery
www.silkroadartgallery.com
210 Keshavarz Blvd.
1417763614 Tehran
Iran
Tel +98 21 2272 7010

Three Shadows Photography Art Centre
www.threeshadows.cn
155A Caochangdi
Beijing City, Chaoyang District 100015
China
Tel +86 10 64322663

Tokyo Photographic Art Museum
www.topmuseum.jp
Yebisu Garden Place
1-13-3 Mita Meguro-ku
Tokyo 153-0062
Japan
Tel +81 3 3280 0099

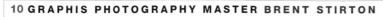

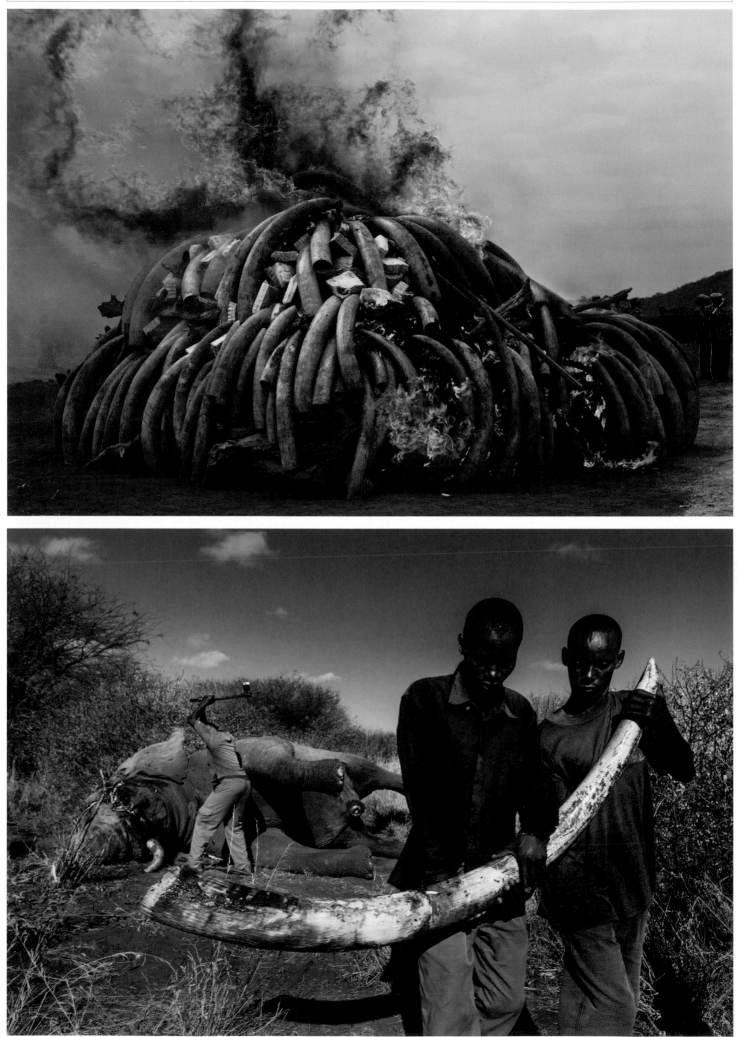

Photography is a weapon to what is wrong in the world. Photos bear witness to the truth.

Brent Stirton, *Photographer*

Starting from Top Left: A pile of ivory is burned in Kenya by the Lusaka Task Force, a group fighting wildlife crime in Africa, in an attempt to deter the illegal ivory trade, which kills 30,000 elephants every year. ■ An undercover Kenya Wildlife Services (KWS) ranger works with villagers to detusk an elephant killed by poachers in the Amboseli ecosystem, Kenya. The ivory was sent to KWS headquarters. ■ A program in southern Kenya recruits Lion Guardians among the Maasai, some former lion killers, to monitor lion movements and prevent conflicts with herders and cattle. ■ Conservation Rangers from an anti-poaching unit work with locals to evacuate the body of a silverback mountain gorilla killed in mysterious circumstances in Virunga National Park, Eastern Congo. In clashes with local illegal operators, more than 100 Rangers have been killed in their efforts to protect the gorillas, among the world's most endangered species.

BRENT STIRTON
A South African native, Brent Stirton is senior photographer for the assignment division of Getty Images. His photographs have appeared in publications including National Geographic, Newsweek, Time, The New York Times Magazine, Geo, The Sunday Times Magazine, and many others. Stirton has won awards from organizations including the United Nations, the Overseas Press Club, World Press Photo, Visa Pour l'Image, and the Lucie Awards.

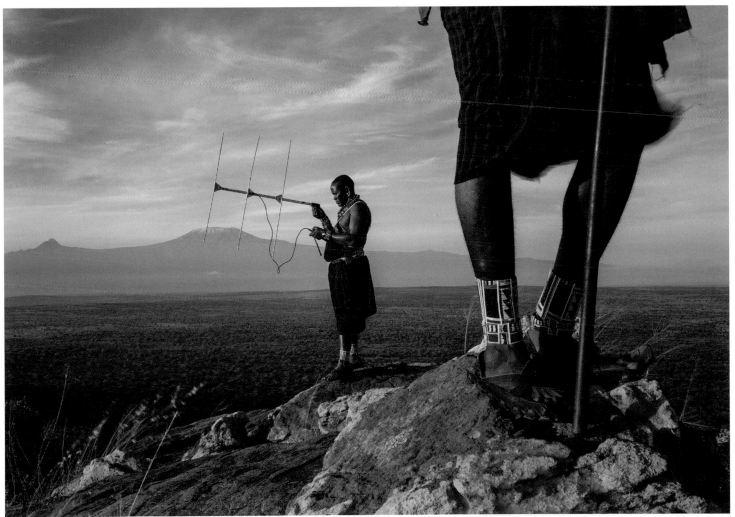

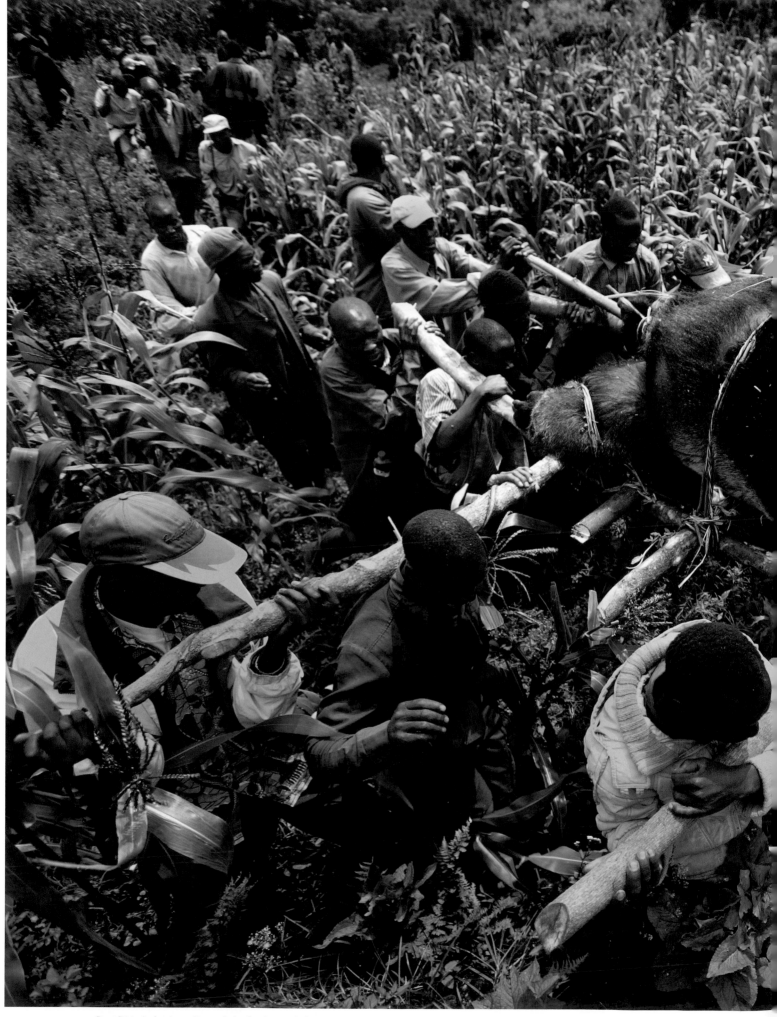

Brent Stirton's photojournalism work shot for clients including National Geographic, Newsweek, Time, The New York Times Magazine, Geo, and others

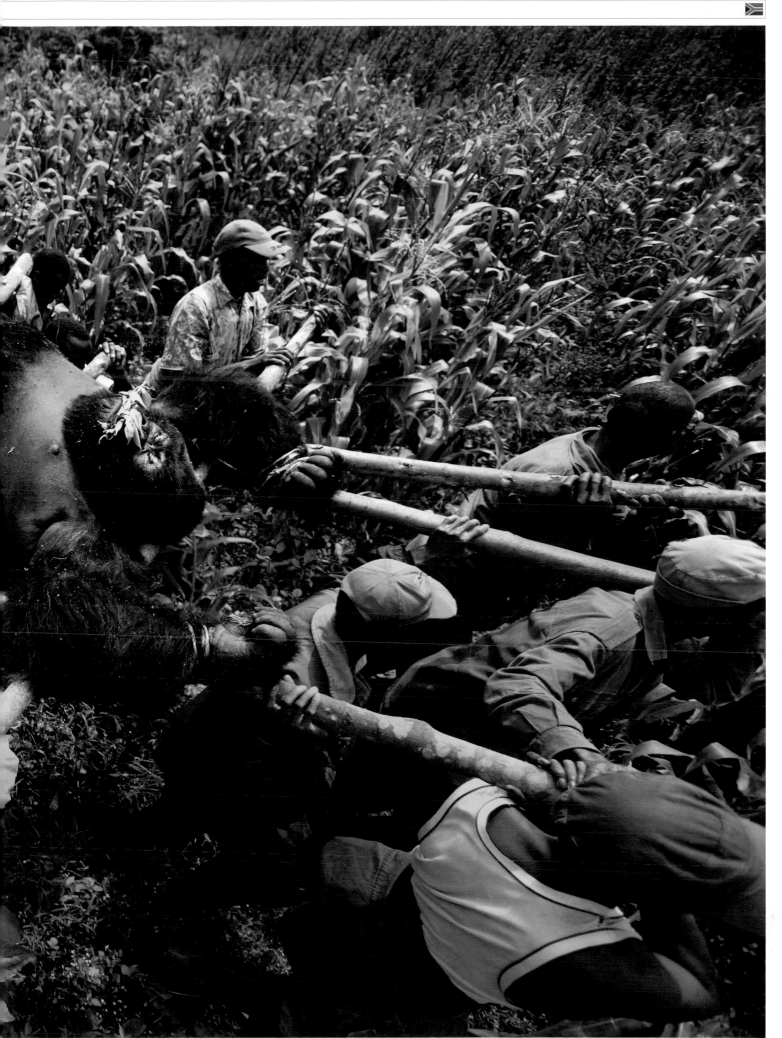

See Brent Stirton's feature in *Graphis Journal Issue #357* to learn more

Most of my career was spent behind an 8×10 Sinar Camera, a single light bank, and a never-ending supply of 8×10 Polaroids.

Terry Heffernan, *Photographer*

TERRY HEFFERNAN Portrait by *Michael Heffernan*
Terry Heffernan is a photographer who splits time between San Francisco and rural Montana. He has produced award-winning photographs for national ad campaigns, annual re-ports, and prestigious publications. Along with his photographs of collections in the National Baseball Hall of Fame, the Peabody Museum, and the American Museum of Fly-Fishing, Heffernan continues to build upon his ongoing museum collections series, American Icons.

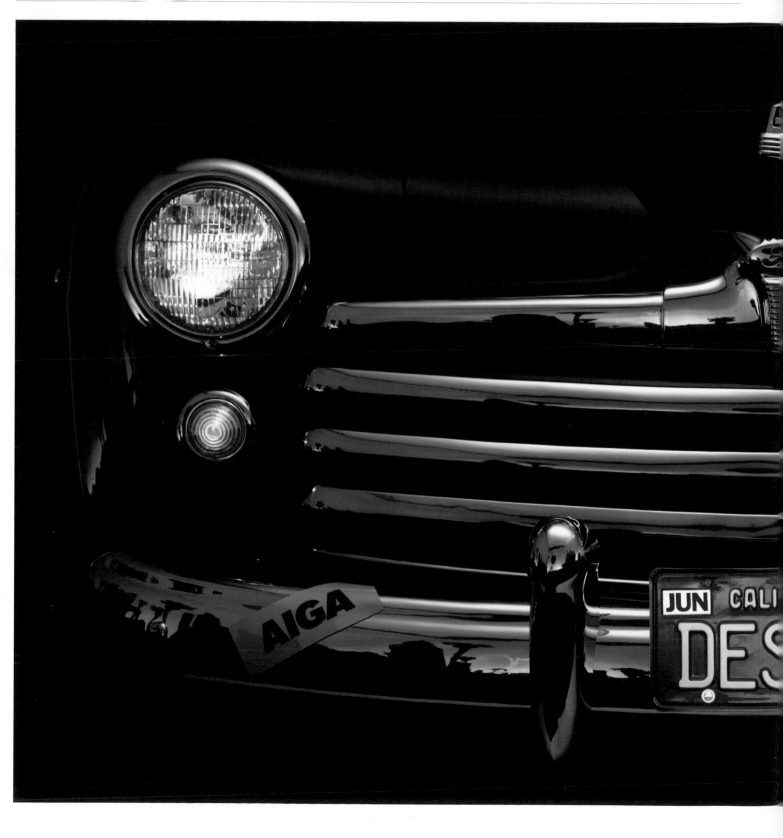

Terry's passions lie in the American spirit. Working tirelessly to present the nostalgia of American flair, Terry Heffernan has spent his entire career propelling Americana values and traditions through photography and film. His subjects range from America's pastime (baseball) to the Civil War. Having worked on numerous national commercial campaigns to bring the American way of life into the products that showcase that ethos, Terry is a true patron of America's soul. He is currently working on a series that is an amalgamation of more than four decades of work in large and medium format. Whether presenting an AIGA conference (as seen above) or the esthetics of fly fishing (spread on next page), Terry's collection of work serves as a visual exploration of what it means to be an American.

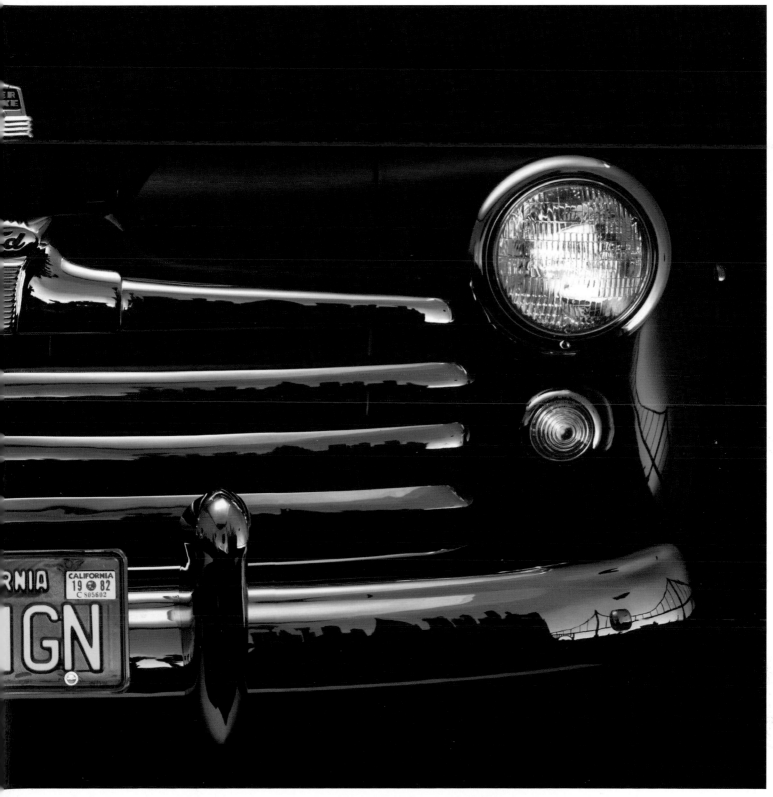

A photograph by Terry Heffernan created for AIGA

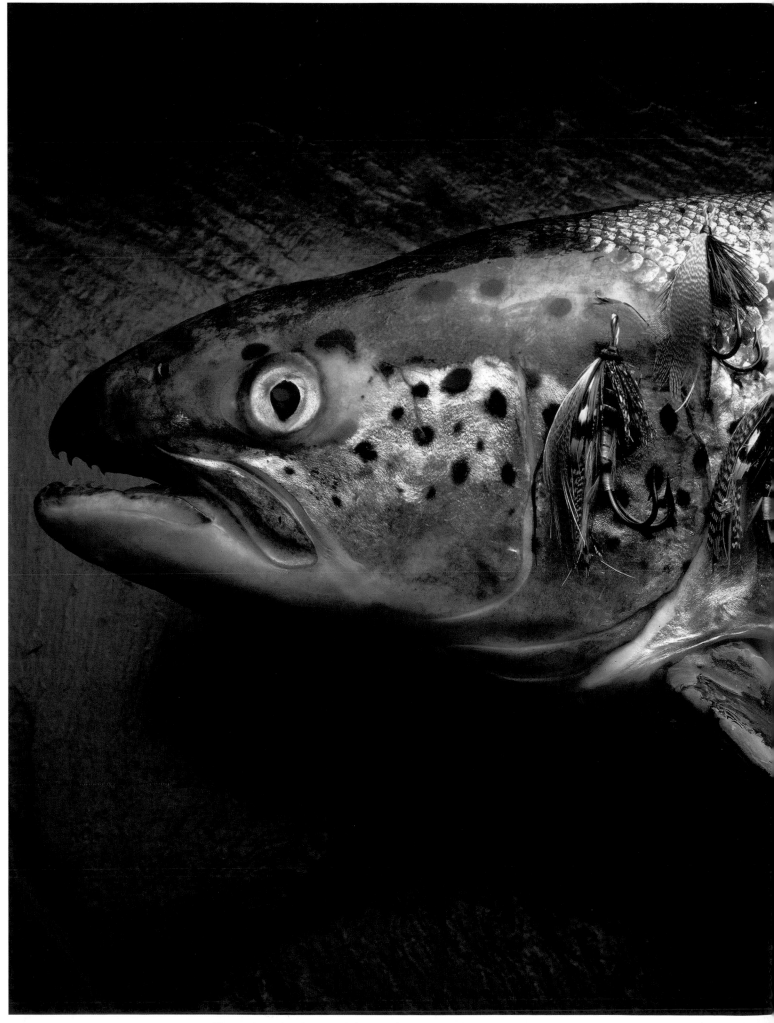

"American Icons: Fly-Fishing Series," drawing on his passion for fly fishing in Montana

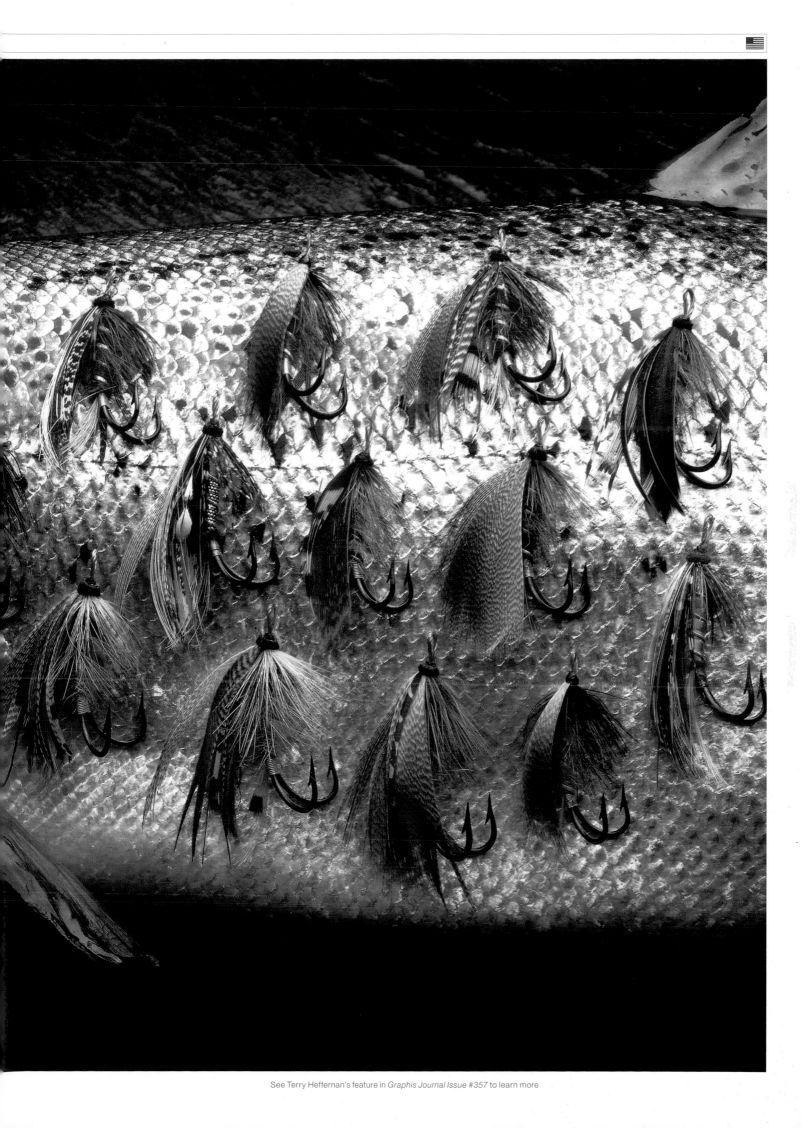

See Terry Heffernan's feature in *Graphis Journal Issue #357* to learn more

Kah Poon | www.kahpoon.com

Biography: Kah Poon is a New York City-based fashion and portrait photographer. He graduated from Brigham Young University in 1995 with a BFA in photography and has been working in New York for the past 24 years. A native of Singapore, Kah is best known for work that is simple, reposed, clean, and graphic. His recent work has crossed over into dance photography. Kah's work has been awarded by Graphis, Polaroid, Fujifilm, Adobe, Hasselblad, Communication Arts, LICC, ICA, and IPA. In addition to photography, Kah is a former competitive swimmer and dancer.

Commentary: After looking through all nine categories, it's good to know that the photography world is continuing to produce innovative and quality work. I saw the most innovation and creativity in the still life category. There were some great ideas there, abstract thinking, and great messages. Almost all the work showed a high degree of technical expertise but the ones that truly stand out combine expertise with artistry, some even with a sense of mystery.

Gregory Reid | www.gregoryreidphoto.com

Biography: Gregory graduated with a BFA in photography from the School of Visual Arts. He currently lives and works in Brooklyn, NY with his studio located in Clinton Hill. Taking influences from Pop Art and Surrealism, he loves working with graphic and bold color compositions to bring in the next generation of still life photography. Gregory is a recent recipient of the Graphis Platinum Award. His work has been featured in editorial publications such as W Magazine, TIME, Newsweek, and The Atlantic; with commercial clients ranging from Coach, Saks Fifth Avenue, Stoli, and Sephora, among others.

Commentary: It was an honor to be on the panel for this year's competition. I really enjoyed getting an inside look at all of the groundbreaking work from around the world. Artists are pushing the envelope, and it's exciting to observe the new wave coming forth in the medium.

Adam & Robin Voorhes | www.voorhes.com

Biography: Adam met Robin. He complimented her shoes, she wasn't buying it. That was the beginning. They were married in a dog park by a fellow photographer who had been ordained online. The only camera at the wedding was a Polaroid SX 70. It has worked out. Adam's talent for pointing lights and pressing shutters pairs well with Robin's ability to build stuff and things out of stuff (& thing). They have brainstormed, sketched, built stuff and photographed things for editorial and commercial clients such as Wired, Fortune, Details, O Magazine, GQ, Ceasars Casinos, and AT&T. When not in their gospel church converted into a studio, they can usually be found on a patio with a margarita in one hand, a sketch pad in the other and two ill behaved bulldogs at their feet.

Christopher Wilson | www.christopherwilsonphotography.com

Biography: After 15 years in the advertising world as a writer and art director, Christopher jumped off a cliff to start Christopher Wilson Photography in 2003. As an advertising creative, Christopher created a vast portfolio of powerful campaigns for some of the most recognized luxury brands there are, including Audi, Infiniti, Jaguar, Nikon and Ritz-Carlton to mention only a few. Now Christopher is bringing all that experience and passion to his photography - and it shows. Christopher leapt from agency creative to global photographer, landing projects with some of the most sought-after brands on the planet, and in just about every country on the planet it seems. Whew. When Christopher was young and dumb, he was a ballet dancer. He danced eight hours a day, made zero money, survived on bread and coffee, lost twenty pounds he didn't have, looked like hell and broke his ankle twice. What an idiot. Before that, he was at Dartmouth College where he studied Ancient Greek and Latin Literature. Good stuff to know, he says, if you ever want to work in the Vatican. He is an obsessed mountain biker and enters races whenever he can, which is never because he is too busy working and taking care of his two beautiful daughters, by far the best things he has ever created. His wife, Cathy, lives in the center of his heart.

Commentary: The only way I know how to judge other people's photography is to judge it the way I critique my own photography, which is ruthlessly. It's either great or it's incomplete. It resonates or it needs more work. It's all there or it requires more thought. I didn't put much weight on the constraints of the assignments, as I feel it's the photographer's responsibility - always - to transcend those chains and engage the audience. To that end I didn't give a lot of points to work that I felt was perfectly executed but lacked substance, as I find pyrotechnics without heart to be soulless. I also didn't give a lot of points to work that was intrinsically compelling but was compositionally weak - which was hard for me, as I feel a lot of these images could have been stunning with more attention to craft. The images that rose to the top for me were the ones that did both - showed technical prowess AND somehow rearranged my molecules a bit. These images were a joy to see, with one of the more inspiring campaigns (for me, anyway) being Todd Anthony's project documenting the truck drivers of Japan. It gave me a glimpse into a world I never knew of. Wonderful stuff. ■ To all the photographers that entered, thank you for putting your work out there. It takes enormous courage to let others judge your babies. I bow to you, your babies and your courage. And to Graphis, thank you so much for letting me be a judge. I guess it means I must be doing something right. I promise not to let it go to my head though. Instead I think I'll just put my head down and work even harder so that when I'm ninety, if someone asks me why I'm still working like a dog at this photography thing, I can say what the legendary cellist, Pablo Casals, said at ninety: "Because I think I'm making progress."

The images that rose to the top for me were the ones that both showed technical prowess *and* somehow rearranged my molecules a bit.

Christopher Wilson, *Photographer*

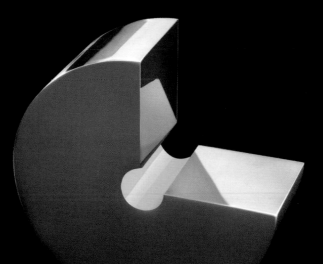

Curious Productions | Page: 22, 23 | www.curious-productions.co.uk

Biography: Curious Productions are an innovative, creatively-driven and independent business that put client collaboration at the forefront of everything we do. Our studios in the heart of London are home to talented photographers, retouching and CGI artists, filmmakers, animators, designers and producers. We partner with global brands and creative agencies to create campaigns from initial concept through to final execution and delivery.

Athena Azevedo | IF Studio | Page: 24 | www.ifstudiony.com

Biography: Athena Azevedo, is a photographer, art director, producer and curator. Her photographs are often bold, colorful and highly graphic, rooted in journalism and fine art.

As the in-house photographer at IF Studio, Athena's work has won numerous awards since 2014.

Athena's photography has been featured in ad campaigns in Vanity Fair, Architectural Digest, New York Magazine and the Wall Street Journal. She has photographed top models Bobby Roache and Tereza Bouchalova, internationally renowned Chef Nobu, as well as portraits of significant emerging and established artists, such as composer João MacDowell, virtual reality filmmaker Eliza McNitt and choreographer Regina Miranda.

Caldas Naya | Page: 25 | www.caldasnaya.com

Biography: Established in 2003, we at Caldas Naya believe that agencies should leave their chic offices in uptown neighborhoods and get out on the streets. By doing it we can be close to people, go where they go, feel what they feel - whether it's a mall, a university, a club or a cafeteria. We don't only rely in statistics and focus groups; we share the experience of living the brand together with the end consumer. Our philosophy doesn't depend on a whim or a fad. We believe that by keen observation of all that surrounds us we can communicate in a way that the consumer will intimately understand an experience the brands.

Michael Schoenfeld | Page: 26-28 | www.michaelschoenfeld.com

Biography: Intimacy is one of those essential, yet hard to quantify traits of being human. Rather late in my life I discovered it's unconscious grip on every moment. The ultimate coin-toss of connection with others. Why did I chose to photograph people? Why did I chose to do it inches from their face, feeling their presence, mostly with strangers? And why was that ritual complete by some moment that I subconsciously knew I had arrived at? I think my childhood was primarily the answer; wonderful, emotionally detached, mid-century, American parents, doing their best, mostly on auto-pilot, teaching me to stay an arm's length from my feelings. Takeaway for me?; no auto-pilot for me; ever, ever. So, here I am, usually approaching those wonderful strangers, and asking (sometimes in Swahili) "May I please take your picture?" It is in that moment I feel them; that I've somehow met them, and I'm satisfied. May I live to be a thousand.

Stan Musilek | Page: 29, 31 | www.musilek.com

Biography: Born in prague (before prague was cool) / makes dark room in mother's pantry / gets grounded / photographs neighbors (relentlessly) / family flees czechoslovakia / becomes German / college in Heidelberg / studies mathematics / realizes photography is sexier than math / assists / shoots girls / forgets math ever existed / becomes American / starves / parties / works ass off / wins ncaa division I soccer championships / trip on motorcycle from nyc to tierra fuego and miraculously back / opens studio in San Francisco / shoots lots of stuff / wins lots of awards / 2nd studio in Paris / makes clients laugh / the phone keeps ringing / we keep picking it up.

Jonathan Knowles | Page: 30 | www.jknowles.com

Biography: Jonathan Knowles is an advertising photographer and film maker. Specializing in drinks, liquids, graphic still life and special effects, Jonathan's unique energetic style and technical ability have earned him award-winning advertising commissions Worldwide.

In the past sixteen years, Jonathan has consistently featured in the '200 Best Advertising Photographers in the World' books. He has been awarded for both stills and moving image by PDN, D&AD, Graphis, The Art Directors' Club of New York, Communication Arts, The Association of Photographers, Campaign, The Globals and others. Notable commissions include campaigns for many globally recognized brands, such as Coca-Cola, Nespresso, Heineken, Rimmel, Glenfiddich, Nike, Guinness and Smirnoff.

Andreas Franke | Staudinger + Franke | Page: 32 | www.staudinger-franke.com

Biography: Andreas Franke studied photography and graphic design in Vienna and started to work as assistant photographer. He has been in the business for nearly 30 years now, specialized in creating still life photographs. During his long career he built a widely recognized photography studio with a reputation that extends far beyond the borders of Austria today.

With his company staudinger+franke he works for clients around the world in Vienna, Milan, Zurich, London, Berlin, Beirut, Dubai and New York and throughout the United States.

Parish Kohanim | Page: 33 | www.parishkohanim.com

Biography: Committed to staying original, diverse, timeless and unique while capturing beauty is Parish's paradigm and philosophy in his personal life and career.

"The very essence of art is beauty. I feel privleged and fortunate to be able to spend time capturing the infinite and sublime beauty of creation. It is a gift that humbles and centers me, letting me to escape from the excessive noise in our world.

A self-taught photographer, holding a degree in film, Parish started his career by photographing hundreds of major advertising campaigns for major clients both domestic and international. He is the recipient of many prestigous awards, and has been commited to focusing on his true calling. He strives to stay fresh and inventive by photographing a broad range of fine art photos.

Joseph Saraceno | Page: 34, 35 | www.josephsaraceno.com

Biography: Toronto born still life photographer Joseph Saraceno started photography as a teenage hobby, which quickly developed into a nagging obsession. Recognized not only in Toronto, but also internationally, Joseph's work covers a broad spectrum.

Joseph takes a fluid approach to his work, letting the formal qualities of an object drive the creative direction. Strong directional lighting, contrasting textures and bold angles are signatures of his work, which has been featured editorially in Sharp Magazine, S Magazine, ELLE Magazine, Globe & Mail and in advertisements for BITE Beauty, SDM, WINNER'S, Holt Renfrew, Hudson's Bay Beauty.

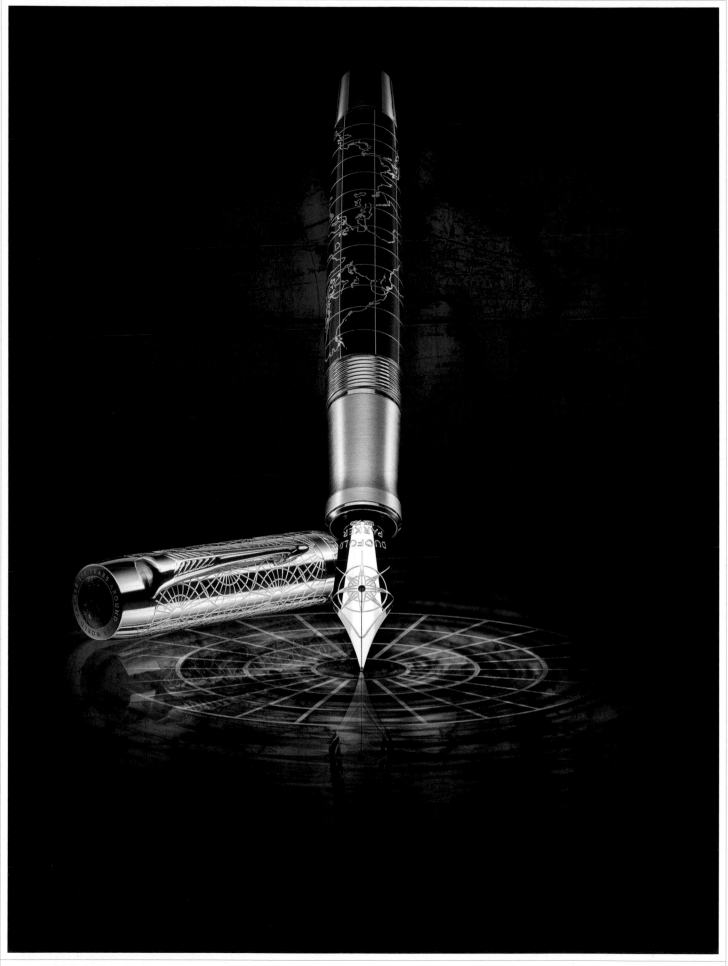

Parker Duofold / The Craft of Travelling | Parker Pens / Newell Brands

Assignment: Celebrate Parker's 130th anniversary and to pay tribute to founder, George Safford Parker.
Approach: Create a premium image that embodied the craft of traveling, whilst making a hero of the pen and its fine detailing.
Results: The image was used worldwide in advertising and promotions.

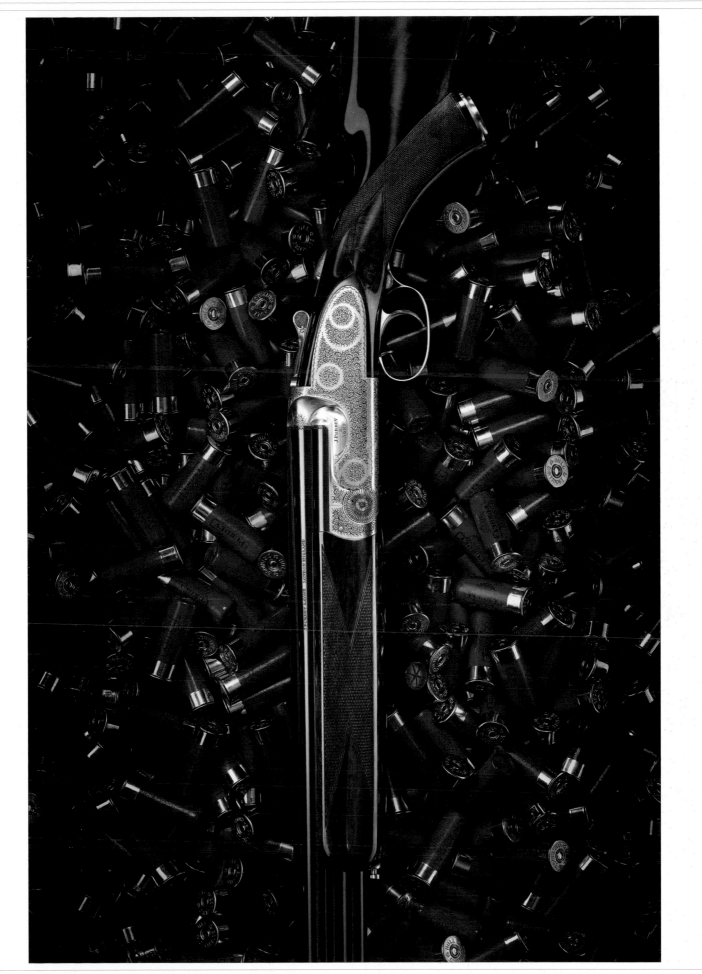

Purdey / Where Style Meets Strength | James Purdey & Sons

Assignment: To shoot and deliver a new advertising hero image to introduce the new Purdey Trigger Plate Over-and-Under Gun.
Approach: Simply nestle the gun on a bed of multiple, fresh Purdey cartridges to leverage the idea that the gun had undergone rigorous testing.
Results: The image was used by Purdey for brand advertising, point of sale and across digital channels.

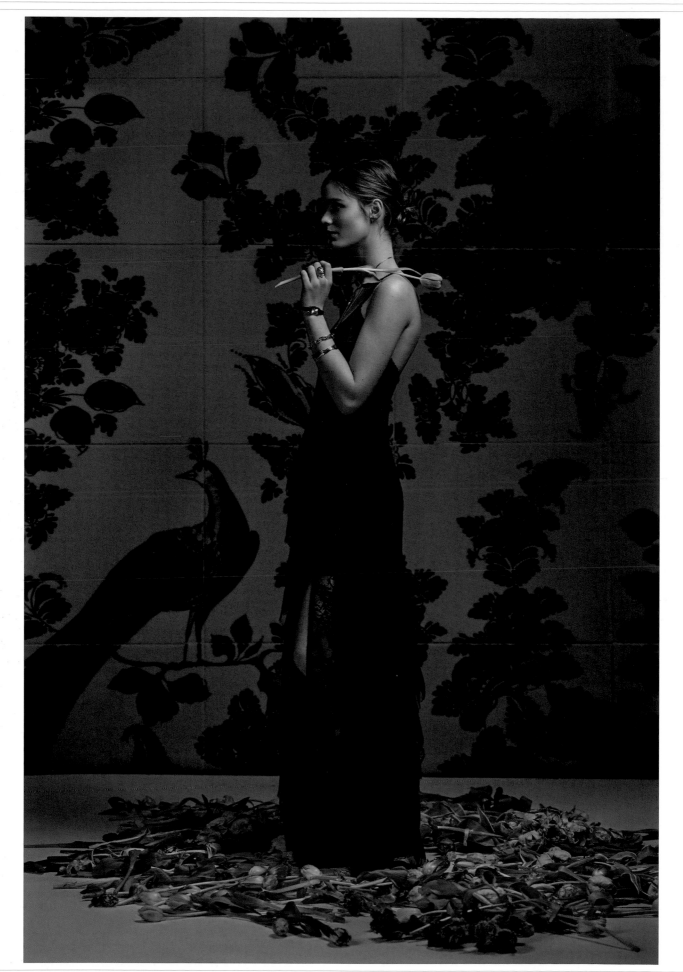

19 Dutch Portrait Woman | Carmel Partners

Assignment: Campaign and brochure photography for 19 Dutch, a luxury rental in the financial district of Manhattan.
Approach: The 19 Dutch campaign we created revolved conceptually around "All things Dutch."
Results: It evokes both the old and new world "Dutch" quality, while serving as an iconic image for the building's marketing materials.

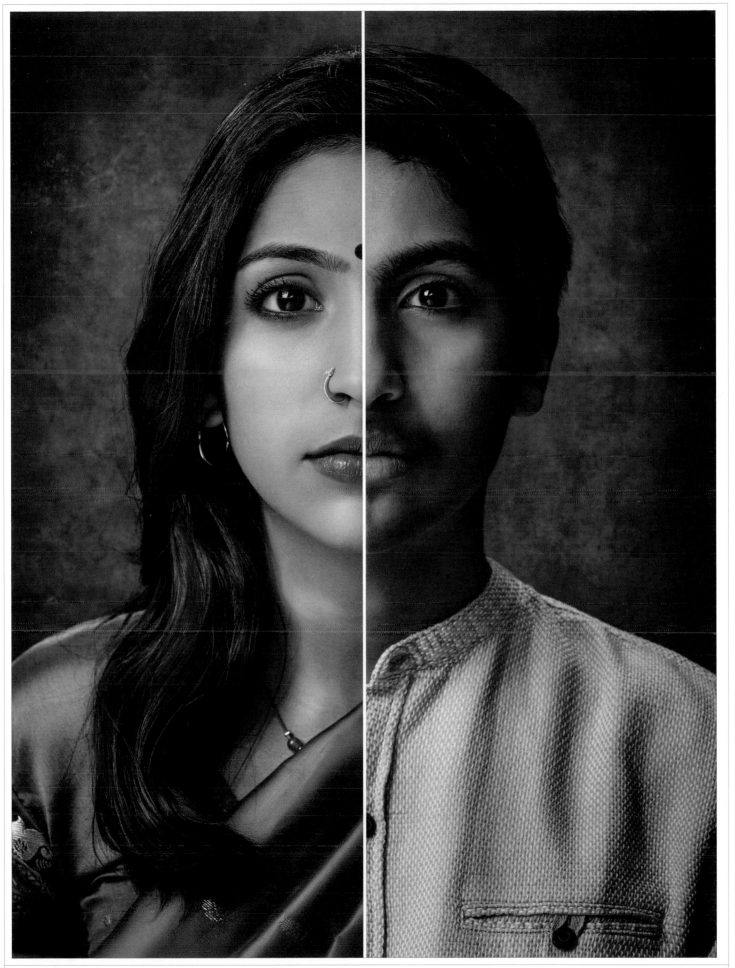

Girl/Boy | Sonrisas de Bombay/Mumbai Smiles

Visit website to view full series

Assignment: Sonrisas de Bombay, an NGO based in Barcelona and Mumbai, asked to create a campaign to denounce the inequality.
Approach: We came up with a simple, direct and "in your face" concept.
Results: The campaign is changing the mentality of people from India, and Sonrisas de Bombay is getting new members every month.

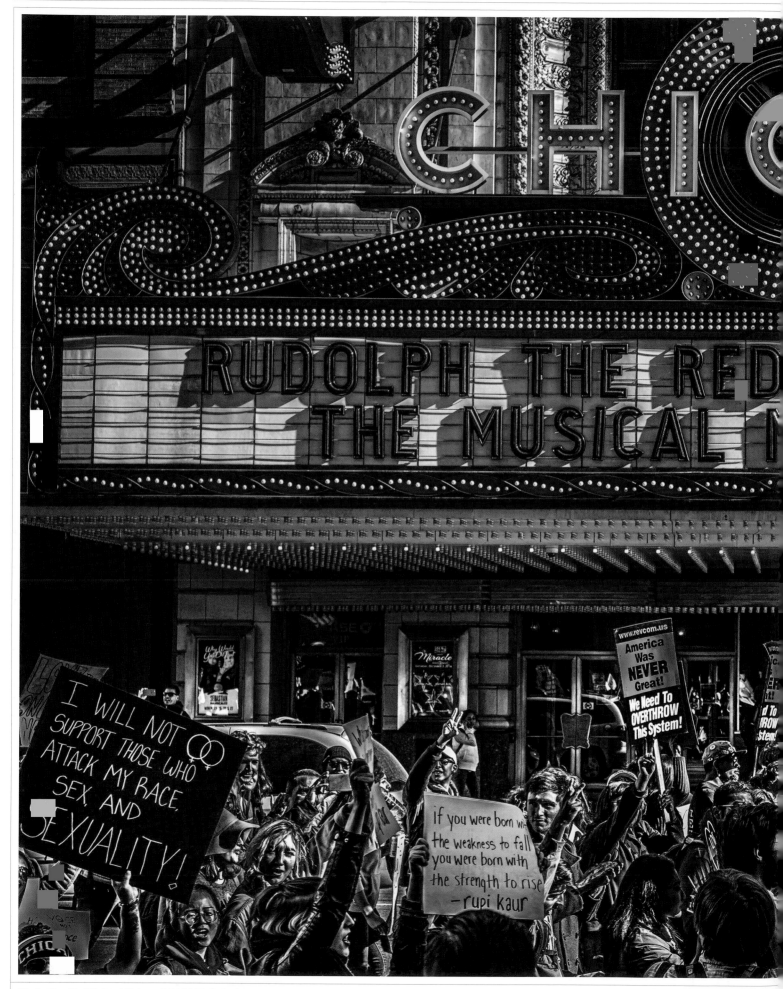

Marketing for Michael Schoenfeld 2018 Color | Self-Initiated

Assignment: Series of images for 2018 marketing campaign.
Approach: I believe all creativity centers around the the subject of intimacy that the artist experiences in the dance with their subject.

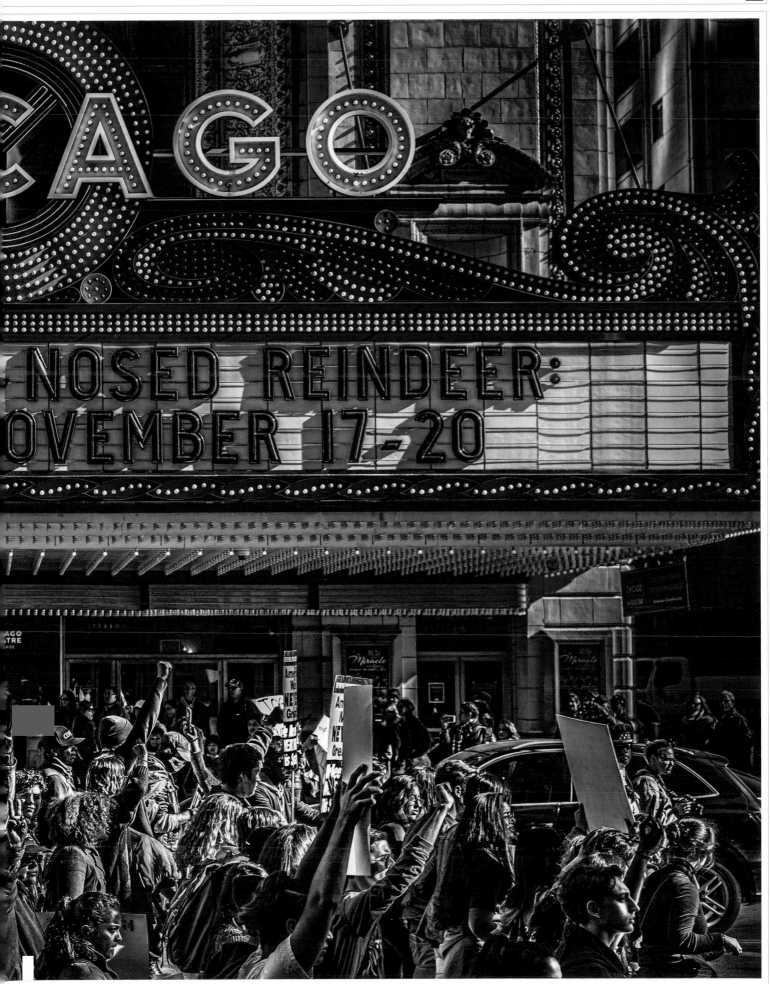

It's therefore very personal, and always says more about the artist than the subjects of the work.
Results: Various national editorial assignments and inquiries.

Marketing for Michael Schoenfeld 2018 Color | Self-Initiated

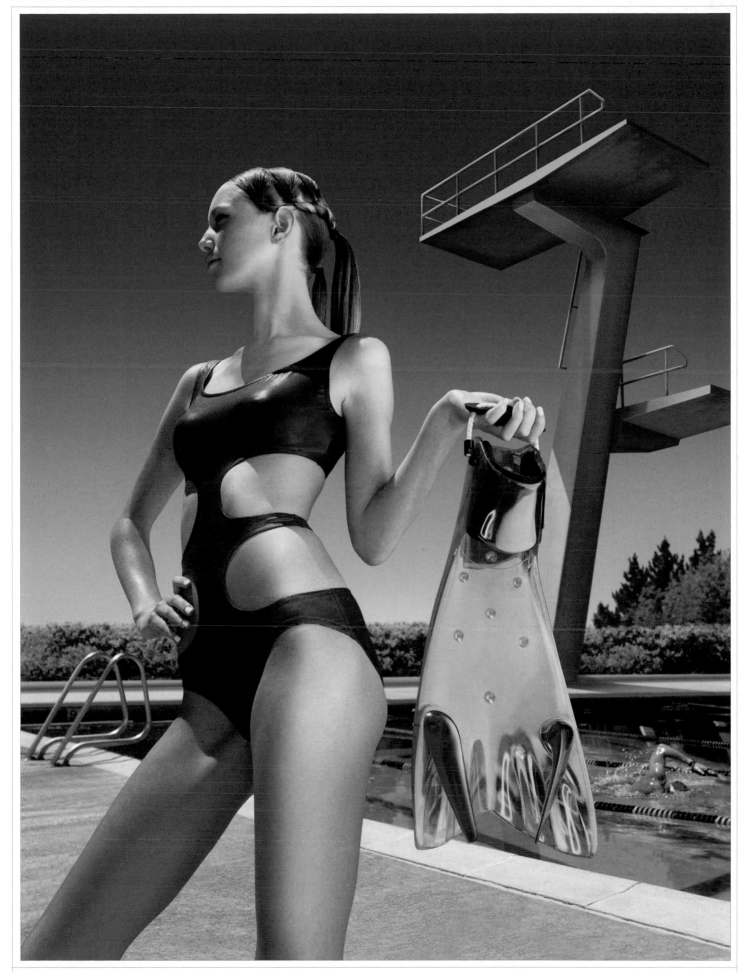

Musilek-Atomic | Atomic

Assignment: Ad for Atomic. They make these very cool fins.
Approach: Location shoot which Stan AD'ed as well.
Results: Happy client, happy crew, happy model - all in all well-rounded day.

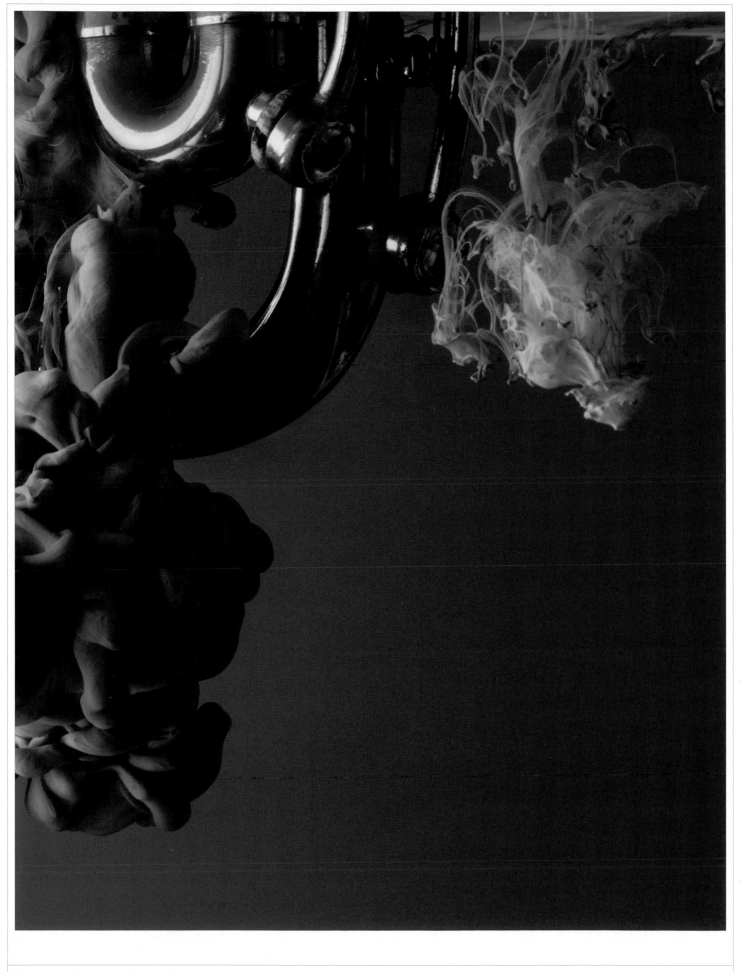

Underwater Symphony | Luxure Magazine

Visit website to view full series

Assignment: This began as a personal project where I took the trumpet I had played as a child and wondered what I could do with it.
Approach: My original thought was to shoot bubbles, but once I created the brown background, I decided to add the brown billowing clouds.
Results: The initial images were seen by Luxure Magazine, who wanted to run it as a fine art story, and for which we shot some additional executions.

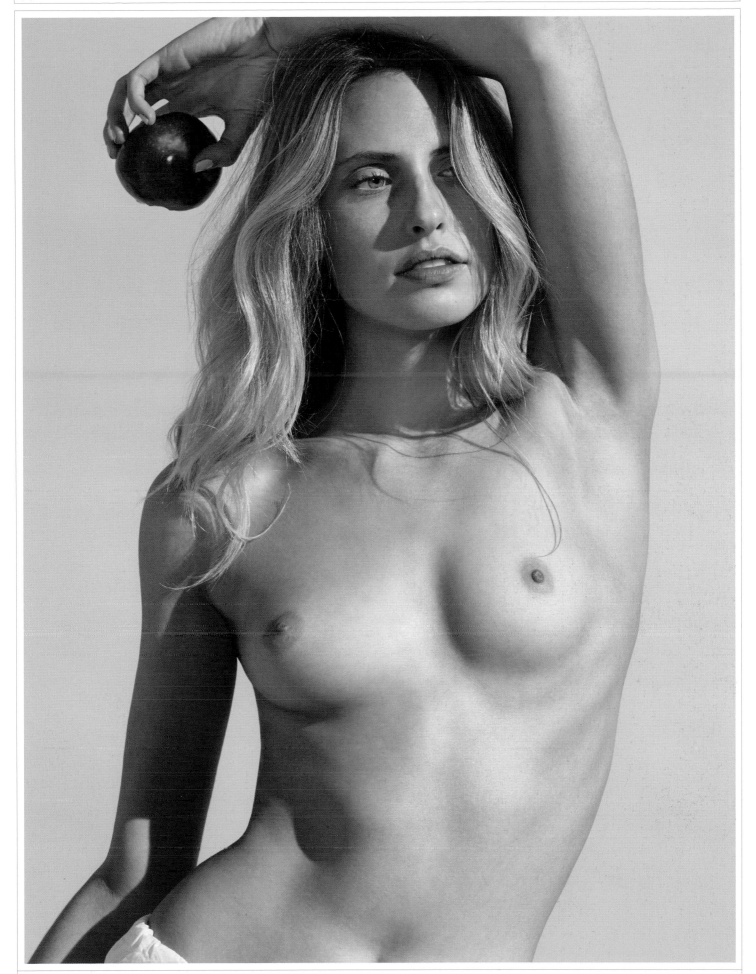

Musilek-Katie-F-temptation | Adcos

Visit website to view full series

Assignment: Skincare ad.
Approach: "Temptation" as a concept.
Results: An apple a day keeps the doctor away ;).

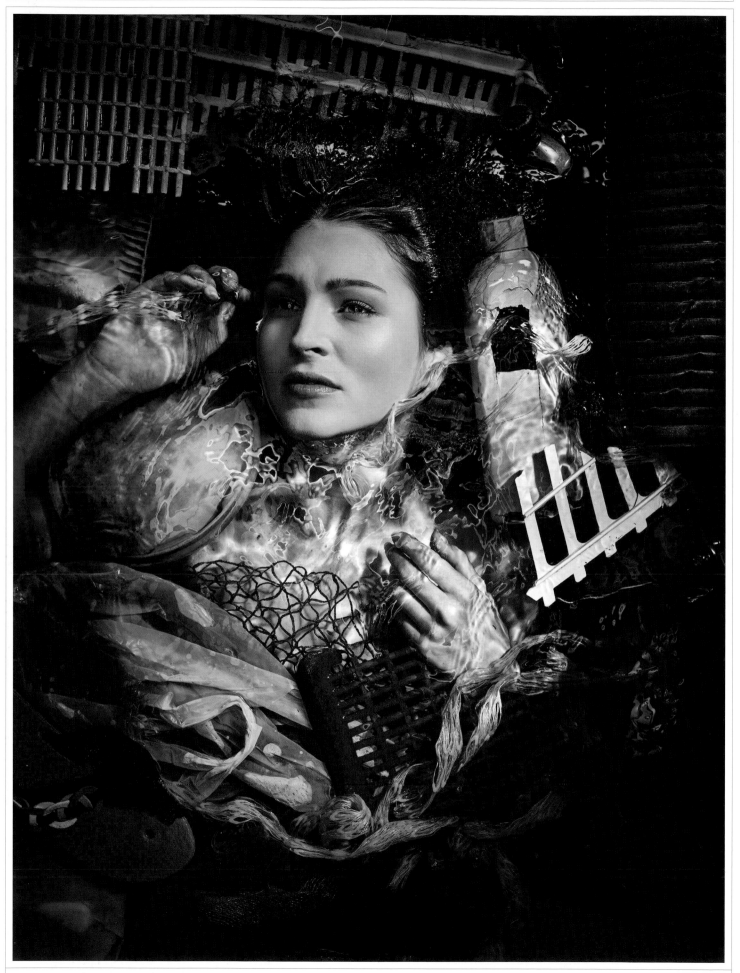

Plastic Ocean | Self-Initiated

Visit website to view full series

Assignment: Development of visually impressive images that should draw attention to the pollution of the oceans with plastic waste.
Approach: All the plastic for this project was collected by hand at beaches along Italy's coastline.
Results: Consistently positive feedback, likes and awards, and hopefully an impetus for everyone to restrict plastic consumption.

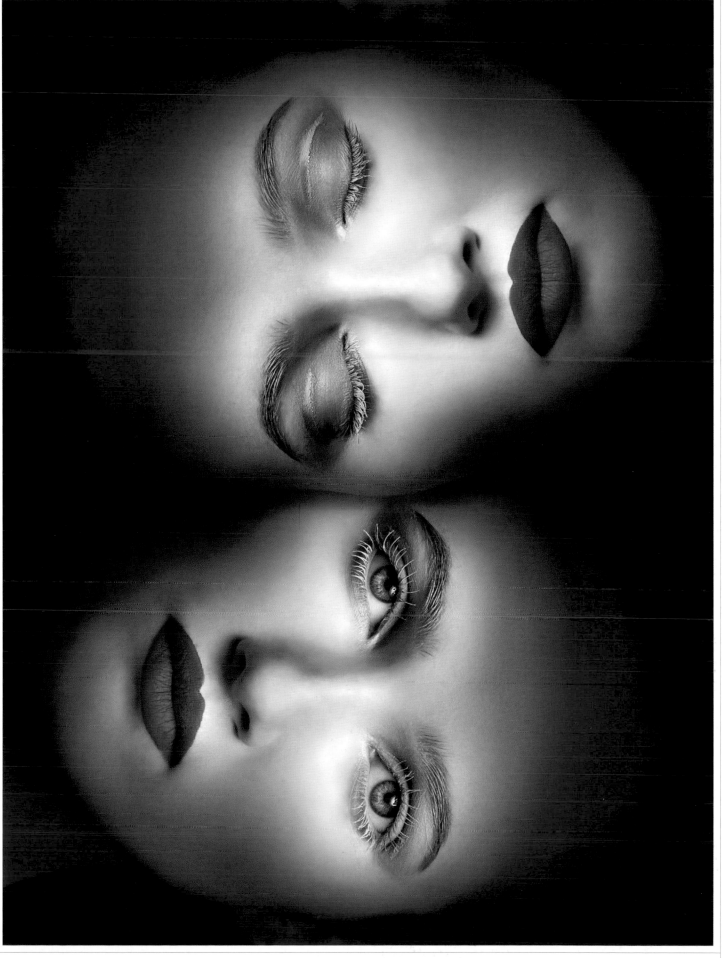

Eyes Open/Closed | Self-Initiated

Assignment: This image depicts the duality of choices that exist in our lives.

Approach: Once I start to photograph, I'm so embraced in the field of non-thinking and focused on an image that has a new and compelling message.

Results: I think this image has been receiving very positive feedback, not only from my clients but also from other galleries that represent my work.

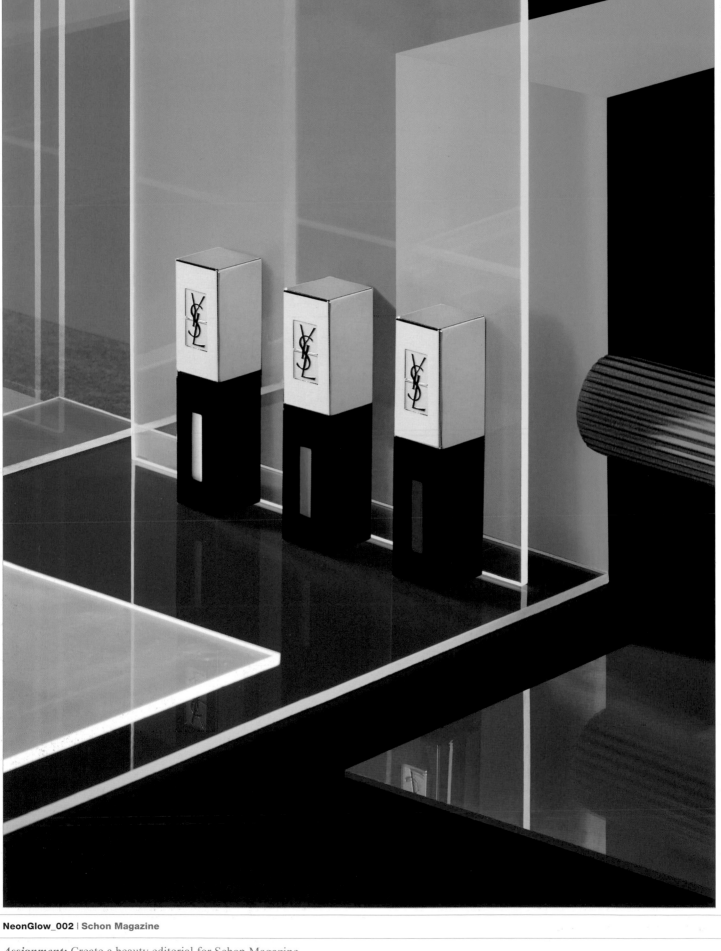

NeonGlow_002 | Schon Magazine

Assignment: Create a beauty editorial for Schon Magazine.
Approach: Using beauty products, coloured plexi and coloured paper to create an editorial.
Results: Editorial for Schon Magazine based in London England.

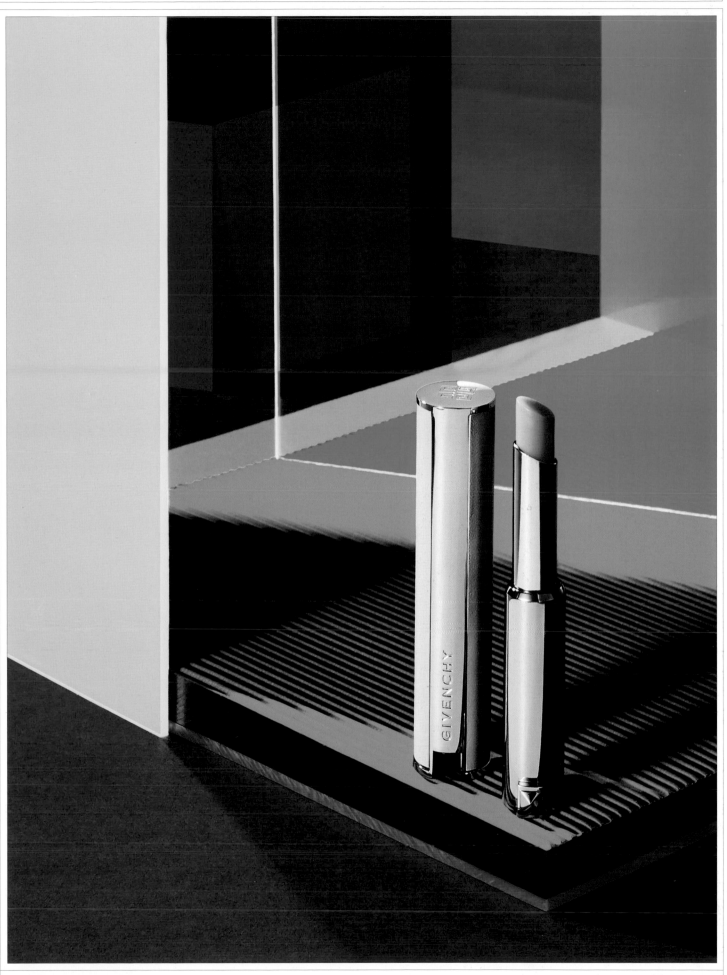

NeonGlow_001 | Schon Magazine

Assignment: Create a beauty editorial for Schon Magazine.
Approach: Using beauty products, coloured plexi and coloured paper to create an editorial.
Results: Editorial for Schon Magazine based in London England.

19 Dutch Portrait Man | Carmel Partners

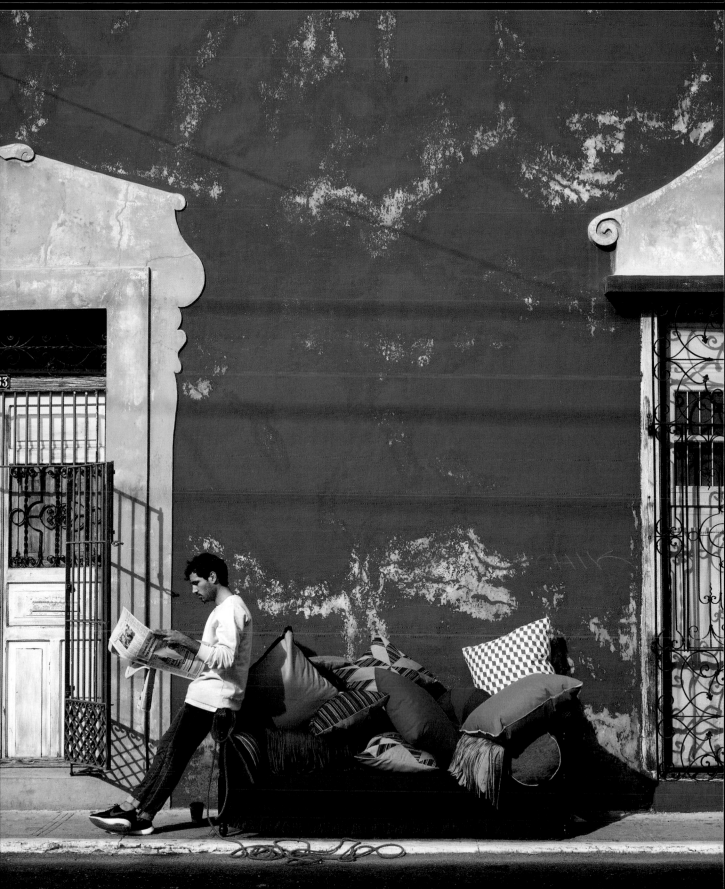

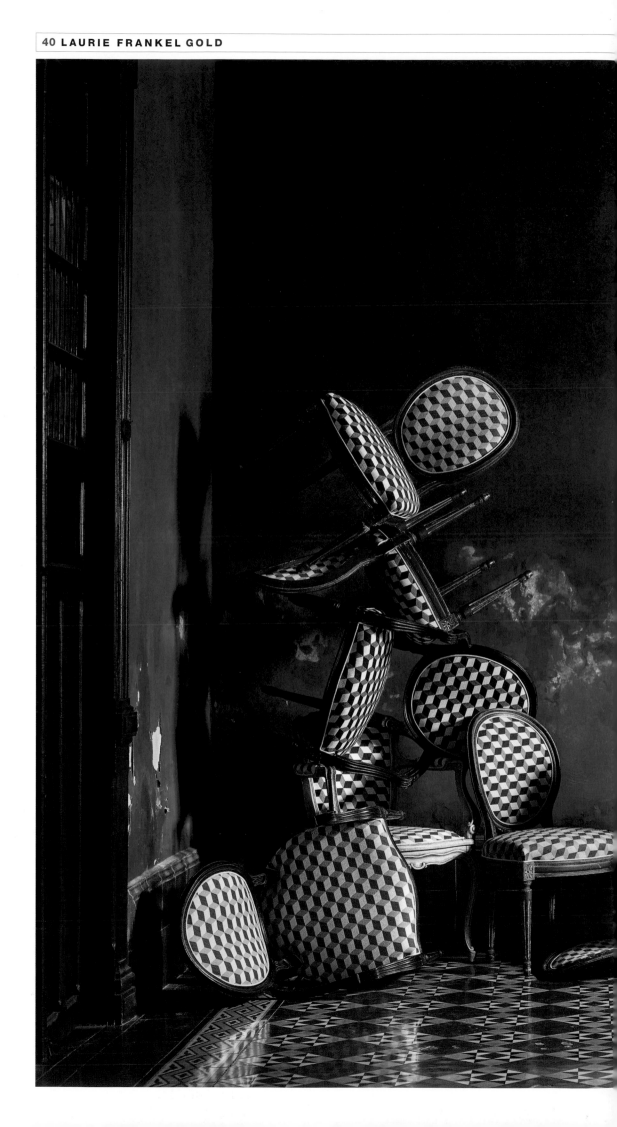

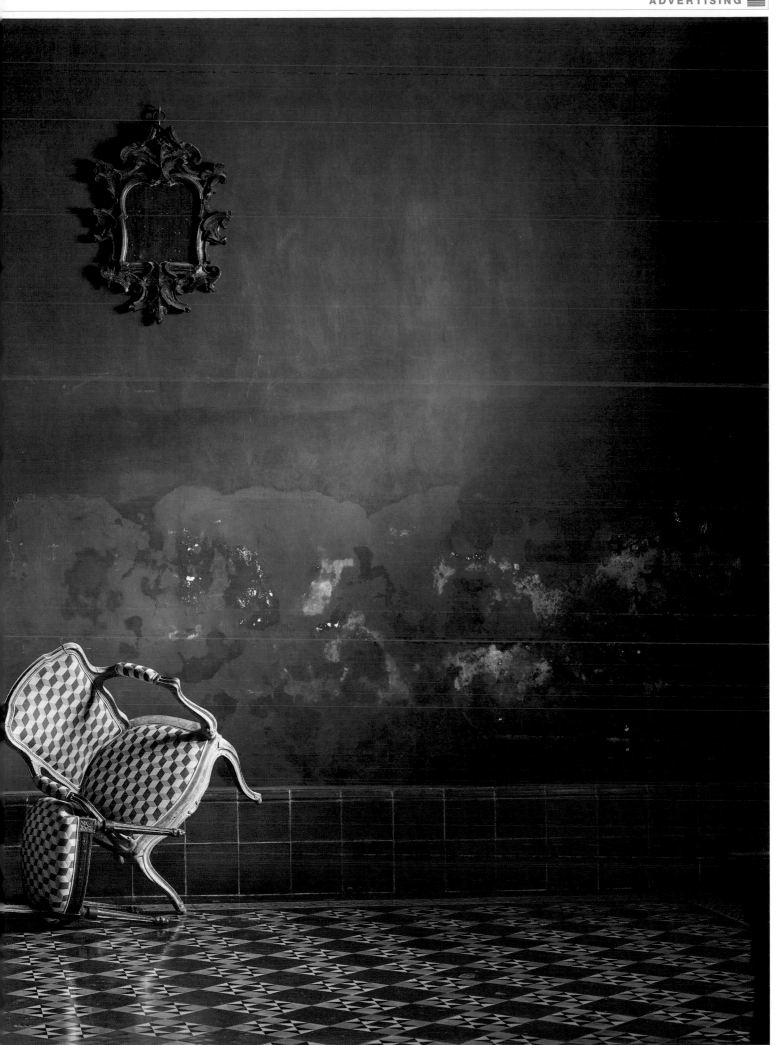

Stacked Chairs | Sunbrella

Who is the real animal? | PETA

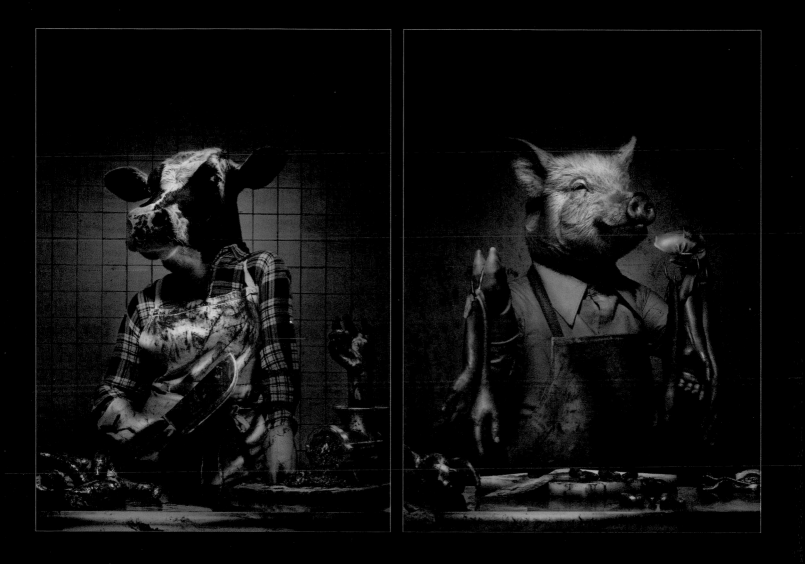

Who is the real animal? | PETA

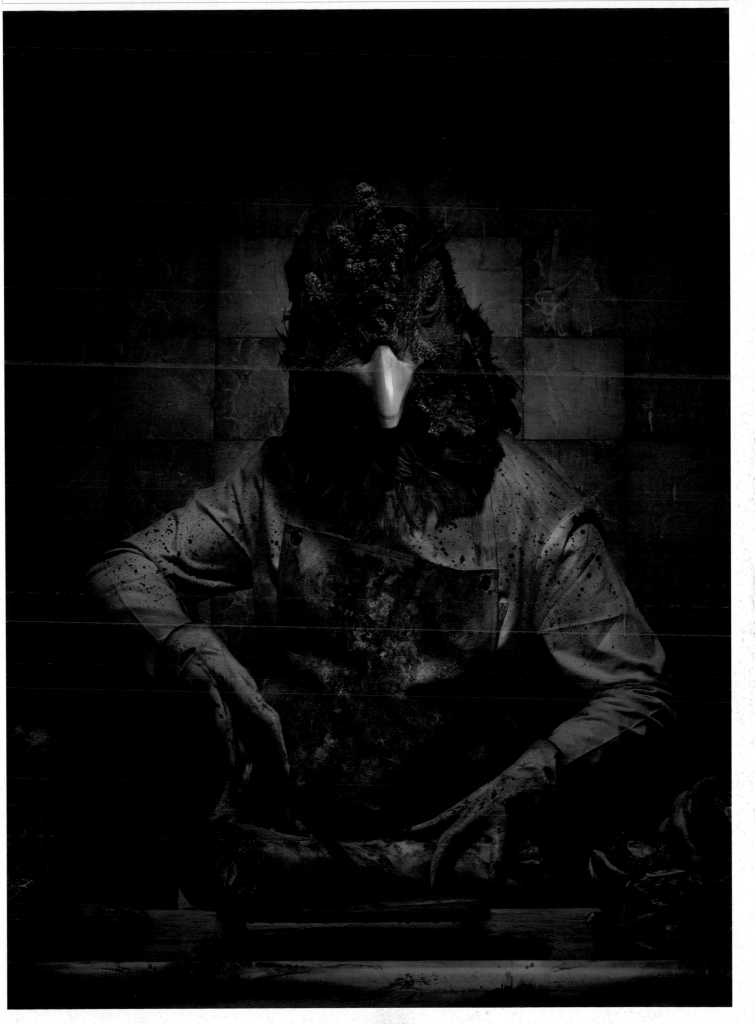

Who is the real animal? | PETA

Sorona Carpet | DuPont

Visit website to view full series

45 MARK BRAUTIGAM GOLD

Toast To Hope | Iron Town Harley-Davidson/ALS Association Wisconsin Chapter Visit website to view full series

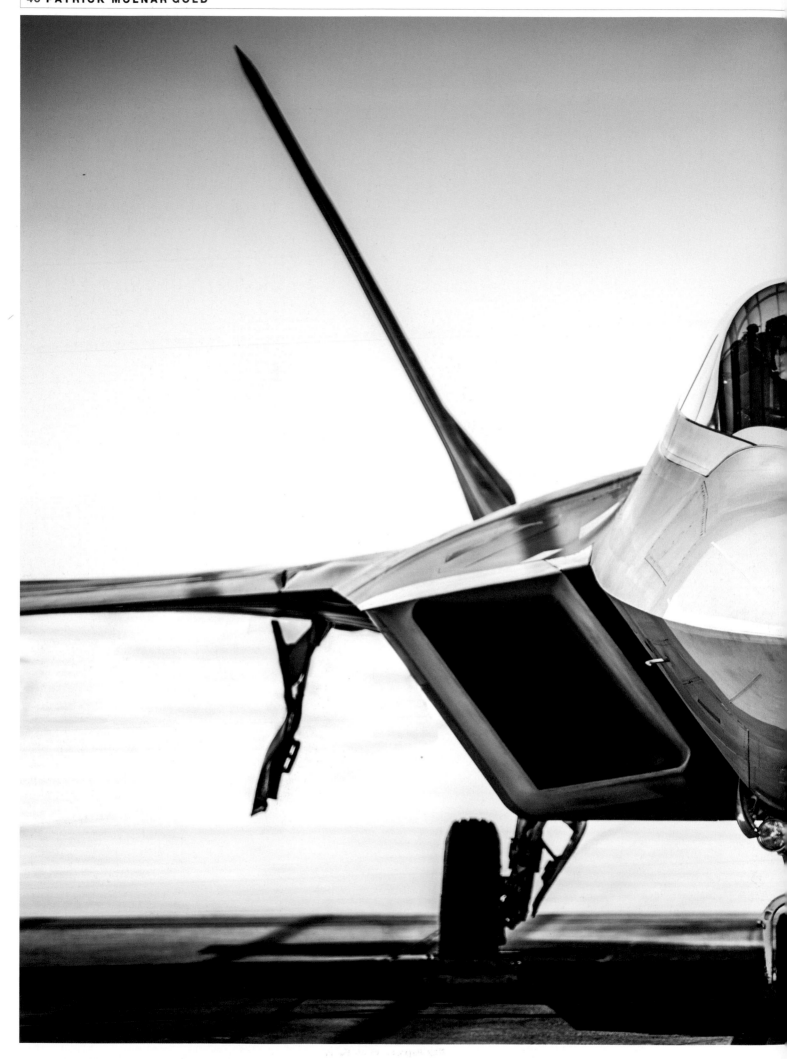

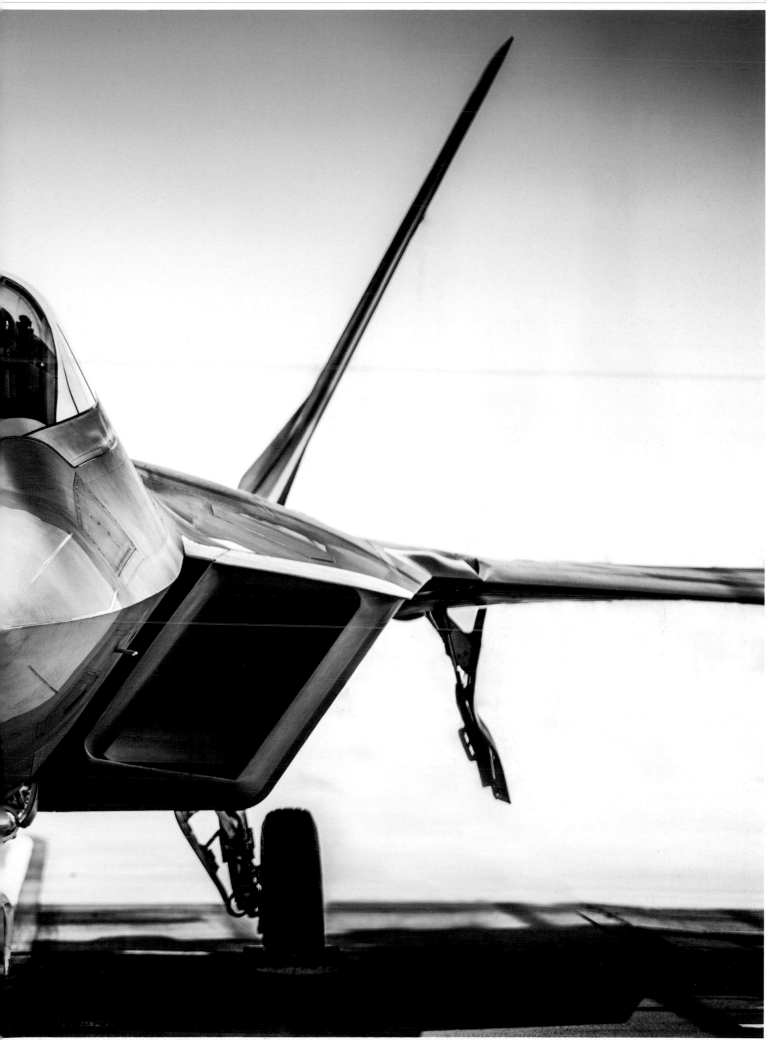

F22 Raptor | US Air Force

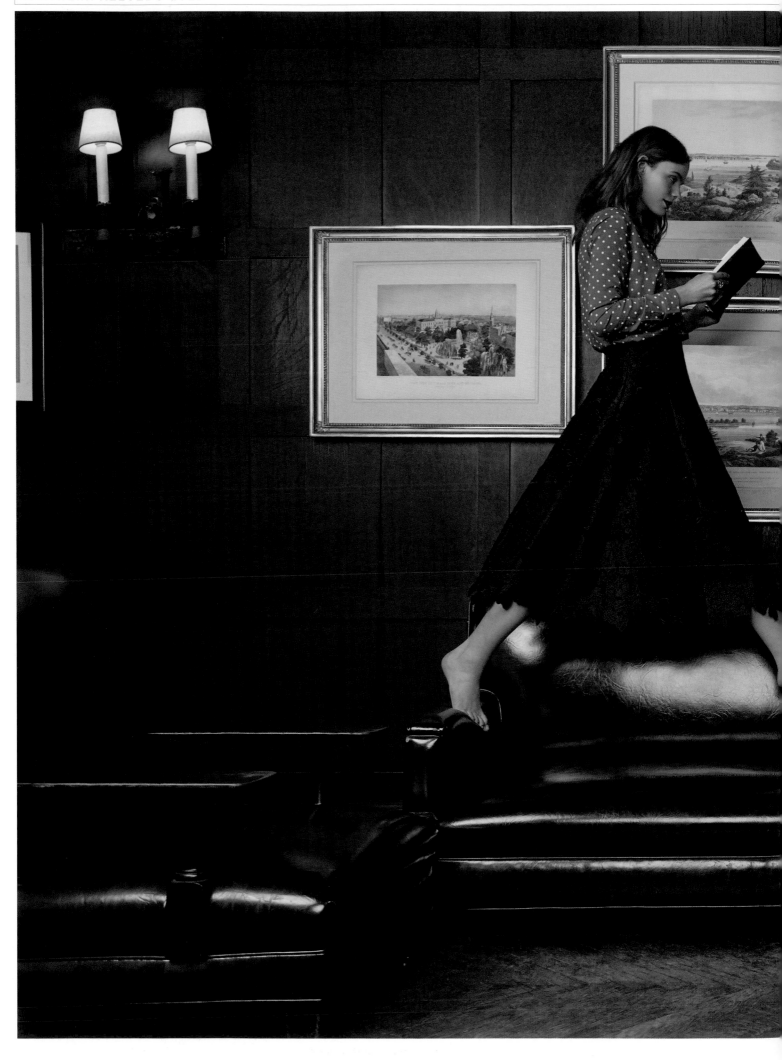

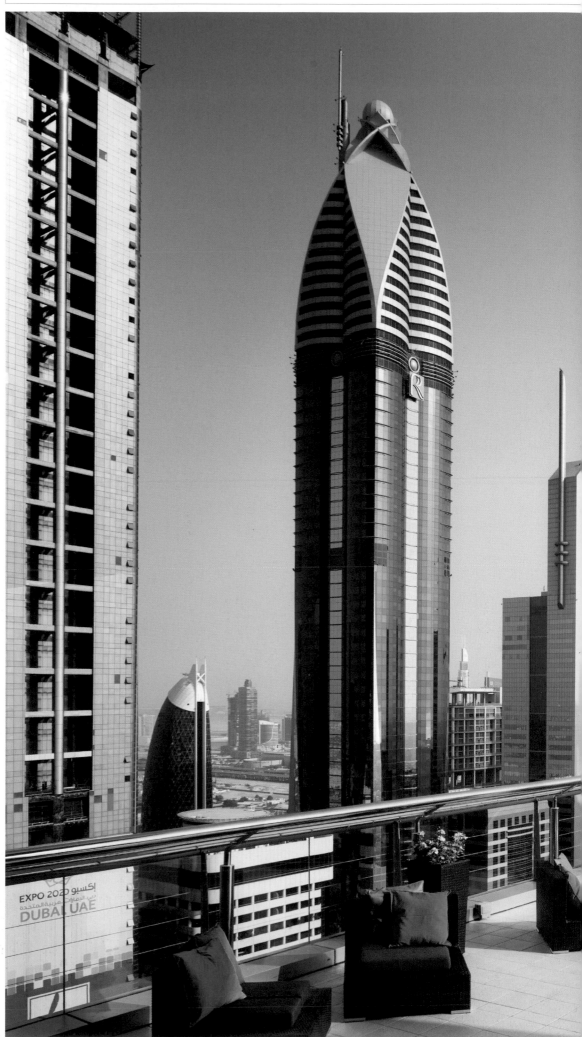

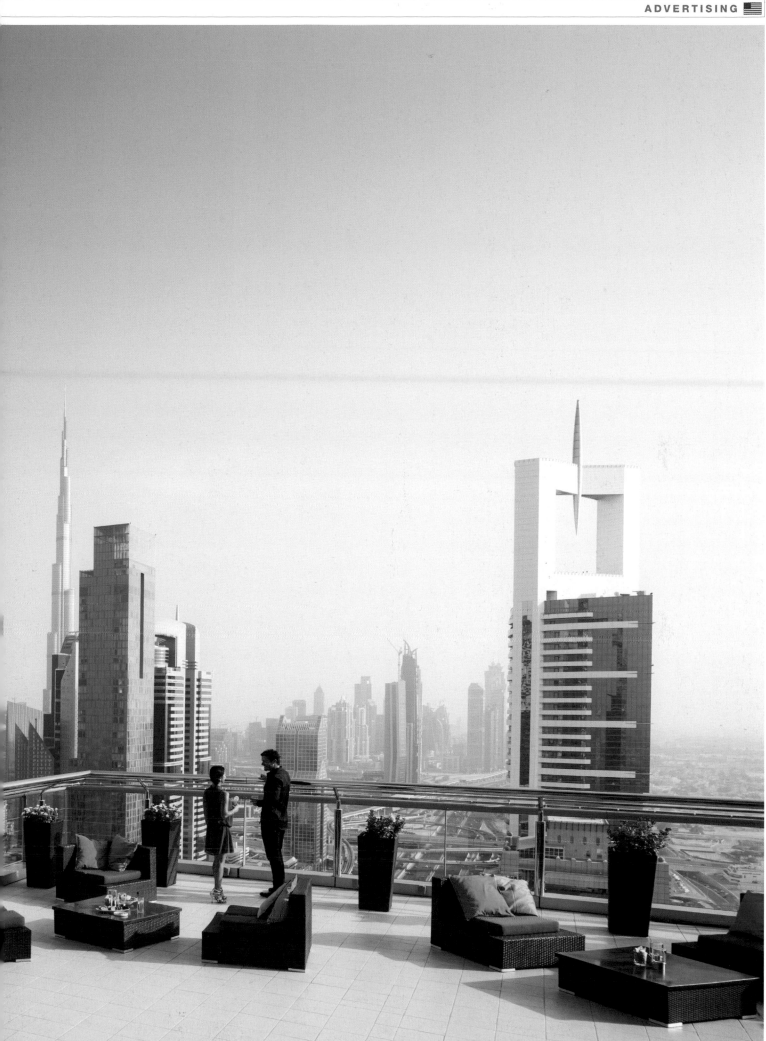

A Toast To Dubai | FCB, Chicago

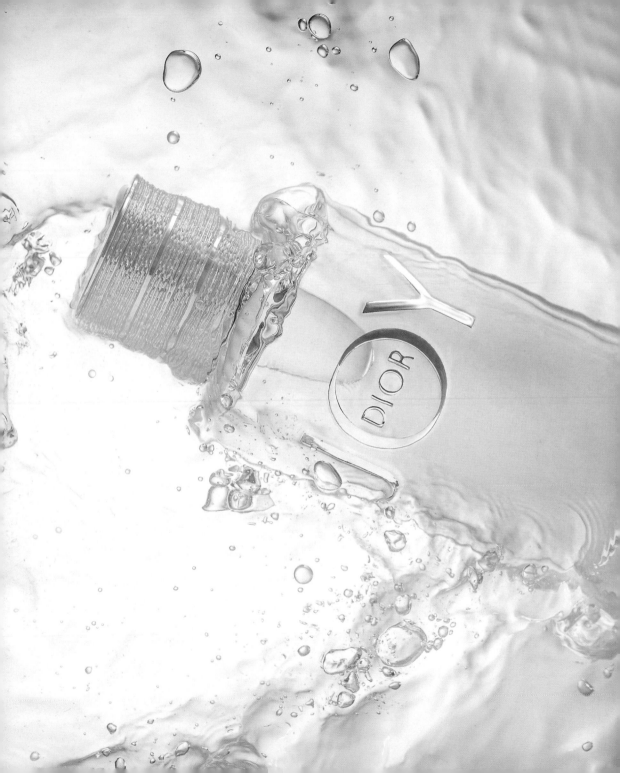

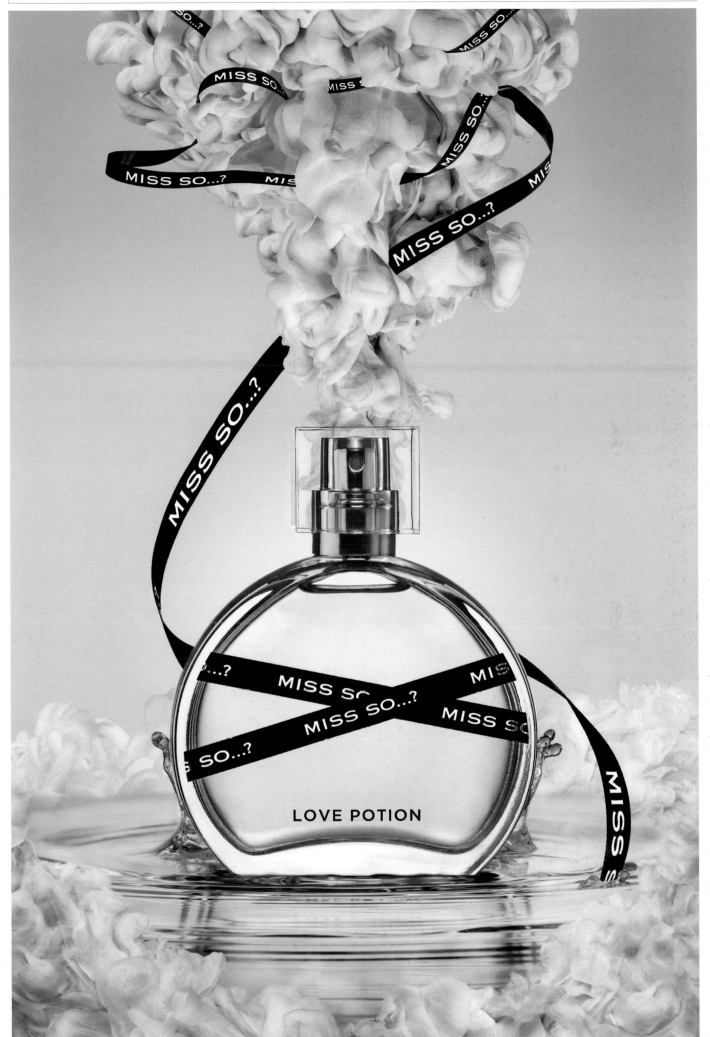

Love Potion | So...?Fragrance

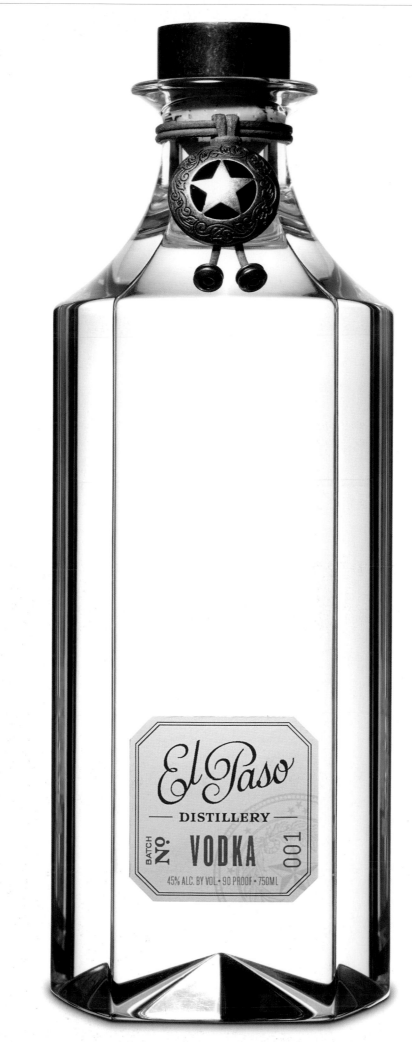

El Paso | Pavement

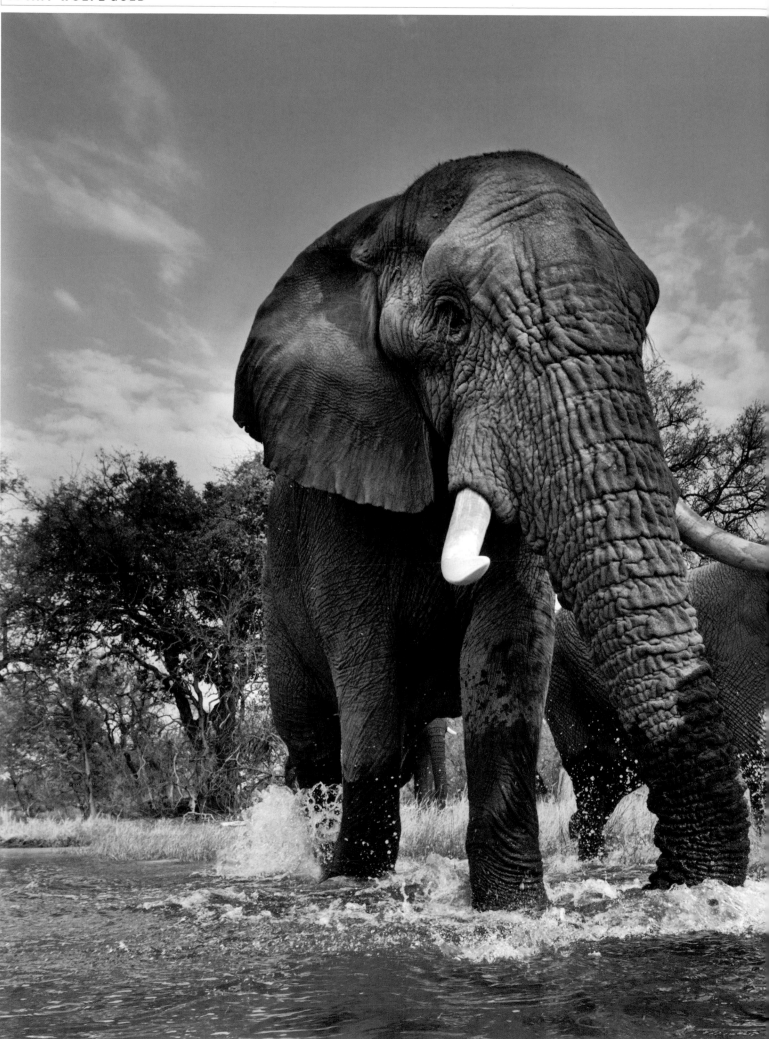

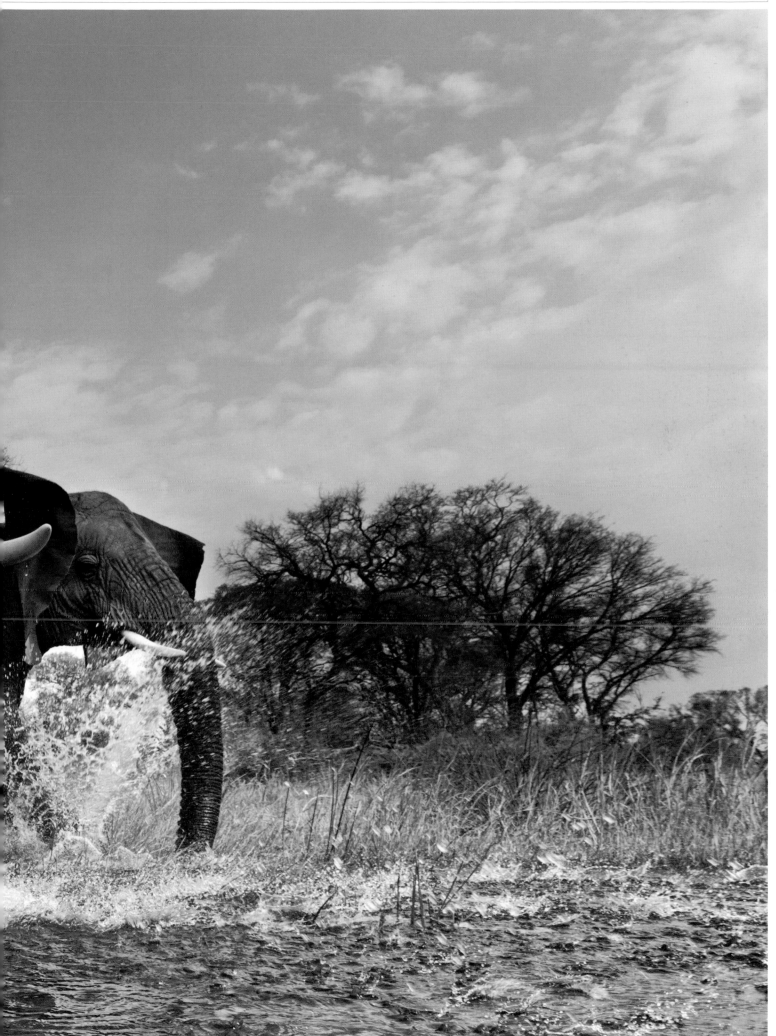

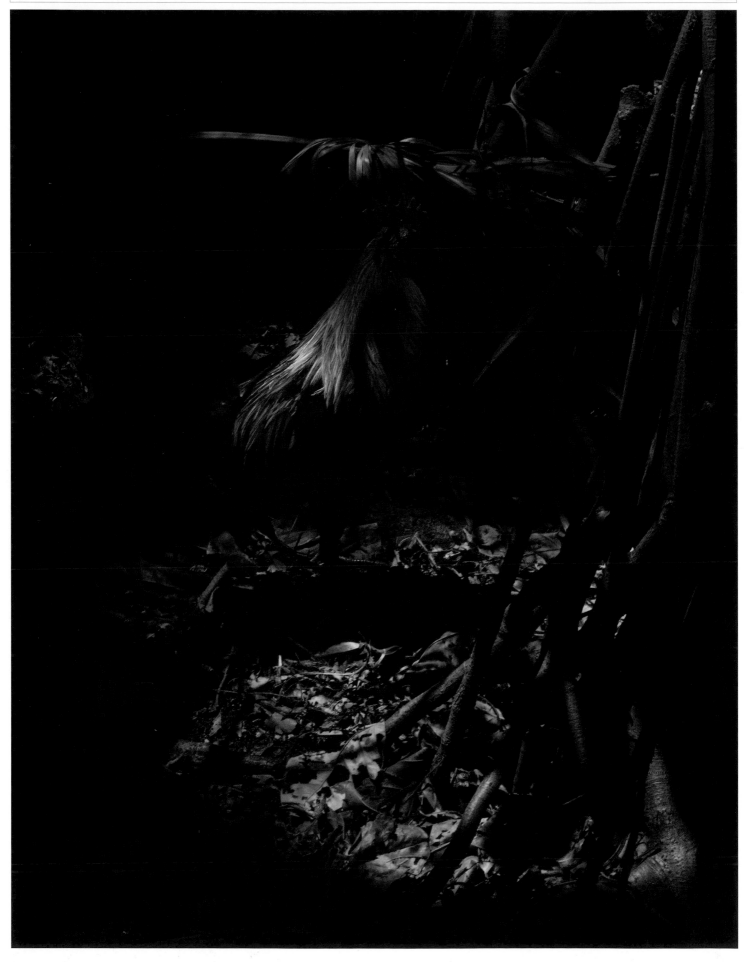

Rooster, Key West | **Self-Initiated**

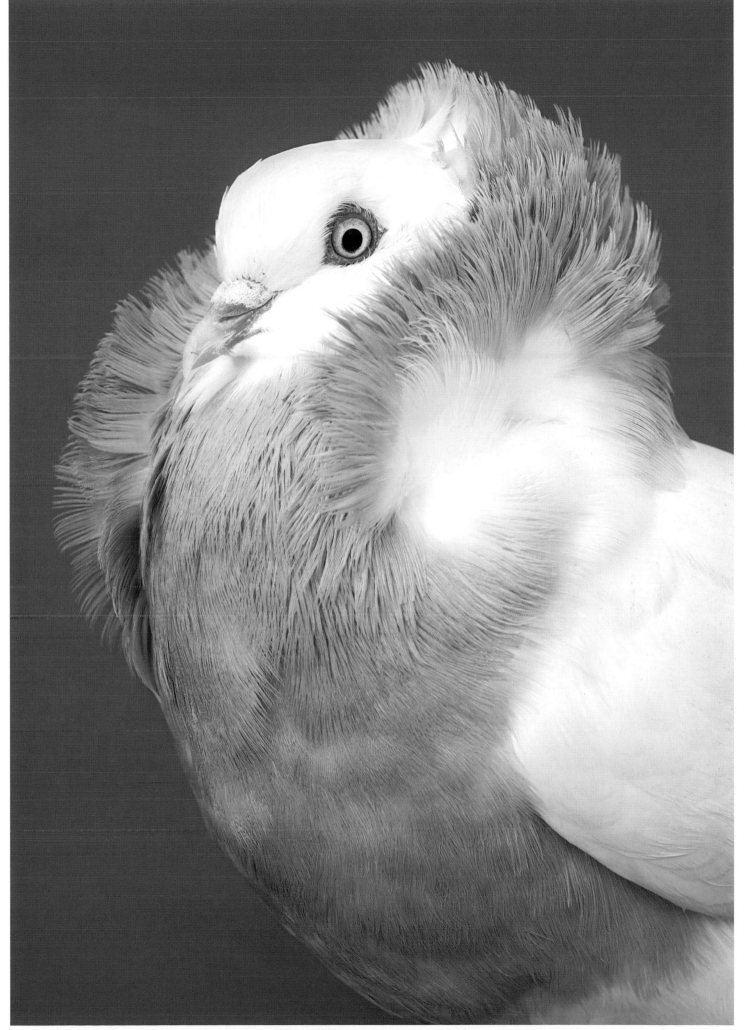

New York Pigeon Fanciers | Self-Initiated

Visit website to view full series

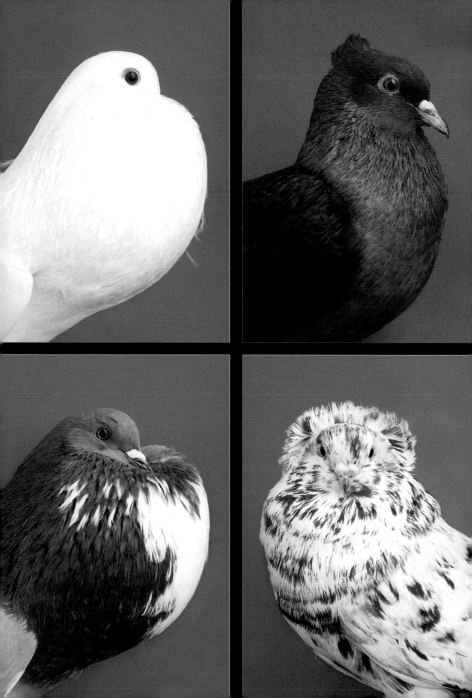

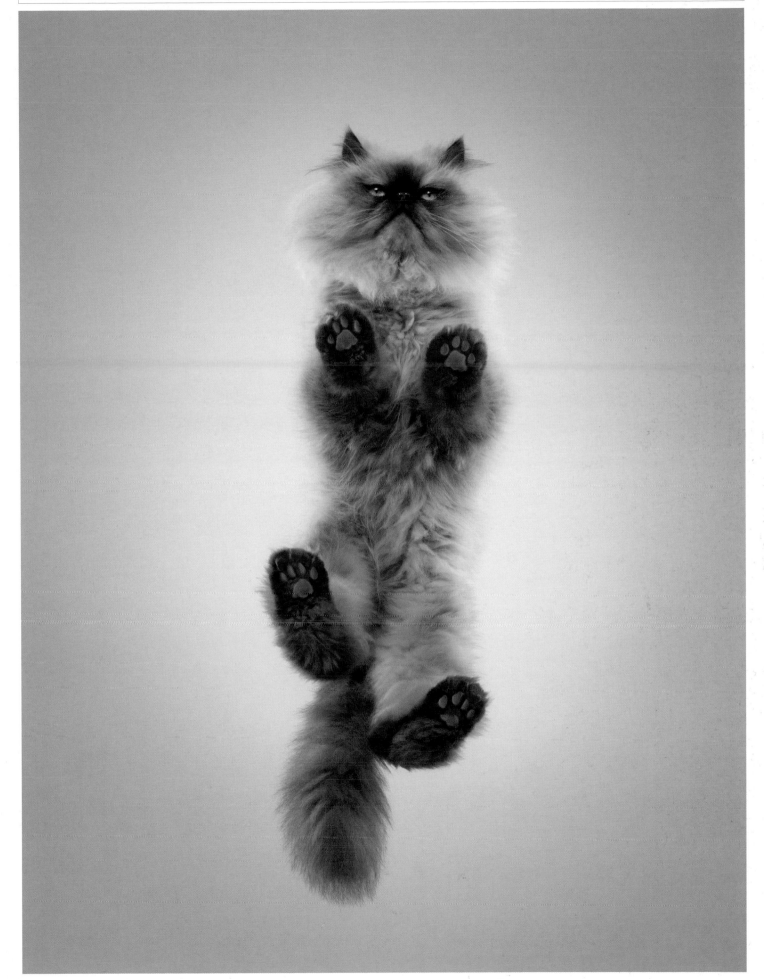

Coco | mcgarrybowen/Fresh Step

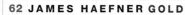

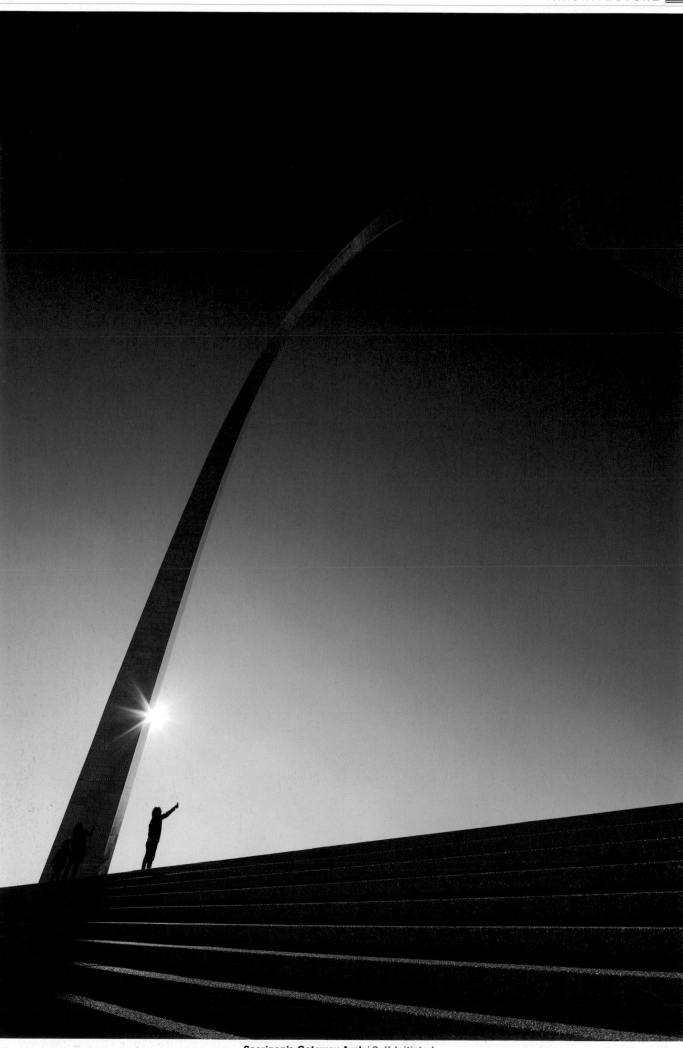

Saarinen's Gateway Arch | Self-Initiated

Naval Base Mercedes | Michael Mayo Photography

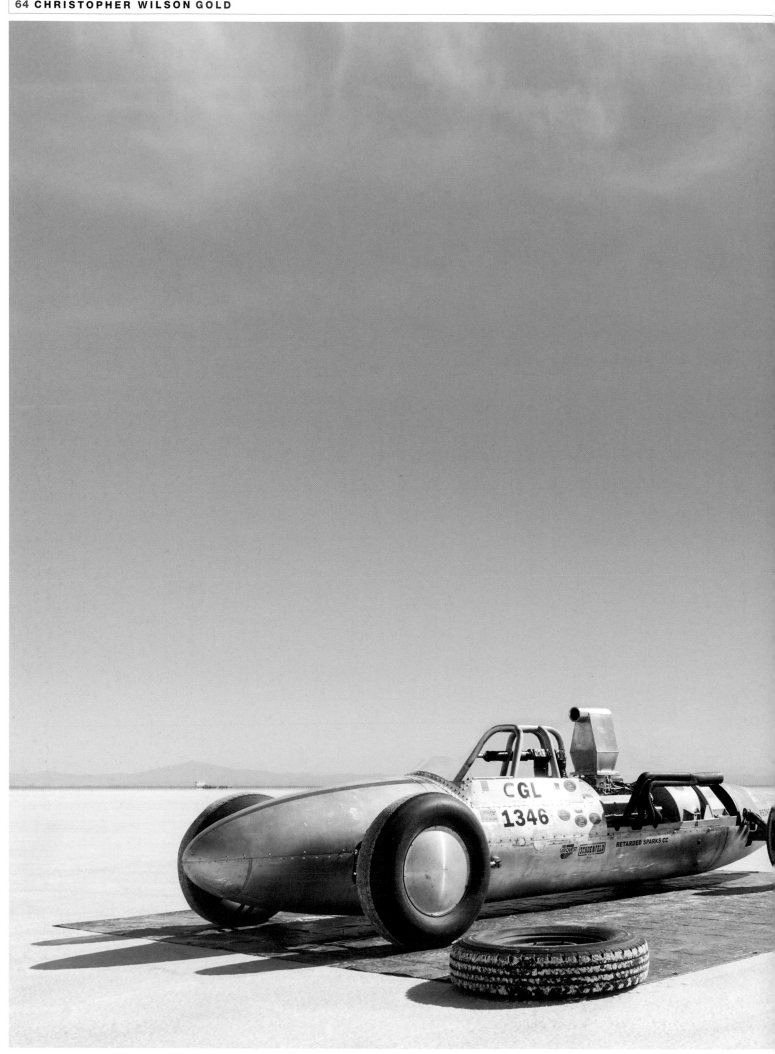

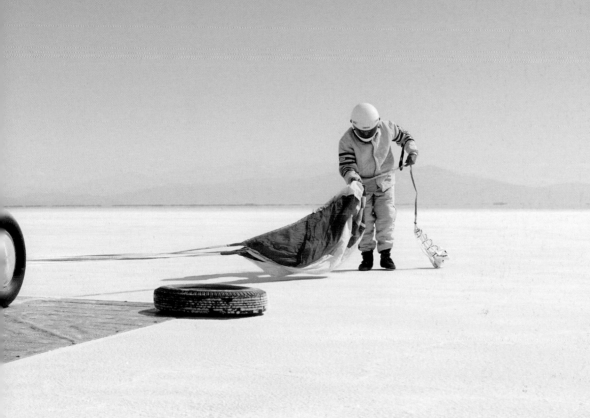

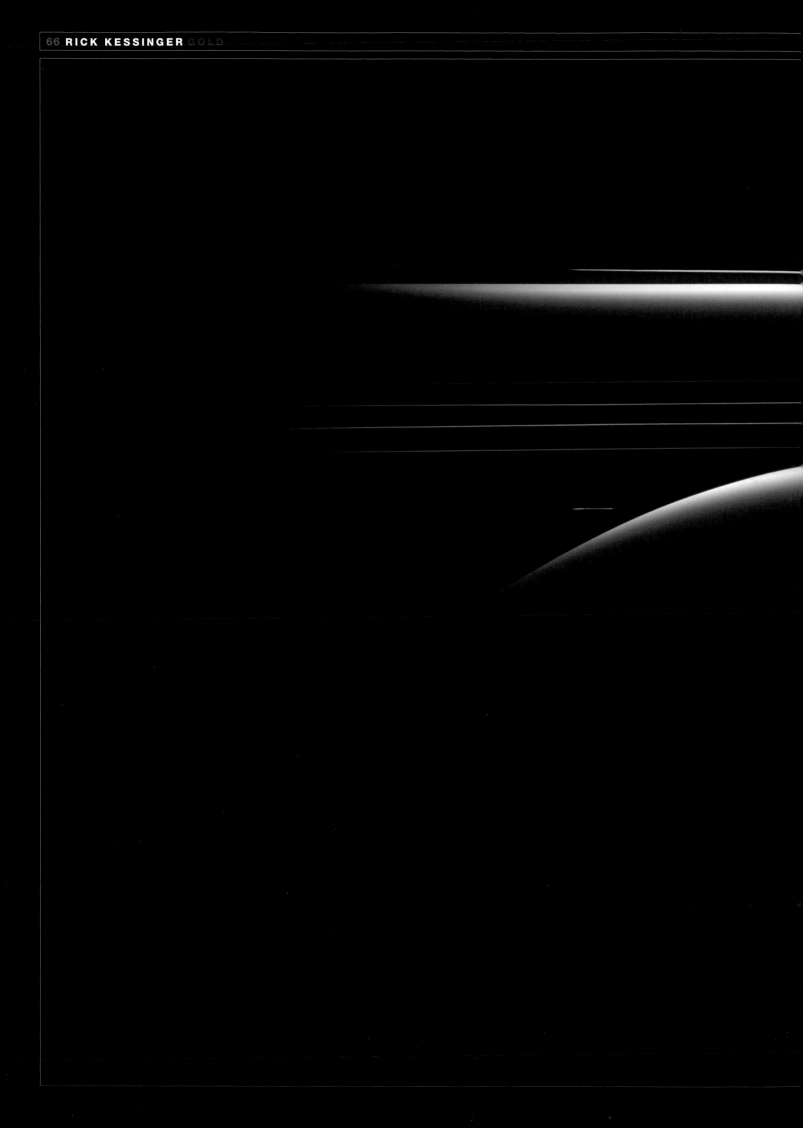

Classic Curves | Russell Maas Restoration

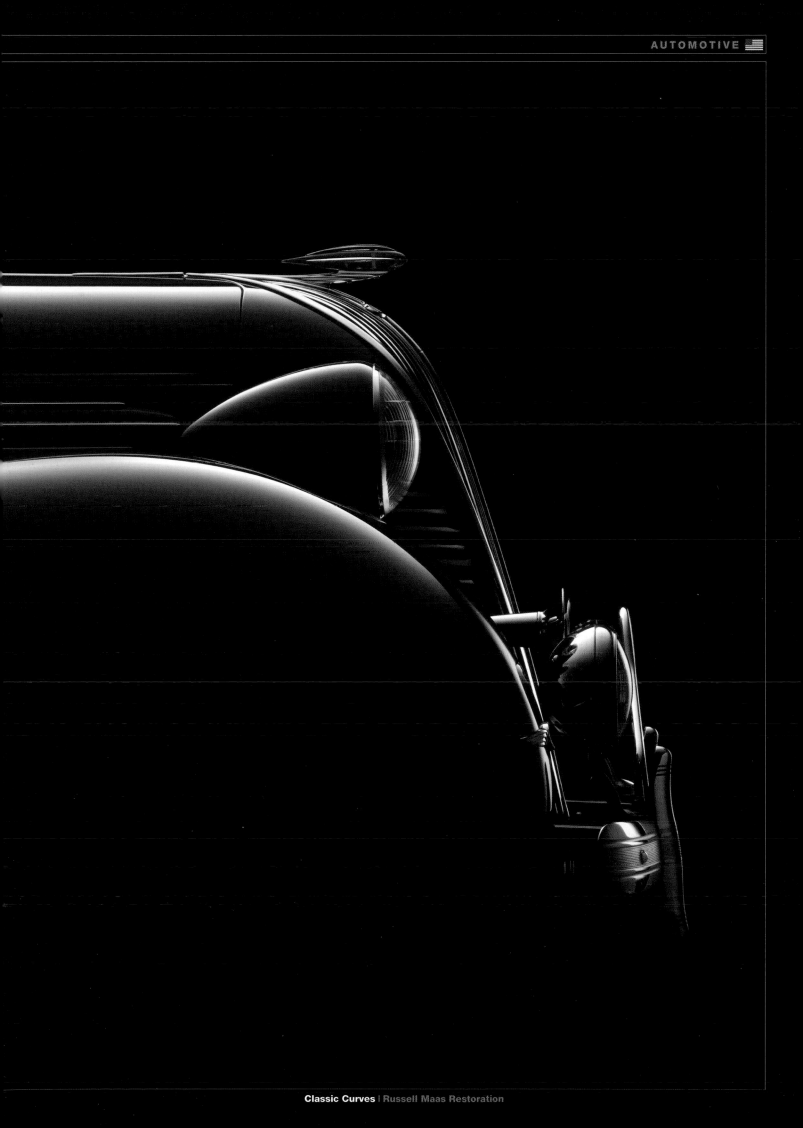

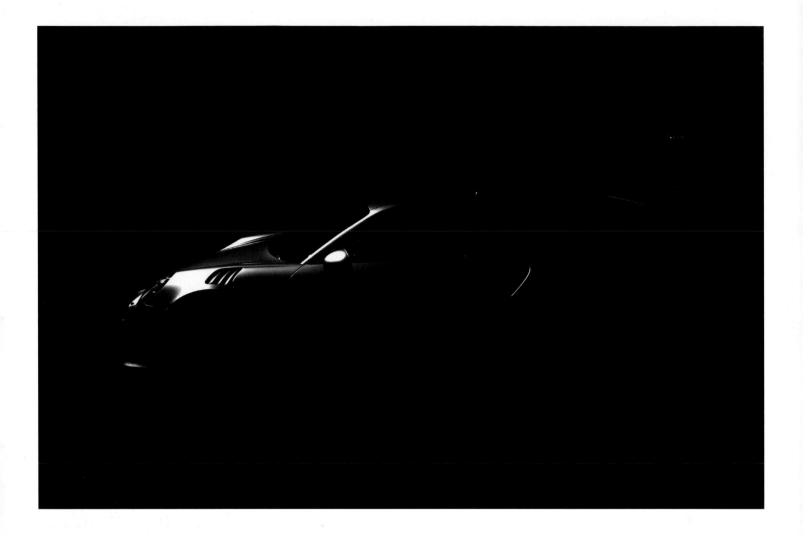

Porsche 911, GT3 RS | Loue la Vie

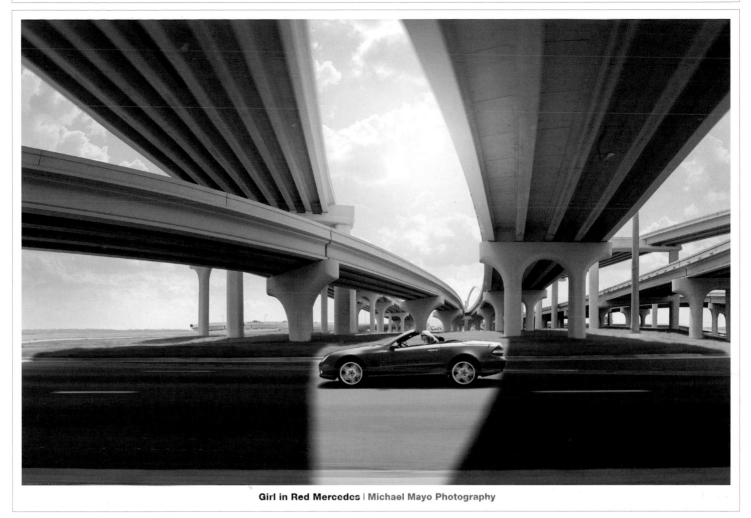

Girl in Red Mercedes | Michael Mayo Photography

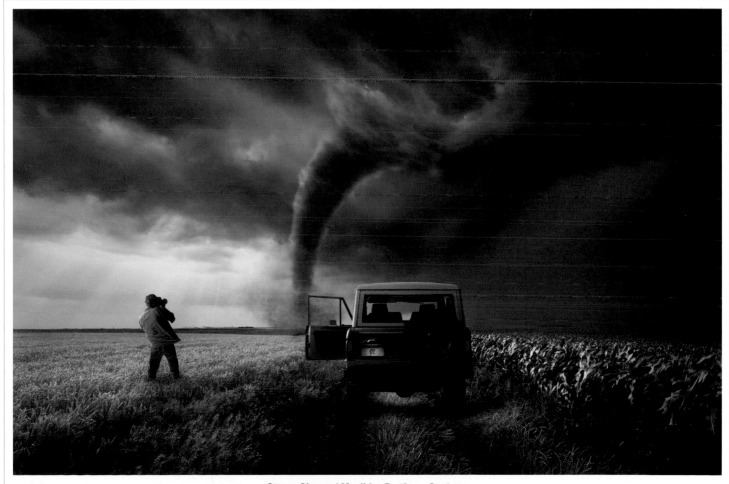

Storm Chaser | Maxlider Brothers Customs

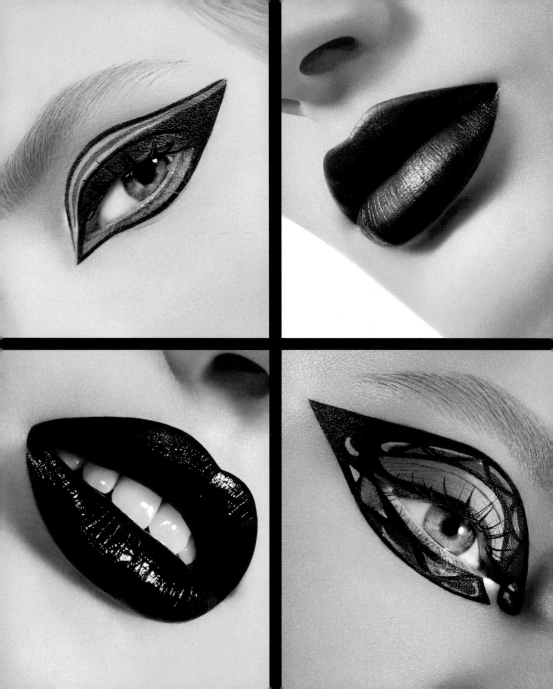

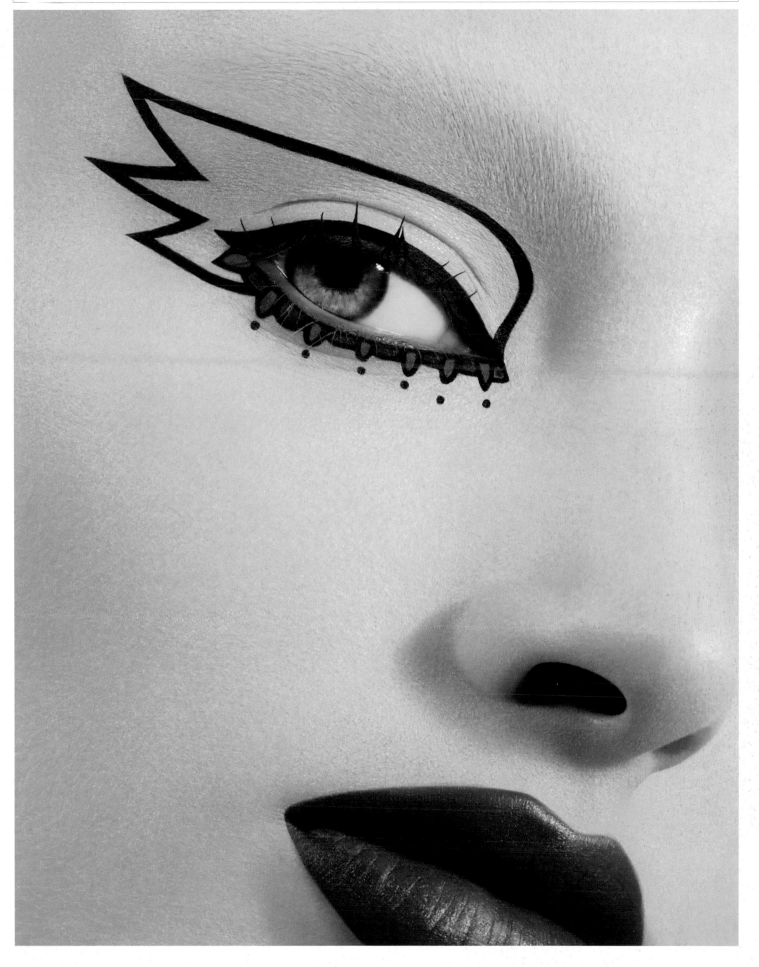

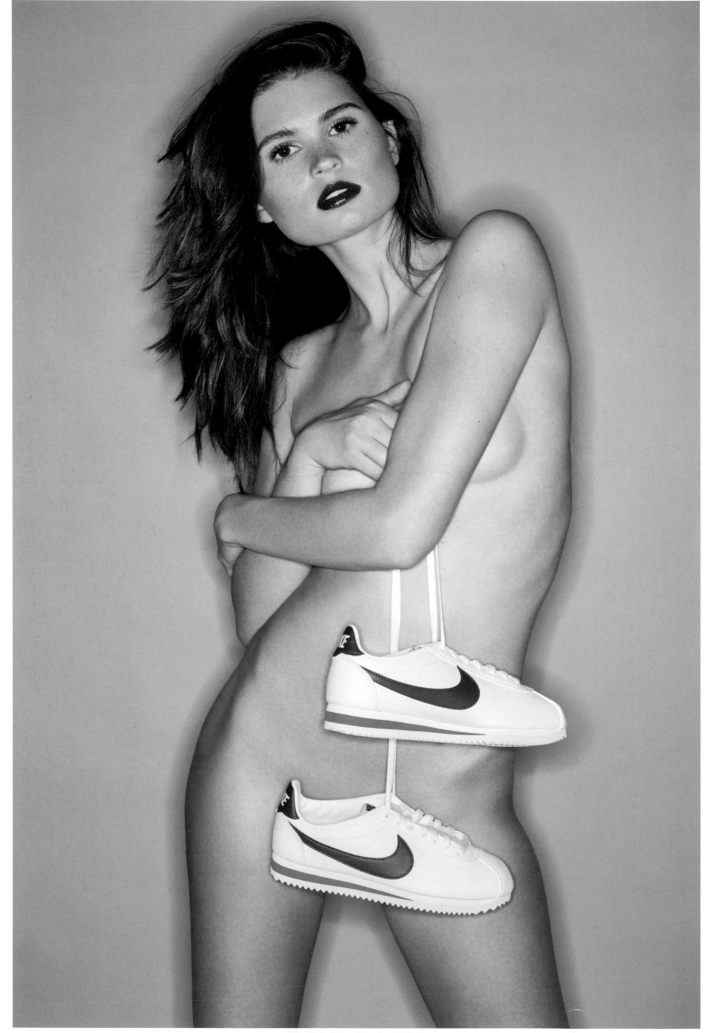

Musilek-Nike-Nicole S. | Lui

Visit website to view full series

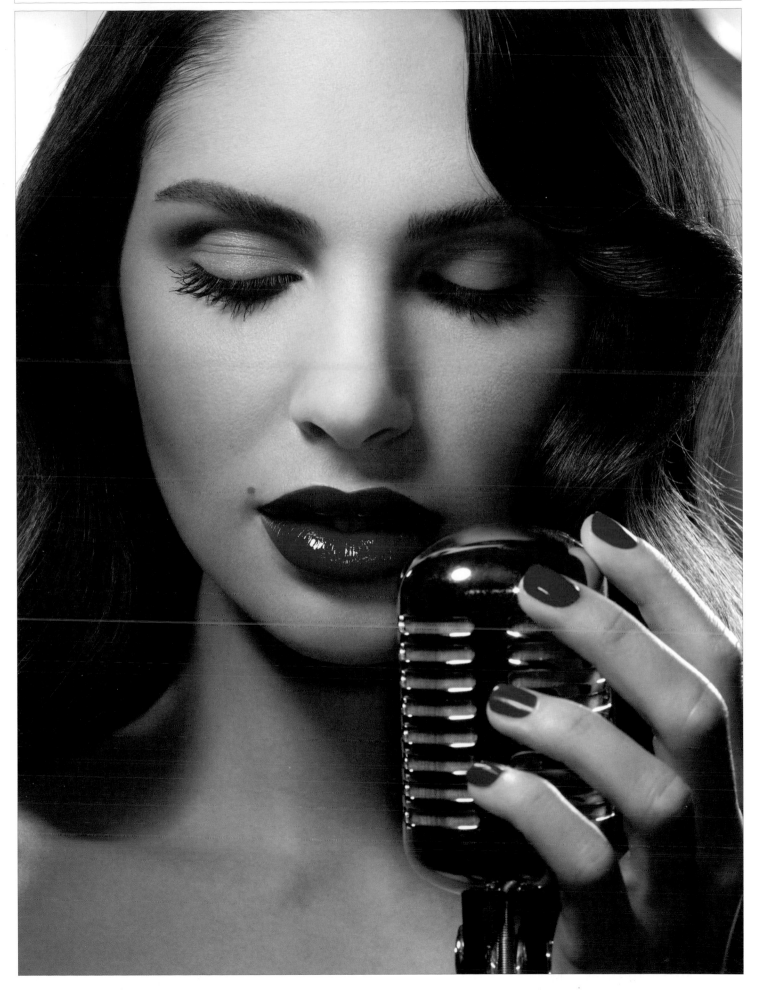

Dior Retro Beauty | Luxure Magazine

Visit website to view full series

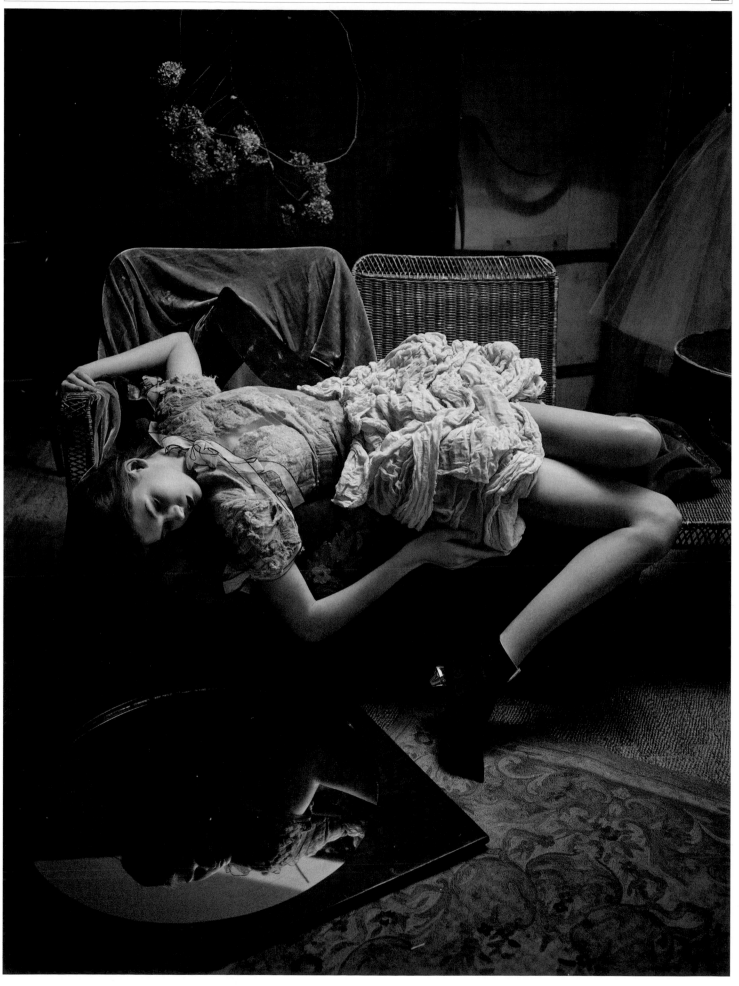

Heeling Powers | Footwear Plus magazine

Visit website to view full series

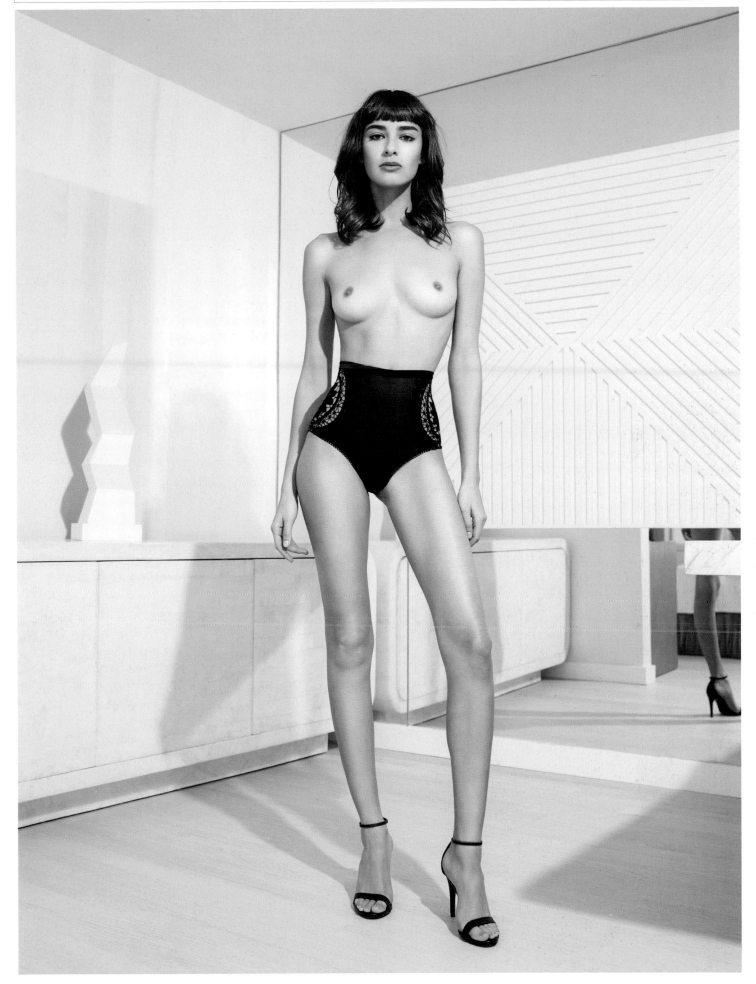

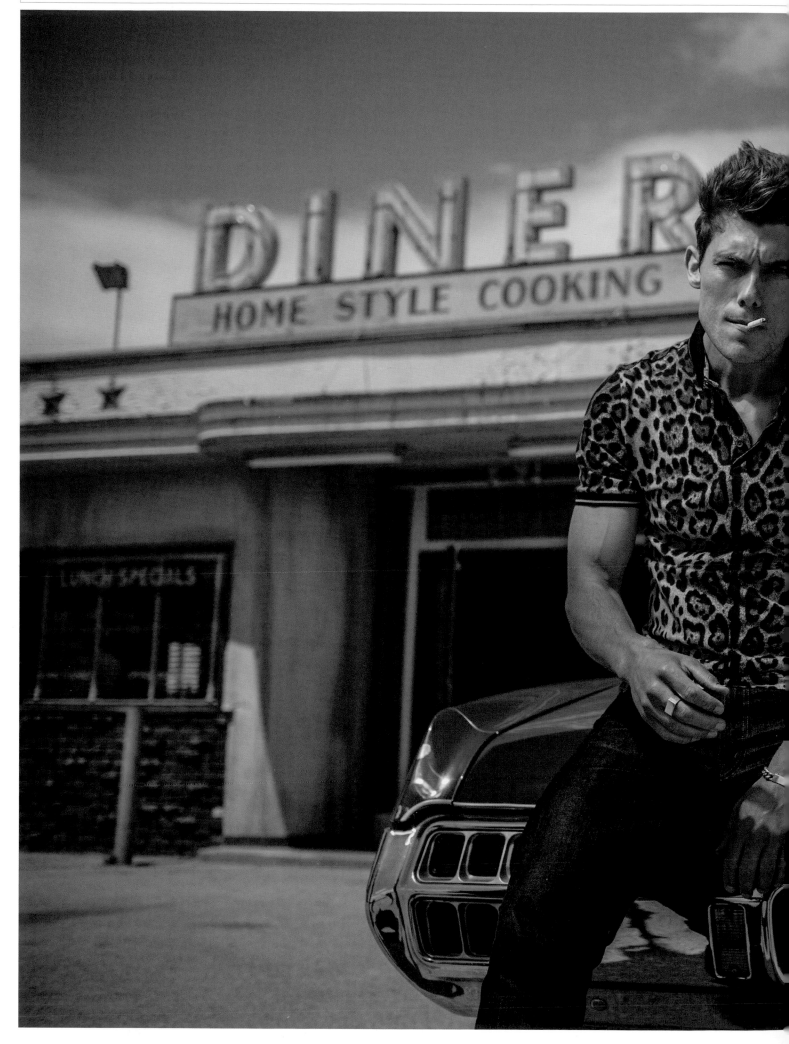

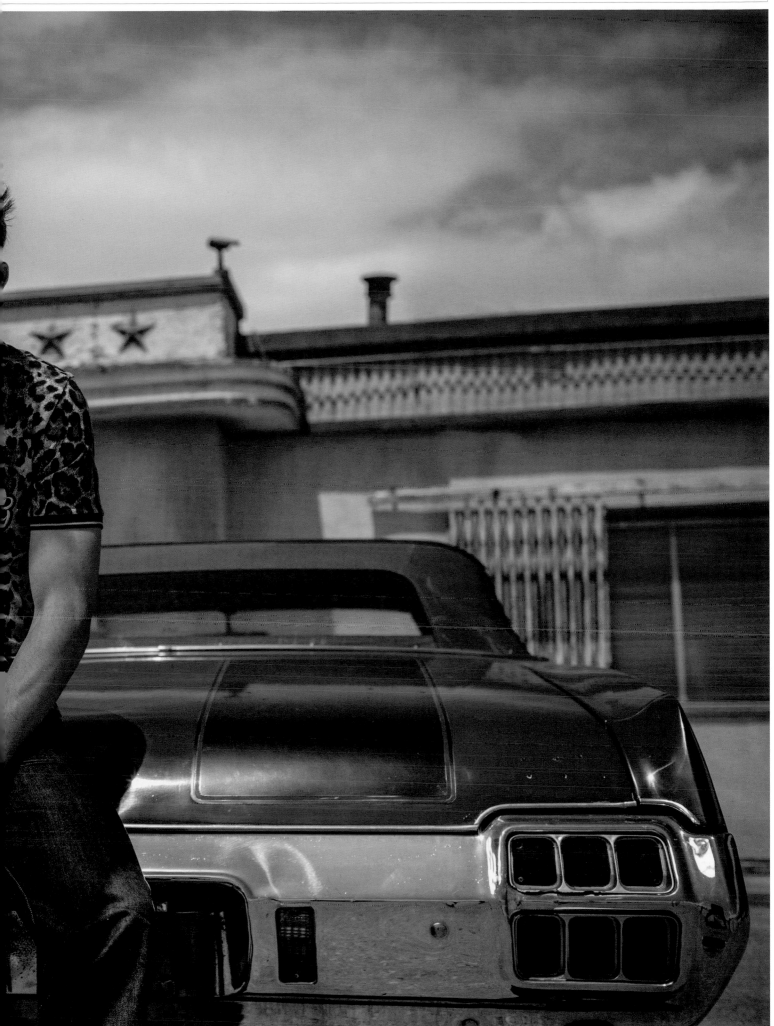

Visit website to view full series

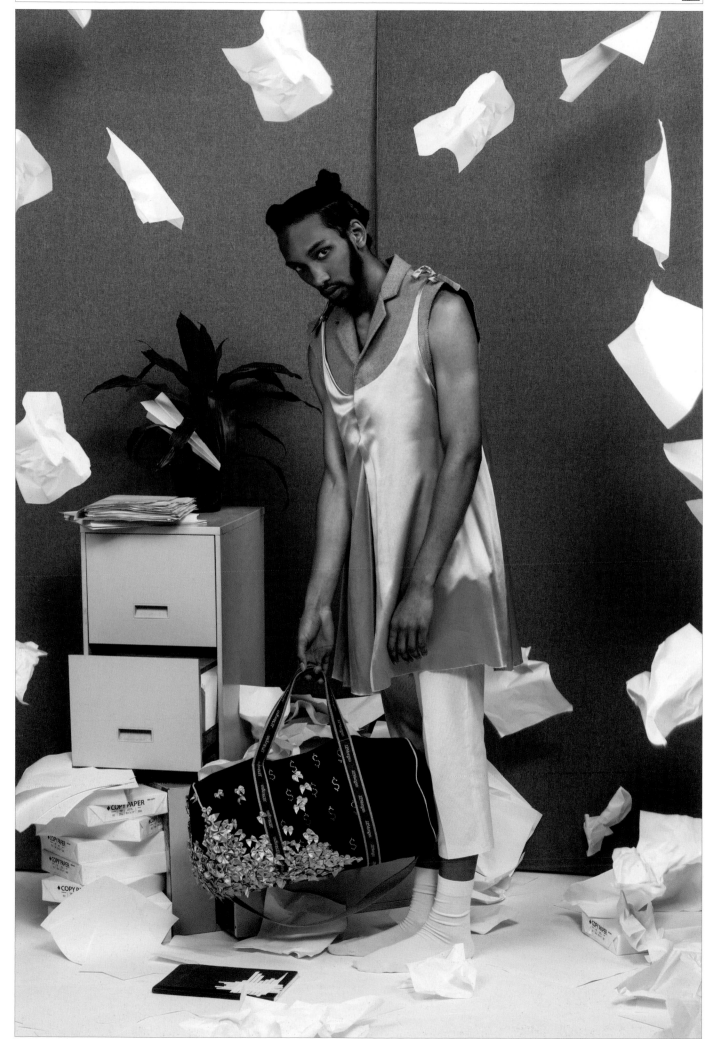

Toxic Office Masculinity | Savannah College of Art and Design

Visit website to view full series

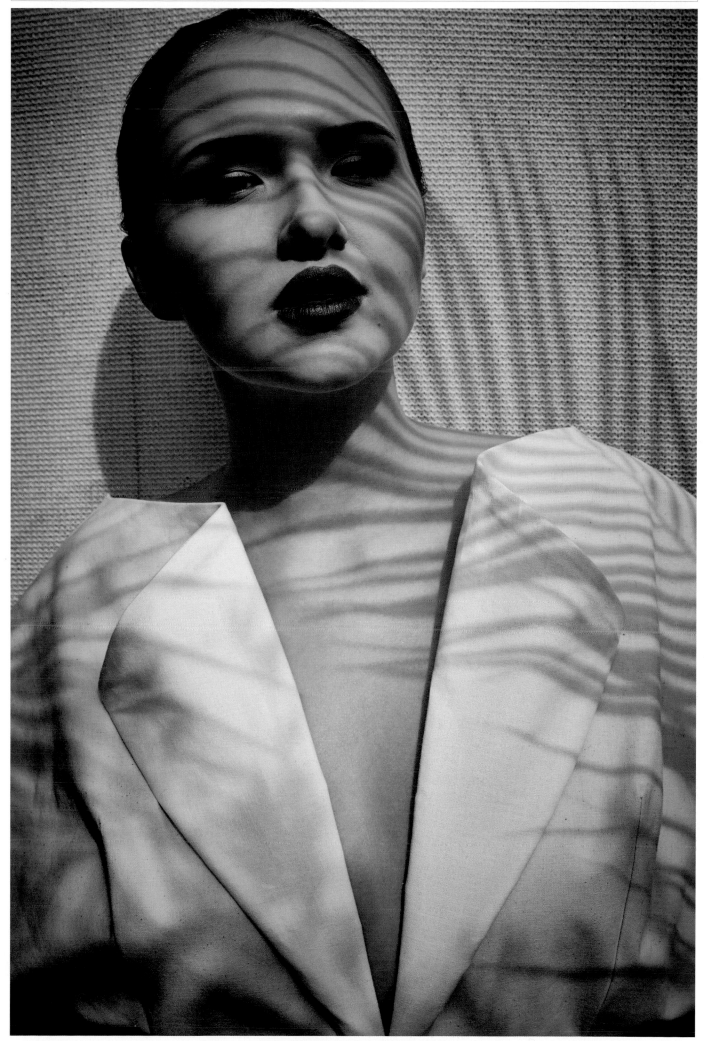

Light + Shadow | AMD Fashion Academy
Visit website to view full series

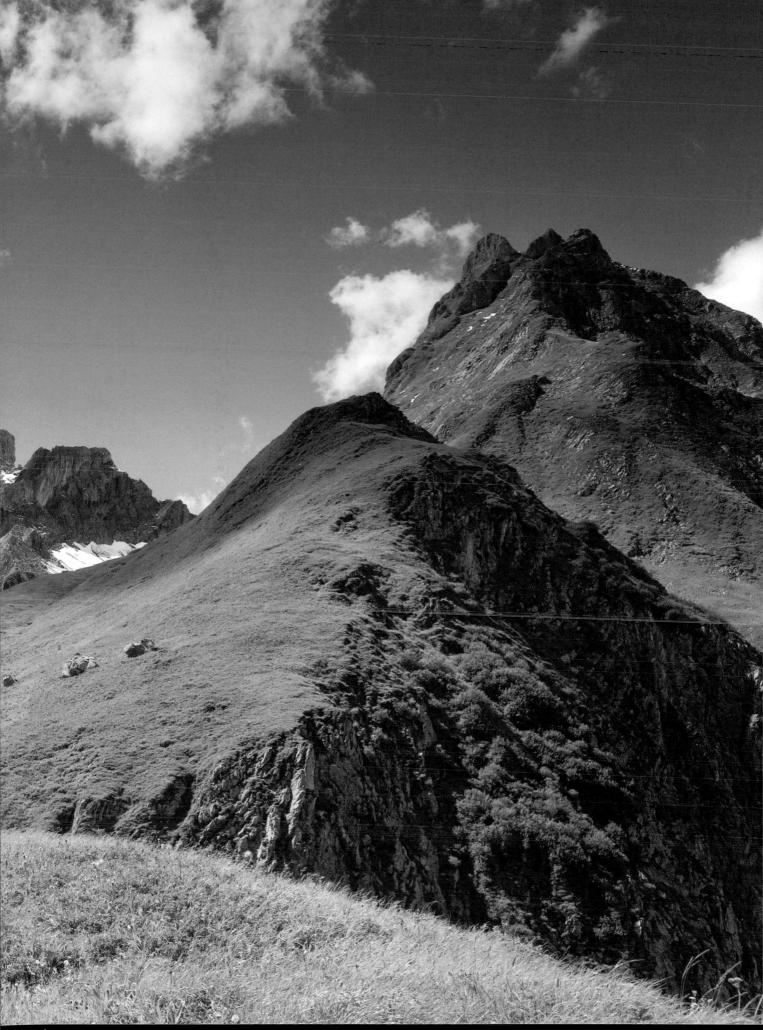

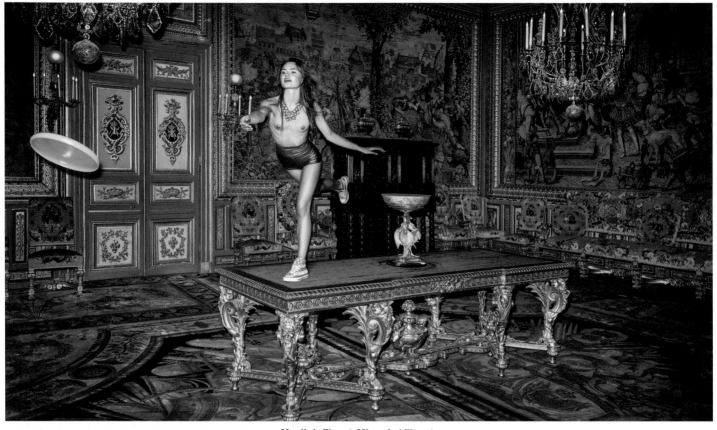

Musilek-Flaunt-Miranda | Flaunt

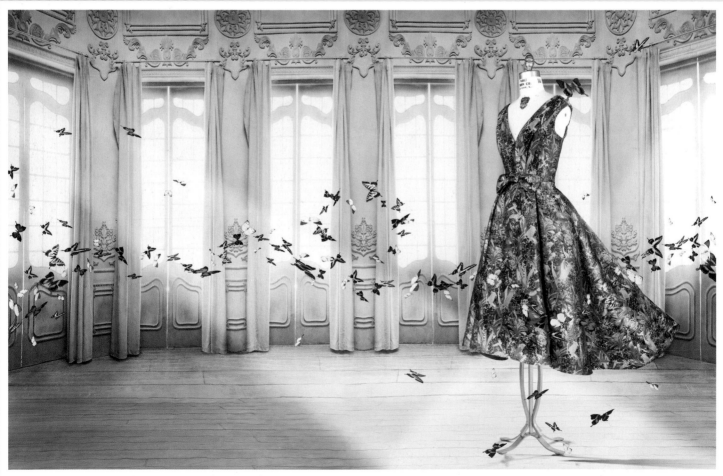

Butterfly Story | Frascara

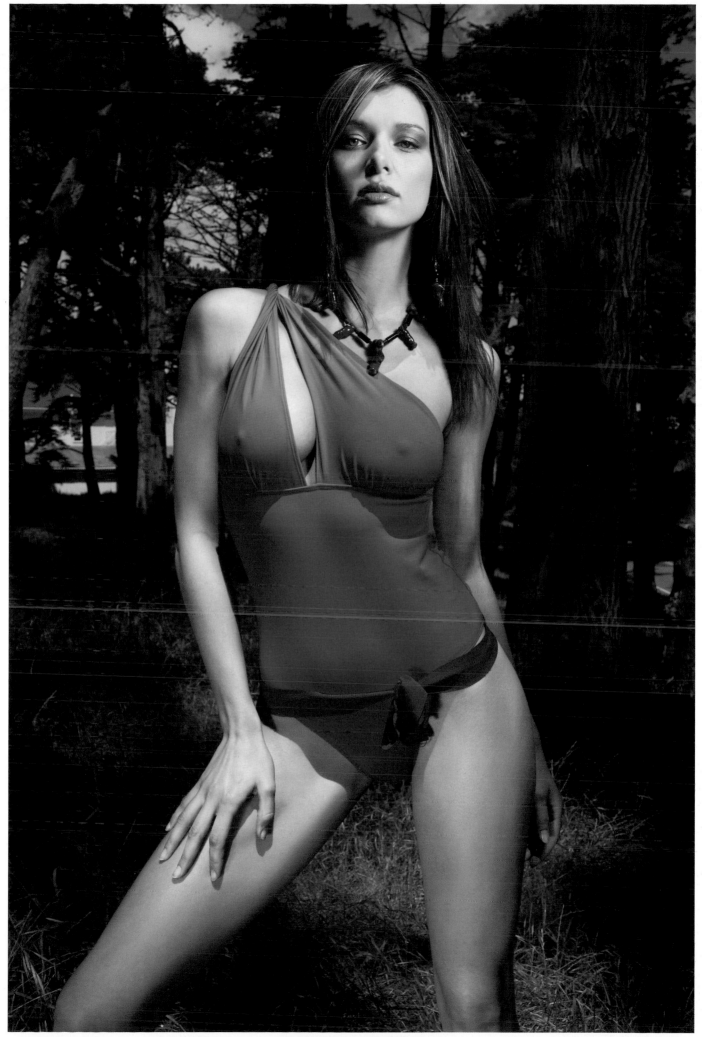

Musilek-Jeanene-Vera-SF | 7x7

Visit website to view full series

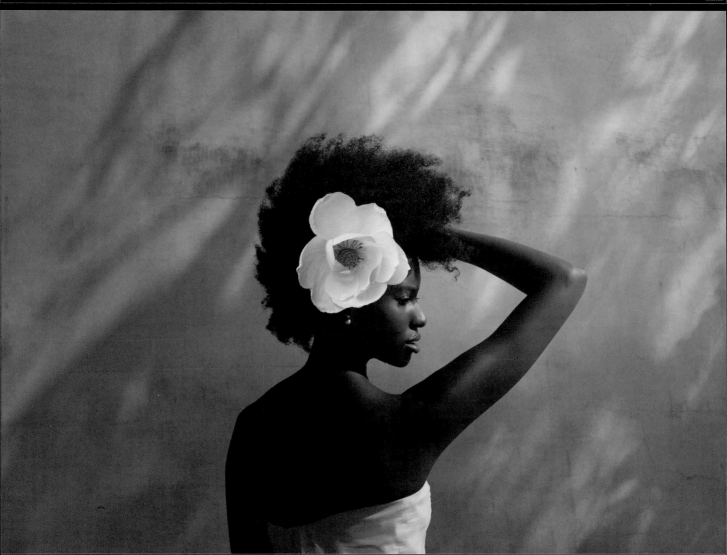

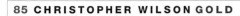

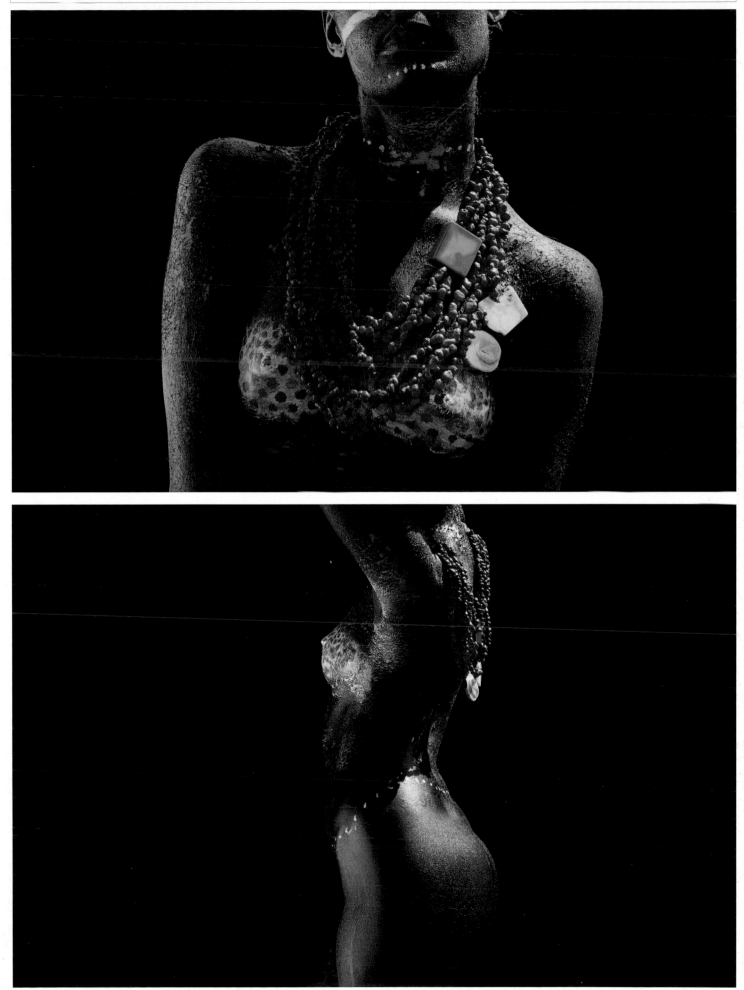

Amor Da Terra | Amor Da Terra, Brazil

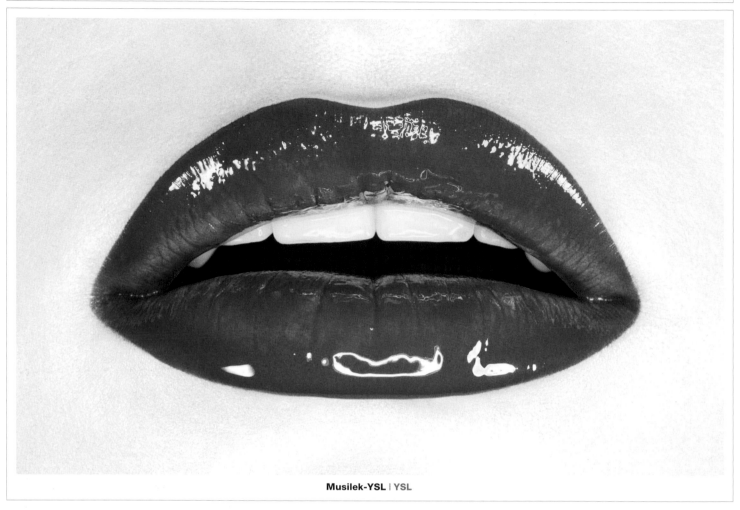

Musilek-YSL | YSL

Musilek-Dior-Annemieke | Louis Vuitton

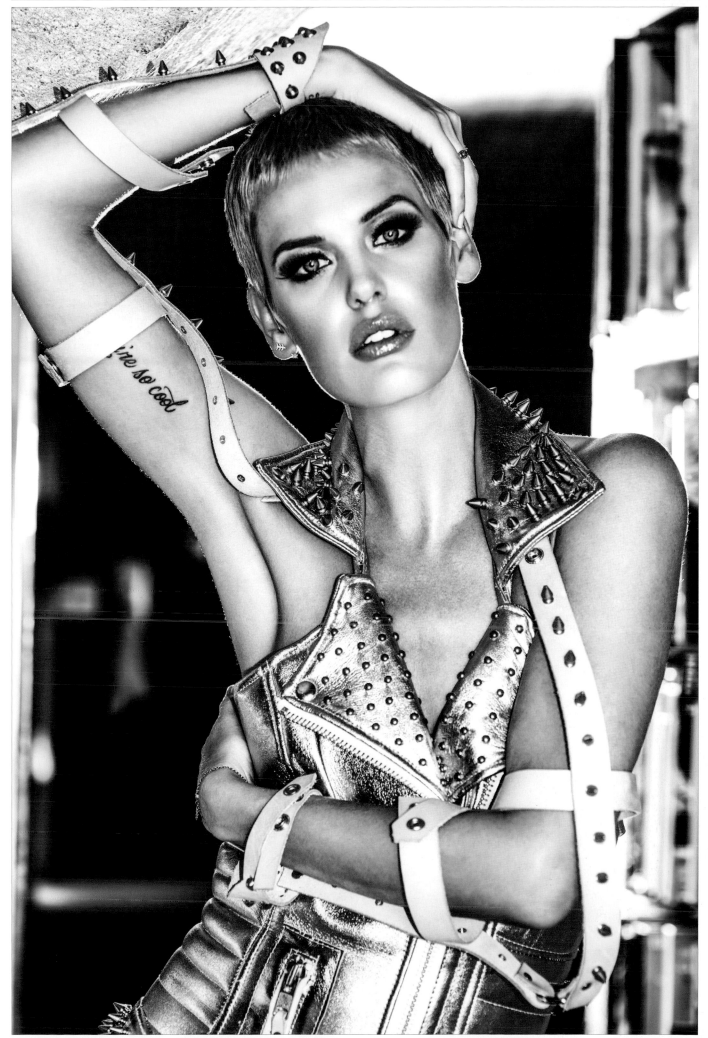

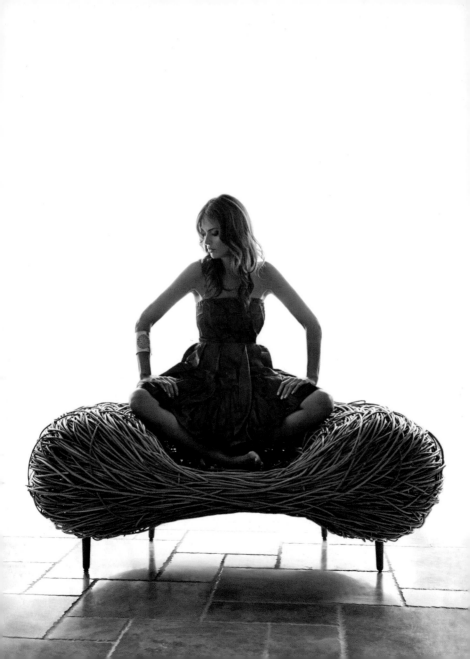

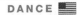

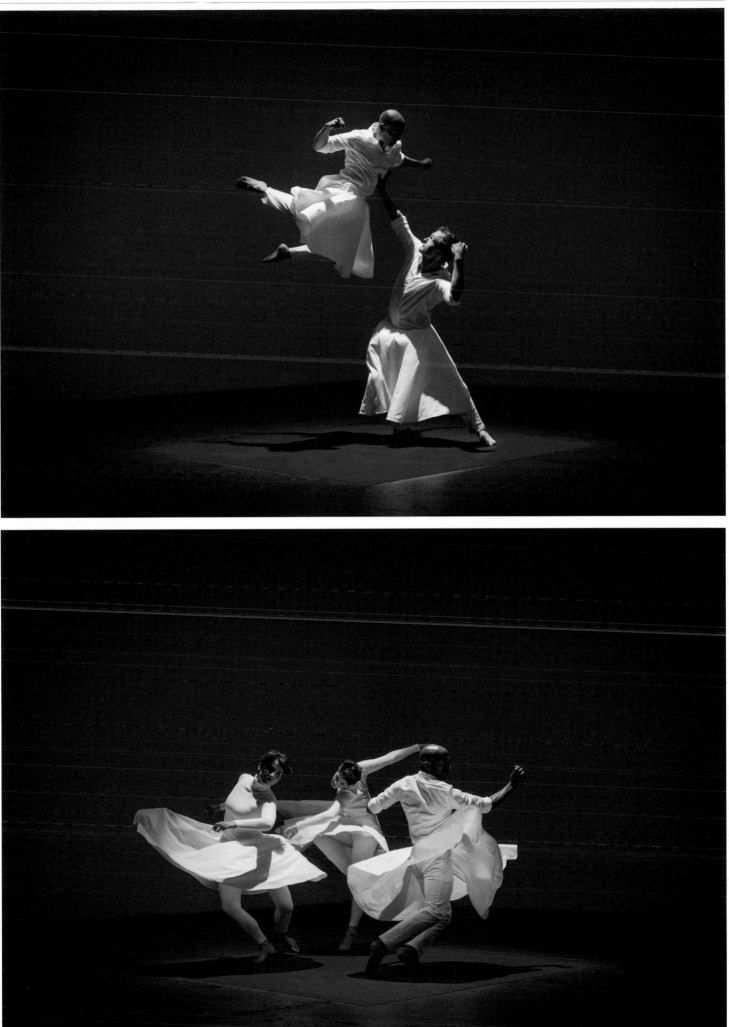

Skies Calling Skies Falling | **Margaret Jenkins Dance Company** Visit website to view full series

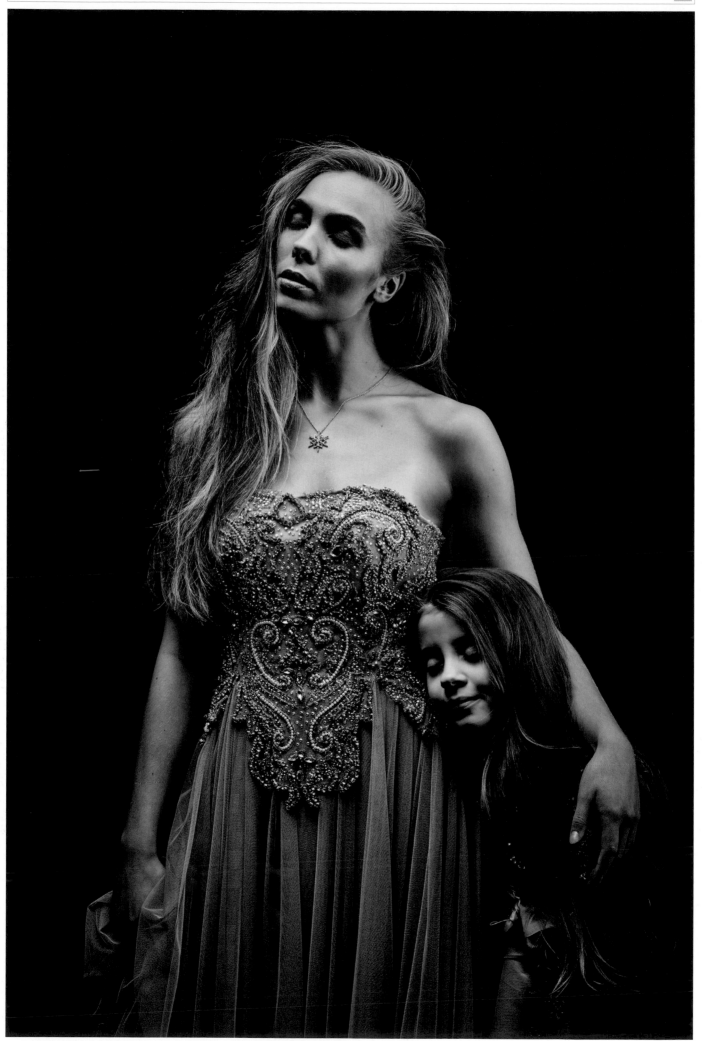

Yasmin + Tess | **artistic project**

Visit website to view full series

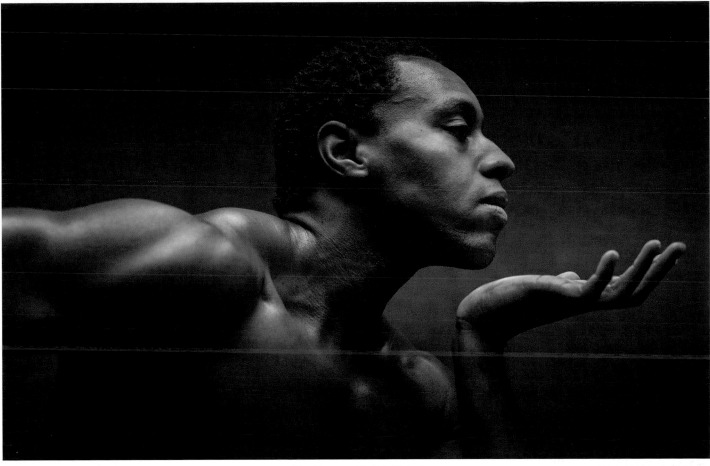

The Dancers | **Self-Initiated**

Visit website to view full series

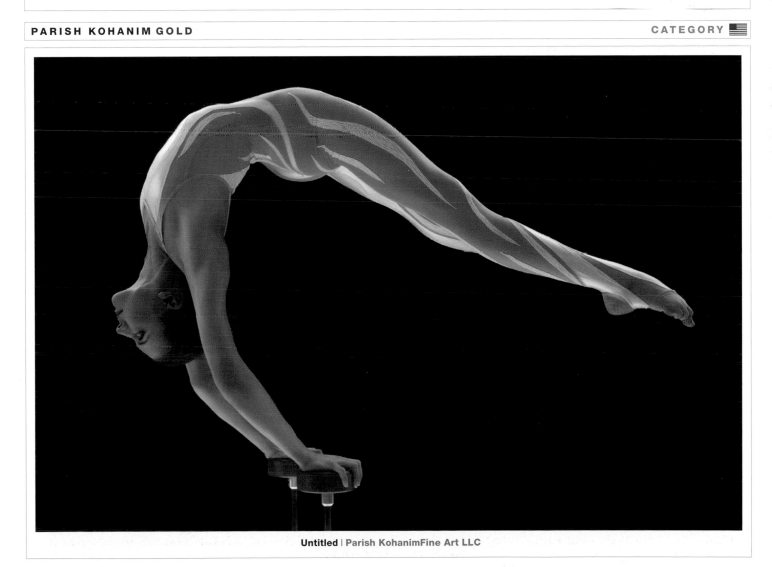

Untitled | **Parish KohanimFine Art LLC**

92 **FRANK P. WARTENBERG** GOLD

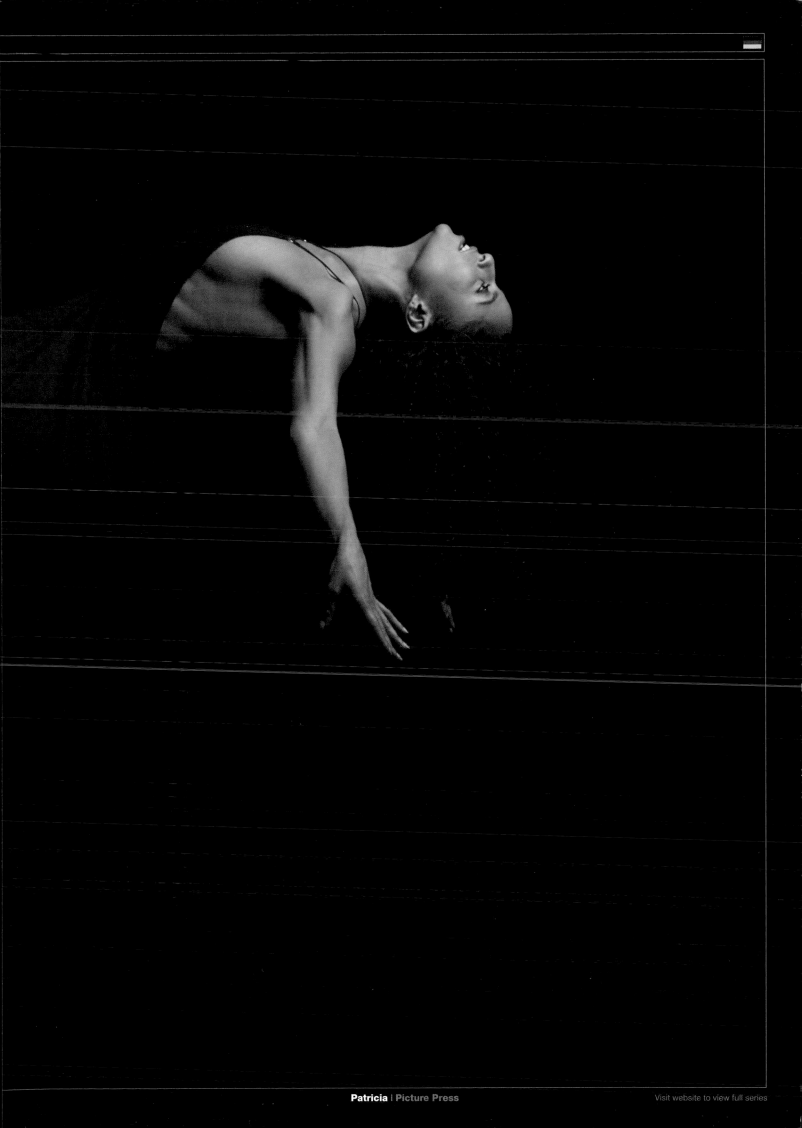

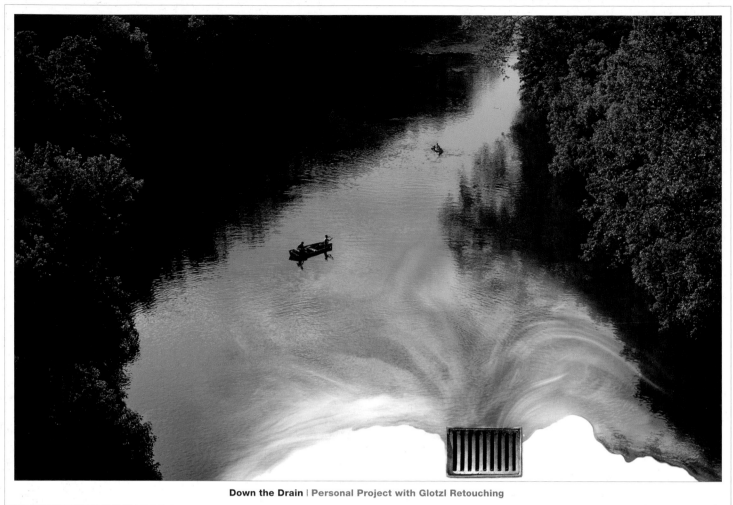

Down the Drain | Personal Project with Glotzl Retouching

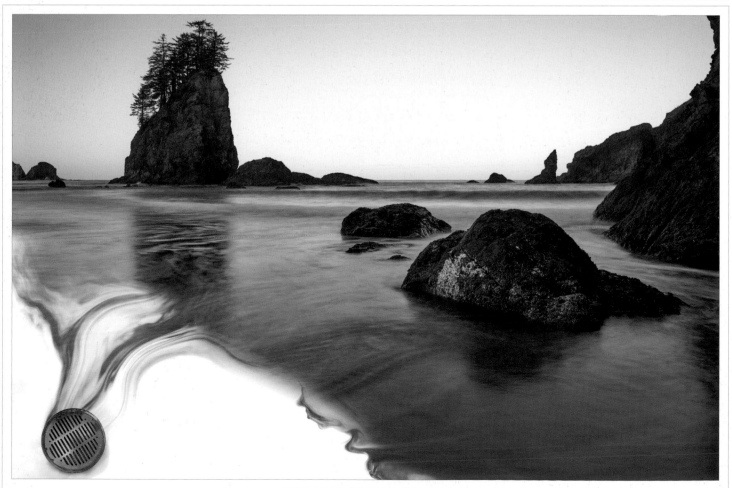

Down the Drain | Personal Project

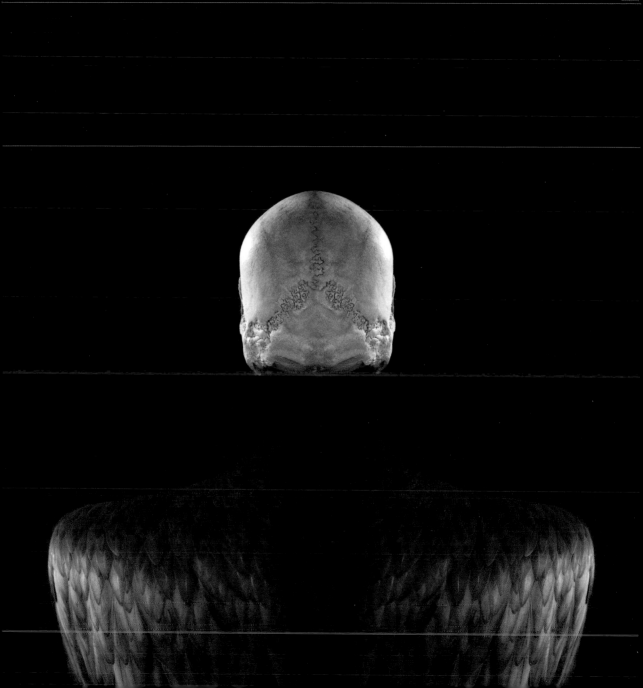

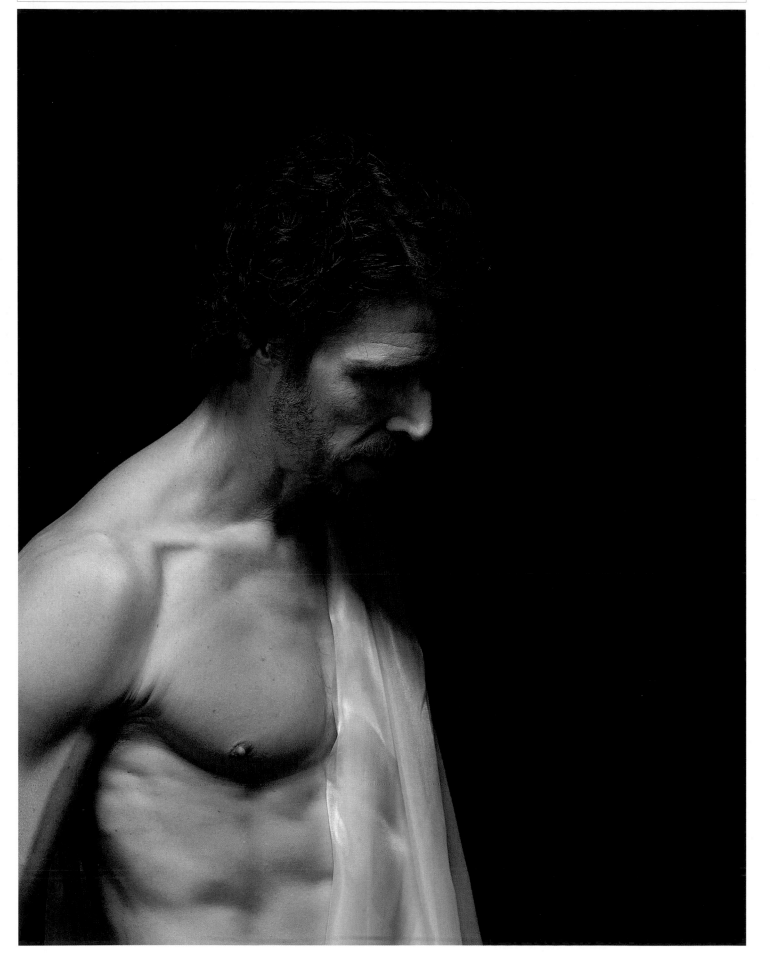

The Death of Heracles | Self-Initiated

Visit website to view full series

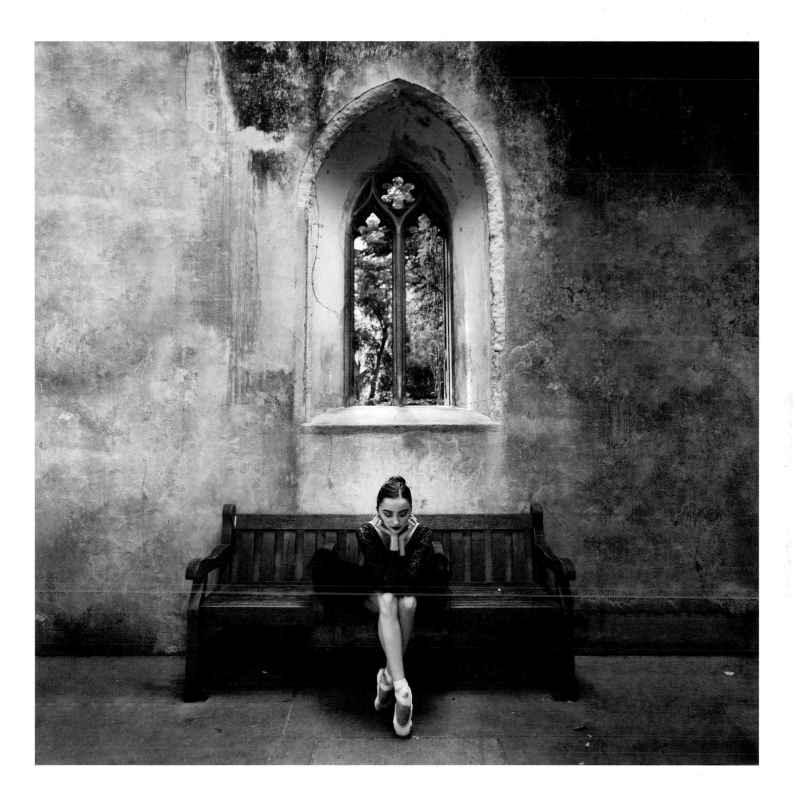

Viola Bella Pantuso | London Abby | Acquisitions of Fine Art | Hinsdale Gallery

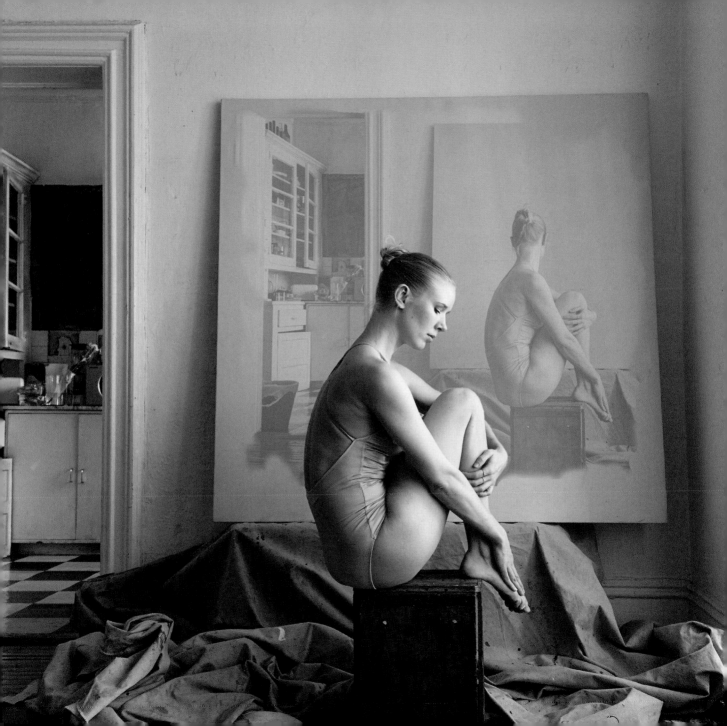

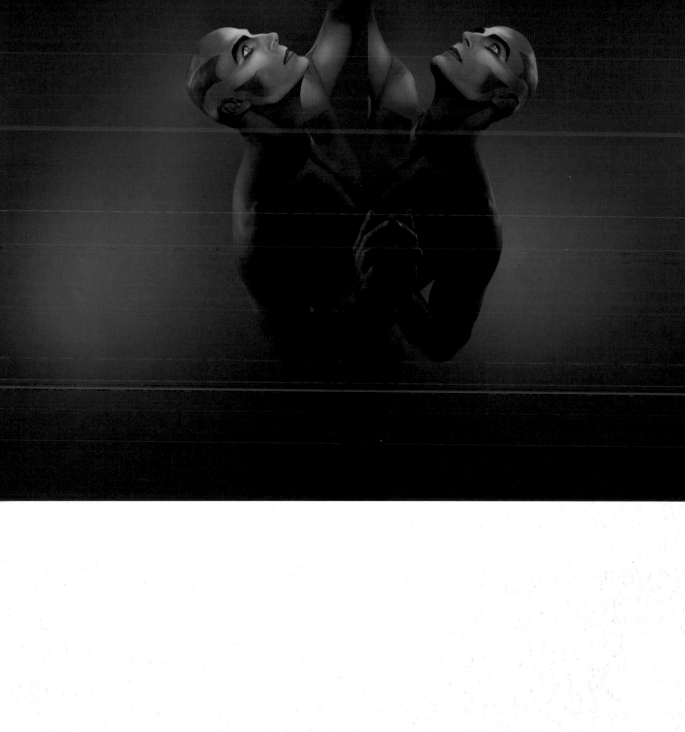

Viktor Kee Study I | Parish Kohanim Fine Art LLC

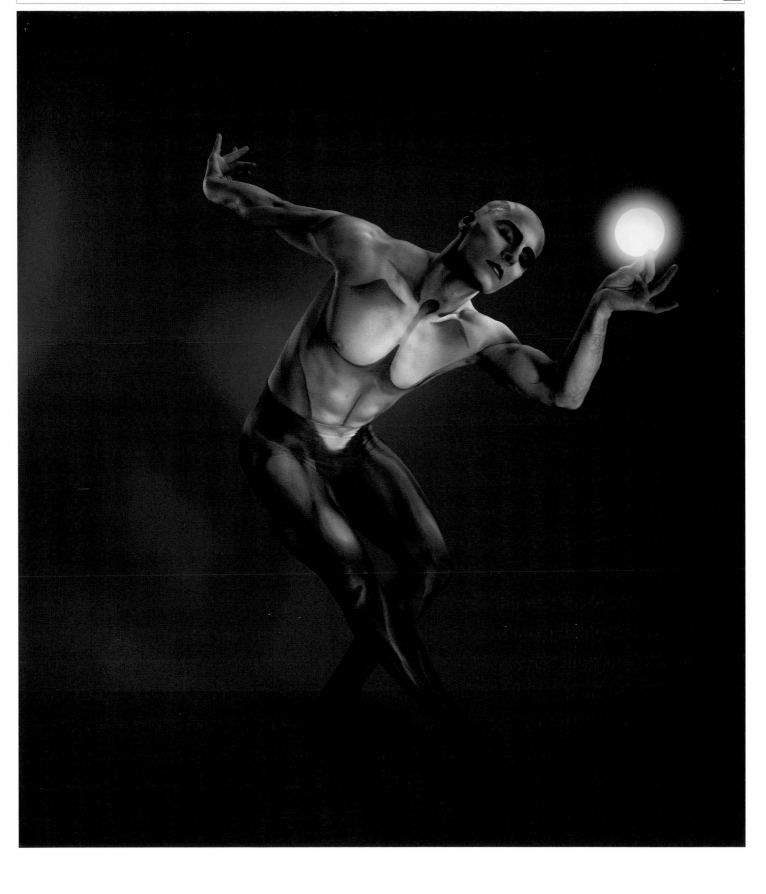

Viktor Kee Study II | Parish Kohanim Fine Art LLC

Reflection | David Hocker

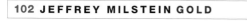

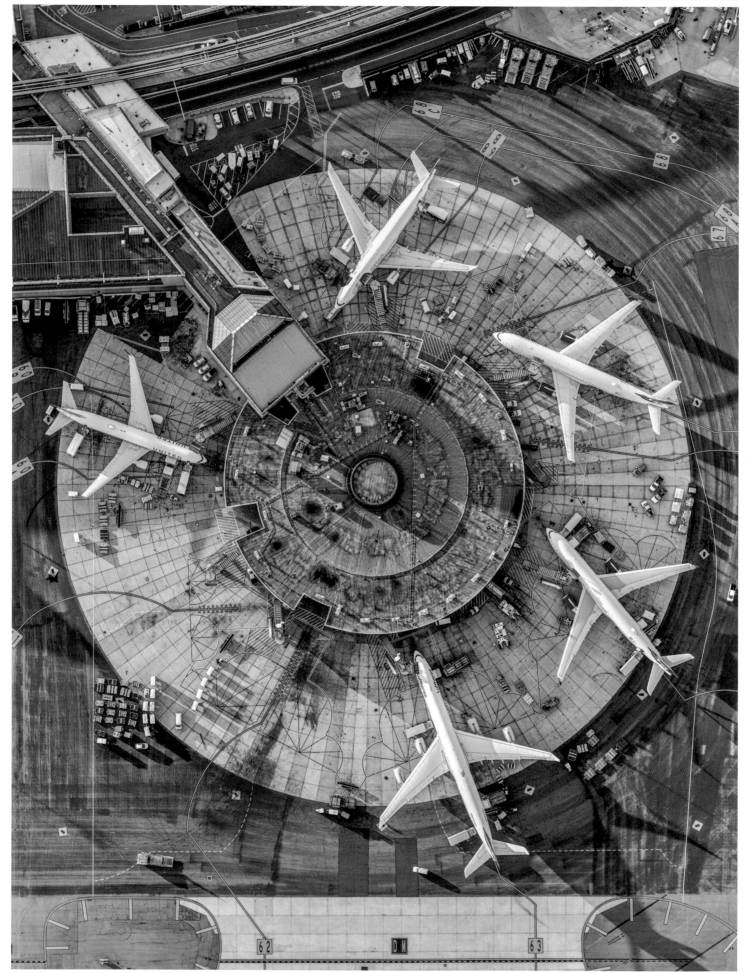

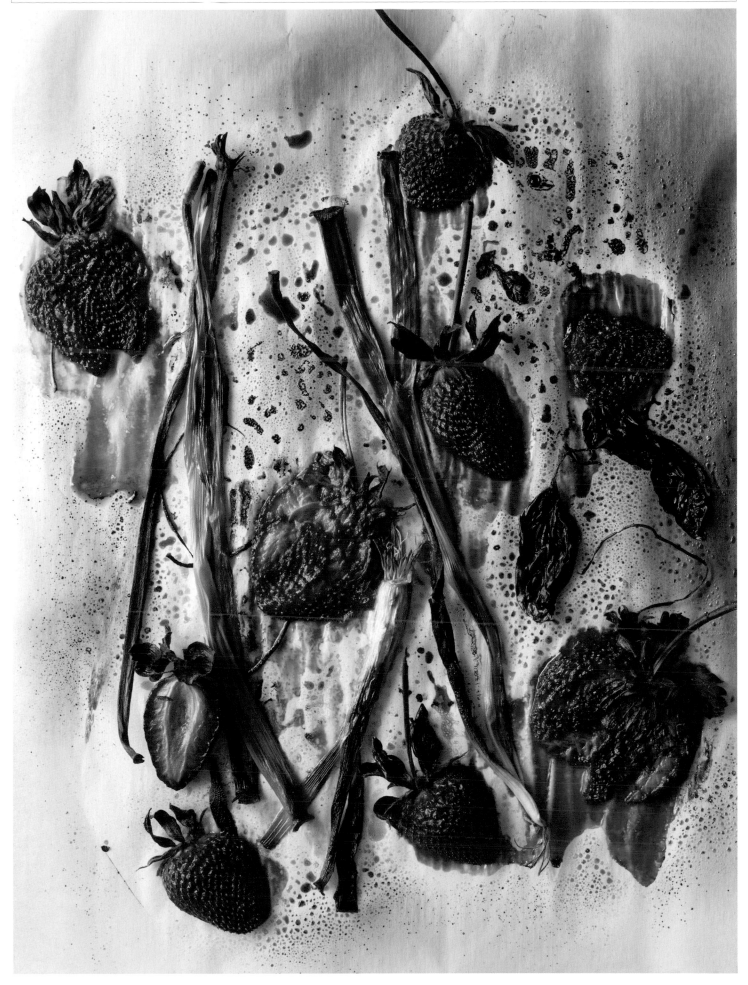

Wallpaper Fruits | Self-Initiated

Visit website to view full series

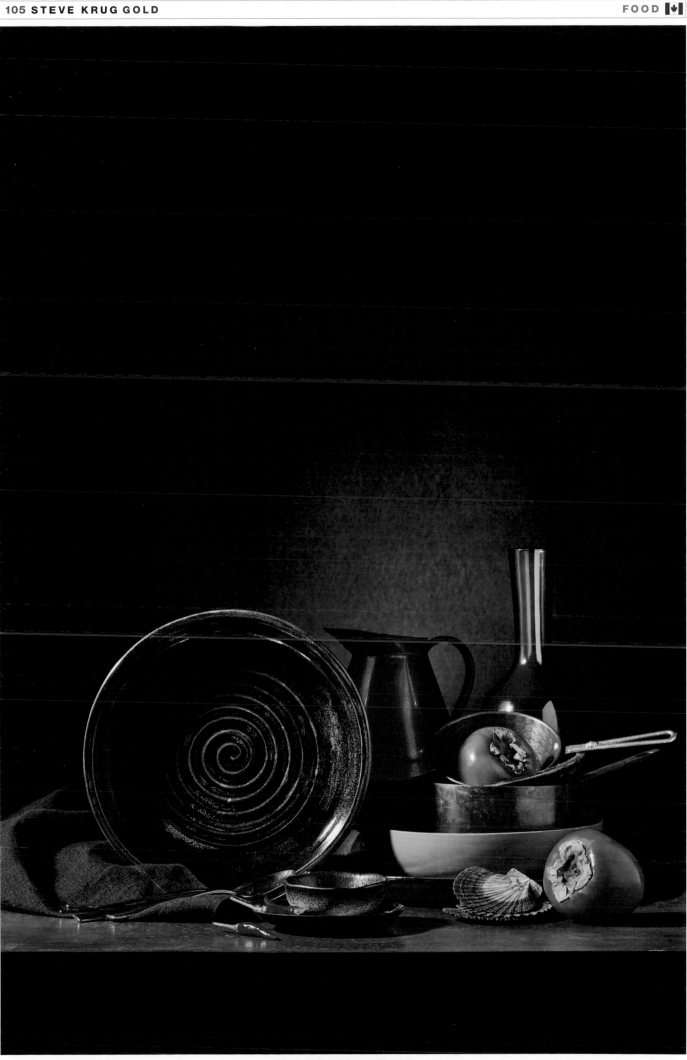

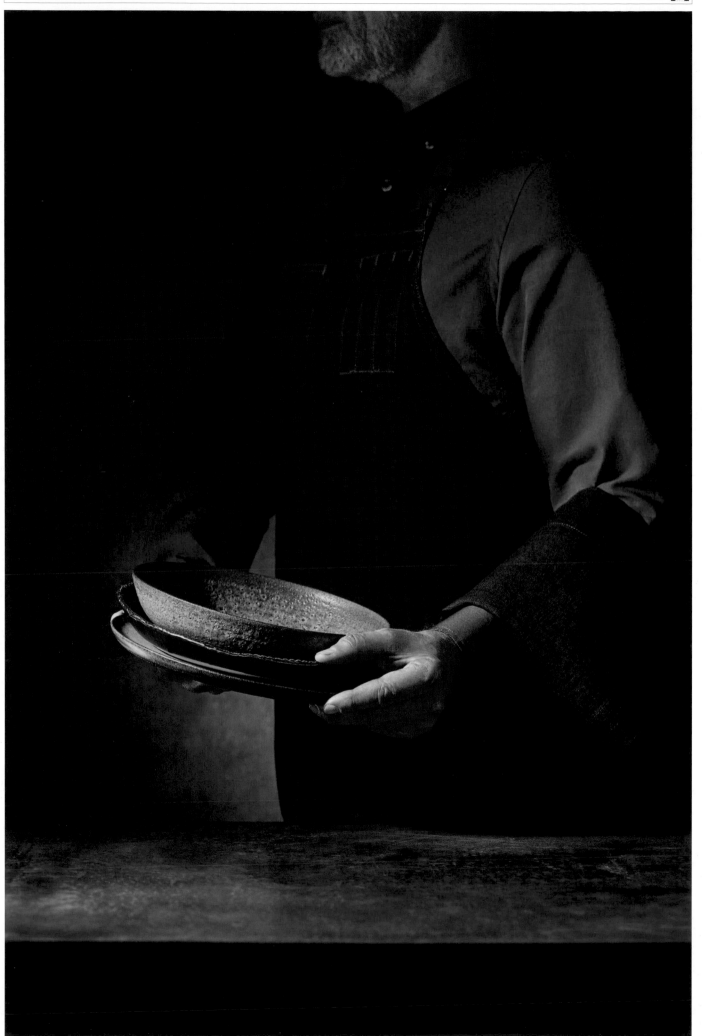

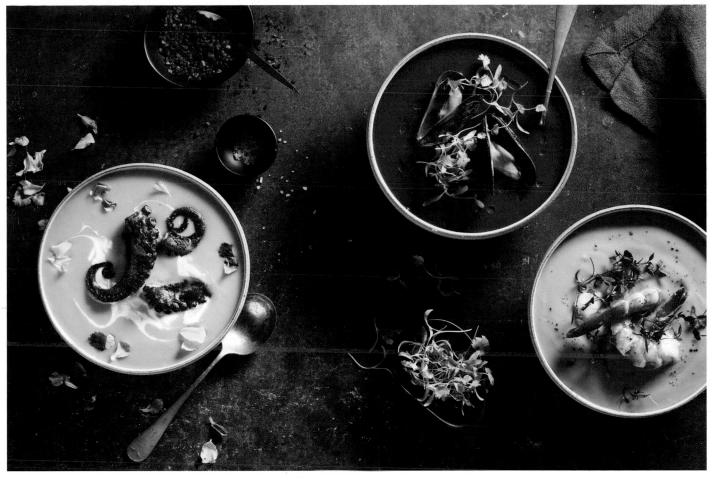

Soup Story | Self-Initiated

Visit website to view full series

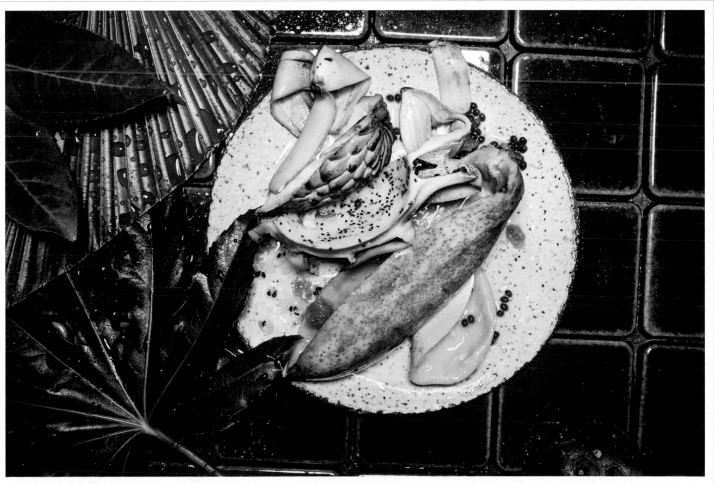

Savages | Self-Initiated

Visit website to view full series

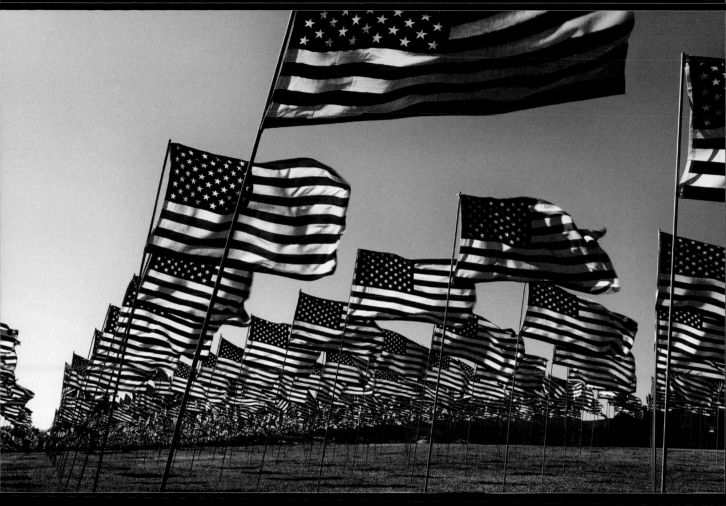

This image was taken at the "Waves of Flags Display" at Pepperdine University that honors the victims of September 11, 2001. There are 2887 flags that roll over the hills of the campus along the Pacific coastline. One for each individual that was lost. What is the most striking and most powerful sense you feel is not the sheer volume of flags you see, but it is the sound of all those flags together in the wind that effected me the most. I felt that removing all color and documenting this in B&W stripped the senses to the core of how I felt being there.

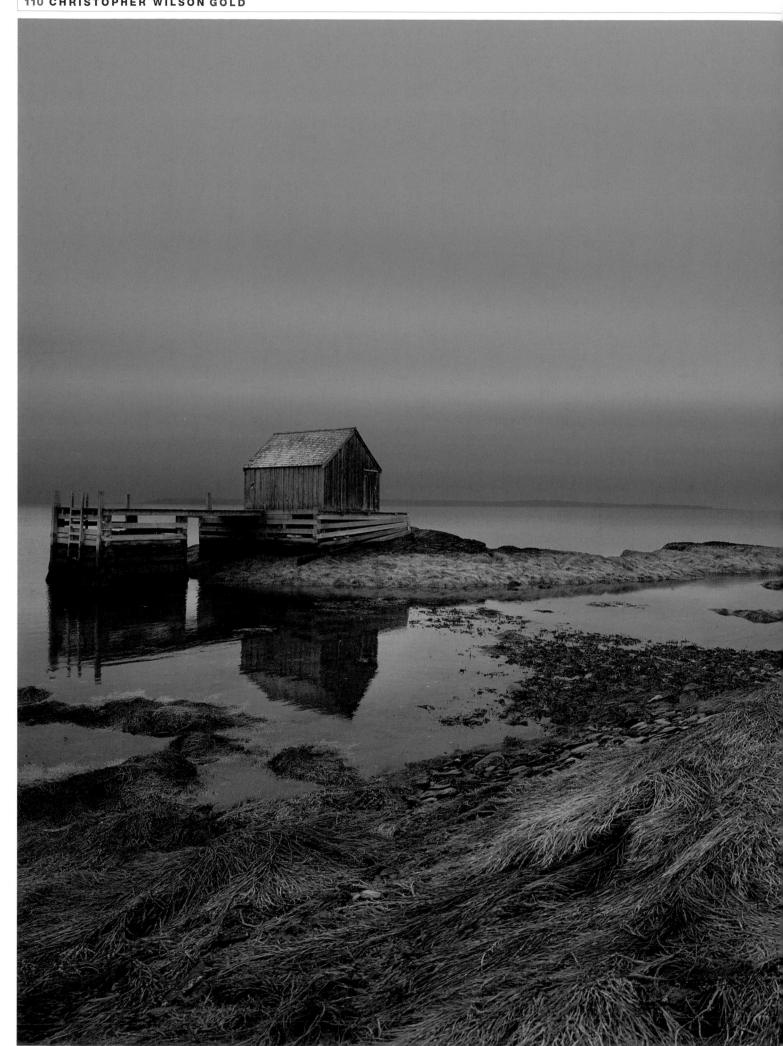

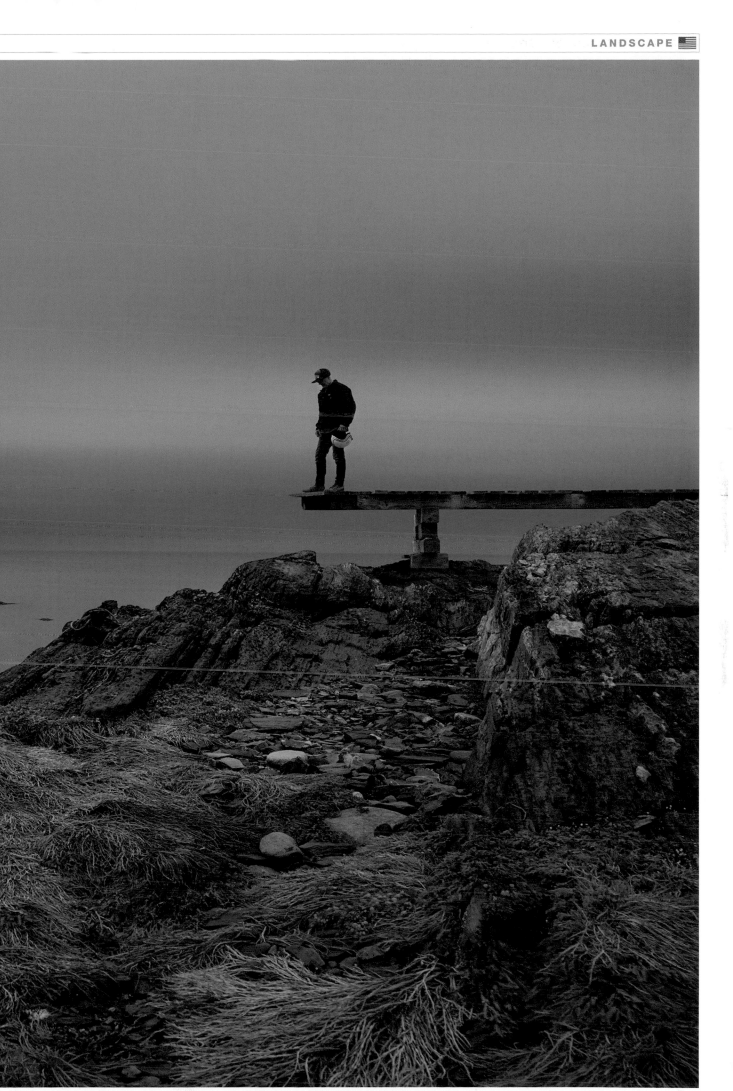

Language Is Speechless | Self-Initiated

Visit website to view full series

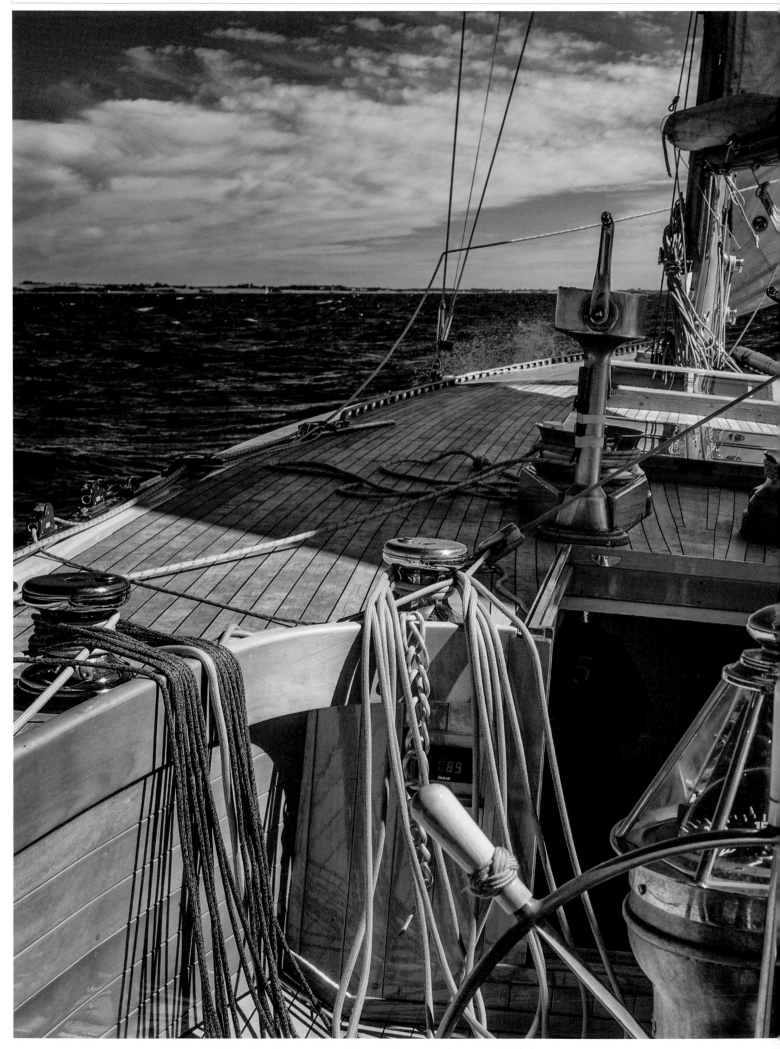

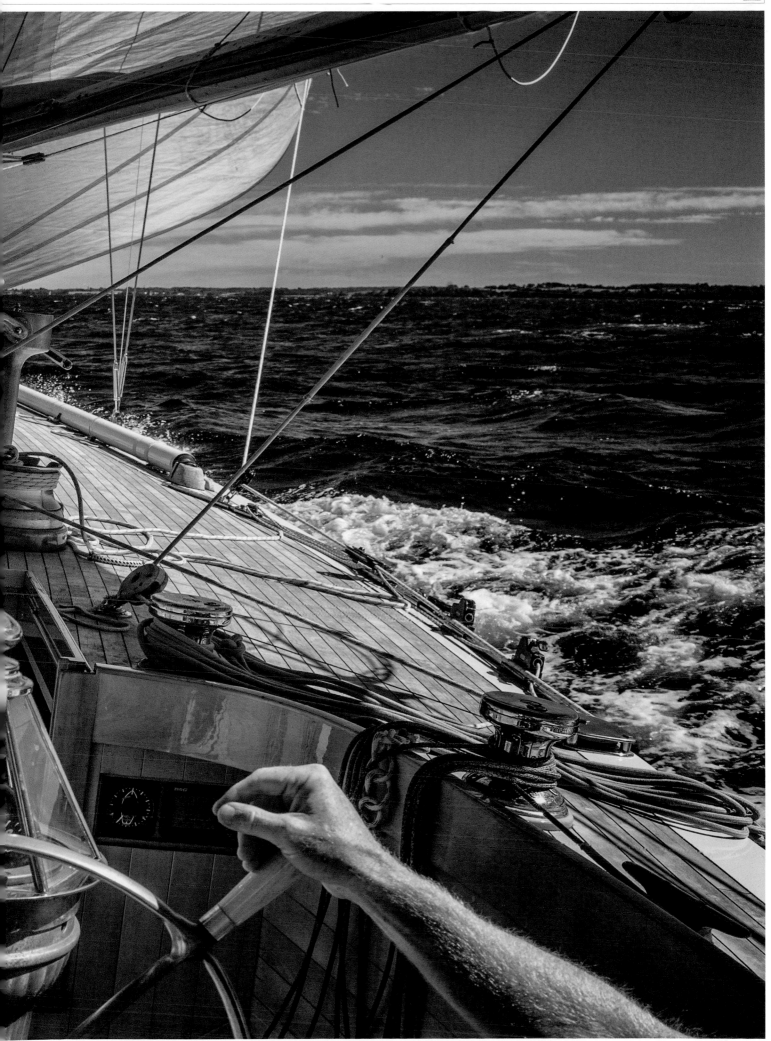

1939 Sparkman & Stephens 12 meter sailboat, "VIM" | **Self-Initiated**

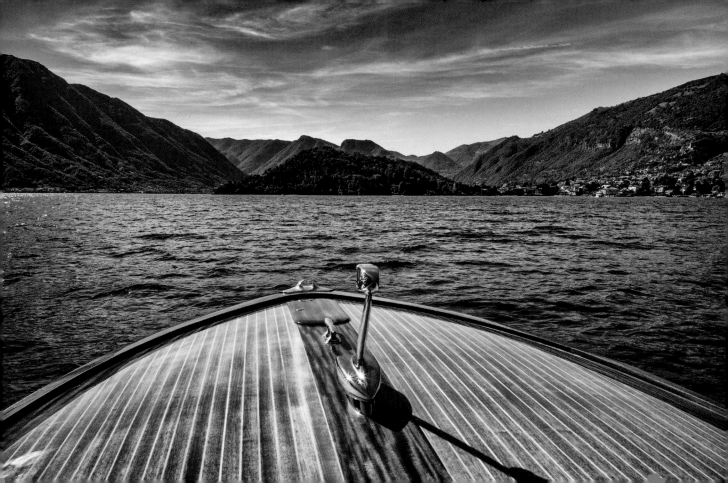

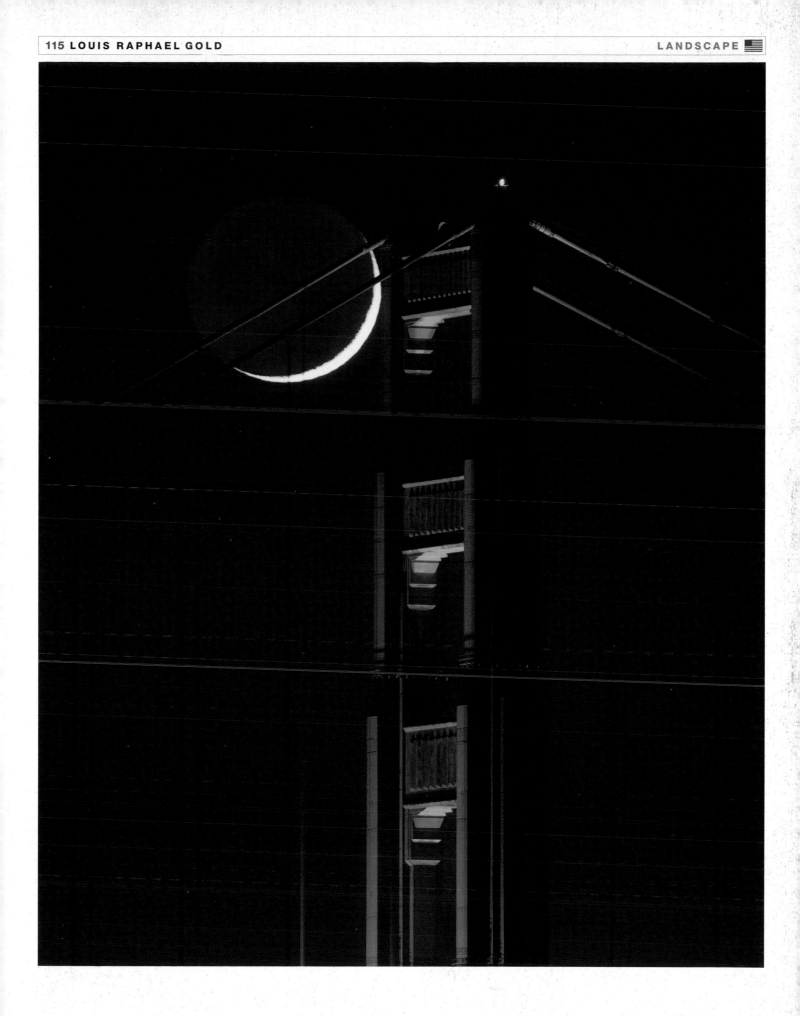

Moon Kisses | San Francisco Travel Association

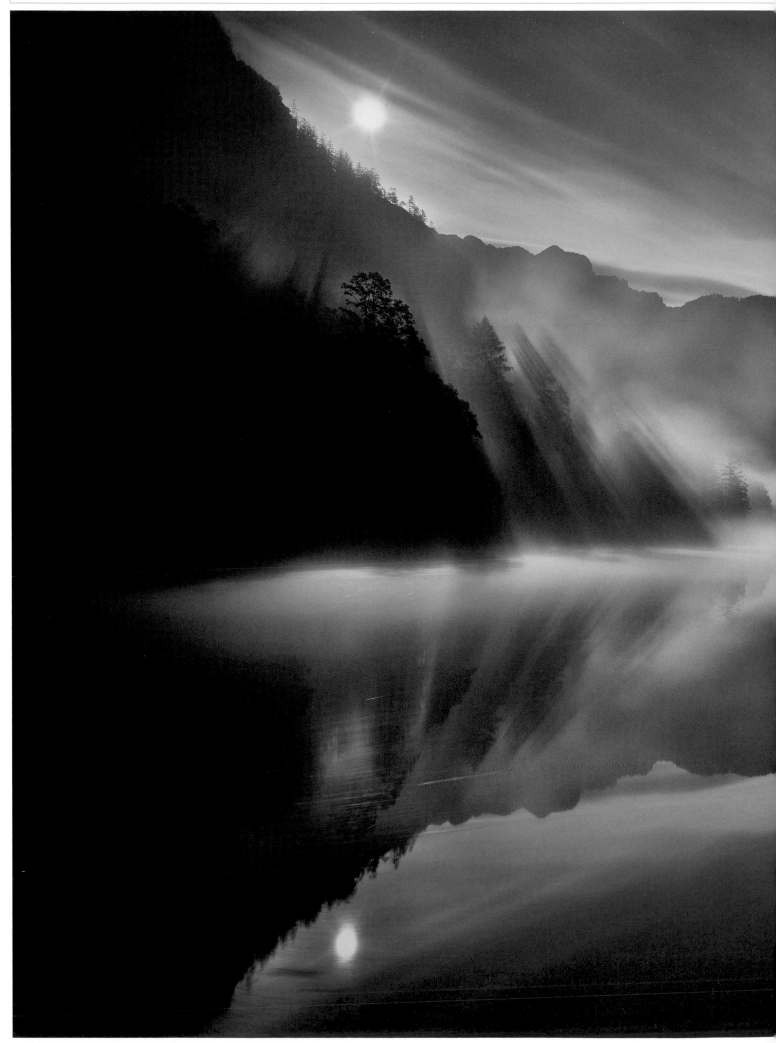

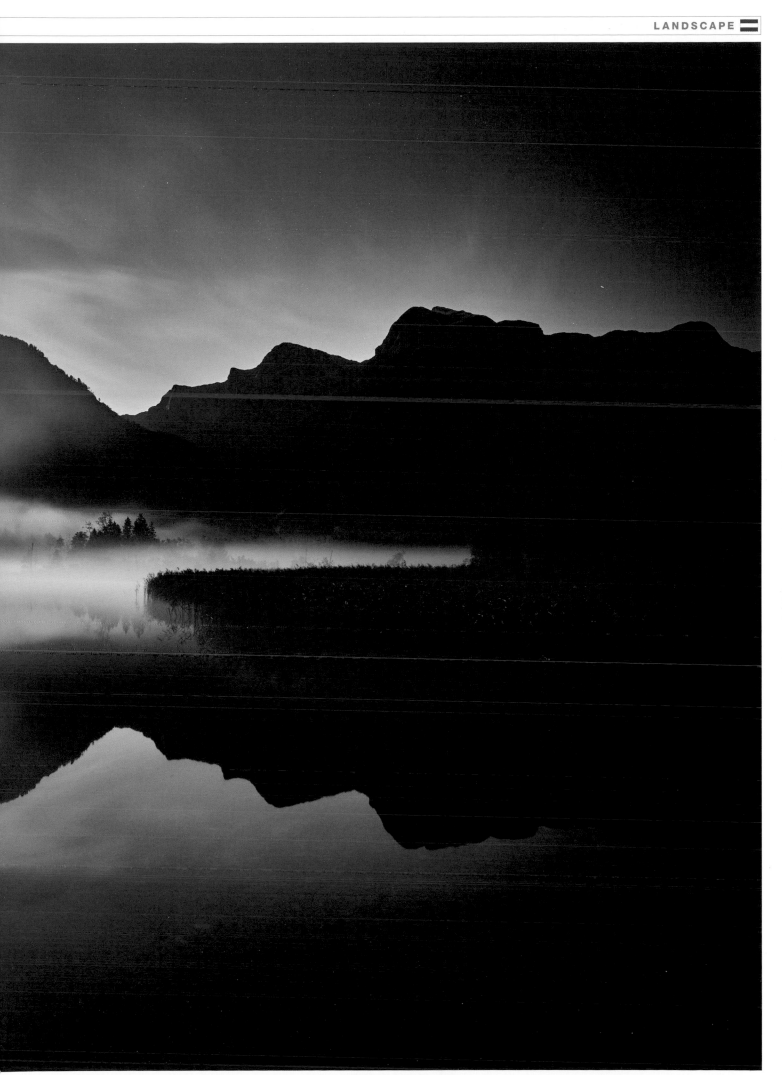

Almsee | Self-Initiated

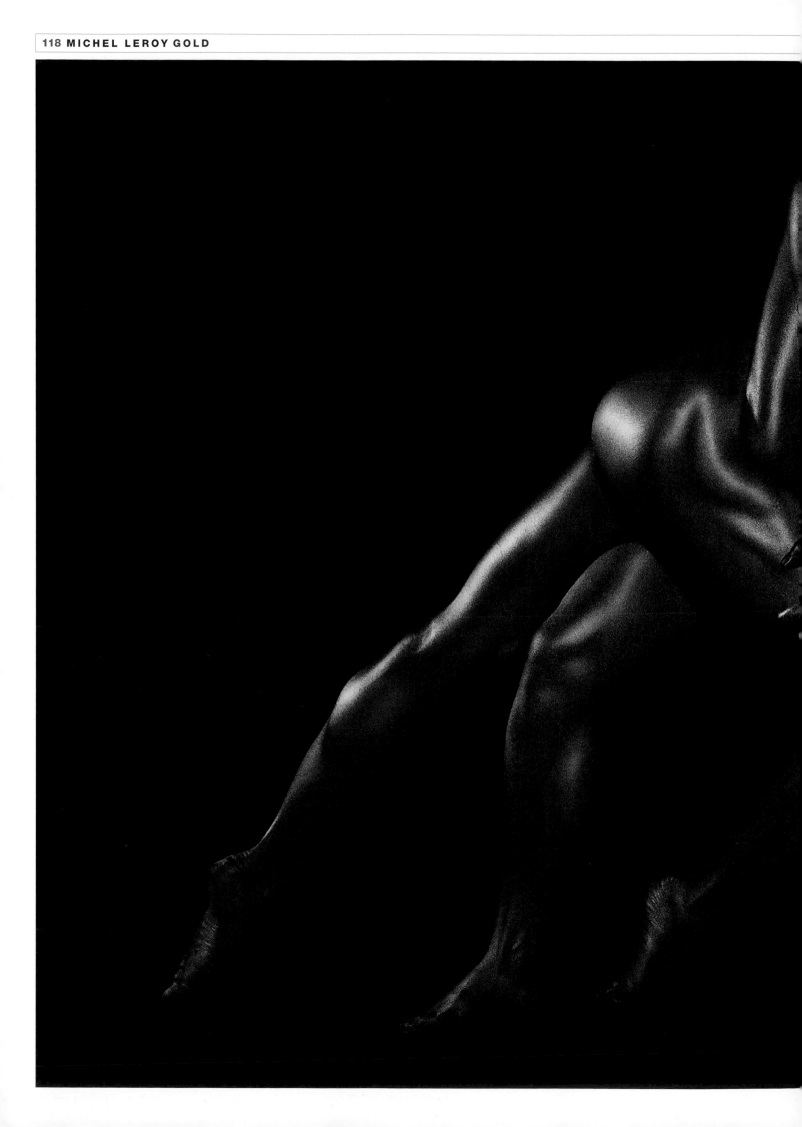

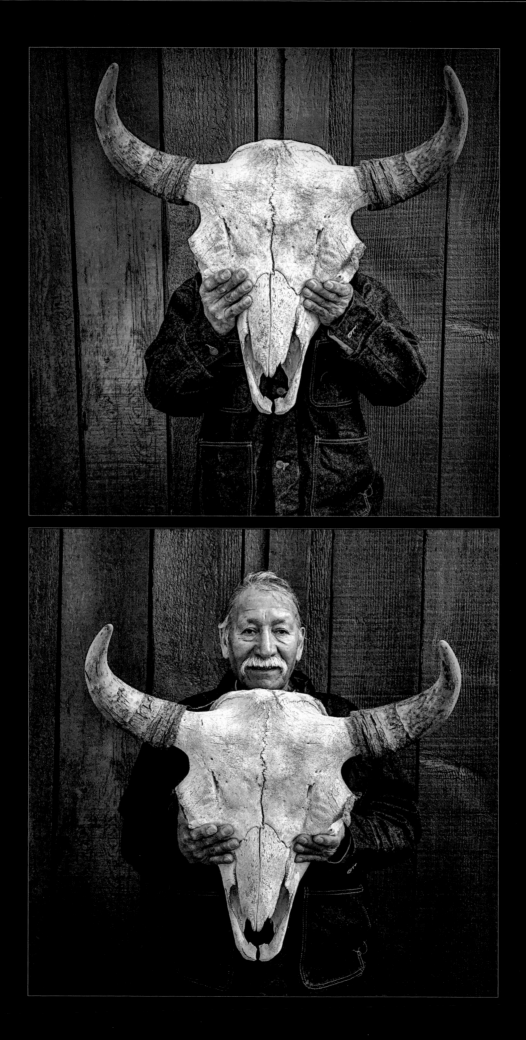

Untitled | Self-Initiated

Xueli | **Xueli**

Visit website to view full series

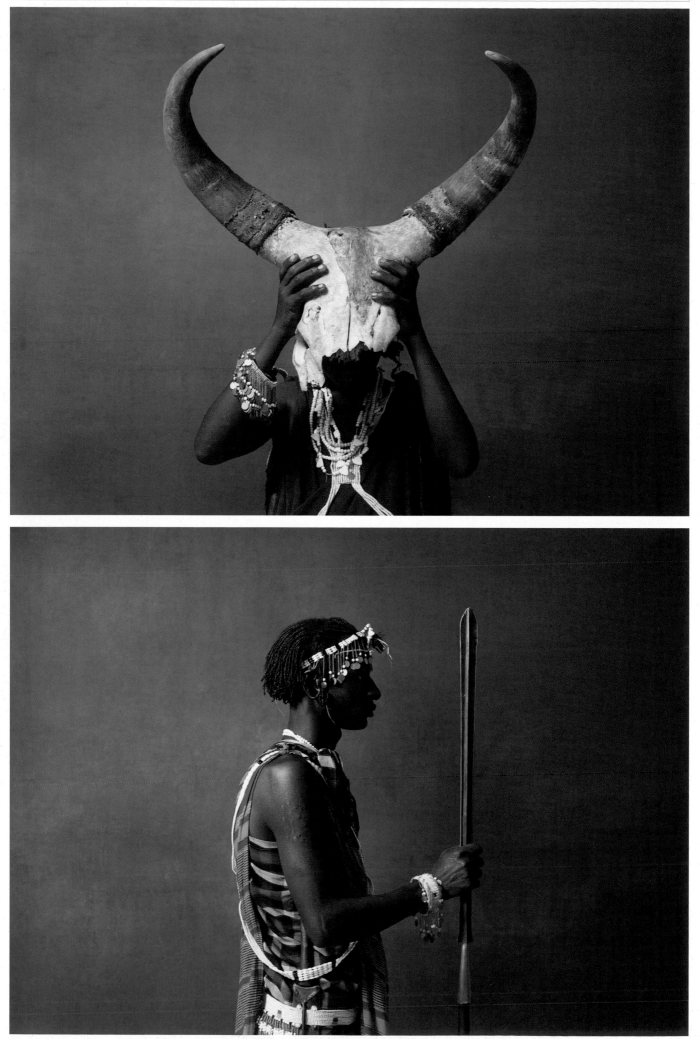

Maasai Warriors | Smithsonian Magazine

Visit website to view full series

Keep the History Alive - William Bonelli | Self-Initiated Visit website to view full series

TROG Portraits - Mrs. Sheets | Self-Initiated

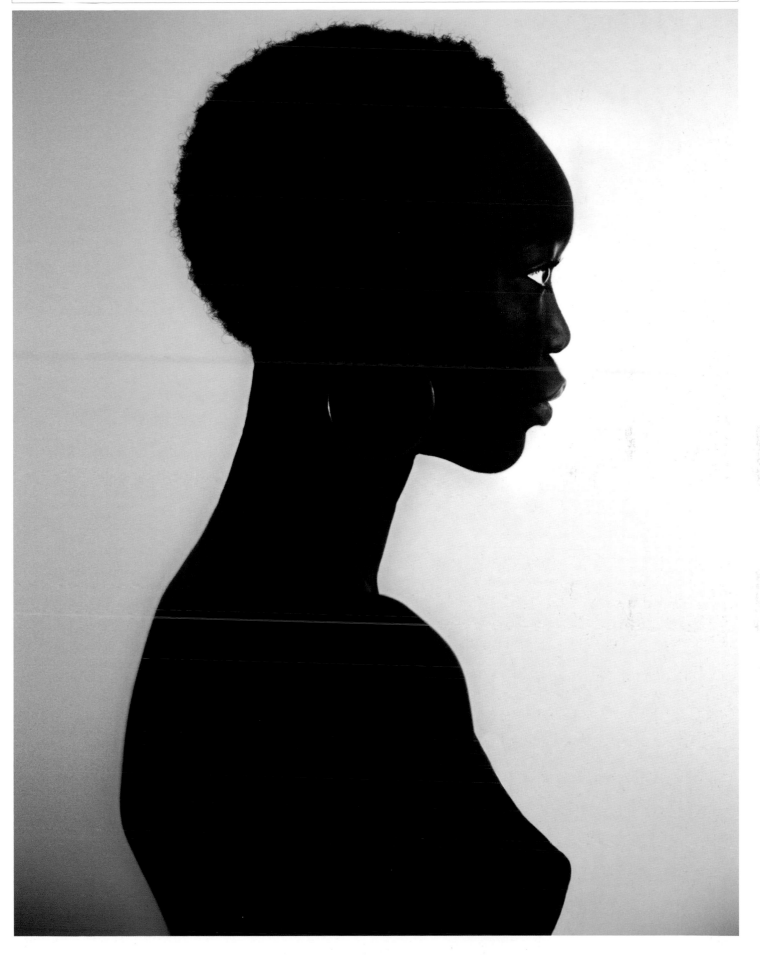

Nya Kong | Self-Initiated

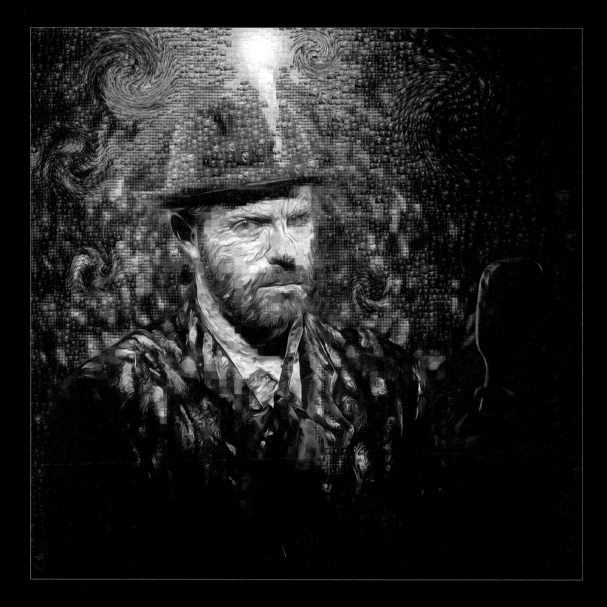

Daniel as Vincent | Self-Initiated

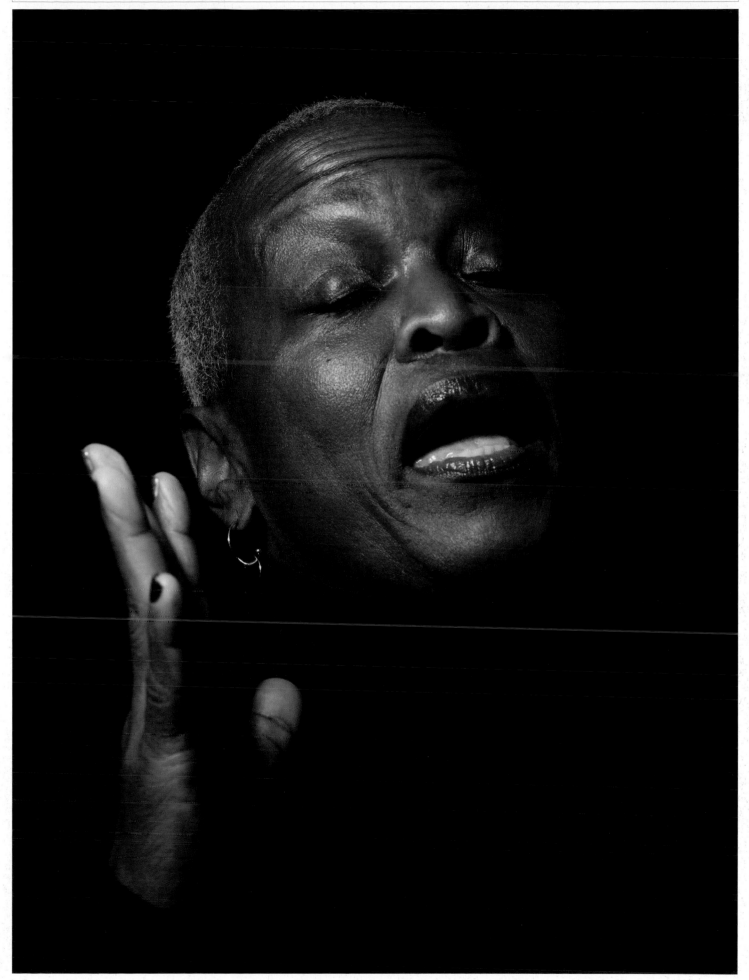

Senior Beauty | Getty Images

Visit website to view full series

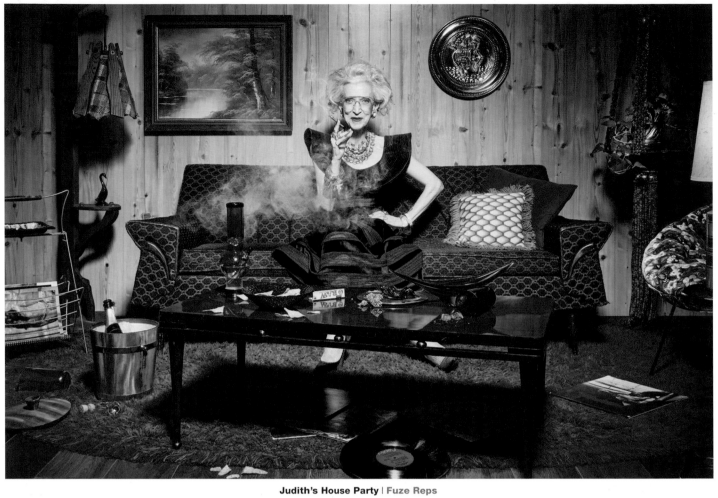

Judith's House Party | Fuze Reps

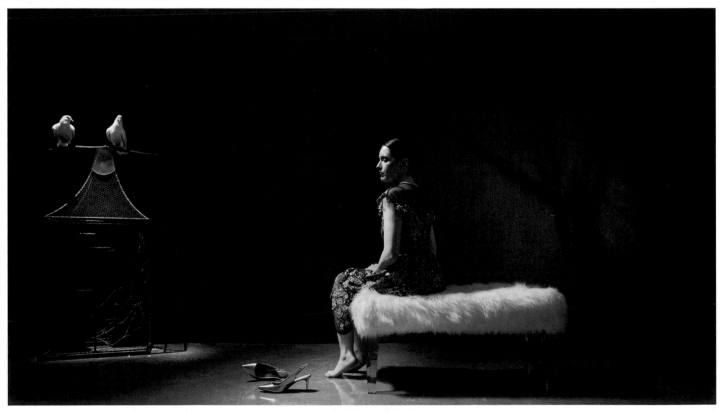

Drizella | Self-Initiated

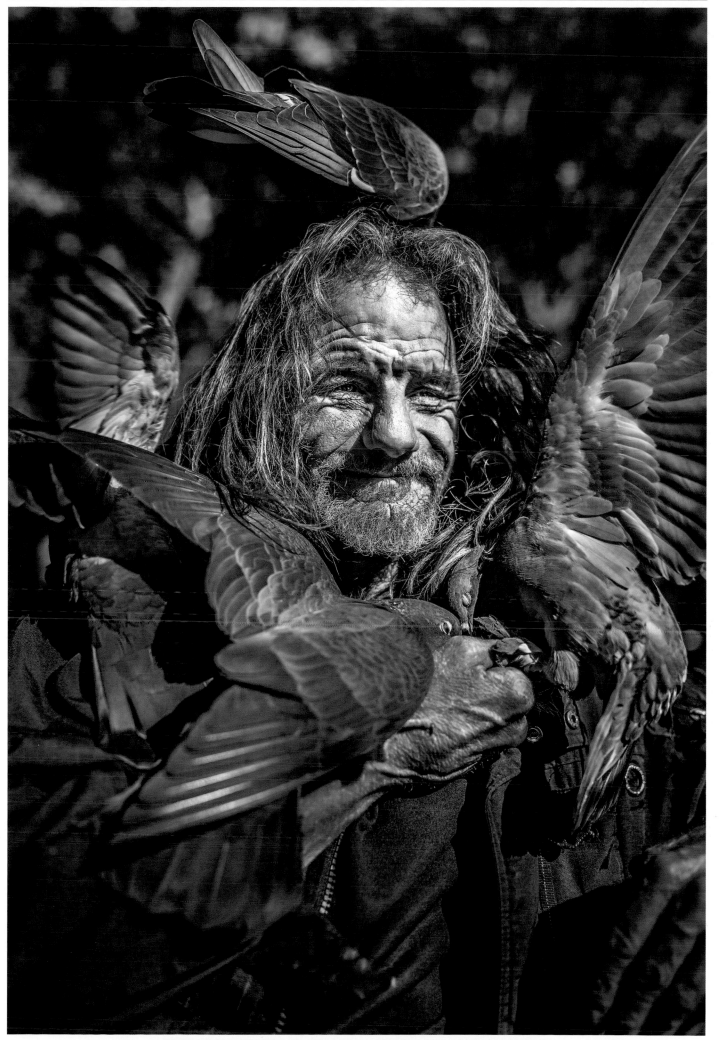

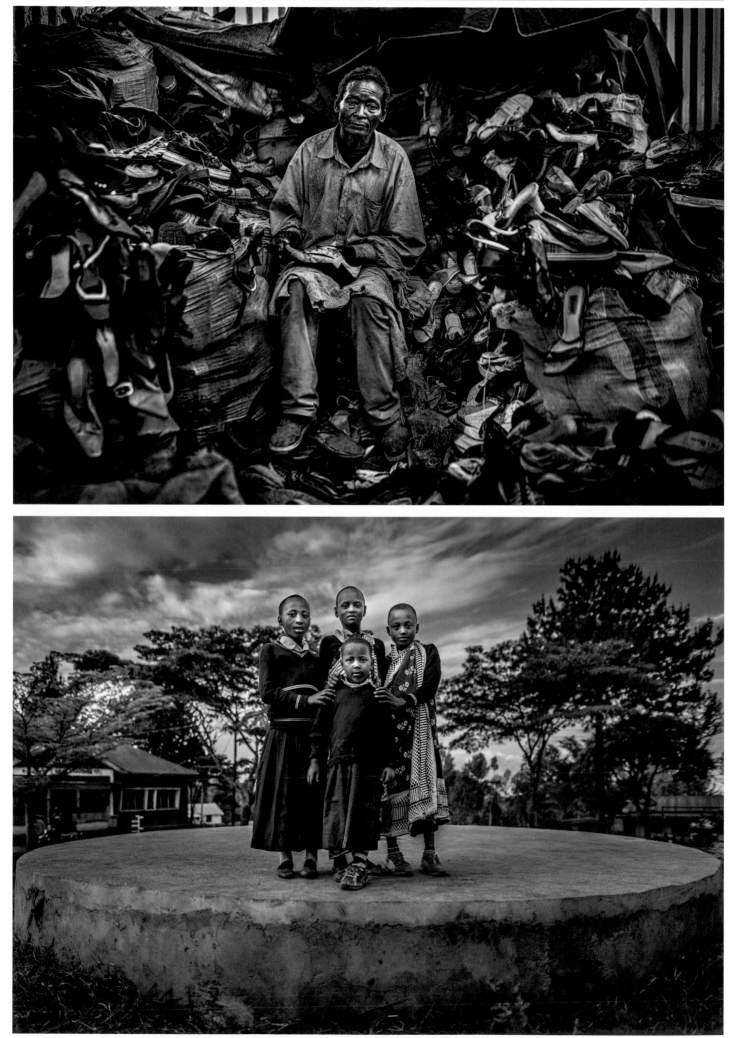

EyeCorps Boston Work in Moshi Tanzania | EyeCorps

Visit website to view full series

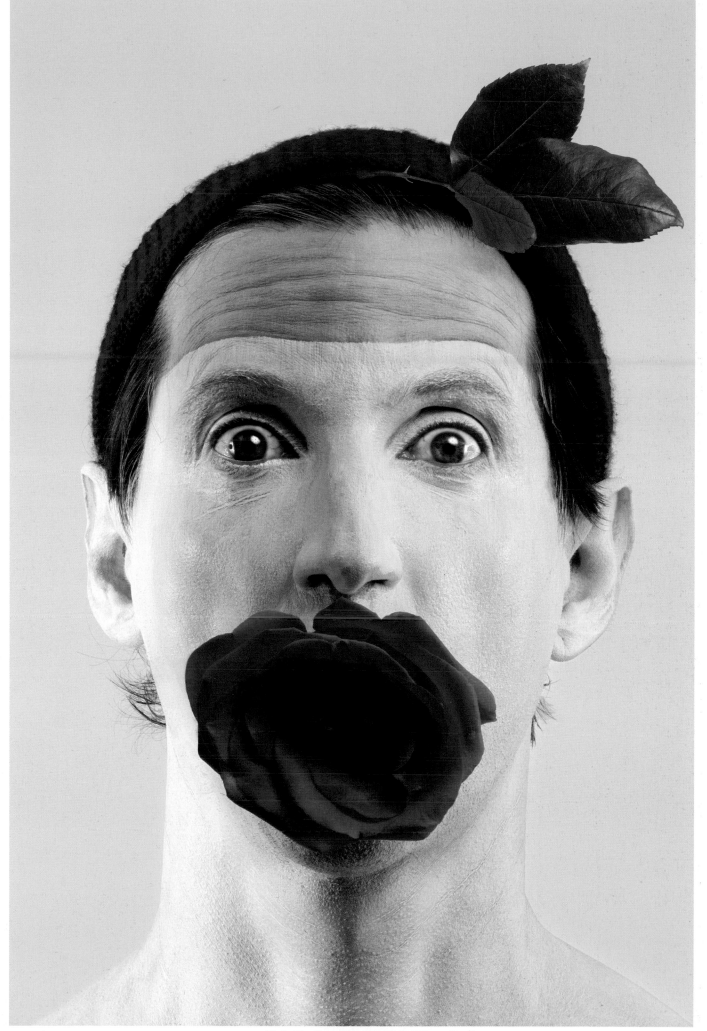

João Macdowell as Joff | Epic Litho

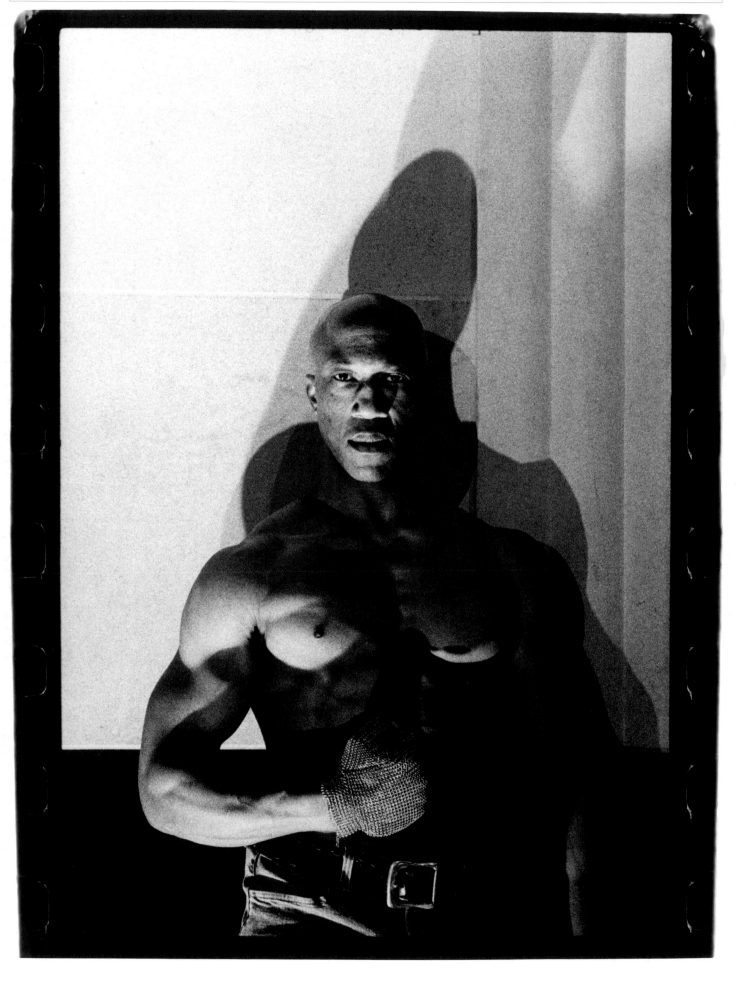

Ric Powell South Beach | Self-Initiated

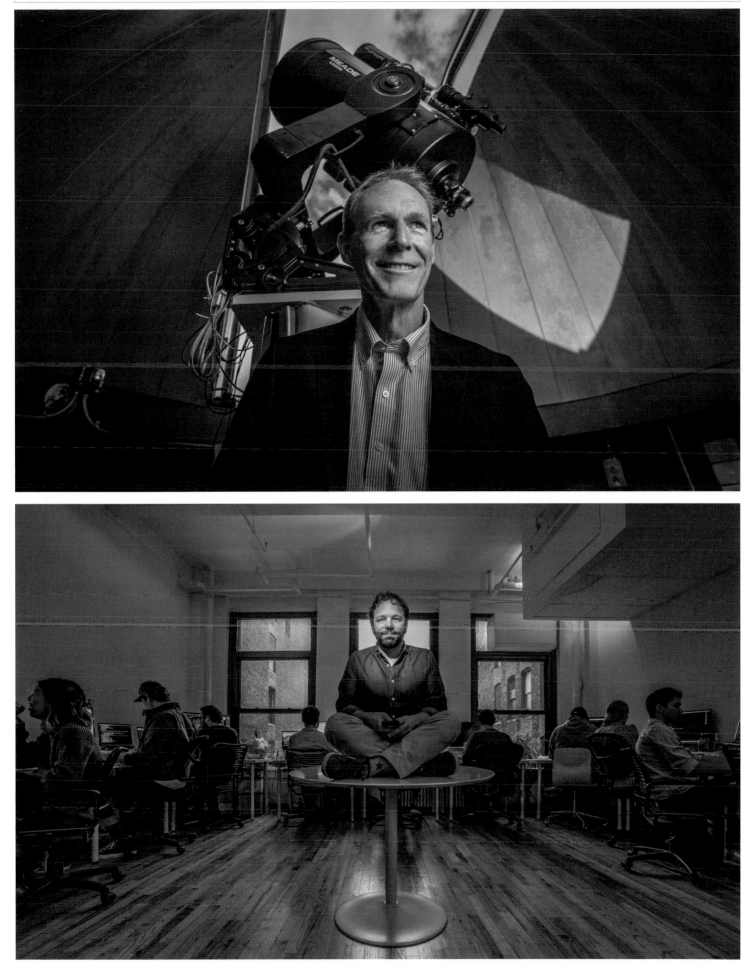

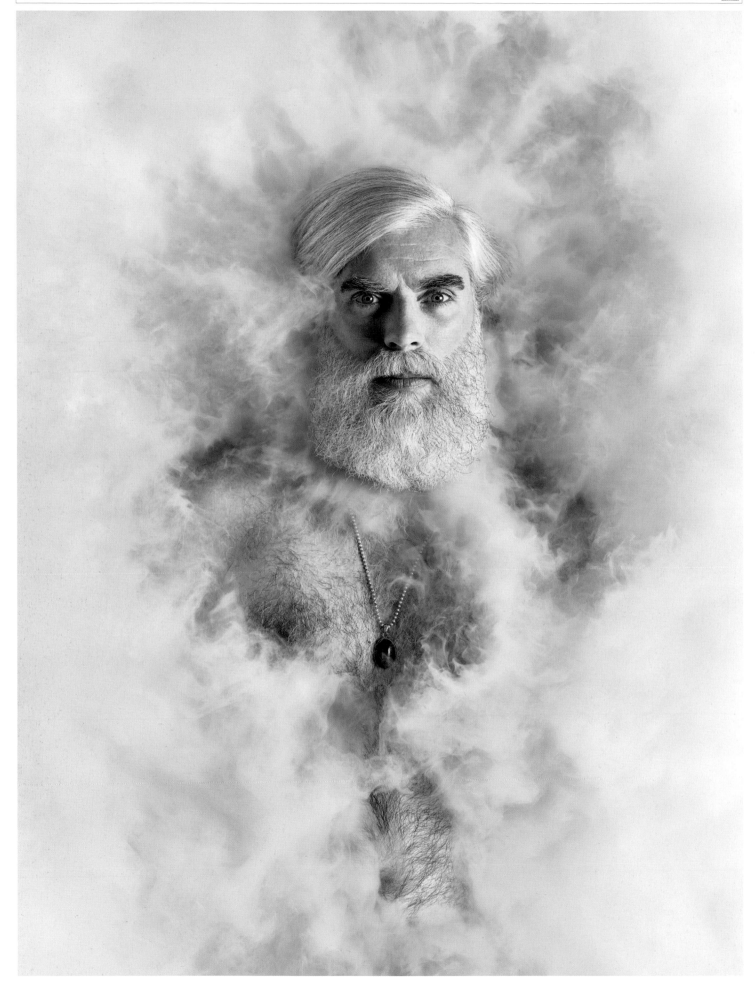

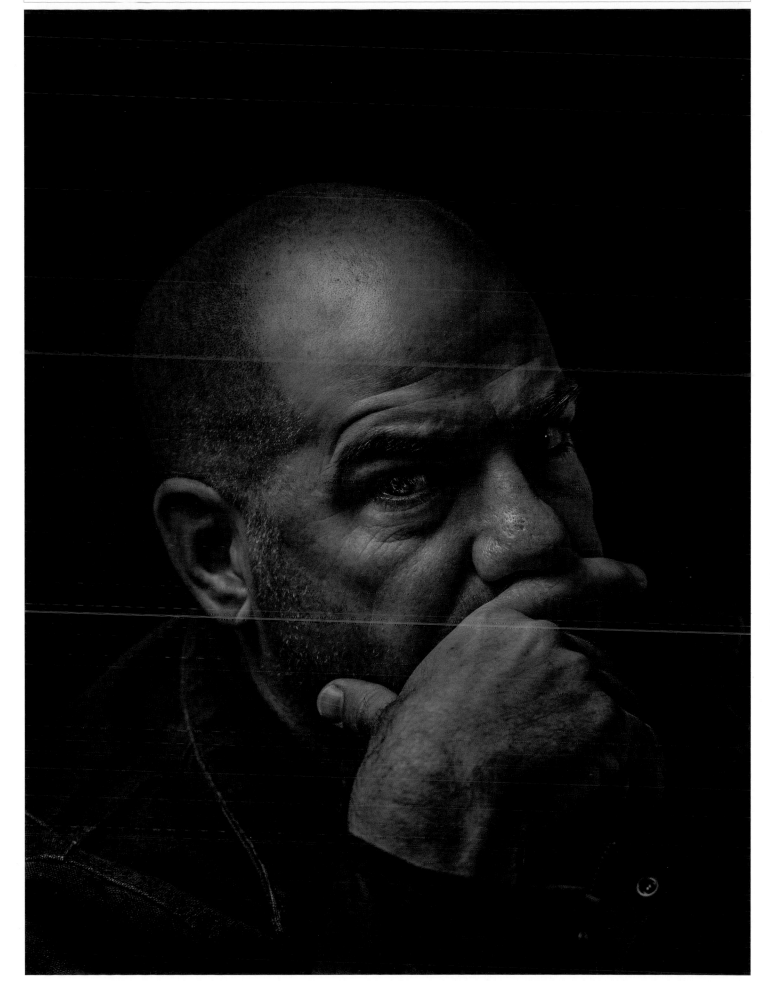

The Actors | Individuals

Visit website to view full series

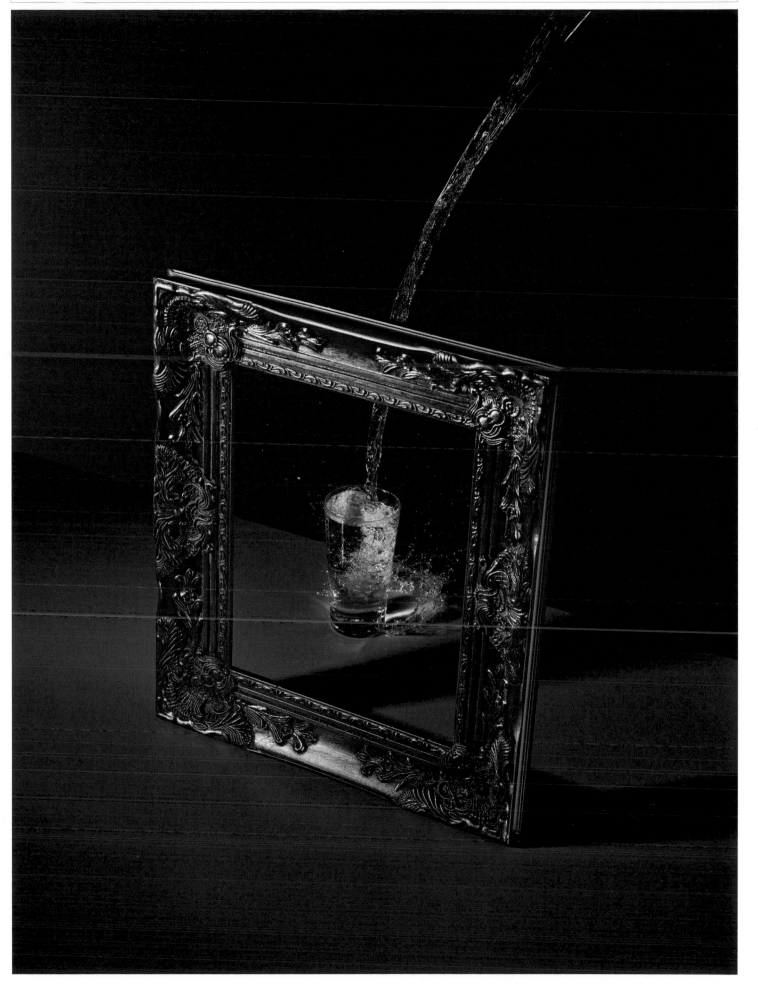

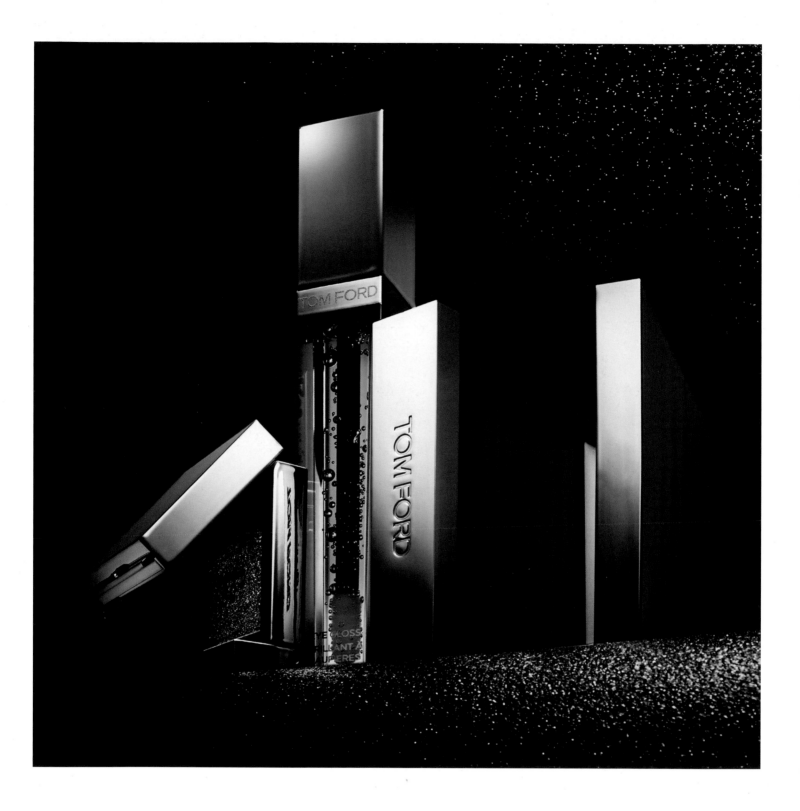

Tom Ford | **Beauty** | **Tom Ford**

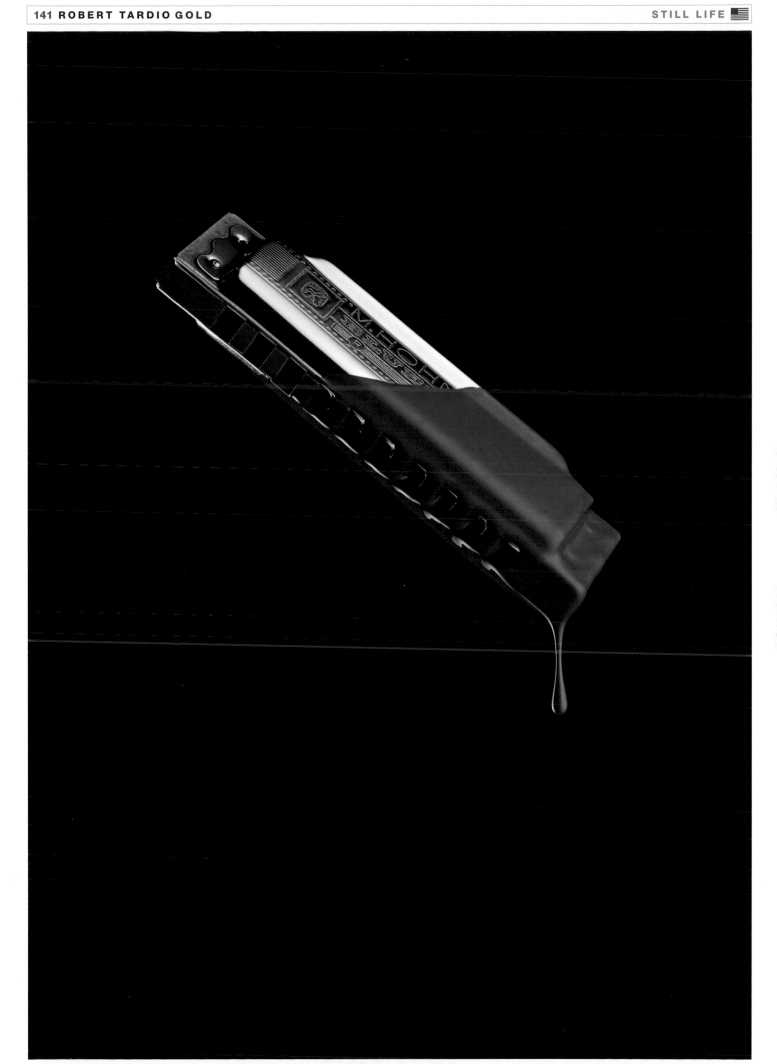

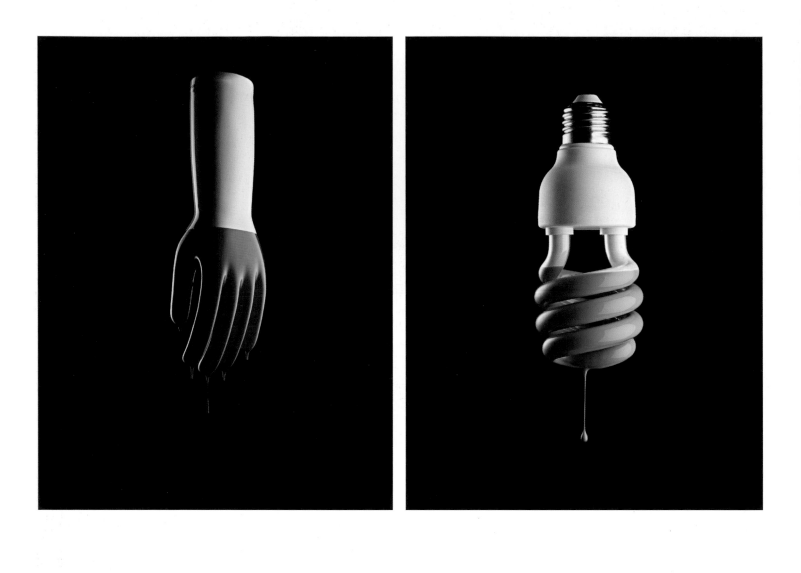

Dipped Series | Self-Initiated

Visit website to view full series

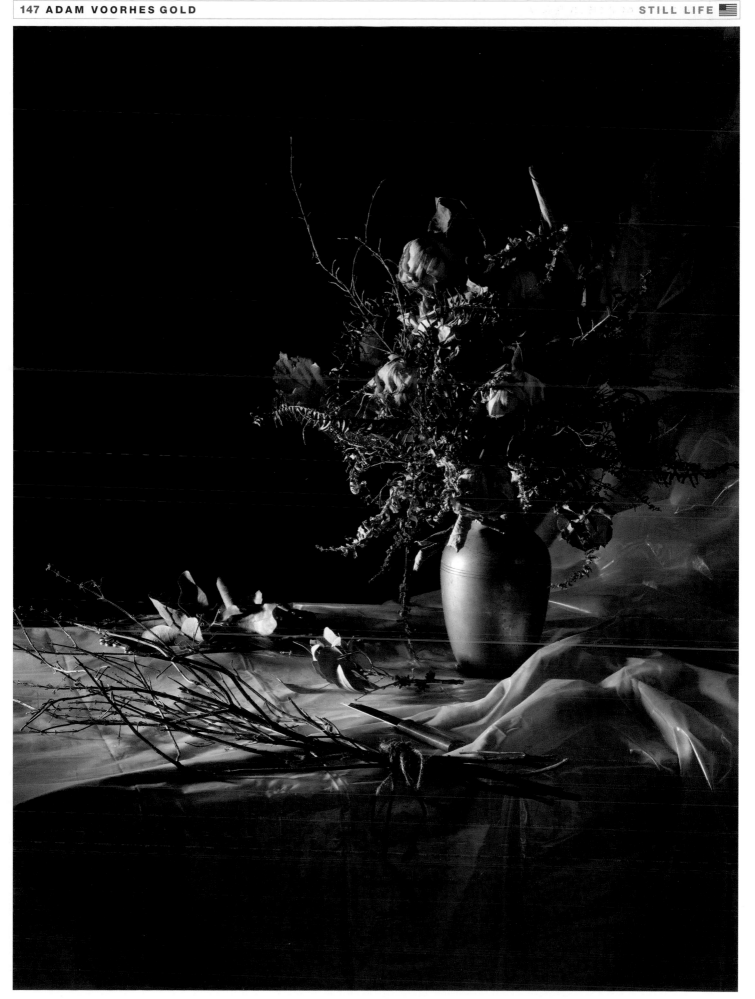

Plaster and Bone | Self-Initiated

Visit website to view full series

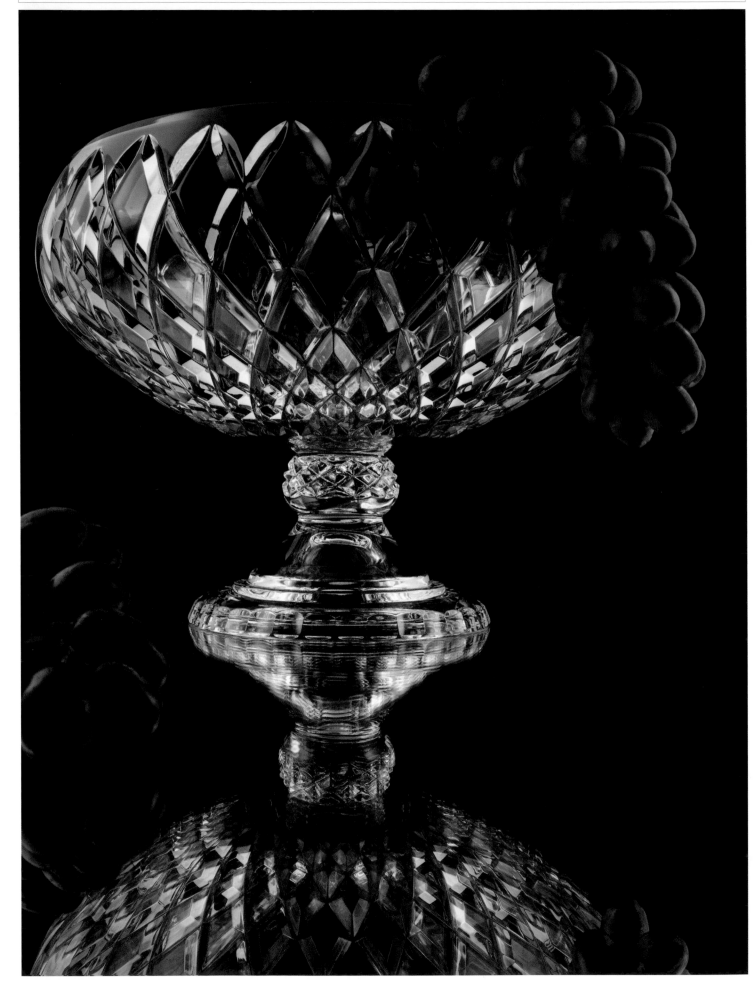

Amber Crystal Bowl | Self-Initiated

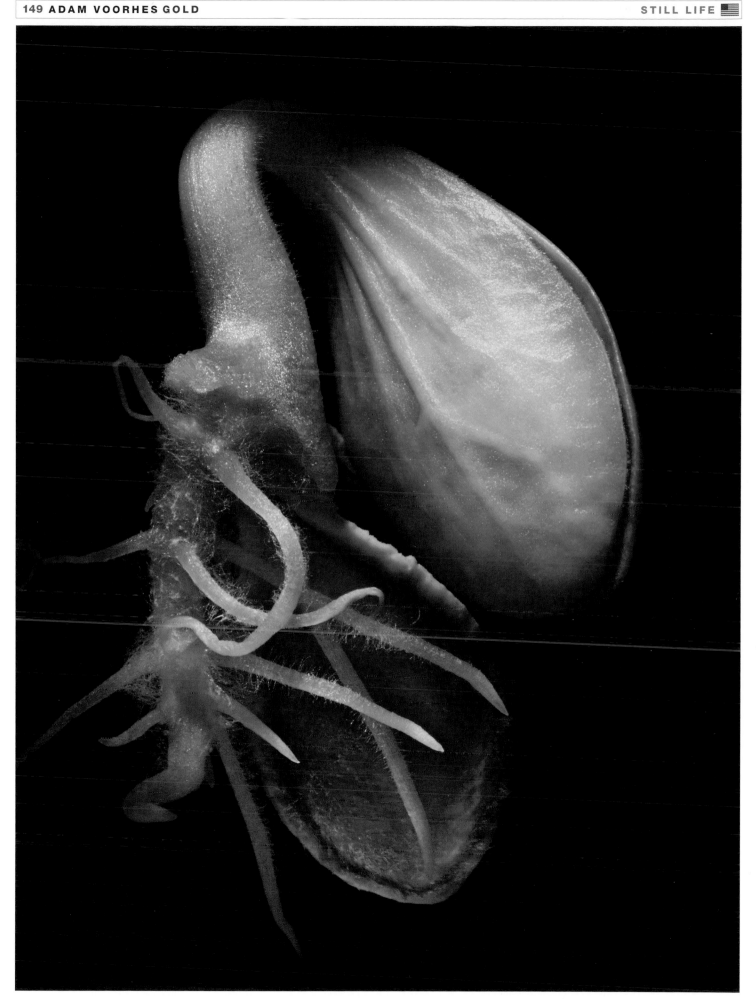

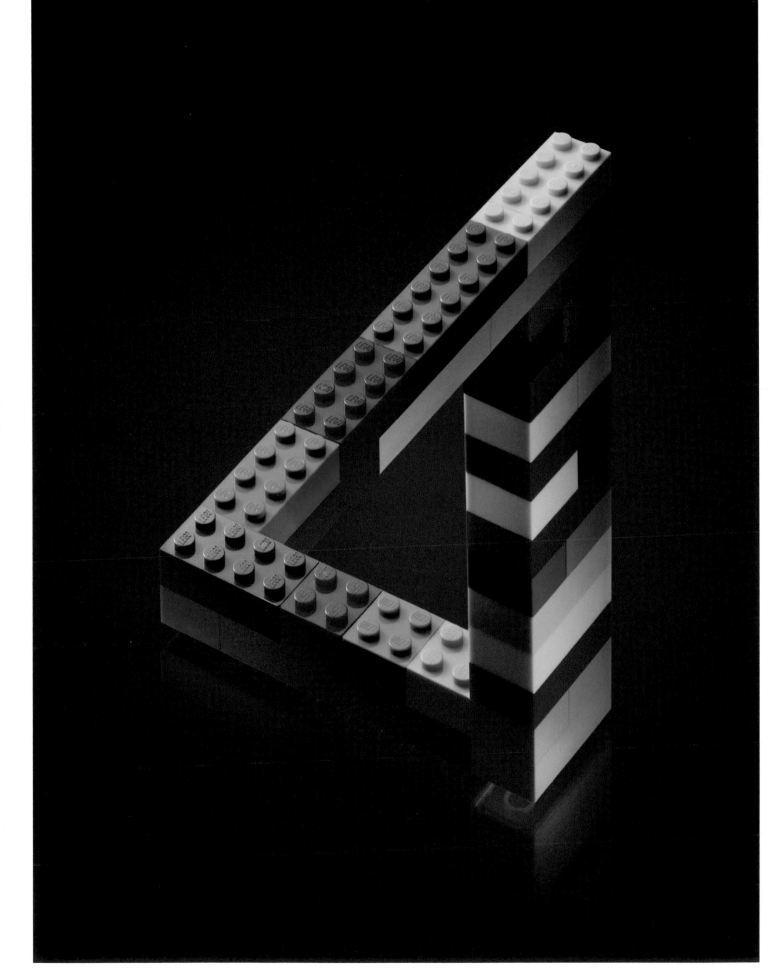

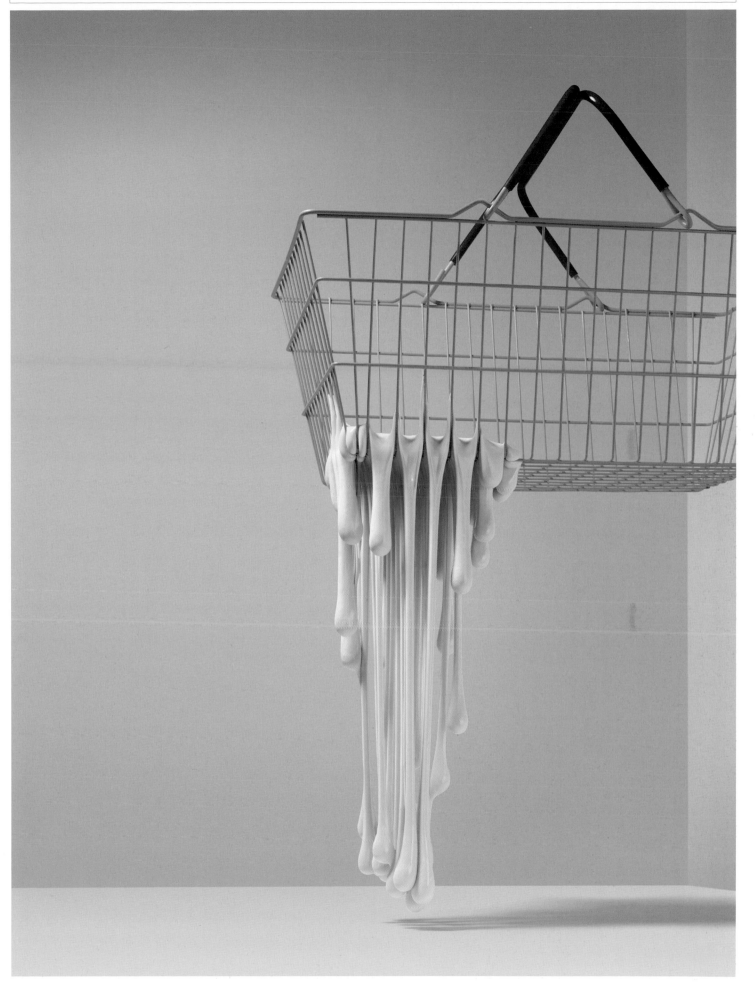

Slime | Self-Initiated

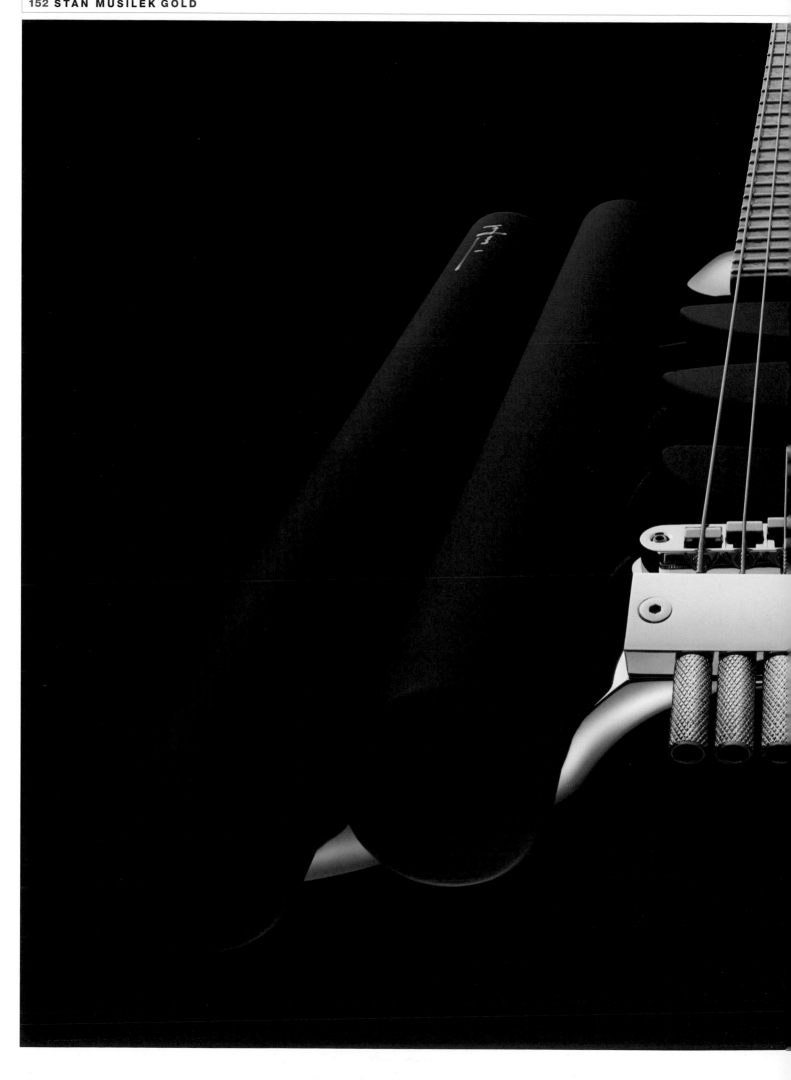

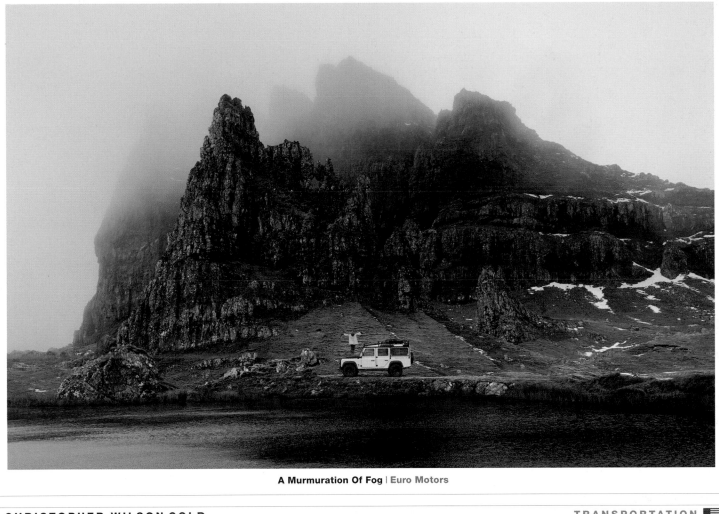

A Murmuration Of Fog | Euro Motors

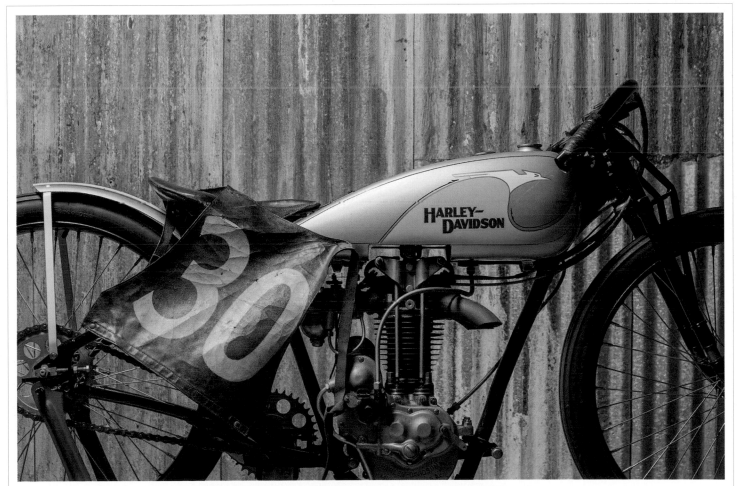

1930 Harley Board Track Racer | Wheels Through Time, 1903 Magazine

Visit website to view full series

JOE MAZZA

Quixote | Writers Theatre | Preproduction poster image | 2018 Season | Writers Theatre, Glencoe, IL

DARNELL MCCOWN

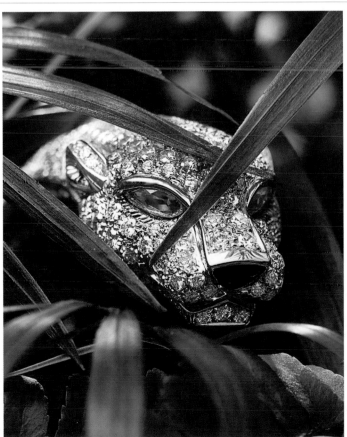

Jewelry in the Jungle | Heritage Auctions

DAVID BUTLER

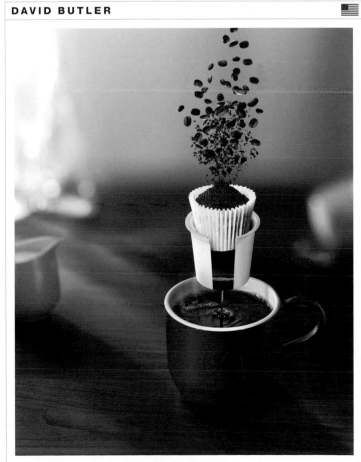

K-Cup Breakaway | Kuerig

JOE MAZZA

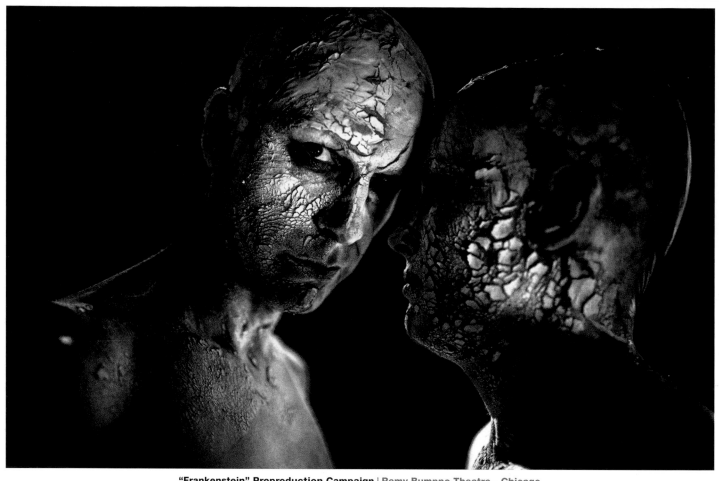

"Frankenstein" Preproduction Campaign | Remy Bumppo Theatre - Chicago

TODD BURANDT

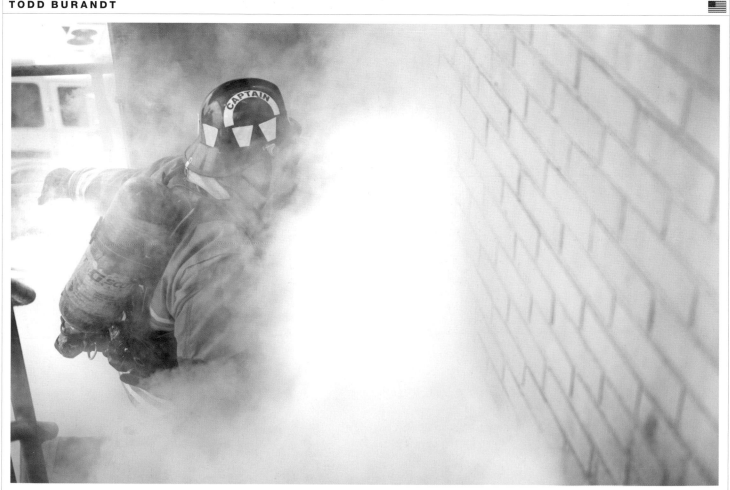

Decatur Firefighter | Ford

TYLER STABLEFORD

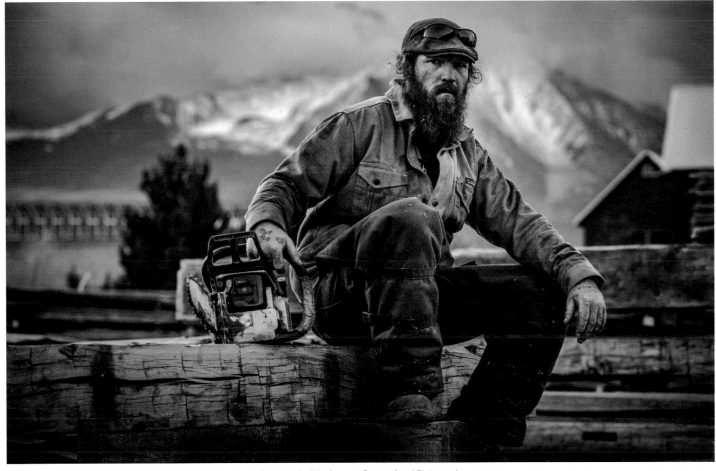

Patagonia Workwear Campaign | Patagonia

ATHENA AZEVEDO

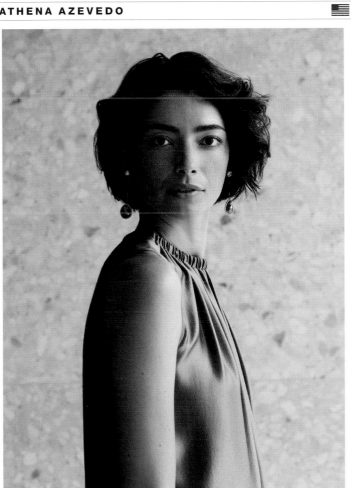

The Bryant | HFZ Capital Group

LAURIE FRANKEL

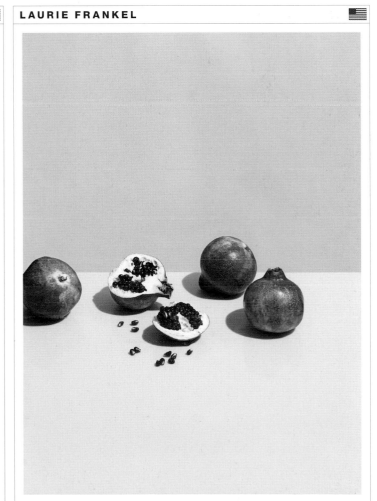

Pomegranate Ingredients | MDSolarSciences

TYLER STABLEFORD

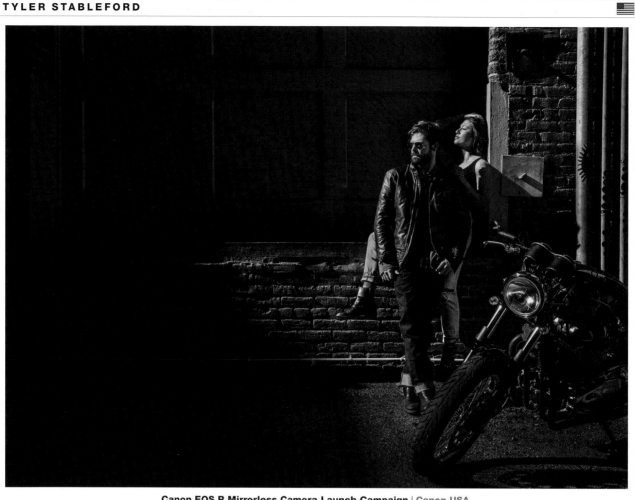

Canon EOS R Mirrorless Camera Launch Campaign | Canon USA

PATRICK MOLNAR

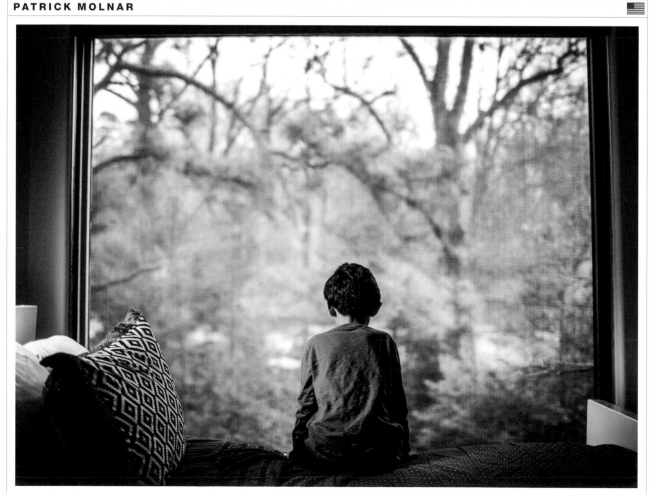

Family #3 | Self-Initiated

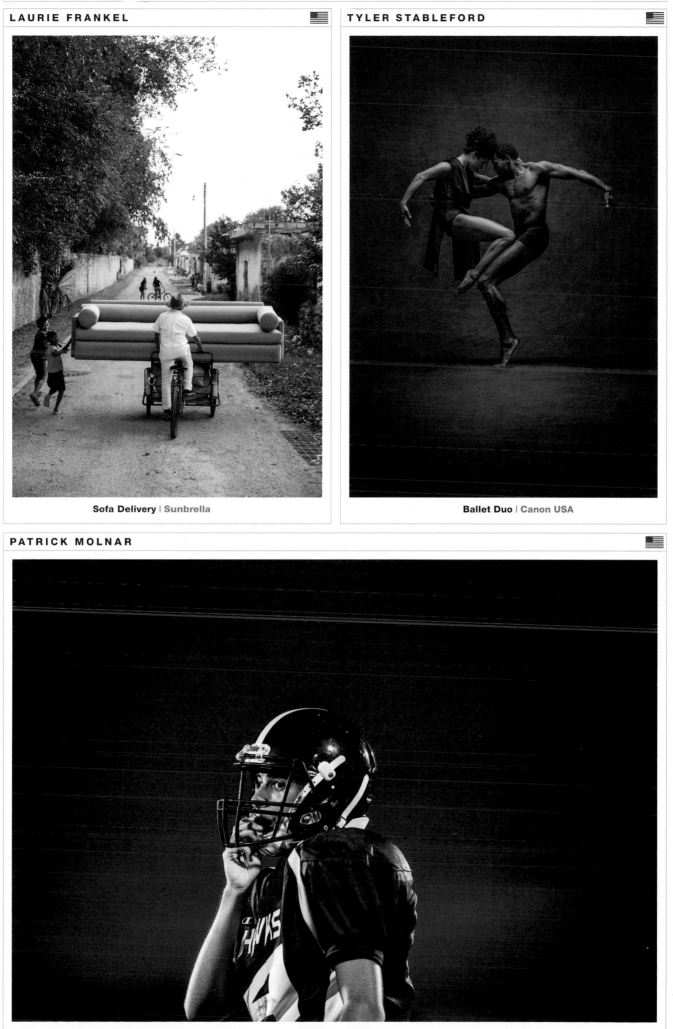

LAURIE FRANKEL

Sofa Delivery | **Sunbrella**

TYLER STABLEFORD

Ballet Duo | **Canon USA**

PATRICK MOLNAR

ESPN #2 | **ESPN**

TYLER STABLEFORD

LINDSAY SIU

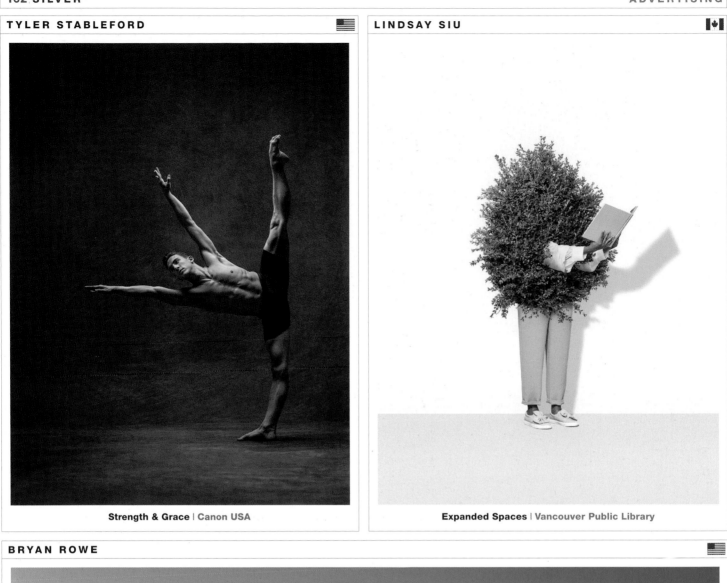

Strength & Grace | Canon USA

Expanded Spaces | Vancouver Public Library

BRYAN ROWE

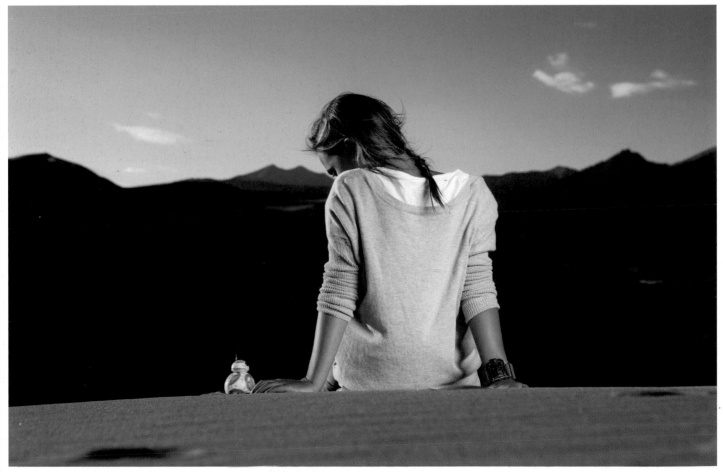

Star Wars Force Band Campaign | Sphero

CRAIG BROMLEY

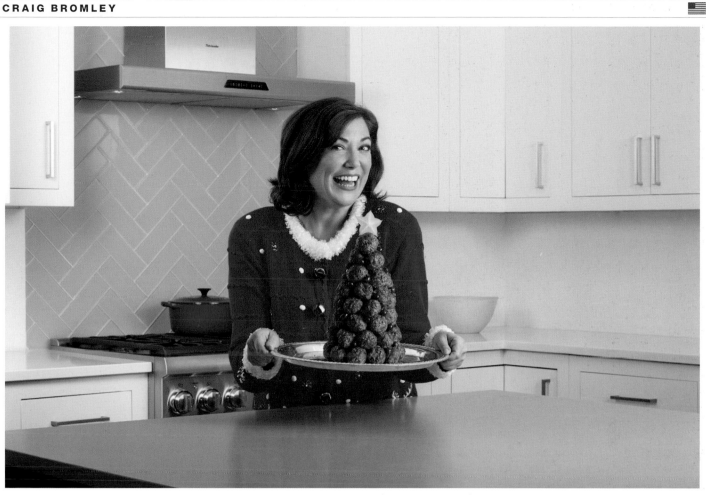

The Party is Always in the Kitchen | Farm Rich

SCOTT LOWDEN

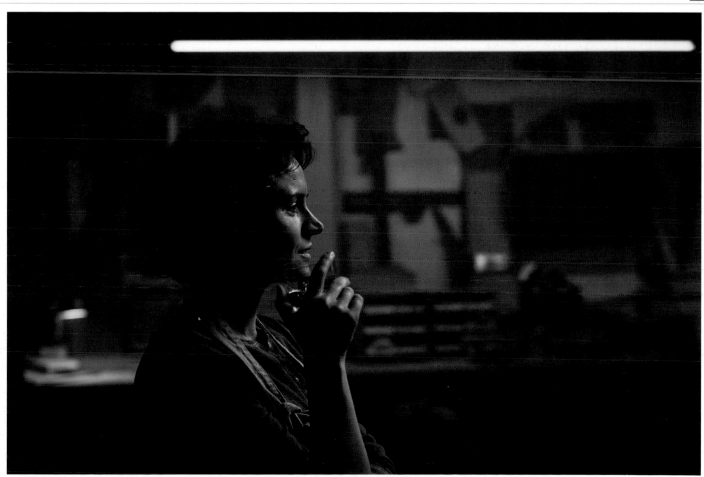

Evan Williams 0615714 | Evan Williams

DYLAN H BROWN

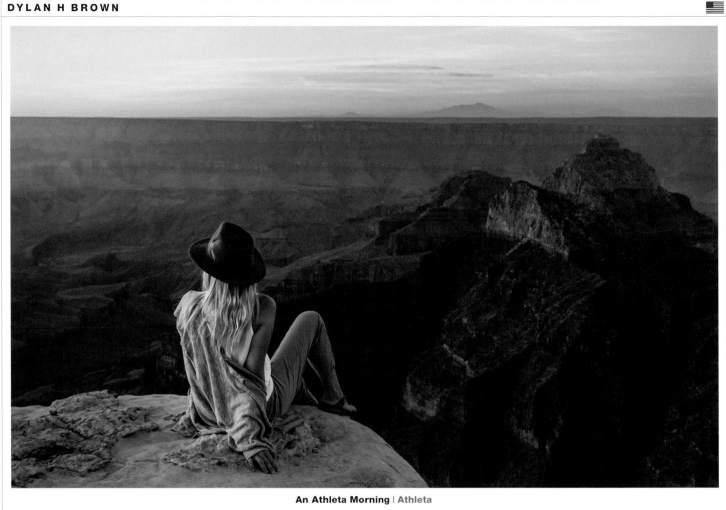

An Athleta Morning | Athleta

CLARENCE LIN

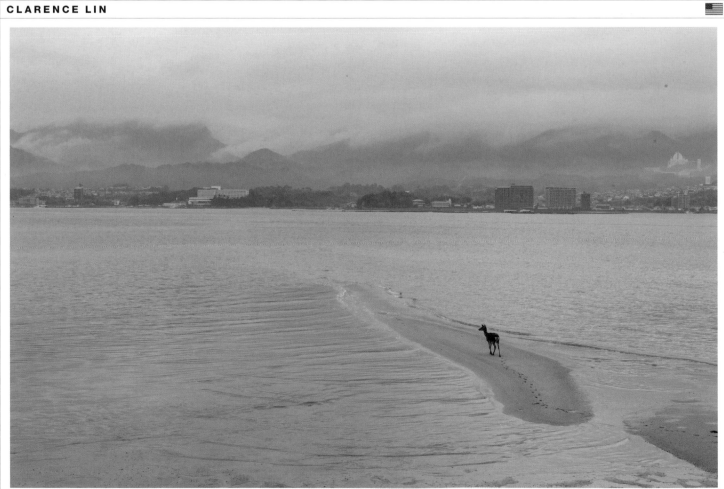

Deer of Miyajima | Self-Initiated

ROSANNE OLSON

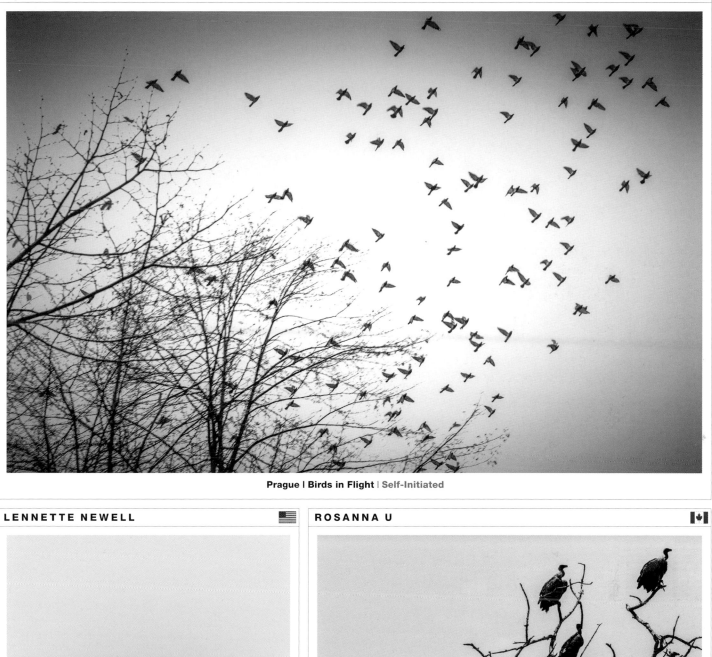

Prague | Birds in Flight | Self-Initiated

LENNETTE NEWELL

ROSANNA U

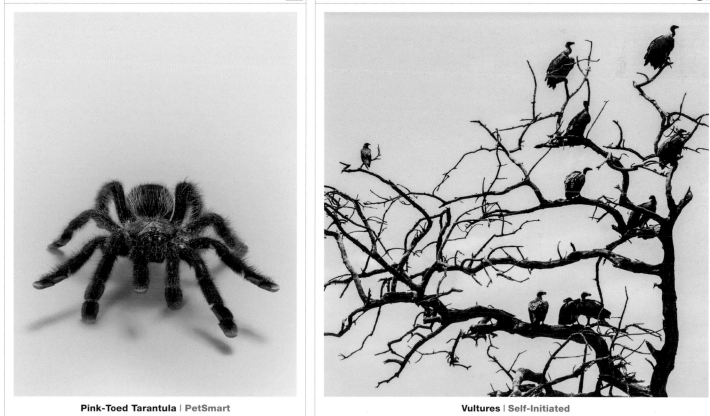

Pink-Toed Tarantula | PetSmart

Vultures | Self-Initiated

A. TAMBOLY

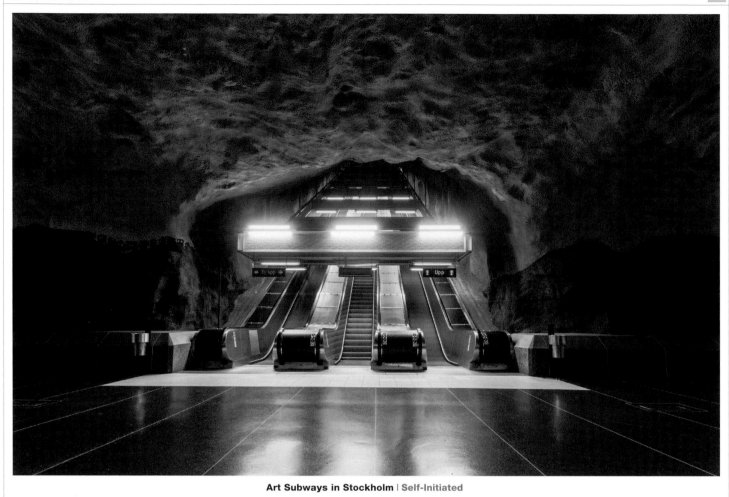

Art Subways in Stockholm | Self-Initiated

BILL HORNSTEIN

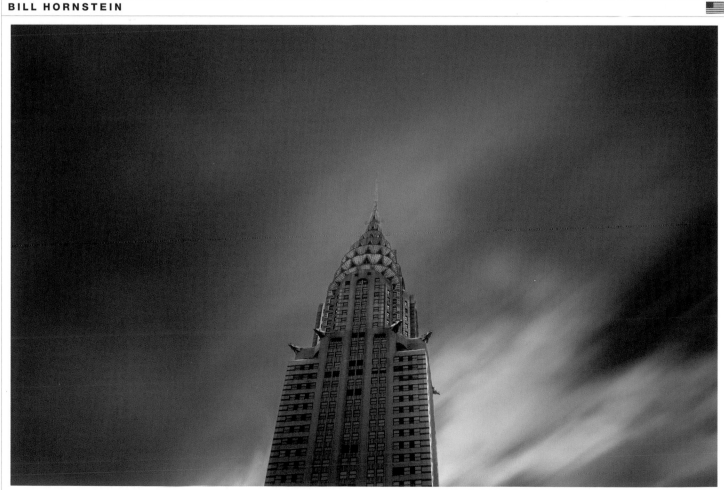

Don't forget to look up. | Hornstein Creative

ROBERTO KAI HEGELER
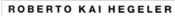

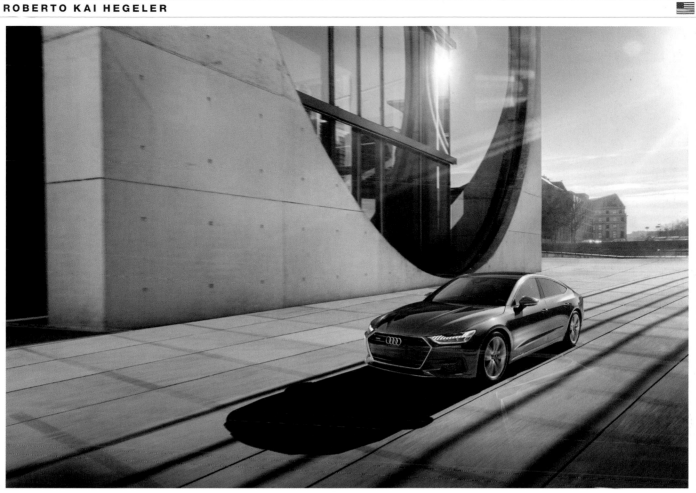

MY19 Audi A7 Brochure Cover | Audi of America

MICHAEL MAYO

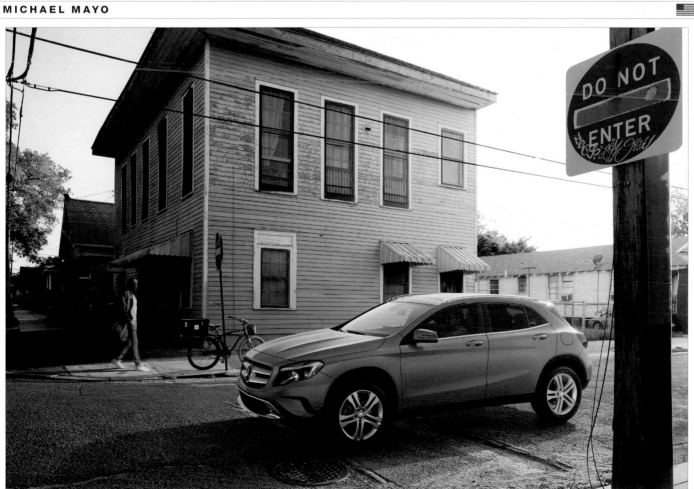

Urban Mercedes | Michael Mayo Photography

CRAIG CUTLER

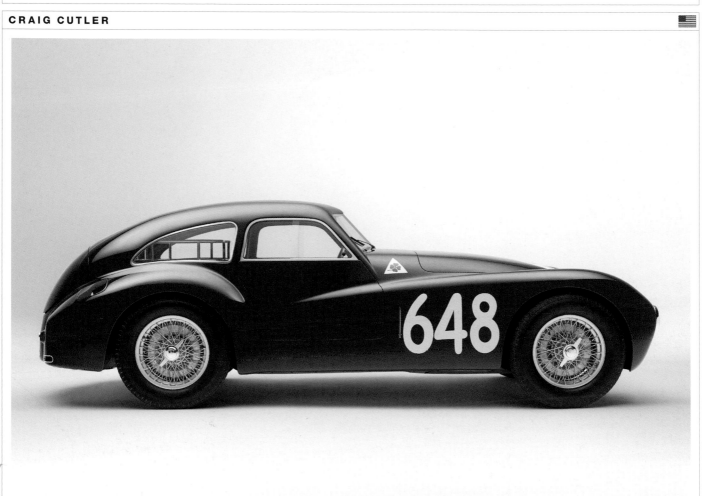

1948 Alfa Romeo 6C 2500 Competizione | Bonhams Auction House

ROBERTO KAI HEGELER

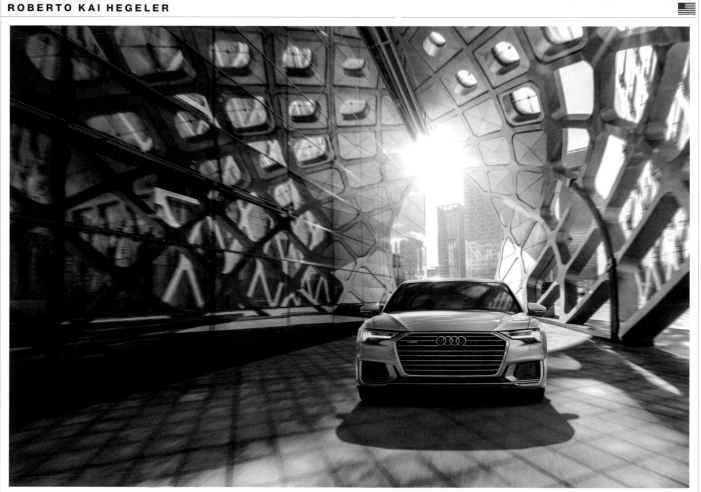

MY19 Audi A6 Brochure Cover | Audi of America

ROBERTO KAI HEGELER

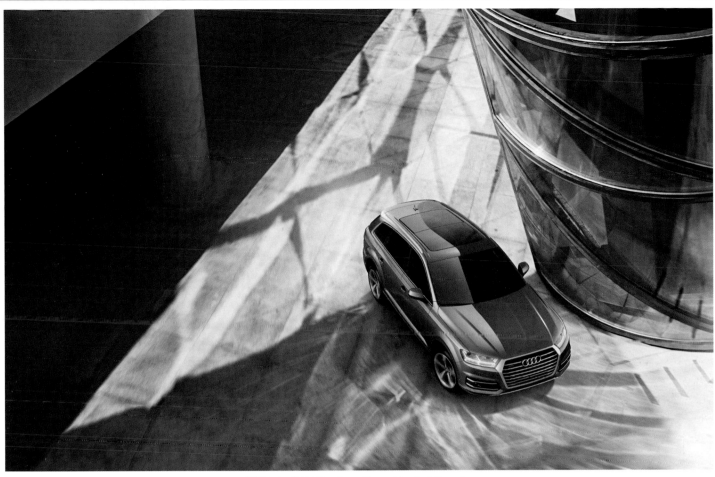

MY19 Audi Q7 Brochure Cover | Audi of America

AARON COBB

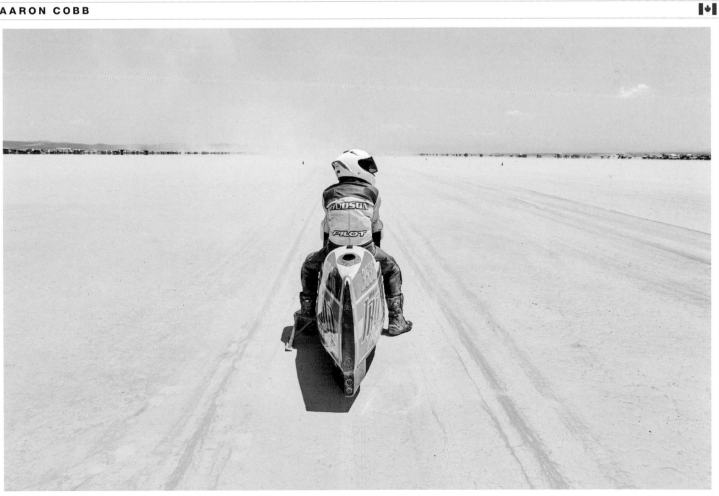

EL MIRAGE DRY LAKE BED RACES | SCTA

CHRISTOPHER WILSON

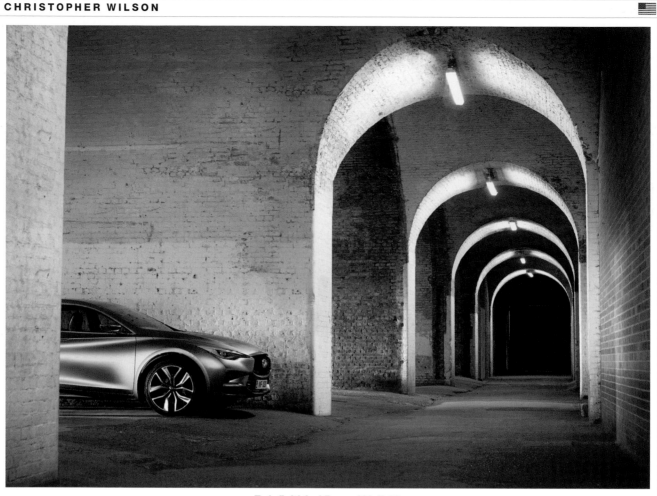

To Infiniti And Beyond | Infiniti

ROBERTO KAI HEGELER

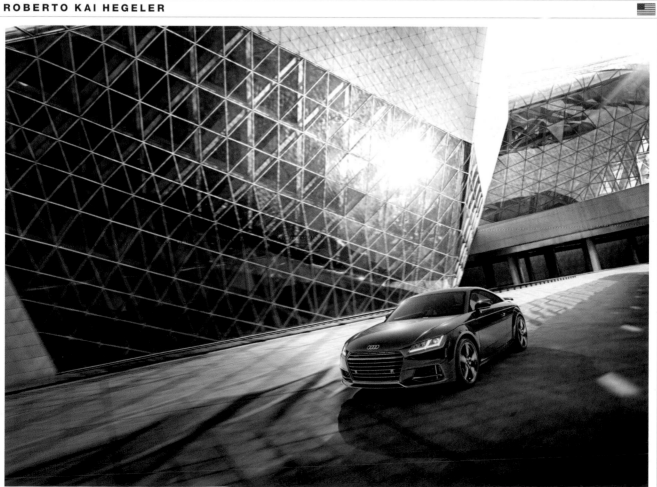

MY19 Audi TT Brochure Cover | Audi of America

MICHAEL MAYO

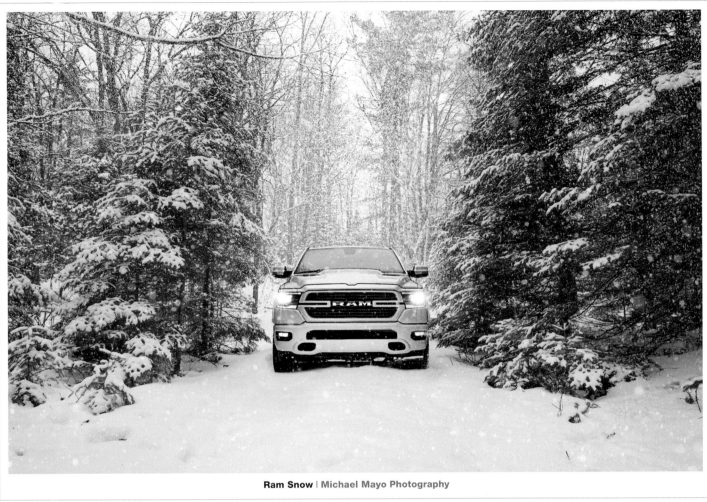

Ram Snow | Michael Mayo Photography

CHRISTOPHER WILSON

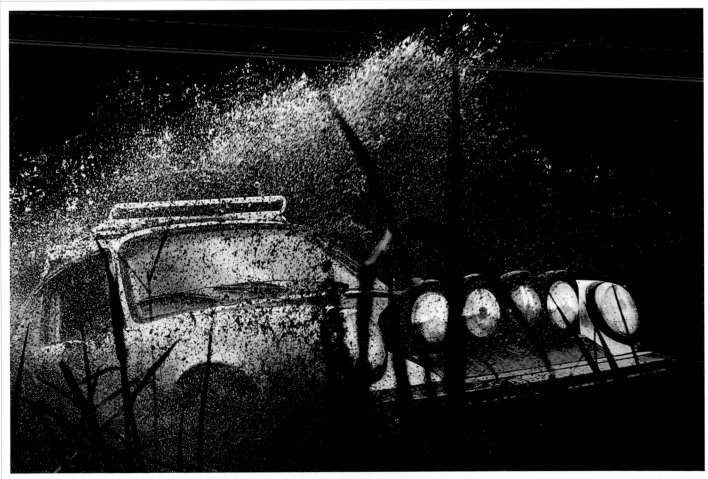

Mud Bath | Self-Initiated

DYLAN WILSON

HADLEY STAMBAUGH

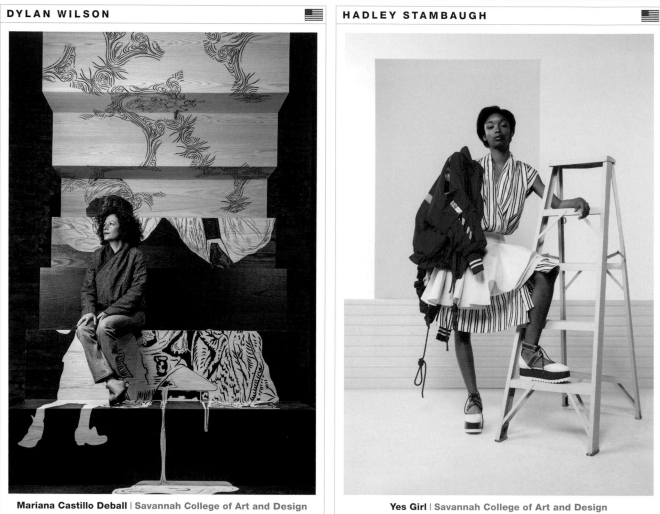

Mariana Castillo Deball | Savannah College of Art and Design

Yes Girl | Savannah College of Art and Design

STAN MUSILEK

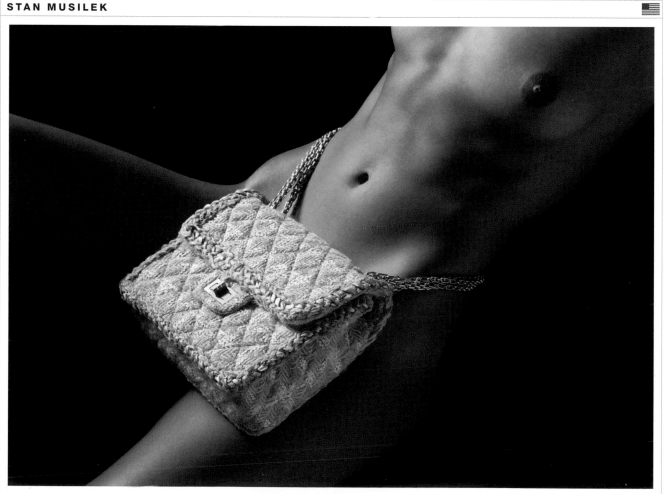

Musilek-Chanel-Purse | Chanel

SARAH SILVER

Bliss Relaunch 2018 | Bliss, Bliss Spa

PATRICK MOLNAR

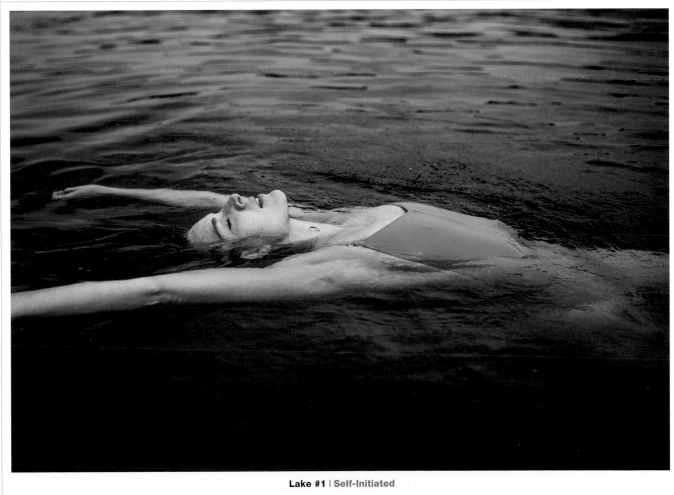

Lake #1 | Self-Initiated

TREVETT MCCANDLISS

Zen Palette | Footwear Plus magazine

STAN MUSILEK

Musilek-Margaux-need-to-talk | Treats!

MICHAEL WINOKUR

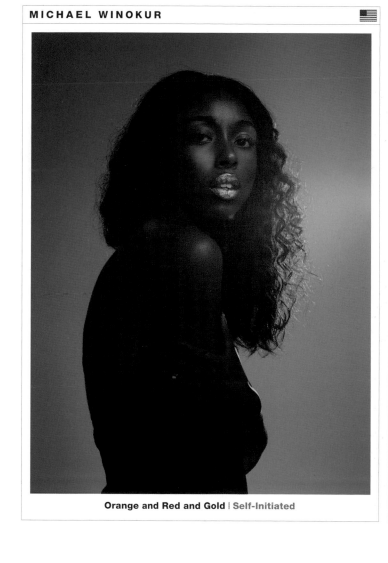

Orange and Red and Gold | Self-Initiated

STAN MUSILEK

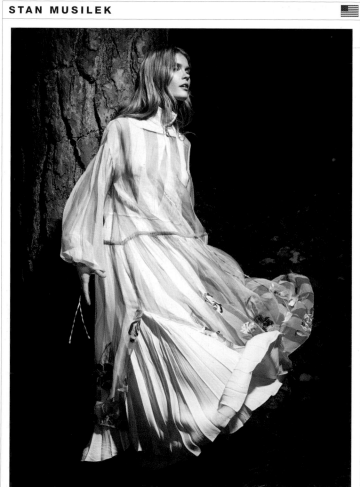

Musilek-fontainebleau-Inca-Maria-Dior | Dior

STAN MUSILEK

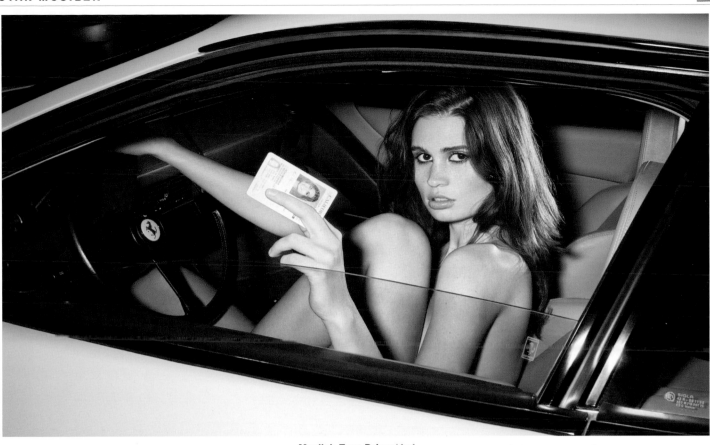

Musilek-Teen Driver | Lui

JAMES EXLEY

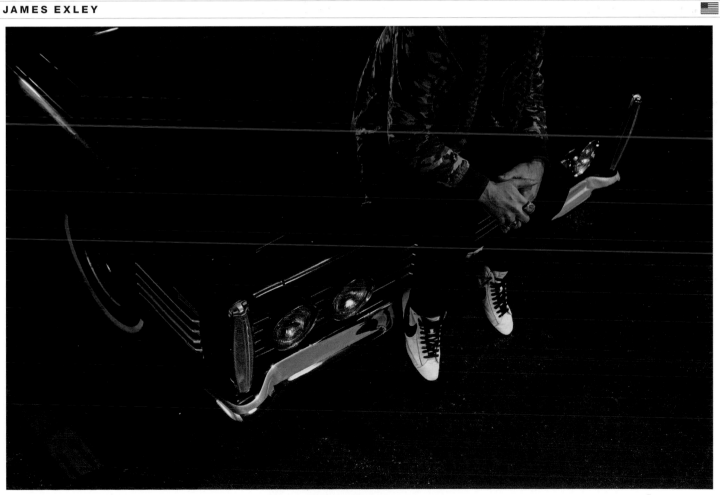

Granite Chief Album Art | Granite Chief

STAN MUSILEK

Musilek-Wolford20 | Wolford

VIKA POBEDA

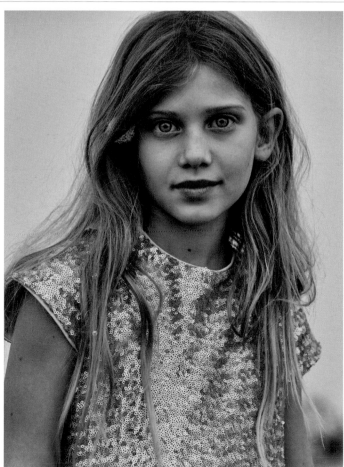

Earth Angels | Earnshaw's magazine

STAN MUSILEK

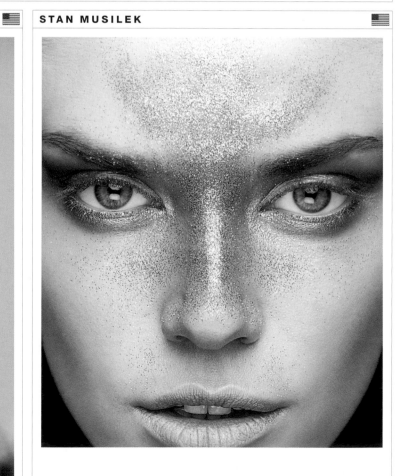

Musilek-Irina-YSL | YSL

CHRISTOPHER WILSON

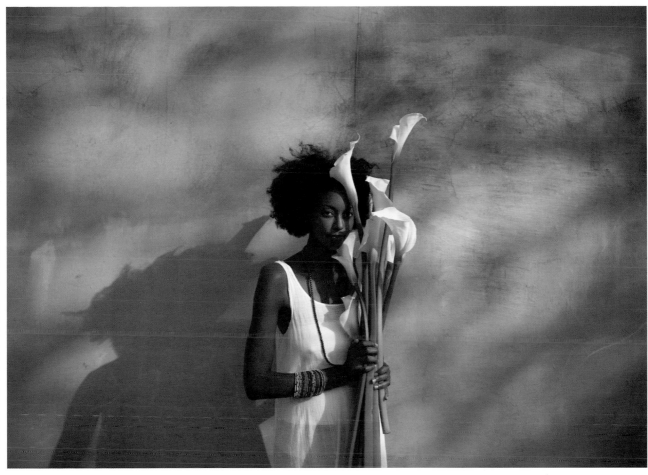

I Love The Flower Girl | Natura Brazil

LINDSAY SIU

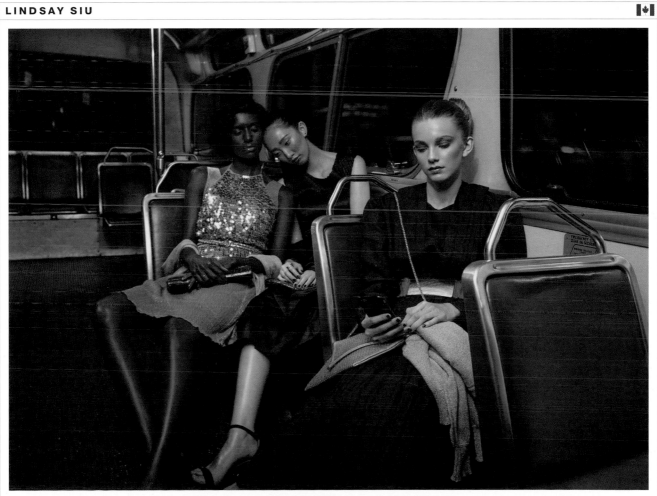

Public Transit, 1957 and 2017 | Lindsay Siu Photographer

PATRICK MOLNAR

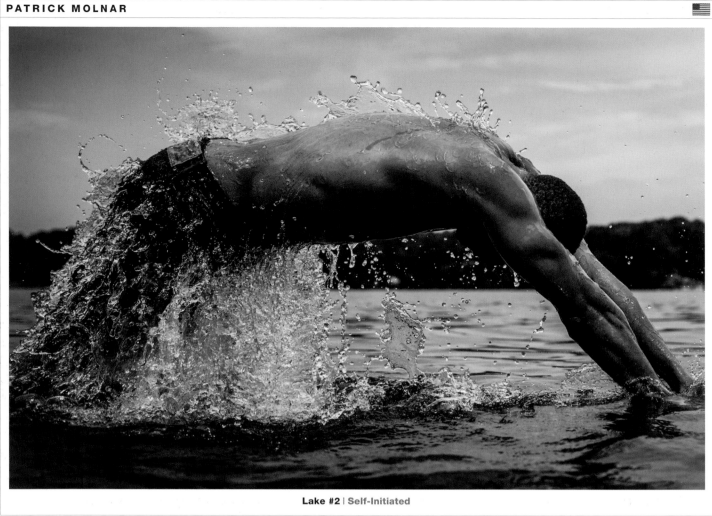

Lake #2 | Self-Initiated

TERRY VINE

Body Treatments | Bergamos Spa

JACK HAWKINS

SUECH AND BECK

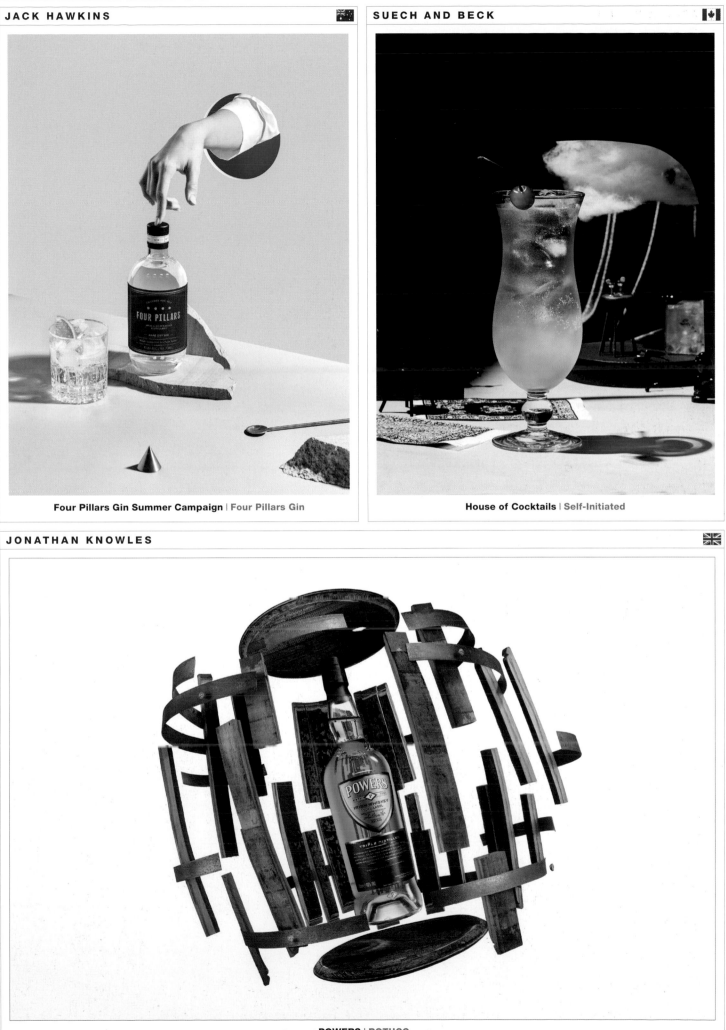

Four Pillars Gin Summer Campaign | Four Pillars Gin

House of Cocktails | Self-Initiated

JONATHAN KNOWLES

POWERS | ROTHCO

JIM NORTON

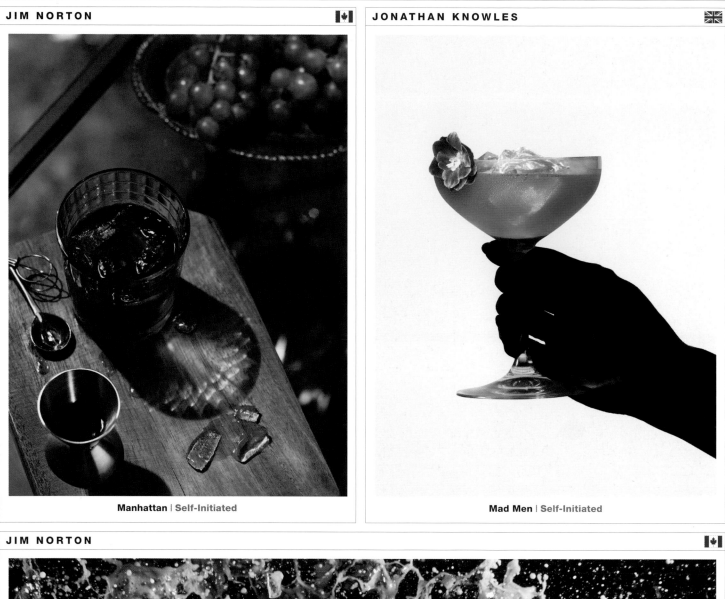

Manhattan | Self-Initiated

JONATHAN KNOWLES

Mad Men | Self-Initiated

JIM NORTON

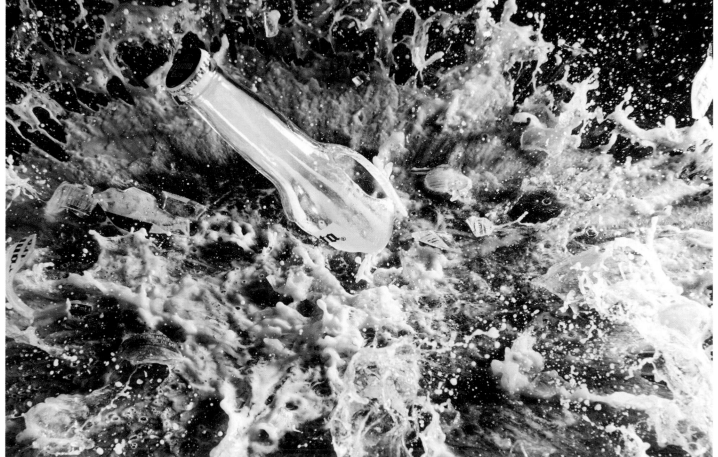

Party Time | Jim Norton/Fuze Reps

PARISH KOHANIM

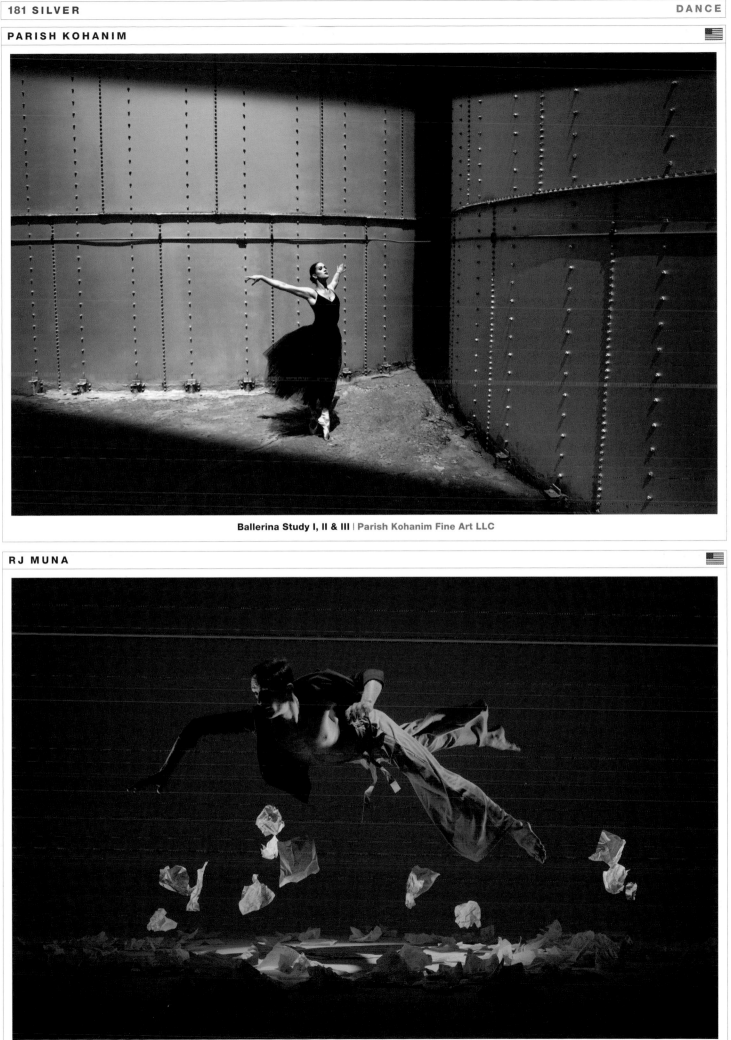

Ballerina Study I, II & III | Parish Kohanim Fine Art LLC

RJ MUNA

I Don't Know and Never Will | Liss Fain Dance

FRANK P. WARTENBERG

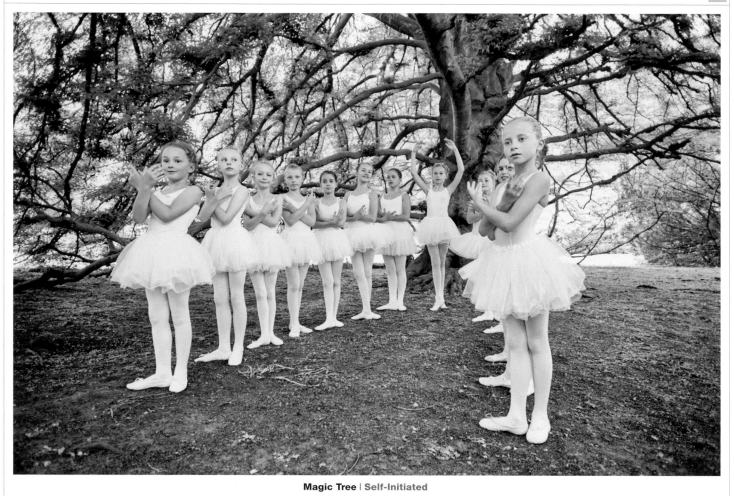

Magic Tree | Self-Initiated

RJ MUNA

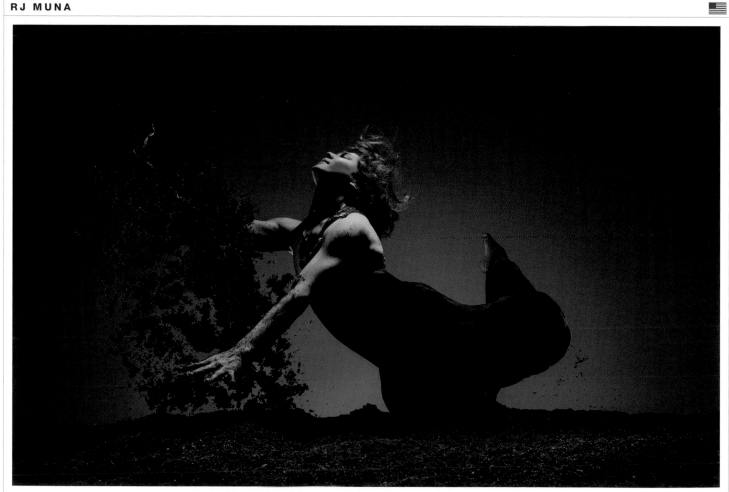

I Don't Know and Never Will | Liss Fain Dance

RJ MUNA

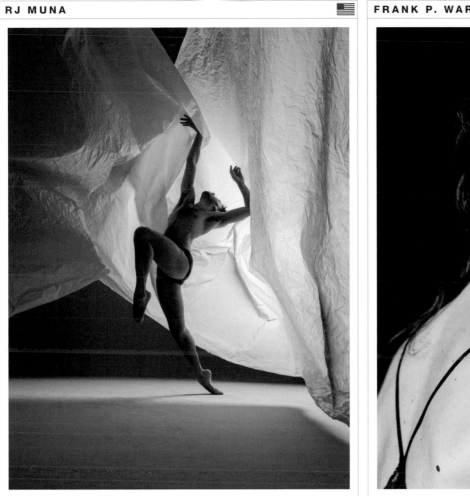

2017 Season | Alonzo King LINES Ballet

FRANK P. WARTENBERG

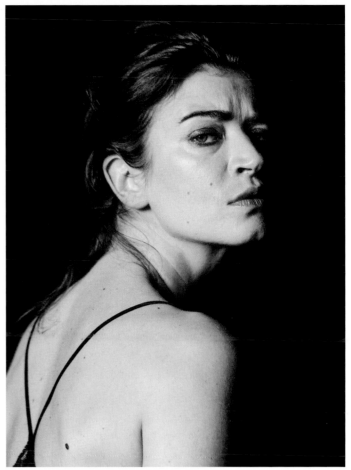

Anna Bederke | EMOTION

TODD ANTONY

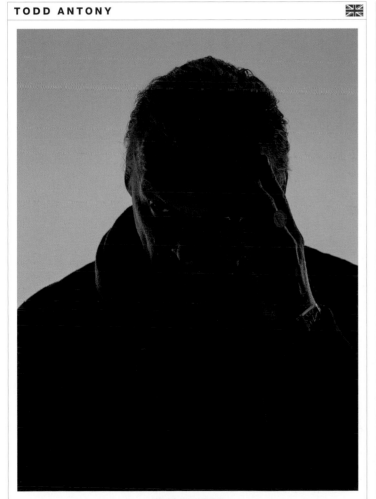

McMafia | BBC

STEPHANIE DIANI

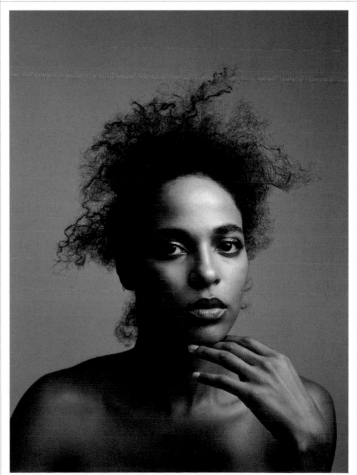

Megalyn Echikunwoke | ID PR

P.J. FUGATZE

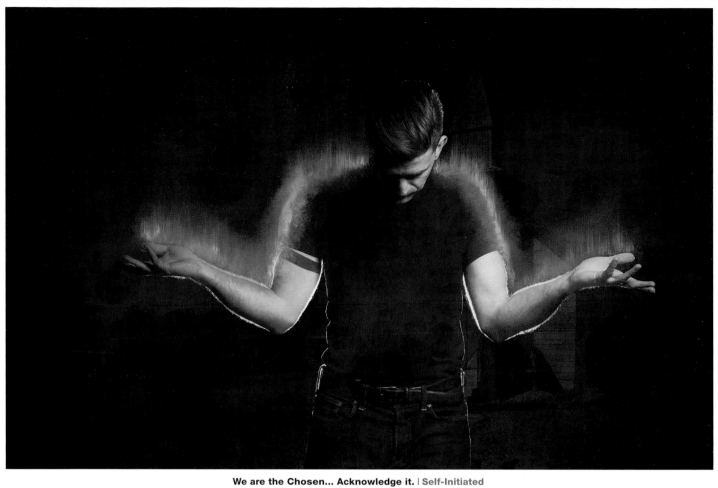

We are the Chosen... Acknowledge it. | Self-Initiated

FRANK P. WARTENBERG

BRIAN NEEL PARKS

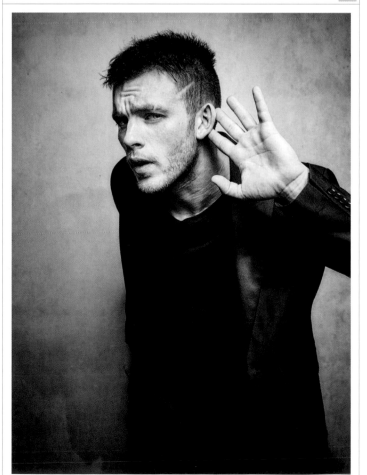

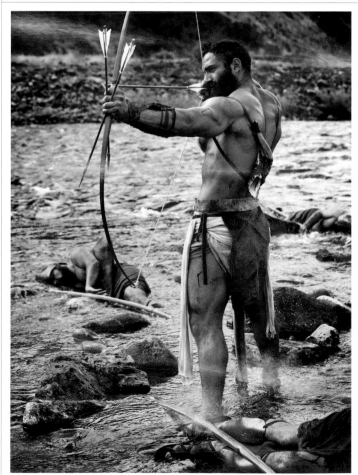

Jannis Niewöhner | **Place to B**

Gideon at the Rock of Oreb | **Self-Initiated**

JACKSON CARVALHO

The Pain that Screams | Phabrica Models

TATSURO NISHIMURA

JAN KALISH

Form in Nature | **Self-Initiated**

Metamorphosis | **Self-Initiated**

CLARENCE LIN

Traffic | Self-Initiated

SAZELI JALAL

HEAVENLY BLOSSOM | Self-Initiated

BARRY BARNES

Dark Fairy | Portfolio - used in 3 x 3 Illustration Directory

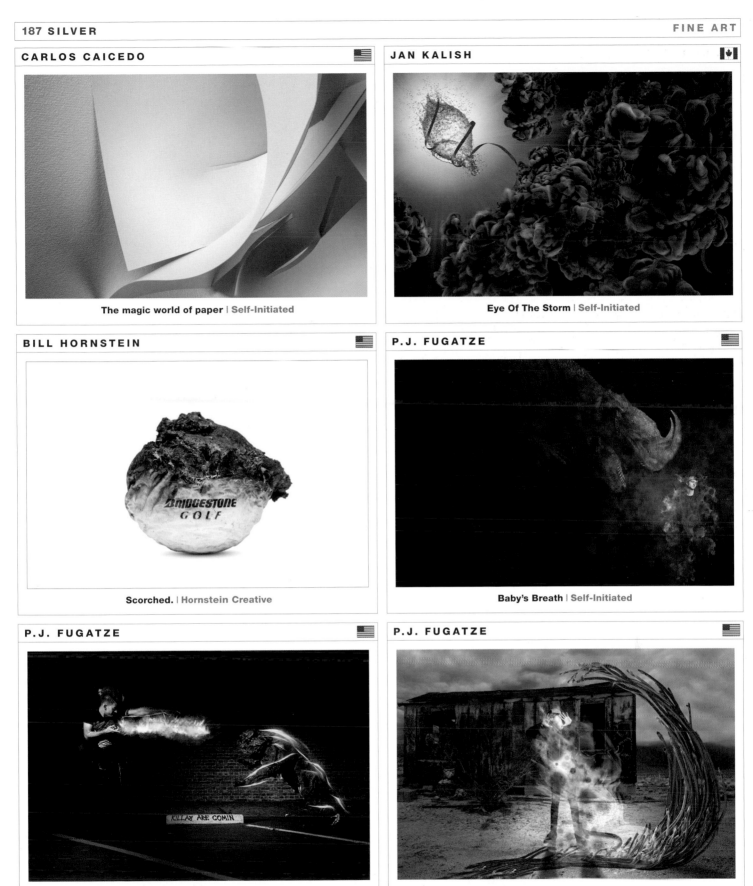

CARLOS CAICEDO

The magic world of paper | Self-Initiated

JAN KALISH

Eye Of The Storm | Self-Initiated

BILL HORNSTEIN

Scorched. | Hornstein Creative

P.J. FUGATZE

Baby's Breath | Self-Initiated

P.J. FUGATZE

Killas are Comin | Self-Initiated

P.J. FUGATZE

Let Your Snake Show | Self-Initiated

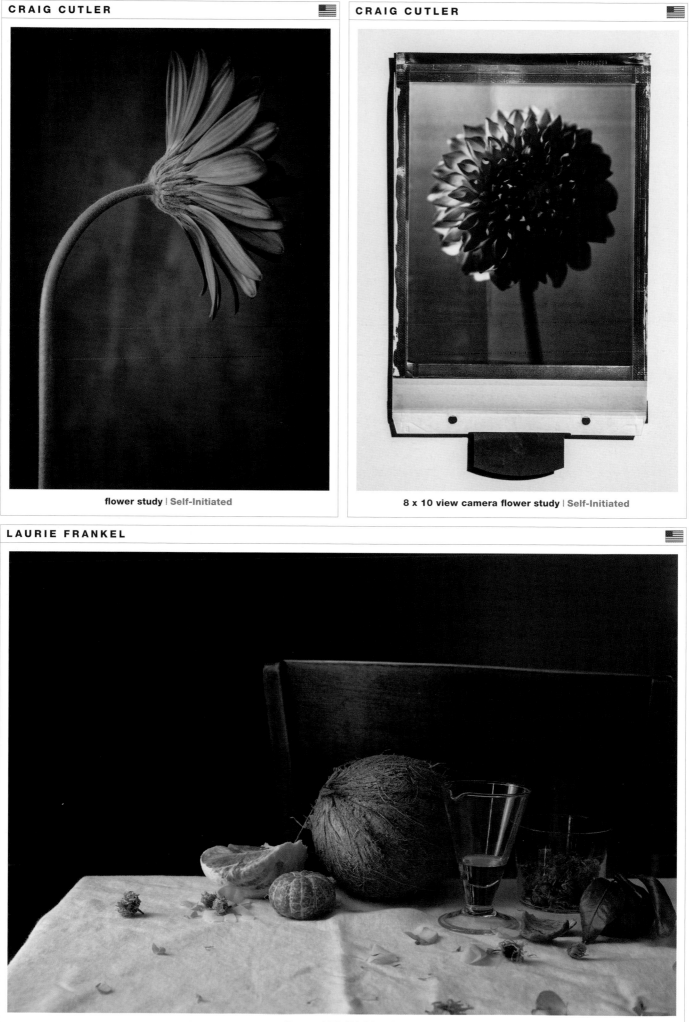

CRAIG CUTLER

flower study | Self-Initiated

CRAIG CUTLER

8 x 10 view camera flower study | Self-Initiated

LAURIE FRANKEL

Coconut | Self-Initiated

MAKITO INOMATA

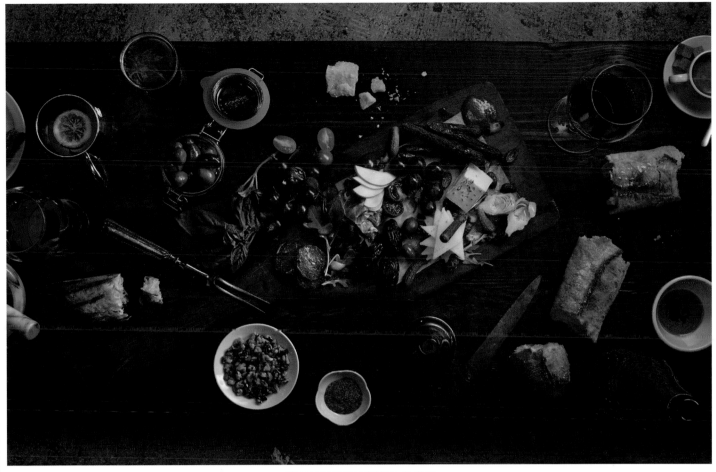

Charcuterie Board | The Parlour

STACEY BRANDFORD

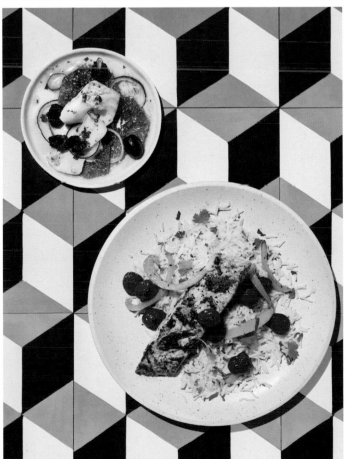

Eat More Fish | Longo's

STACEY BRANDFORD

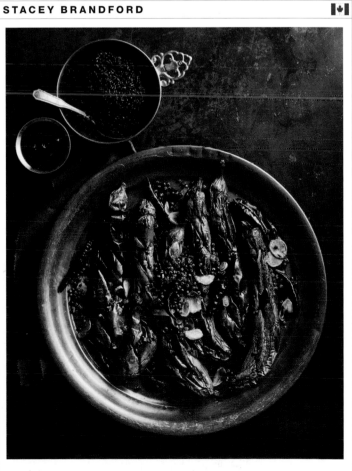

Jaggery | Self-Initiated

STEVE KRUG

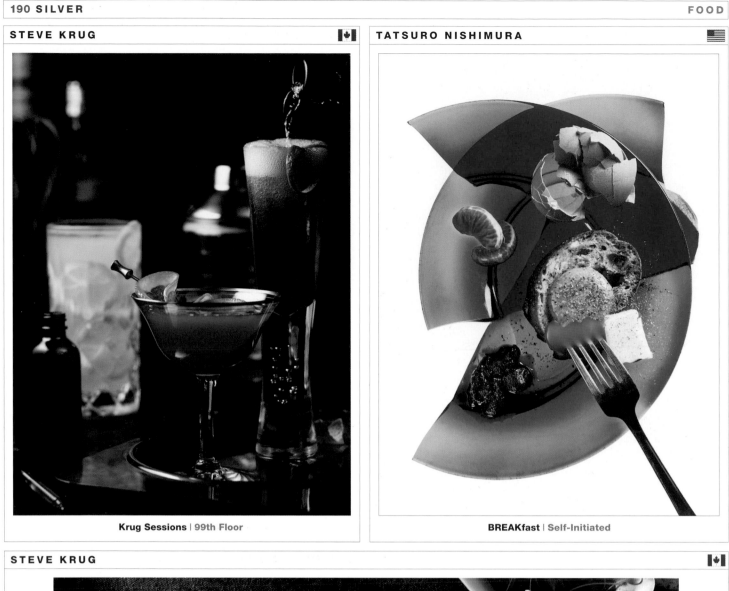

Krug Sessions | **99th Floor**

TATSURO NISHIMURA

BREAKfast | **Self-Initiated**

STEVE KRUG

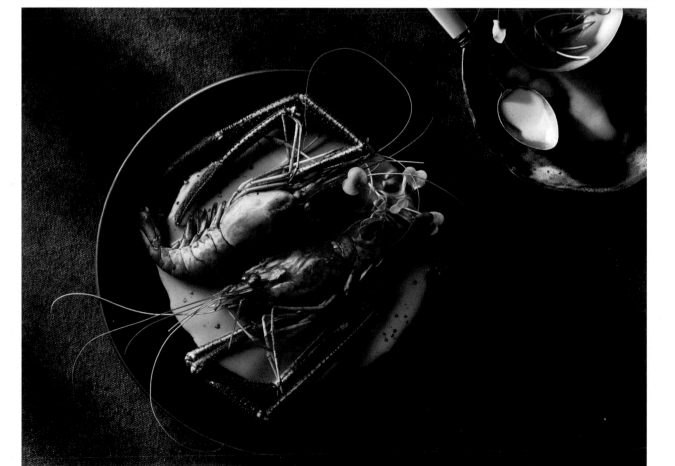

Krug Sessions | **99th Floor**

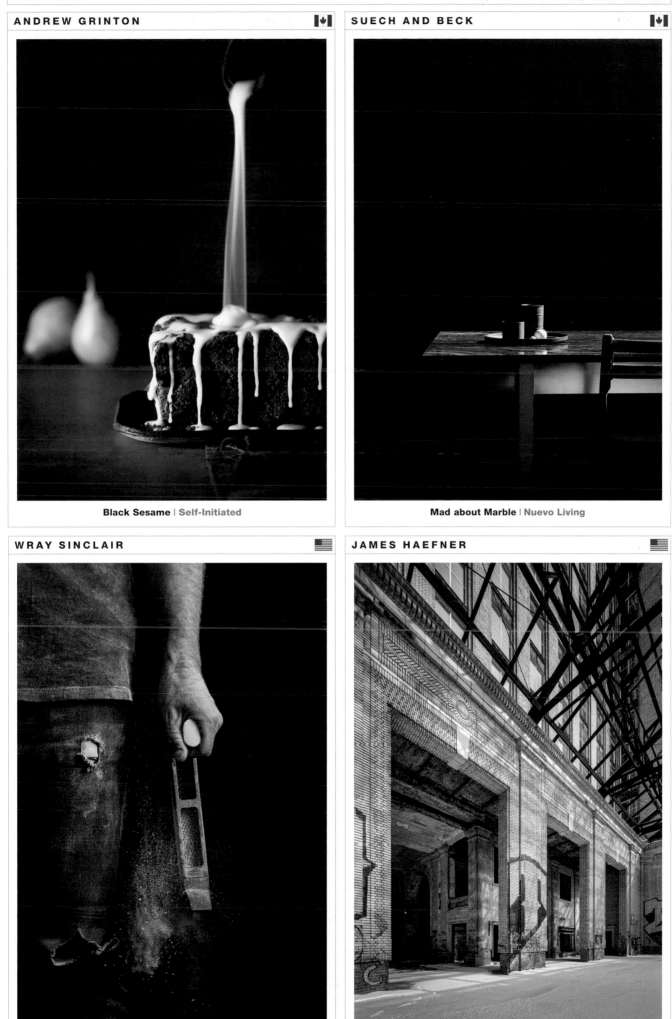

ANDREW GRINTON

Black Sesame | Self-Initiated

SUECH AND BECK

Mad about Marble | Nuevo Living

WRAY SINCLAIR

Surfboard Shaper | Self-Initiated

JAMES HAEFNER

Pre renovation photography of Ford's Michigan Central Station | Ford

STEVE GREER

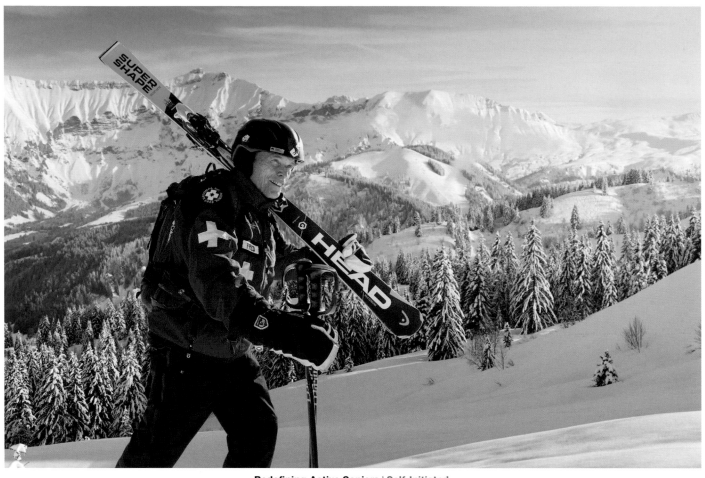

Redefining Active Seniors | **Self-Initiated**

SCOTT LOWDEN

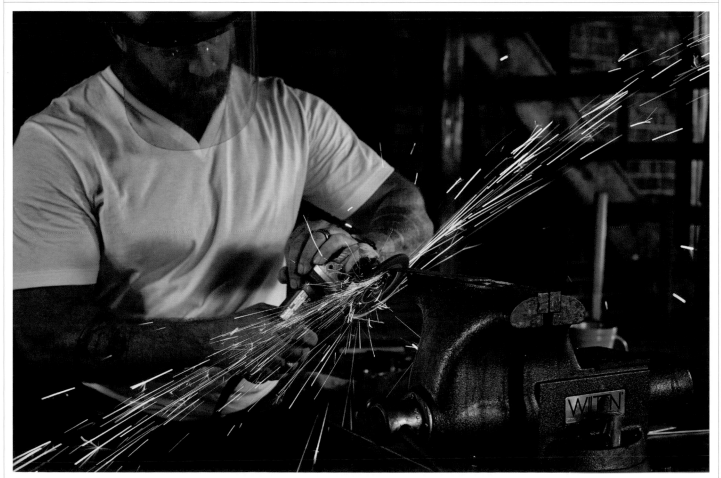

Rebel Americana, Custom Shop | **Rebel Americana**

TODD ANTONY

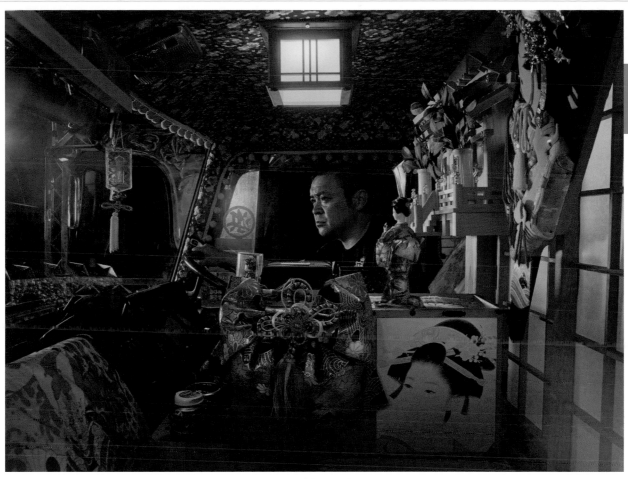

Dekotora | Self-Initiated

WARREN EAKINS

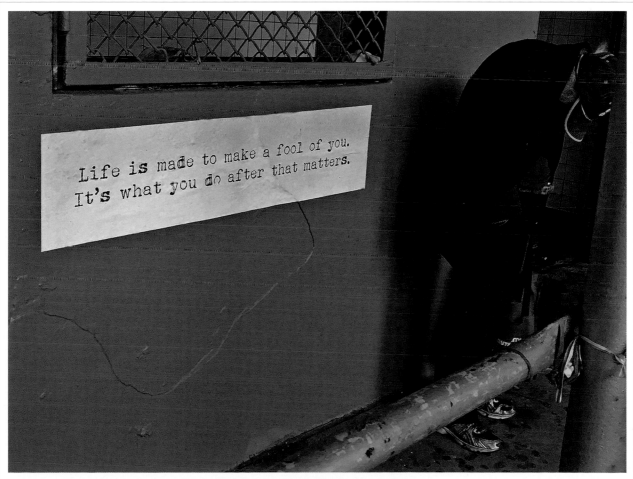

"Banking on an Afterlife" | Warren Eakins Inc

JESSE REED

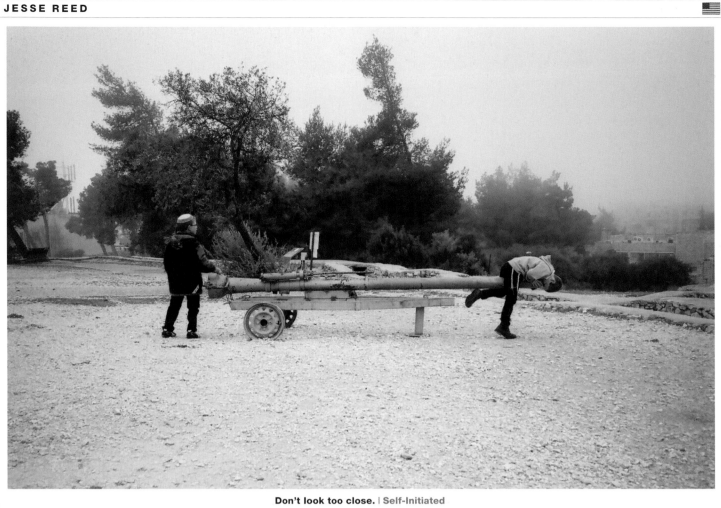

Don't look too close. | Self-Initiated

DAVID WESTPHAL

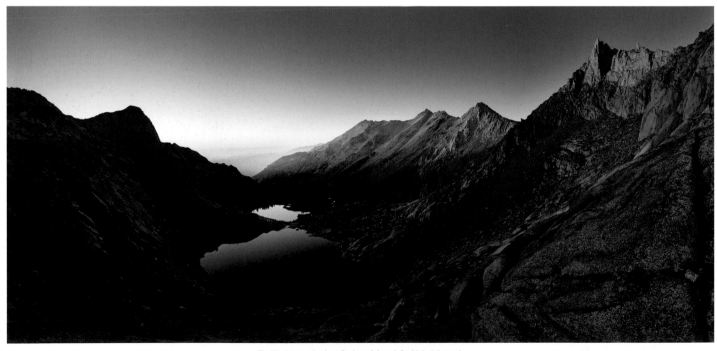

Twilight on Lake Columbine | Self-Initiated

ALINA HOLODOV

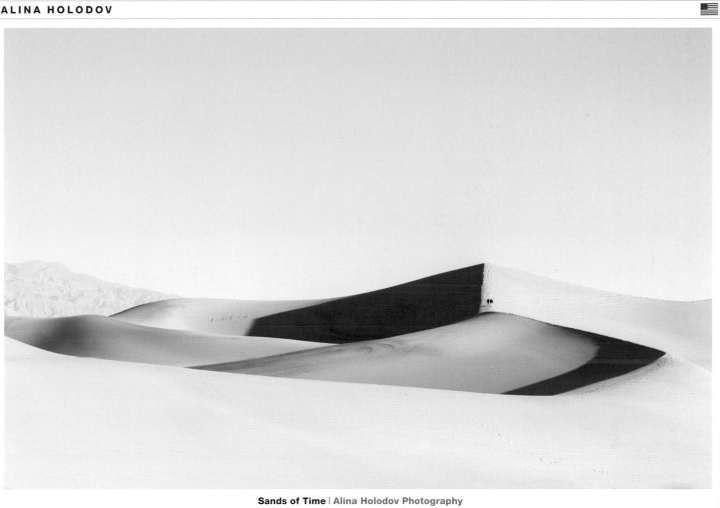

Sands of Time | Alina Holodov Photography

JIM NORTON

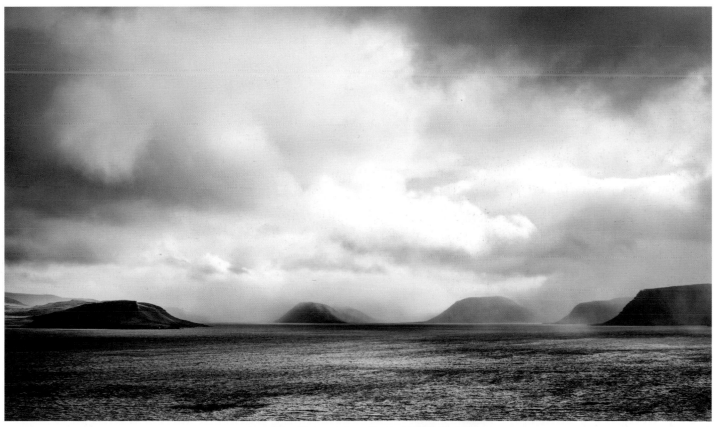

Receding Storm at Arnarfjordur | Self-Initiated

MICHAEL SCHOENFELD

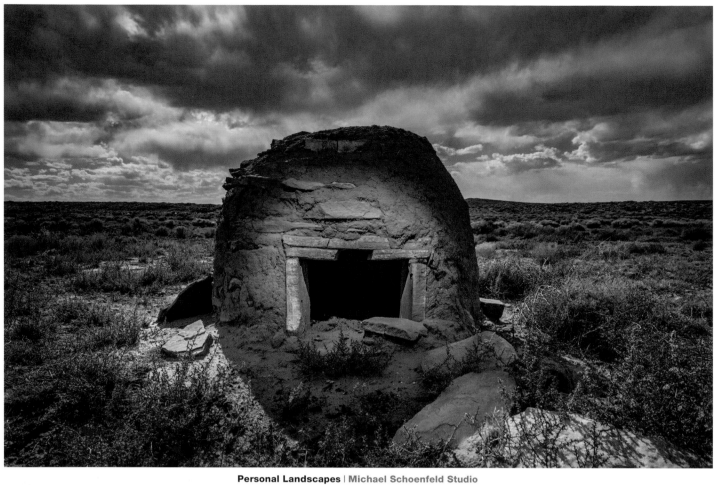

Personal Landscapes | Michael Schoenfeld Studio

STAUDINGER+FRANKE

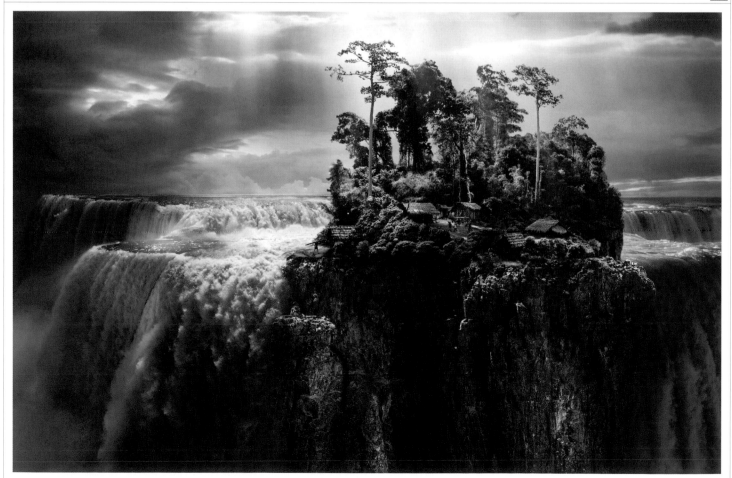

FairMed "Jungle" | FairMed

ROSANNA U

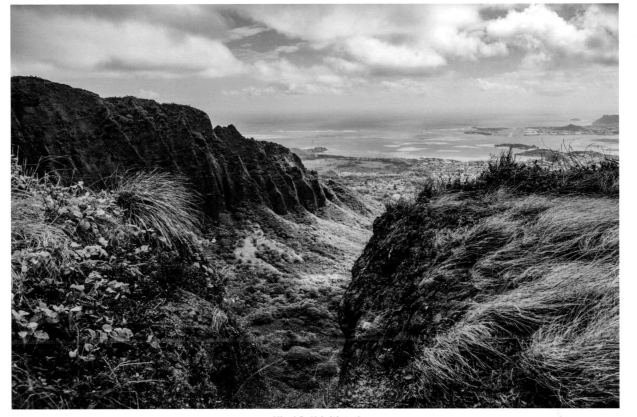

Uka | Self-Initiated

JOHN HAYNES

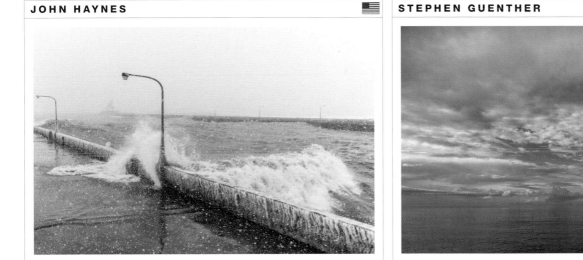

Duluth, MN | Self-Initiated

STEPHEN GUENTHER

Sky Meets Water image

SKY MEETS WATER | Self-Initiated

CAMERON DAVIDSON

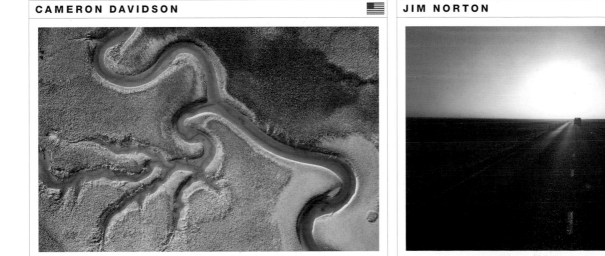

Virginia Coastal Reserve | Self-Initiated

JIM NORTON

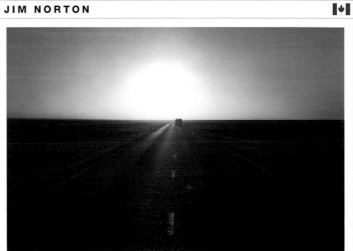

Skeiðarársandur Sandstorm | Self-Initiated

CAMERON DAVIDSON

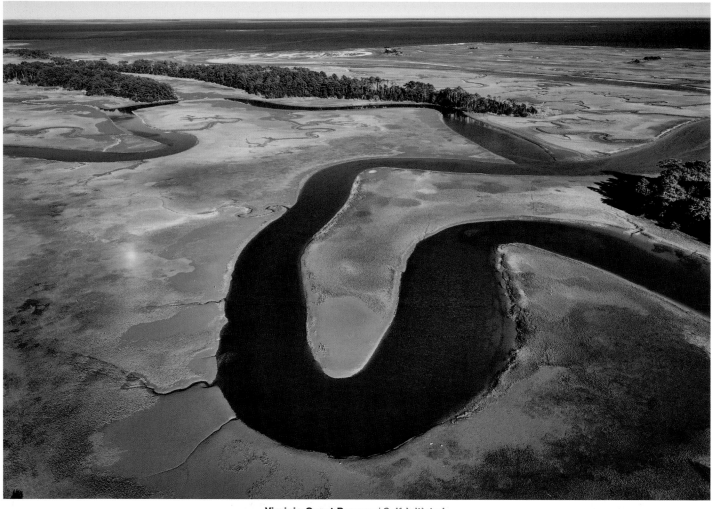

Virginia Coast Reserve | Self-Initiated

DYLAN H BROWN

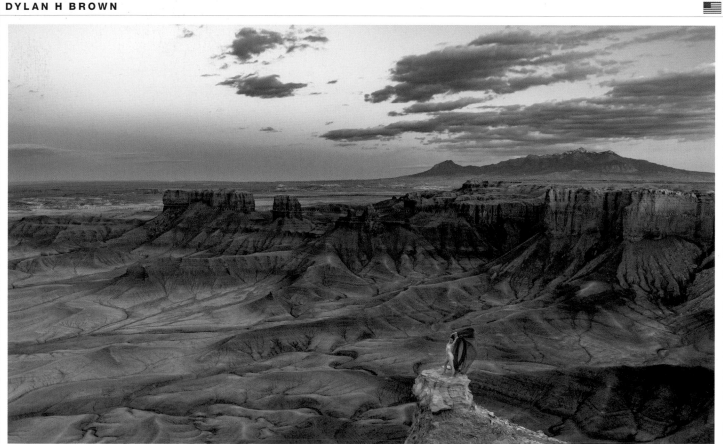

Dancing on the Moon | Self-Initiated

WRAY SINCLAIR

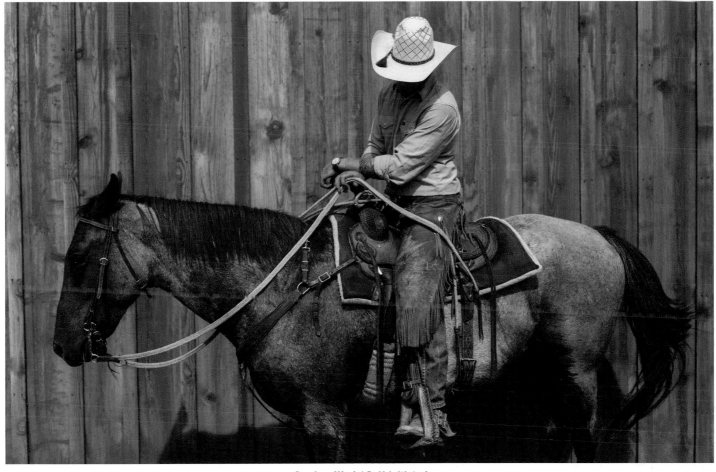

Cowboy Work | Self-Initiated

HADLEY STAMBAUGH

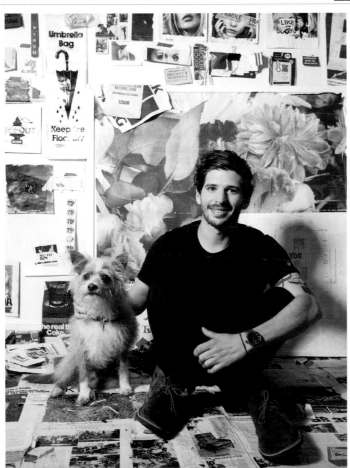

Joaquin Salim | Savannah College of Art and Design

EMILY NEUMANN

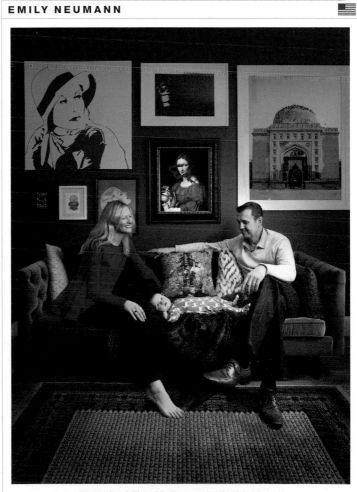

Portrait of Finn McCormack | Self-Initiated

HADLEY STAMBAUGH

MICHAEL WINOKUR

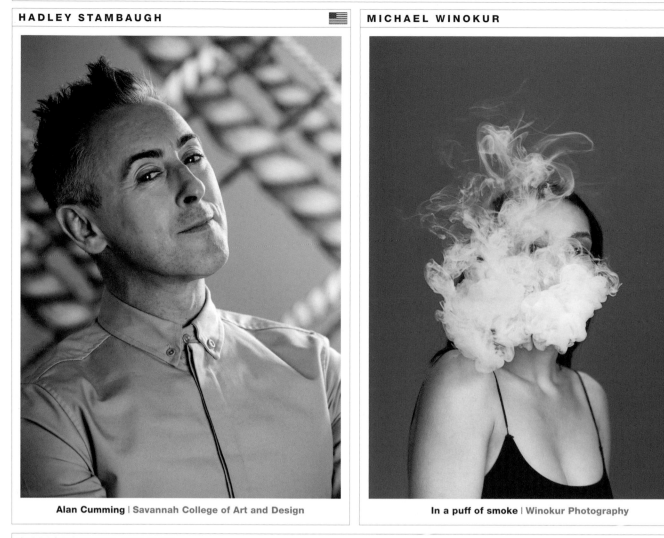

Alan Cumming | Savannah College of Art and Design

In a puff of smoke | Winokur Photography

CHRISTOPHER WILSON

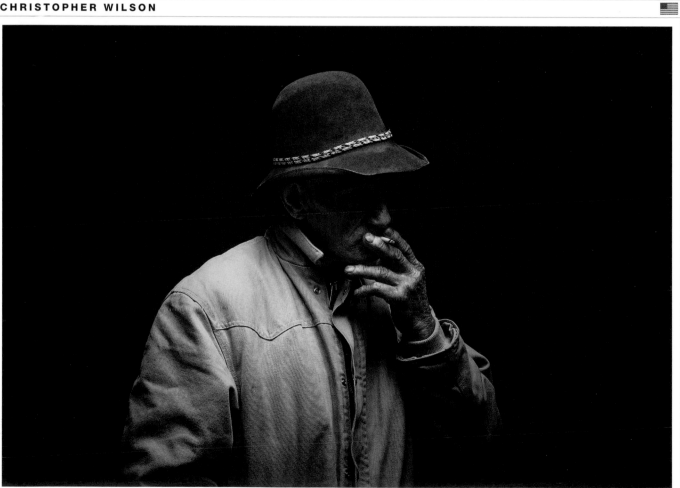

R.I.P. | Nokota Horse Conservancy

TOM BARNES

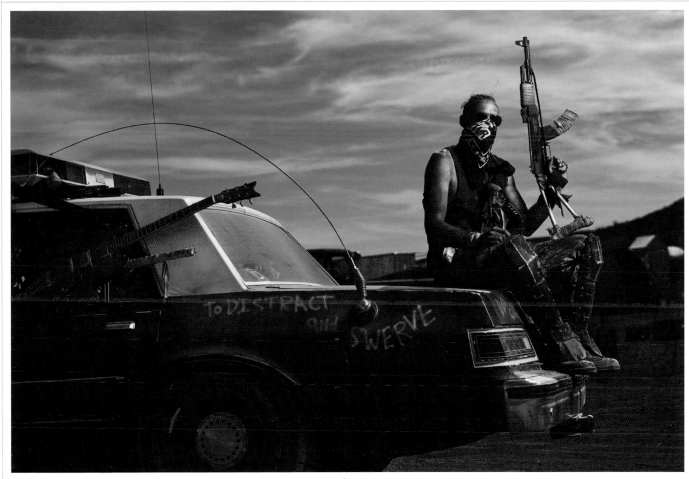

Oh, what a day! | Self-Initiated

MICHAEL CONFER

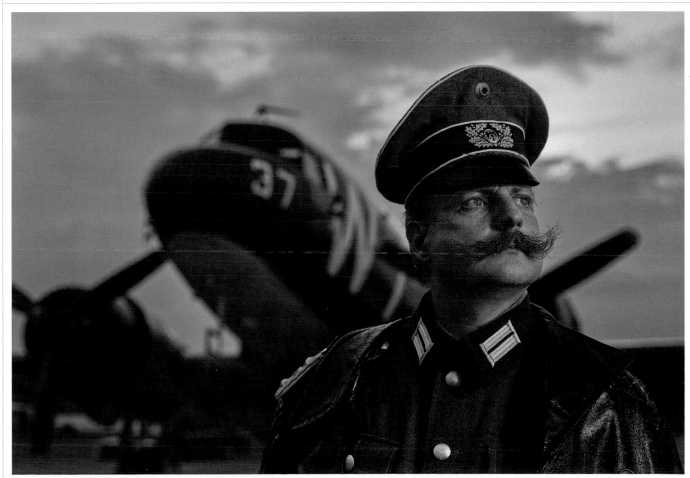

Keep the History Alive - German Wehrmacht | Self-Initiated

JAMES MARTIN

Jungle Camp | **CBS Interactive**

MICHAEL CONFER

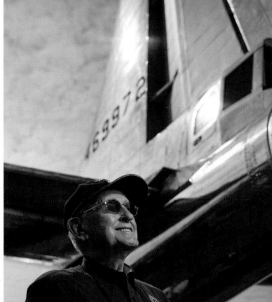

Keep the History Alive - Norris Jernigan | **Self-Initiated**

HOWARD ROSENBERG

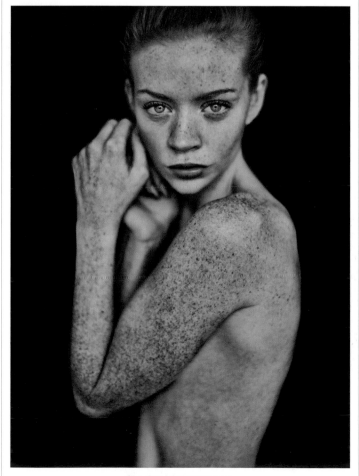

Cherish | **Self-Initiated**

CALLIE LIPKIN

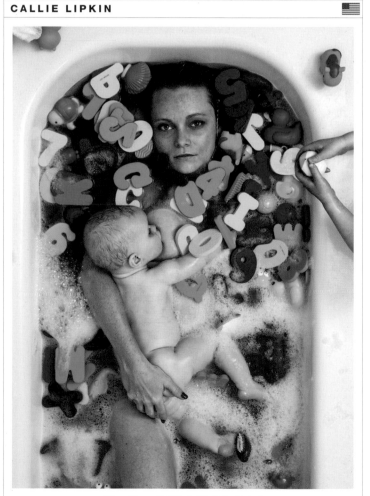

Mom Time Bathtub | **Self-Initiated**

PATRICK MOLNAR

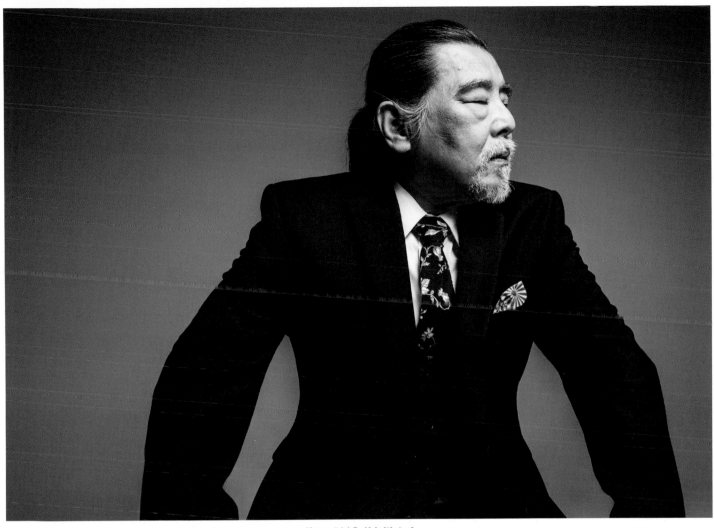

Keng #1 | Self-Initiated

MICHAEL CONFER

HOWARD ROSENBERG

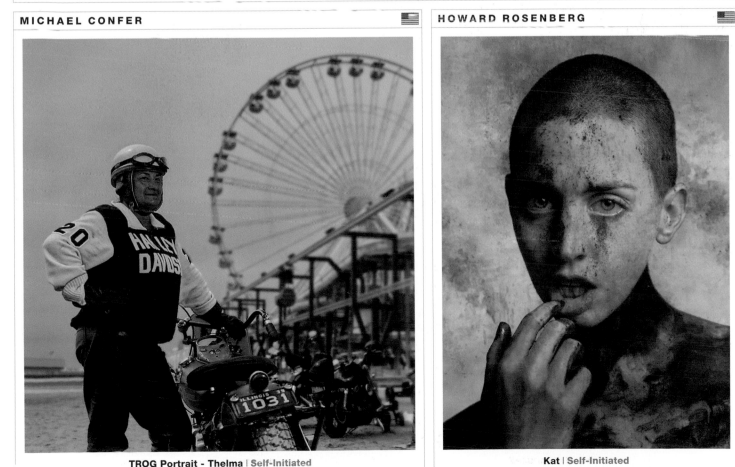

TROG Portrait - Thelma | Self-Initiated

Kat | Self-Initiated

CHRISTOPHER WILSON

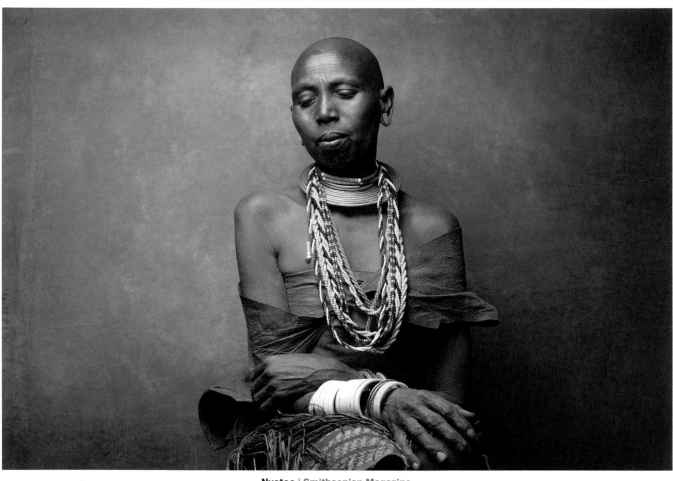

Nyotee | Smithsonian Magazine

DYLAN WILSON

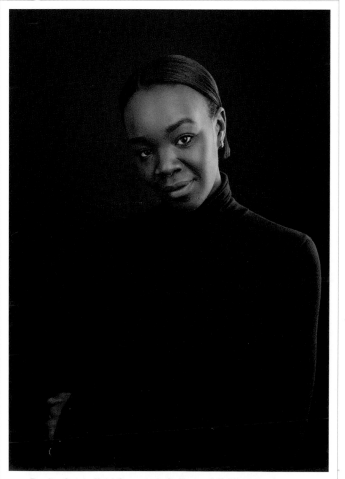

Recho Omondi 1 | Savannah College of Art and Design

HOWARD ROSENBERG

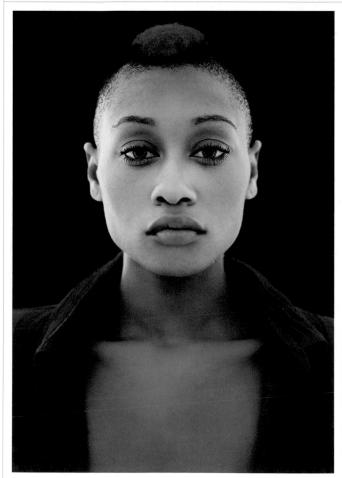

Sara | Self-Initiated

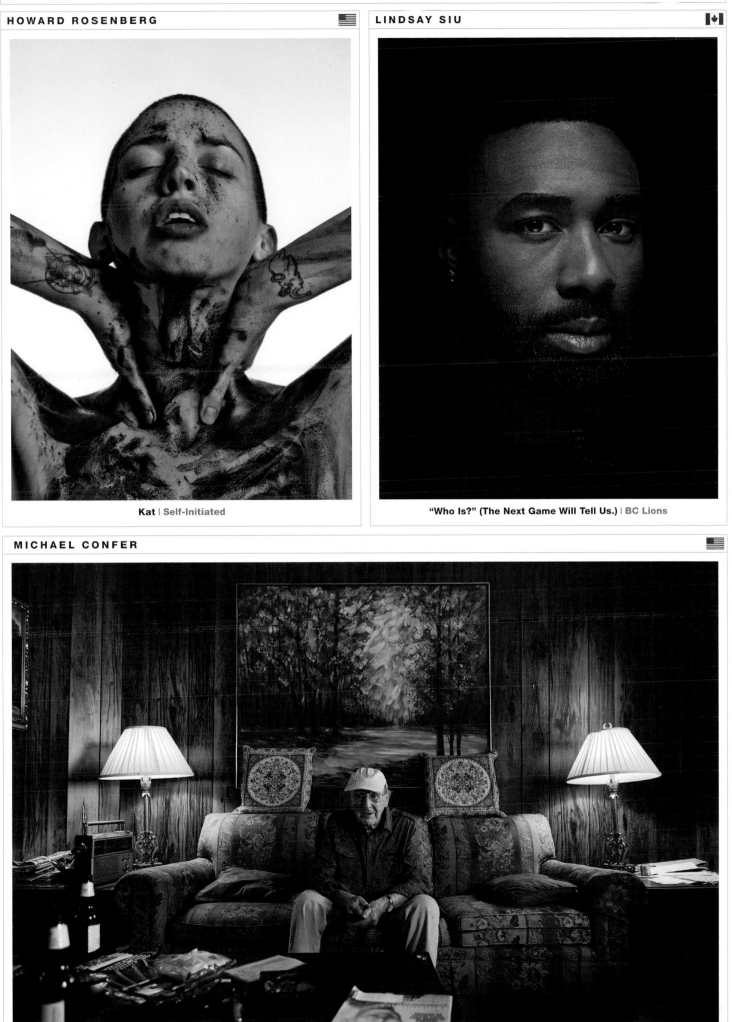

HOWARD ROSENBERG

Kat | Self-Initiated

LINDSAY SIU

"Who Is?" (The Next Game Will Tell Us.) | BC Lions

MICHAEL CONFER

Keep the History Alive - Sgt. Francis Ryan | Self-Initiated

MICHAEL CONFER

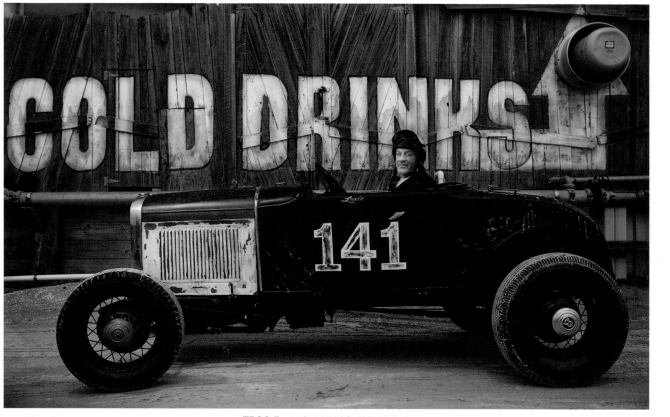

TROG Portrait #141 | Self-Initiated

CALLIE LIPKIN

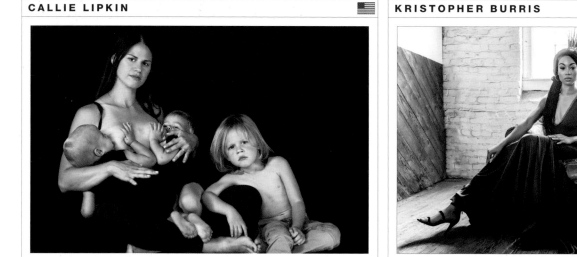

Mom Time Jennifer | Self-Initiated

KRISTOPHER BURRIS

Royalty | Self-Initiated

DAVE MOSER

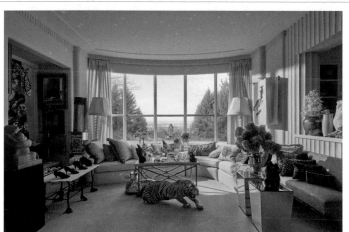

Vignettes - Ilene #0196 | Self-Initiated

STAN MUSILEK

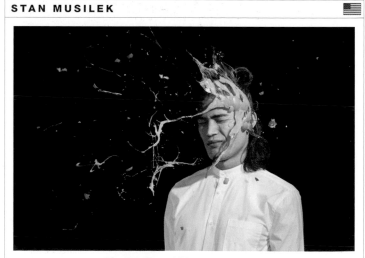

Musilek-Egged-Man-bun | Zebule

LINDSAY SIU

Spring Portraits | Lindsay Siu Photographer

TONY KEMP

Dakota | Self-Initiated

RJ MUNA

Dancer Portraits | Alonzo King LINES Ballet

MARK BATTRELL

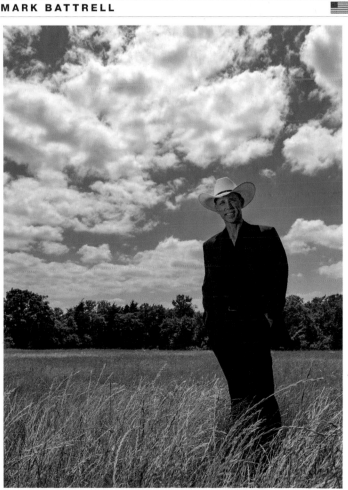

Employee Recognition Portrait | CDW

TODD BURANDT

Mohammed Massaquoi | Mohammed Massaquoi

MARK BATTRELL

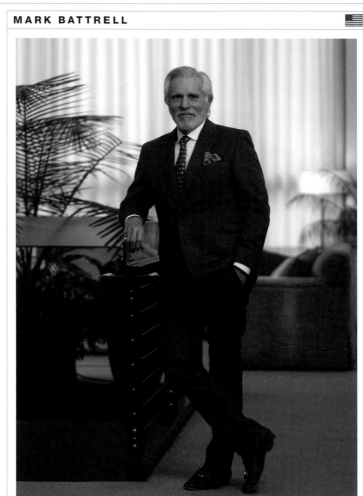

Annual Report Portrait | Alliance Francaise Chicago

CRAIG BROMLEY

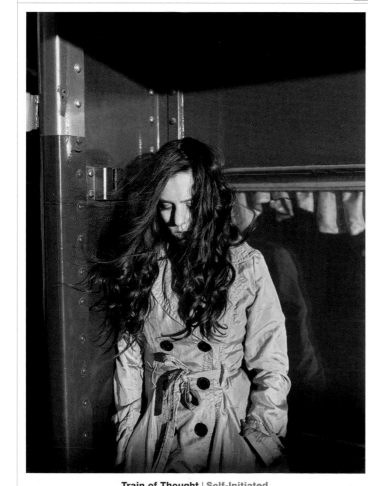

Train of Thought | Self-Initiated

MATT HAWTHORNE

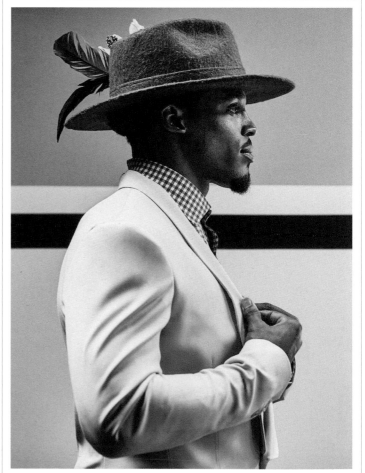

Cam Newton | Gatorade

STAN MUSILEK

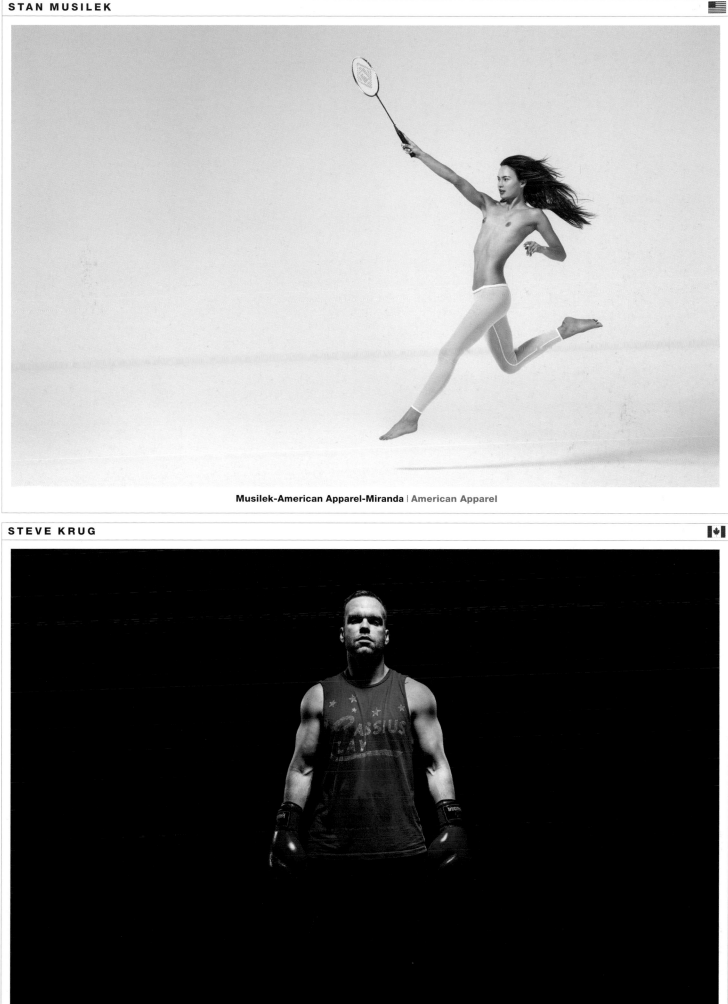

Musilek-American Apparel-Miranda | American Apparel

STEVE KRUG

Boxer | Dave McGregor

TERRY VINE

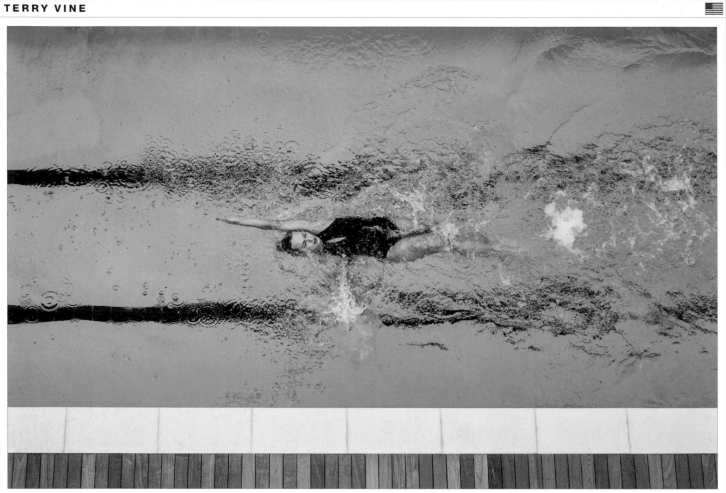

Swimmer | The Preserve

CHRISTOPHER WILSON

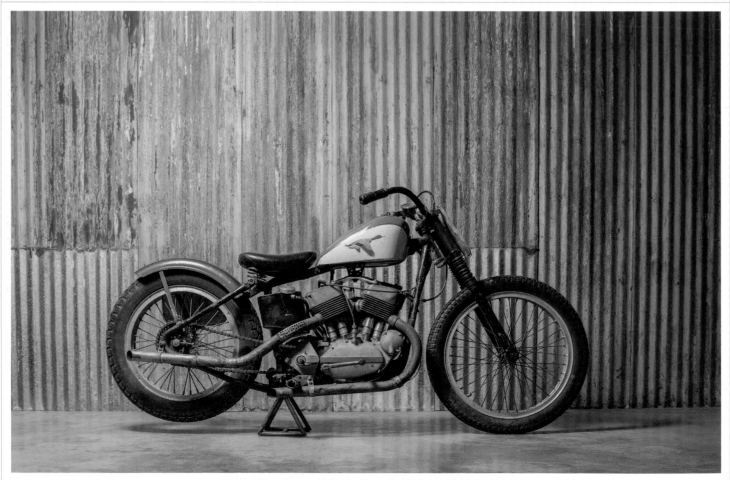

Harley Blue Goose | Wheels Through Time, 1903 Magazine

JOSEPH SARACENO

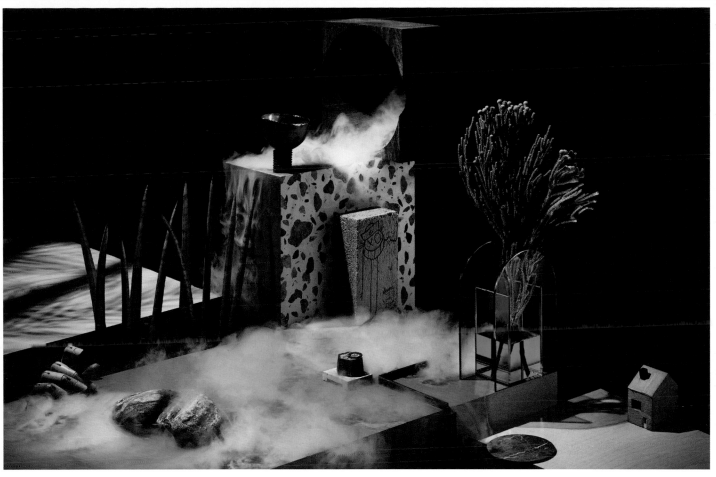

Anachronism_003 | DLTD Magazine

JOSEPH SARACENO

STACEY BRANDFORD

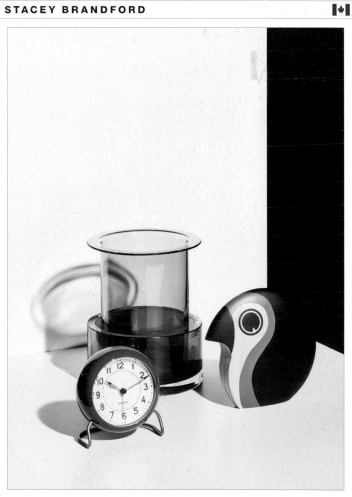

Edge | Sylvanus Urban

Must Haves | re:porter

JOSEPH SARACENO

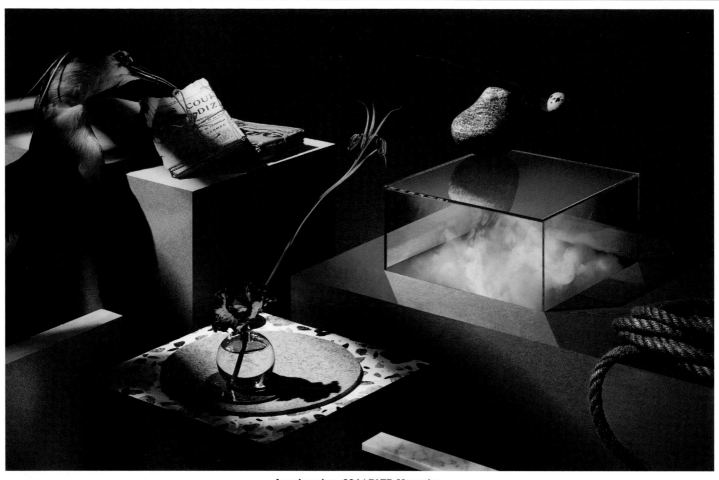

Anachronism_001 | DLTD Magazine

STEVE KRUG

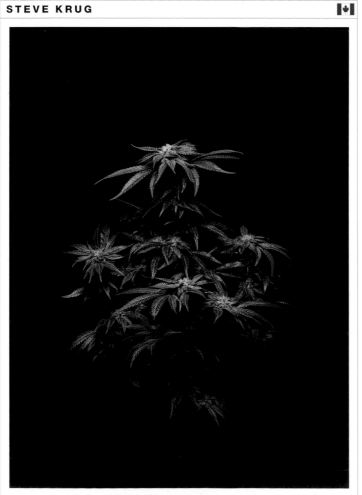

Purple Cannabis Plants on Black | Up Cannabis

JOSEPH SARACENO

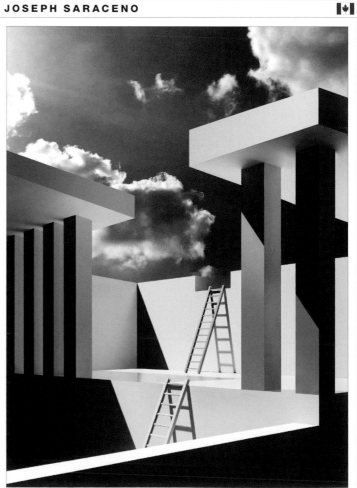

Space | Sylvanus Urban Magazine

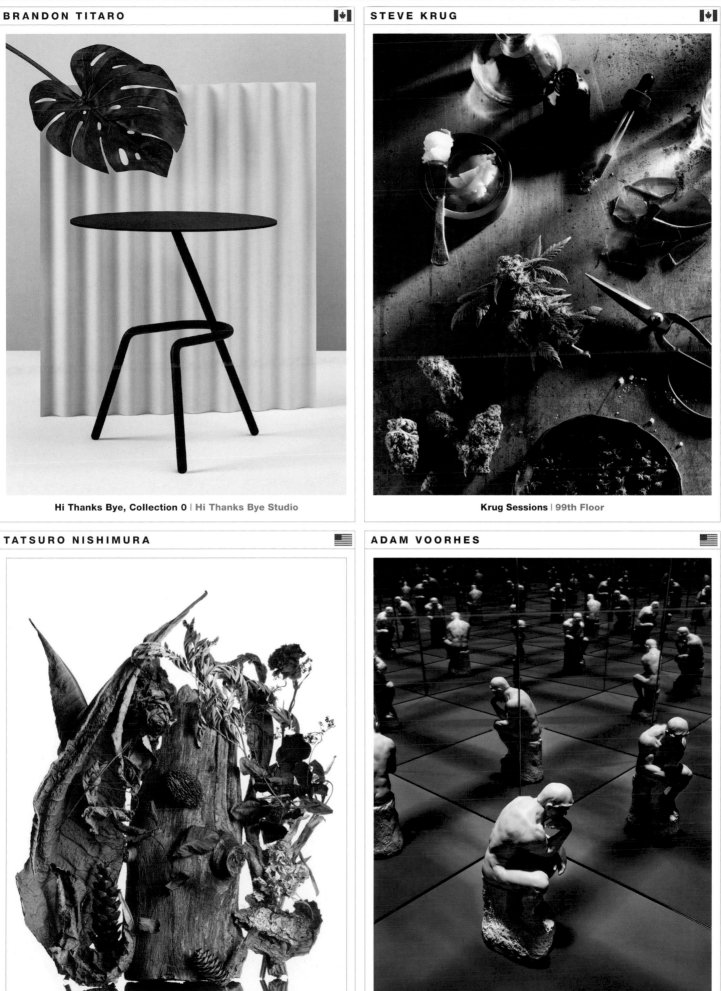

BRANDON TITARO

Hi Thanks Bye, Collection 0 | Hi Thanks Bye Studio

STEVE KRUG

Krug Sessions | 99th Floor

TATSURO NISHIMURA

Nature Still Life | Self-Initiated

ADAM VOORHES

Masculinity | GLAMOUR Magazine

NICHOLAS DUERS

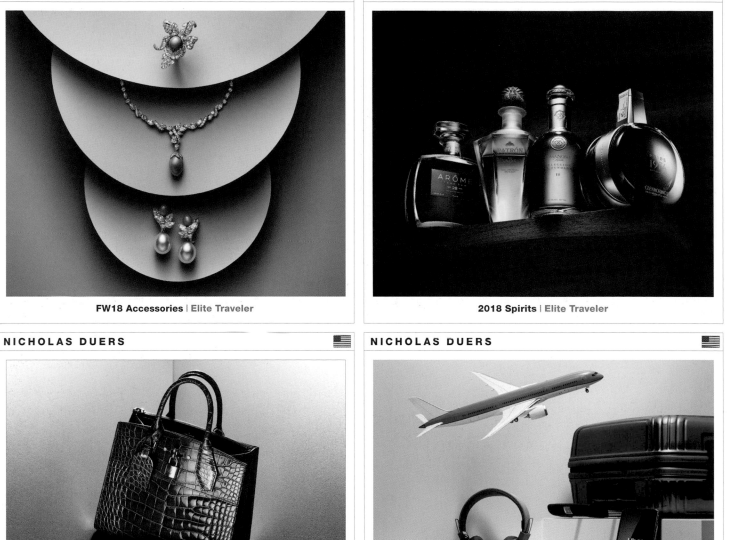

FW18 Accessories | Elite Traveler

NICHOLAS DUERS

2018 Spirits | Elite Traveler

NICHOLAS DUERS

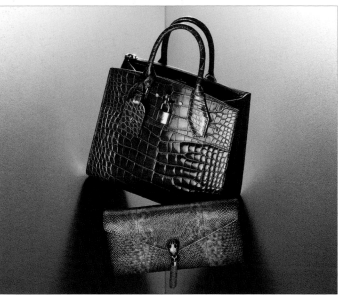

Elite Traveler FW18 | Elite Traveler

NICHOLAS DUERS

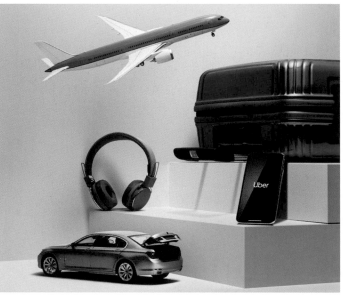

Uber 2018 | Uber

FJ HUGHES

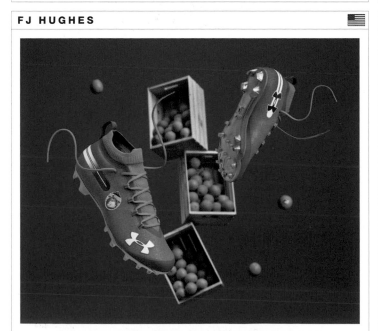

Under Armour AFC-NFC Pro Bowl Cleats | Under Armour

NICHOLAS DUERS

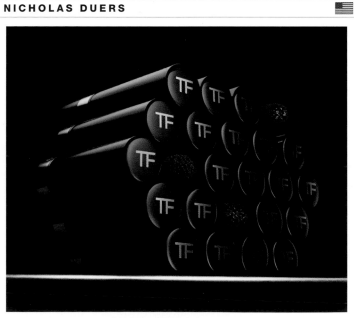

Tom Ford | Beauty | Tom Ford

JONATHAN KNOWLES

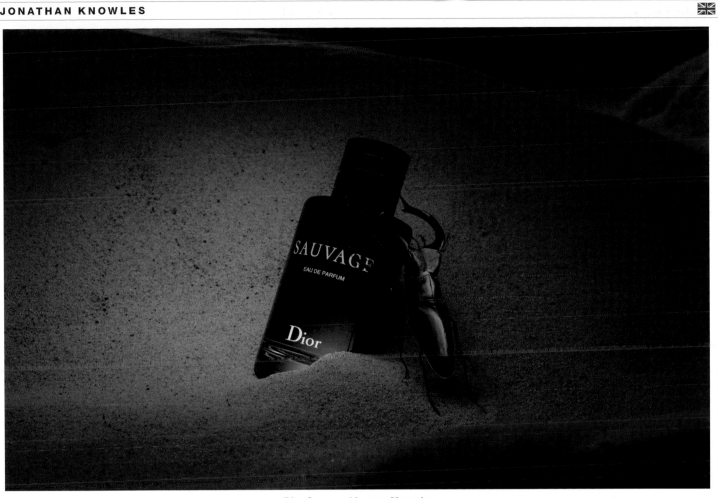

Dior Sauvage | Luxure Magazine

BRUCE PETERSON

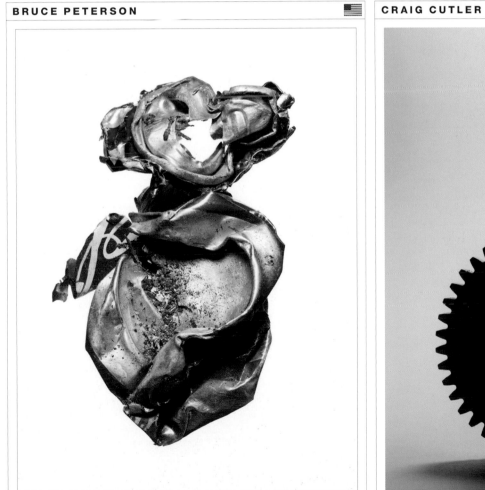

SIFIMD (Sh*t I found in my driveway) | Self-Initiated

CRAIG CUTLER

Gear Abstracts | Self-Initiated

BRUCE PETERSON

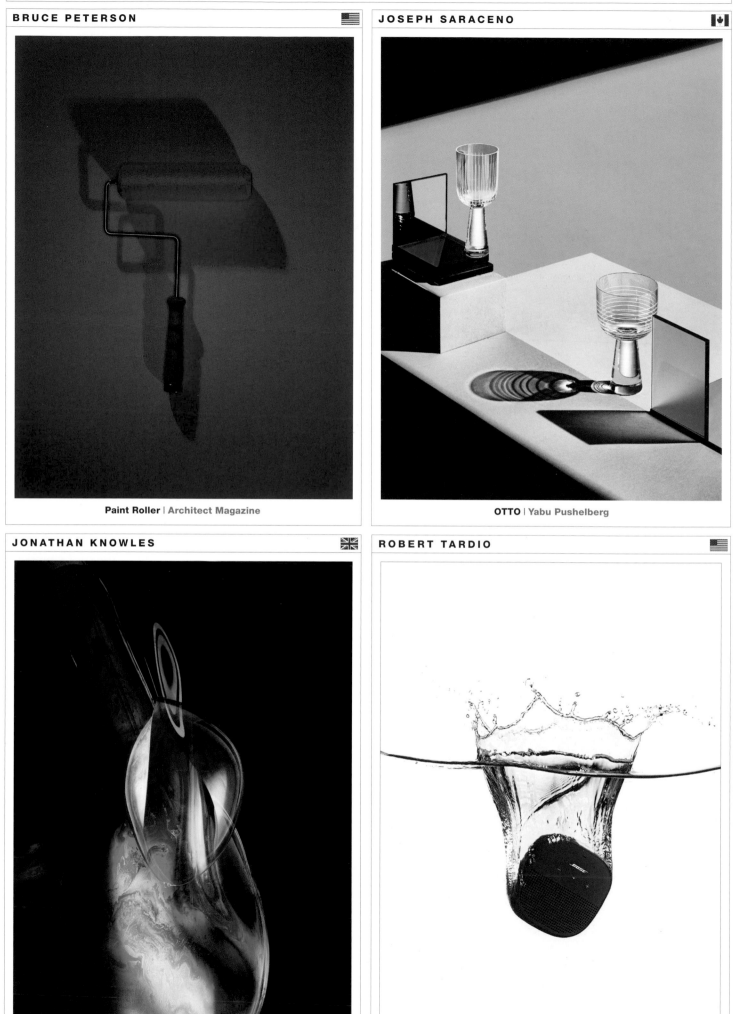

Paint Roller | Architect Magazine

JOSEPH SARACENO

OTTO | Yabu Pushelberg

JONATHAN KNOWLES

Cosmic Bubbles | Self-Initiated

ROBERT TARDIO

Speaker Splash | Bose

BRUCE PETERSON

Dirty Sponges | Self-Initiated

GREGORY REID

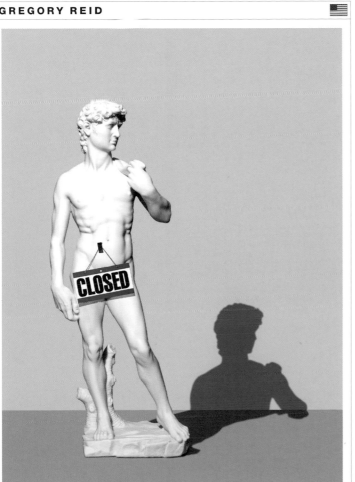

Sperm Und Drang | Newsweek

ADAM VOORHES

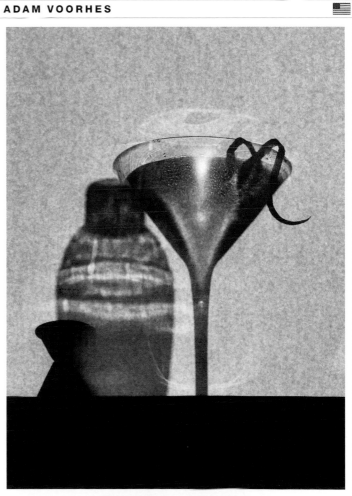

Paper & Shadow | Self-Initiated

TAKAHIRO IGARASHI

Iconic Grooves | Rimowa

JONATHAN KNOWLES

Colour Explosion | Graff Diamonds

NICHOLAS DUERS

Tom Ford | Men's Accessories | Tom Ford

NICHOLAS DUERS

Cosmetics | Lash Star Beauty

WILLIAM BARTLETT

Range | Self-Initiated

CHRISTOPHER WILSON

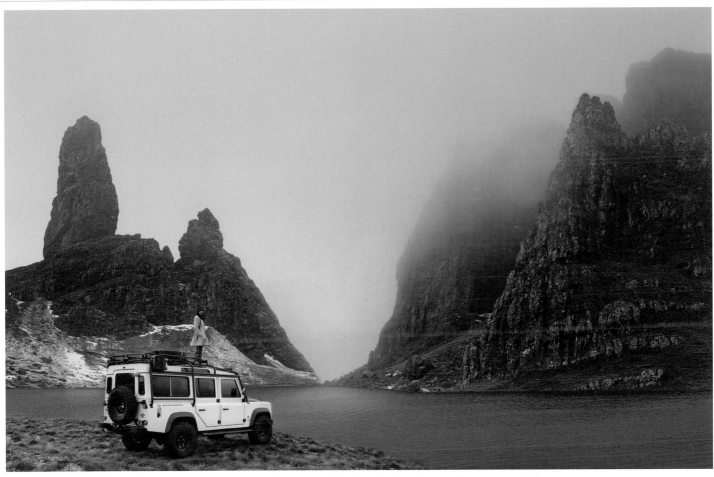

Heaven Is In The Clouds | **Euro Motors**

JAMES EXLEY

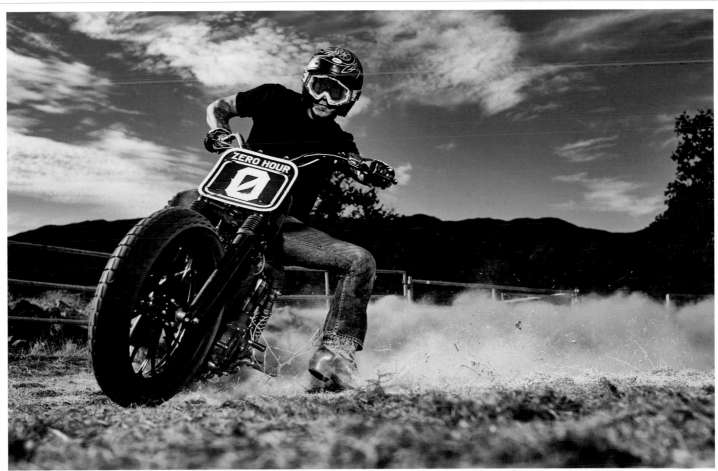

Jimmy Burnouts | **Self-Initiated**

CHRISTOPHER WILSON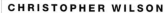

Lovejoy Speedster | Amelia Island Tourism

When I'm ninety years old, if asked why I'm still working at this photography thing, I can say what the legendary cellist, Pablo Casals, said at ninety: "Because I think I'm making progress."

Christopher Wilson, *Photographer*

It's good to know that the photography world is continuing to produce quality and innovative work.

Kah Poon, *Photographer*

Stan Musilek

Craig Bromley

Matt Hawthrone

Giuseppe De Lauri

Tatsuro Nishimura

Wray Sinclair

Mark Battrell

Stan Musilek

Nyk Sykes

Hadley Stambaugh

Lindsay Siu

Stan Musilek

Hadley Stambaugh

Hadley Stambaugh

Jérôme Brunet

Tatsuro Nishimura

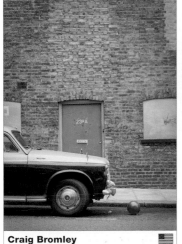

Craig Bromley 🇺🇸

P.J. Fugatze 🇺🇸

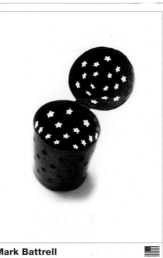

Mark Battrell 🇺🇸

Tony Kemp 🇺🇸

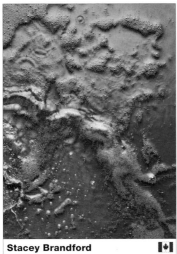

Stacey Brandford 🇨🇦

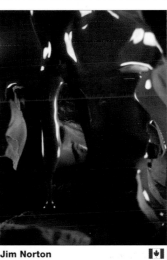

Stacey Brandford 🇨🇦

Jim Norton 🇨🇦

Laurie Frankel 🇺🇸

Stacey Brandford 🇨🇦

Warren Eakins 🇺🇸

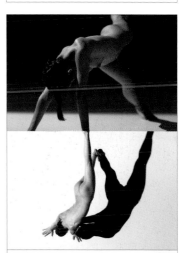

Stephen Guenther 🇺🇸

Ricardo de Vicq de Cumptich 🇧🇷

Howard Rosenberg 🇺🇸

Mark Battrell 🇺🇸

Michael Winokur 🇺🇸

Dave Roberts 🇺🇸

Gene Smirnov 🇺🇸

Howard Rosenberg 🇺🇸

Ethan Pines 🇺🇸

Emily Neumann 🇺🇸

Dylan Wilson 🇺🇸

Hadley Stambaugh 🇺🇸

Hadley Stambaugh 🇺🇸

Howard Rosenberg 🇺🇸

Matt Hawthorne 🇺🇸

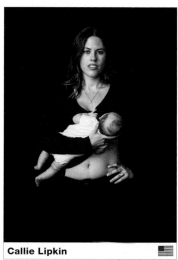

Callie Lipkin 🇺🇸

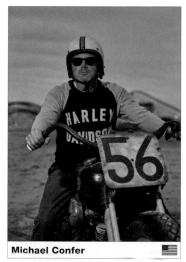

Dave Roberts 🇺🇸

Michael Confer 🇺🇸

Jim Norton 🇨🇦

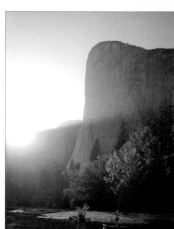

Dylan H. Brown 🇺🇸

Robert Tardio 🇺🇸

Steve Krug 🇨🇦

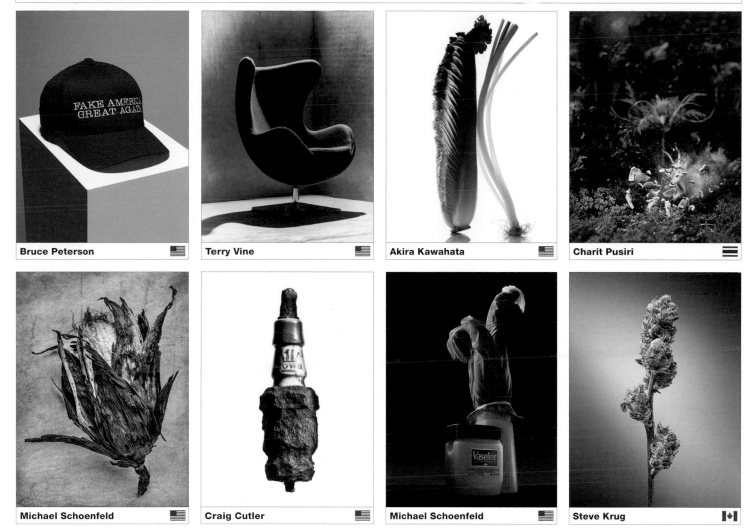

Bruce Peterson

Terry Vine

Akira Kawahata

Charit Pusiri

Michael Schoenfeld

Craig Cutler

Michael Schoenfeld

Steve Krug

To all the photographers that entered, thank you for putting your work out there. It takes enormous courage to let others judge your babies.

Christopher Wilson, *Photographer*

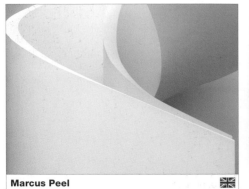

Marcus Peel 🇬🇧

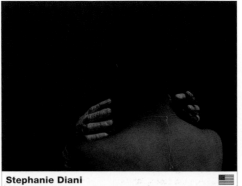

Stephanie Diani 🇺🇸

David Butler 🇺🇸

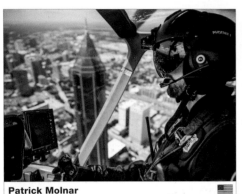

Patrick Molnar 🇺🇸

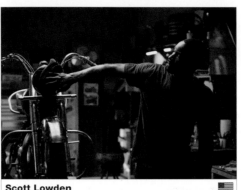

Scott Lowden 🇺🇸

James Martin 🇺🇸

Patrick Molnar 🇺🇸

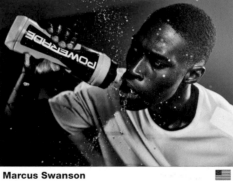

Marcus Swanson 🇺🇸

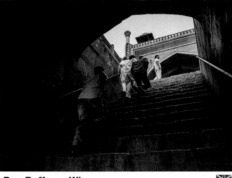

Ben Buffone, Wiser 🇬🇧

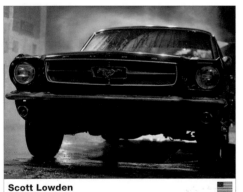

Scott Lowden 🇺🇸

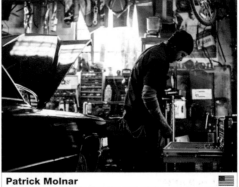

Patrick Molnar 🇺🇸

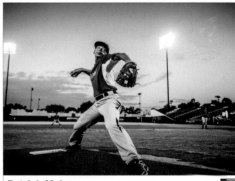

Patrick Molnar 🇺🇸

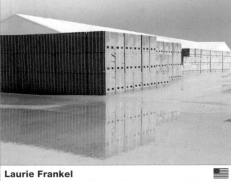

Laurie Frankel 🇺🇸

Jonathan Knowles 🇬🇧

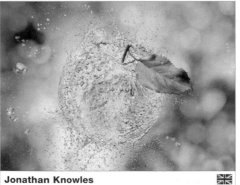

Patrick Molnar 🇺🇸

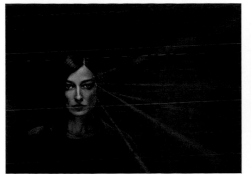

Staudinger+ Franke

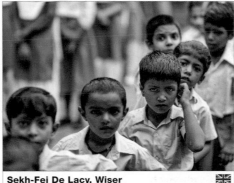

Sekh-Fei De Lacy, Wiser

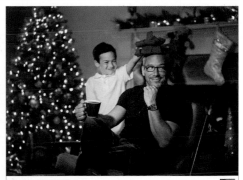

Craig Bromley

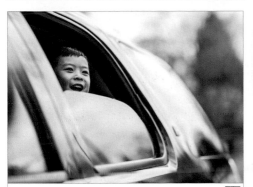

Patrick Molnar

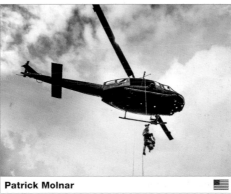

Scott Lowden

Patrick Molnar

Scott Lowden

Patrick Molnar

Craig Bromley

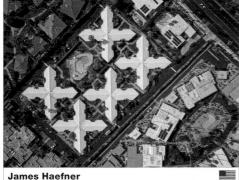

Steve Krug

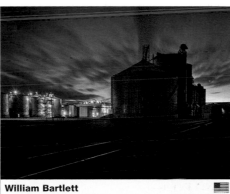

William Bartlett

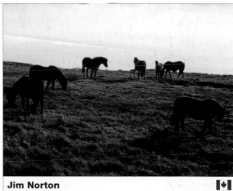

Jim Norton

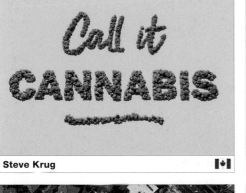

James Haefner

Alina Holodov

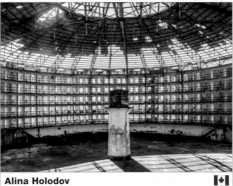

Marc Engenhart

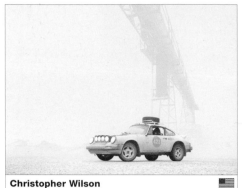

Christopher Wilson 🇺🇸

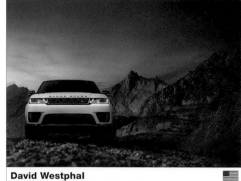

David Westphal 🇺🇸

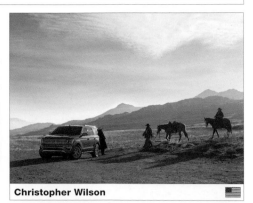

Christopher Wilson 🇺🇸

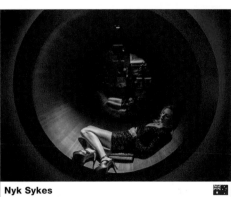

Roy Ritchie 🇺🇸

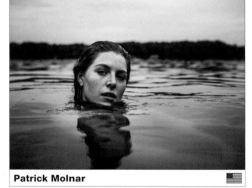

Roberto Kai Hegeler 🇺🇸

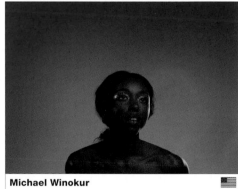

Scott Lowden 🇺🇸

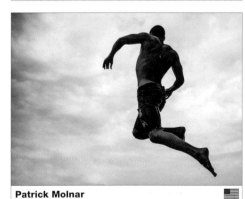

Nyk Sykes 🇦🇺

Patrick Molnar 🇺🇸

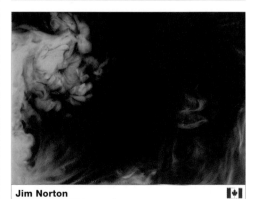

Michael Winokur 🇺🇸

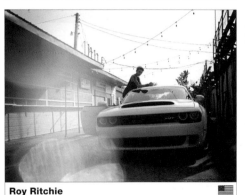

Patrick Molnar 🇺🇸

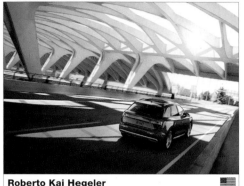

Jonathan Knowles 🇬🇧

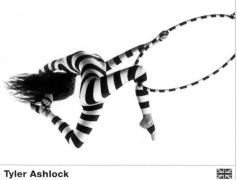

Jim Norton 🇨🇦

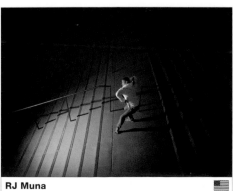

RJ Muna 🇺🇸

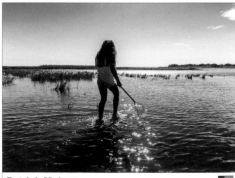

Tyler Ashlock 🇬🇧

Patrick Molnar 🇺🇸

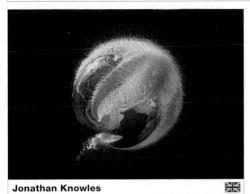

Jonathan Knowles 🇬🇧

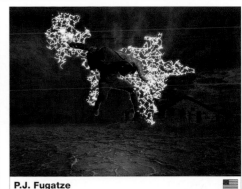

Lonnie Duka 🇺🇸

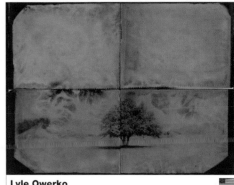

P.J. Fugatze 🇺🇸

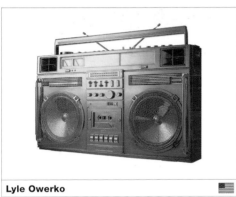

Scott Lowden 🇺🇸

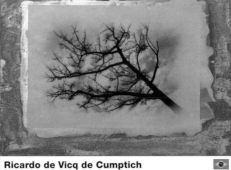

Ricardo de Vicq de Cumptich 🇧🇷

Lyle Owerko 🇺🇸

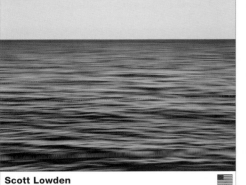

Lyle Owerko 🇺🇸

Lyle Owerko 🇺🇸

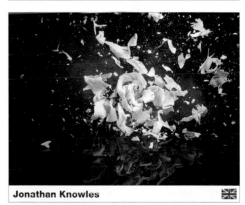

Lyle Owerko 🇺🇸

Lyle Owerko 🇺🇸

Lyle Owerko 🇺🇸

Jonathan Knowles 🇬🇧

Nyk Sykes 🇦🇺

Makito Inomata 🇨🇦

Ricardo de Vicq de Cumptich 🇧🇷

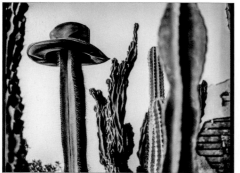
John Haynes

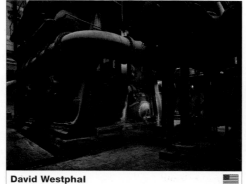
David Westphal

Rick Soto

Cameron Davidson

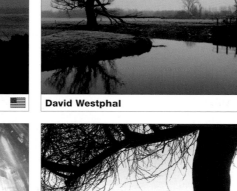
David Westphal

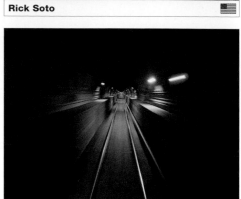
Cameron Davidson

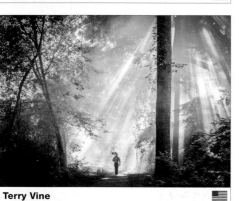
Terry Vine

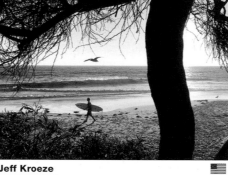
Jeff Kroeze

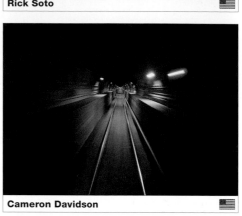
Darnell McCown

Alistair Gutherie

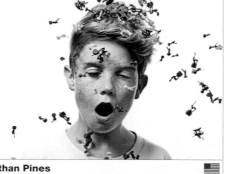
Ethan Pines

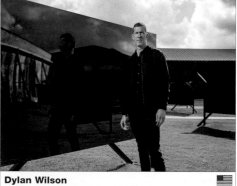
Dylan Wilson

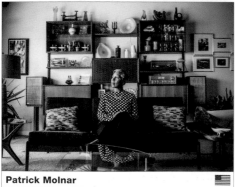
Patrick Molnar

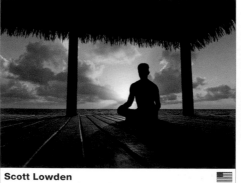
Scott Lowden

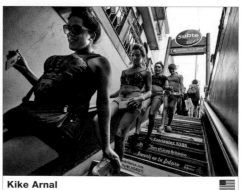
Kike Arnal

Visit website to view full series

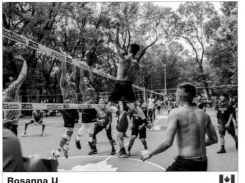

Rosanna U 🇨🇦

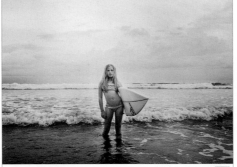

Tyler Stableford 🇺🇸

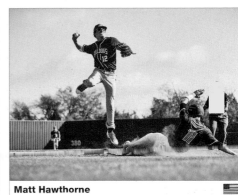

Gene Smirnov 🇺🇸

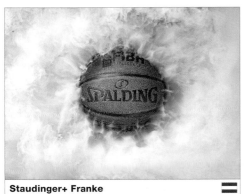

Staudinger+ Franke

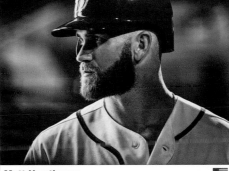

Matt Hawthorne 🇺🇸

Matt Hawthorne 🇺🇸

Selman 🇺🇸

Adam Voorhes 🇺🇸

Robert Tardio 🇺🇸

James Martin 🇺🇸

Takahiro Igarashi 🇺🇸

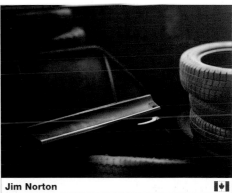

Jim Norton 🇨🇦

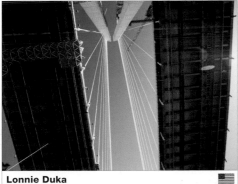

Lonnie Duka 🇺🇸

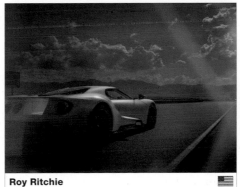

Roy Ritchie 🇺🇸

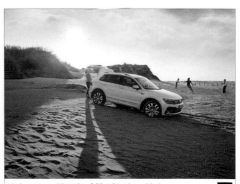

Johannes Hartig / Katharina Kehm 🇩🇪

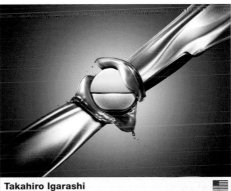
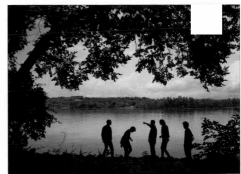

Credits & Commentary

PLATINUM WINNERS:

22 PARKER DUOFOLD / THE CRAFT OF TRAVELLING | Photographer: Jonathan Knowles
Client: Parker Pens / Newell Brands | Equipment: Hasselblad | Creative Director: John Fairley
Ad Agency: Splash Worldwide

Assignment: Parker launched the 2018 Duofold Limited Edition to celebrate its 130th anniversary and to pay tribute to its founder, George Safford Parker, with an exceptional pen that traces back his travels around the world.

Approach: Parker wanted to demonstrate its craftsmanship, and developed a pen in homage of its history, a bridge between the past and today, which will contribute to build the brand identity and strengthen the brand image. ■ The photographic brief for this 2018 Duofold Limited Edition pen was to create a premium image that embodied the craft of traveling, whilst making a hero of the pen and its fine detailing.

Results: Only 1300 numbered pieces of the 2018 Duofold Limited Edition were produced, as a testament to its 130th anniversary. The image was used worldwide in advertising and promotions.

23 PURDEY / WHERE STYLE MEETS STRENGTH | Production Company: Curious
Productions | Photographer: Dan Humphreys | Client: James Purdey & Sons
Equipment: Canon 5DS | Retoucher: Rob Lanario | Head of Production: Tom Gibson
Creative Director: John Fairley Art Director: John Fairley | Agency Producers: Harley Brooks,
Chloe Cunningham | Account Director: Dean Agambar | Ad Agency: Curious Productions

Assignment: To shoot and deliver a new advertising hero image to introduce the new Purdey Trigger Plate Over-and-Under Gun.

Approach: In designing this new, premium Purdey Gun, research told us that the Purdey Trigger Plate Over-and-Under Gun had been tested with more than 150,000 cartridges to prove that it could meet the highest demands of today's sporting conditions. Our direction was to simply nestle the gun on a bed of multiple, fresh Purdey cartridges to leverage the idea that the gun had undergone its rigorous testing.

Results: The image was used by Purdey for brand advertising, point of sale and across digital channels. With a single gun costing over $160,000, it was vital that the image imbued all the quality and craftsmanship inherent in the long-established Purdey brand.

24 19 DUTCH PORTRAIT WOMAN | Design Firm: IF Studio | Company: IF Studio
Photographer: Athena Azevedo | Client: Carmel Partners | Equipment: Canon 5DS
Creative Directors: Toshiaki Ide, Hisa Ide

Assignment: Campaign and brochure photography for 19 Dutch, a luxury rental in the financial district of Manhattan.

Approach: The 19 Dutch campaign we created revolved conceptually around "All things Dutch". Appropriately, we integrated Dutch themes into the photo shoot: delft tiles and sequentially blue and tulips.

Results: The final 19 Dutch portrait of a woman evokes both the old and new world "Dutch" quality, while serving as an iconic image for the building's marketing materials.

25 GIRL/BOY | Ad Agency: Caldas Naya | Photographer: Juan Cruz Durán
Client: Sonrisas de Bombay/Mumbai Smiles | Equipment: Canon EOS 5D SR
Digital Artist: Rubén Tresserras | Creative Director: Gustavo Caldas
Account Executive: Aketz Zubia | Account Director: Fabiana Casañas

Assignment: Sonrisas de Bombay an NGO based in Barcelona and Mumbai, asked to create a campaign to denounce the inequality and lack of rights of women in India.

Approach: We came up with a simple, yet direct and "in your face" concept. The campaign showed the image of an Indian girl with the following headline: "In India a woman is raped every 60 minutes." ■ On the following page, we showed that same girl with makeup, transformed into a boy with the following headline: "Do they have to go so far to have the same rights as men?"

Results: The campaign is starting to help and change the mentality of the people from India. It seems that Sonrisas de Bombay is getting new members and collaborators every month.

26-28 MARKETING FOR MICHAEL SCHOENFELD 2018 COLOR | Photographer: Michael
Schoenfeld | Client: Self-Initiated | Equipment: Sony A7rII & A7rIII 50mm and 24mm lens

Assignment: Series of images for marketing campaign 2018

Approach: I believe all creativity centers around the subject of intimacy that the artist experiences in the dance with their subject. It's very personal, and says more about the artist than the subjects of the work.

Results: Various national editorial assignments and inquiries

29 MUSILEK-ATOMIC | Photographer: Stan Musilek | Client: Atomic | Equipment: Phase One

Assignment: Ad for Atomic. They make these very cool fins.

Approach: Location shoot which Stan AD'ed as well.

Results: Happy client, happy crew, happy model, all in a day.

30 UNDERWATER SYMPHONY | Photographer: Jonathan Knowles
Client: Luxure Magazine | Equipment: Hasselblad

Assignment: This began as a personal project where I took the trumpet I played as a child and wondered what I could do with it. The valves were stuck fast, and so I immersed it in water with the intention of freeing them up, and then decided this was the route to travel.

Approach: My original thought had been to shoot bubbles coming from the end of it, but once I created the subdued brown background for the set up, I decided to add the additional layer of brown billowing clouds.

Results: The initial images were seen by Luxure Magazine, who wanted to run it as a fine art story, and for which we shot some additional executions.

31 MUSILEK-KATIE-F-TEMPTATION | Photographer: Stan Musilek
Client: Adcos | Equipment: Phase One

Assignment: skincare ad

Approach: temptation as concept

Results: apple a day keeps the doctor away ;)

32 PLASTIC OCEAN | Photographer: Staudinger+Franke | Client: Self-Initiated
Equipment: PhaseOne XF, Capture One Pro, Broncolor, Tether Tools, Photoshop

33 EYES OPEN/CLOSED | Photographer: Parish Kohanim | Client: Self-Initiated
Company: Parish Kohanim Photography | Printing: Photographic print in Diasec | Size: 48x44"

Assignment: This image depicts the duality of choices that exist in our lives. ■ We have a choice to go through life with eyes closed metaphorically (and miss out on all the gifts of our universe. ■ The other choice is to go through life with eyes wide open enjoy and savor all the sublime gifts that the universe is presenting.

Approach: It's hard to pin point the main purpose of the approach. Once I start to photograph, I am so embraced in the field of non-thinking, and yet focusing on an image that has a fresh, compelling message.

Results: I think this image has been receiving very positive feedback, not only from my clients but also from other galleries that represent my work.

34 NEONGLOW_002 | Photographer: Joseph Saraceno | Client: Schon Magazine | Stylist:
Wilson Wong @P1M | Equipment: canon 1DS MarkIII | Creative Director: Wilson Wong @P1M

Assignment: Create a beauty editorial for Schon Magazine

Approach: We used beauty products, colored plexi and colored paper.

Results: Editorial for Schon Magazine based in London England

35 NEONGLOW_001 | Photographer: Joseph Saraceno | Client: Schon Magazine | Stylist:
Wilson Wong @P1M | Equipment: Canon 1DS MarkIII | Creative Director: Wilson Wong @P1M

Assignment: Create a beauty editorial for Schon Magazine

Approach: We used beauty products, colored plexi and colored paper.

Results: Editorial for Schon Magazine based in London England

GOLD WINNERS:

37 19 DUTCH PORTRAIT MAN | Design Firm: IF Studio | Company: IF Studio
Photographer: Athena Azevedo | Client: Carmel Partners | Equipment: Canon 5DS
Creative Directors: Toshiaki Ide, Hisa Ide

Assignment: Campaign and brochure photography for 19 Dutch, a luxury rental in the financial district of Manhattan.

Approach: The 19 Dutch campaign we created revolved conceptually around "All things Dutch". Appropriately, we integrated Dutch themes into the photo shoot: delft tiles and sequentially blue and tulips.

Results: The portrait evokes the old and new world "Dutch" quality, and serves as an iconic image for the building's marketing materials.

38 ELTE | Photographer: Stacey Brandford | Client: Elte | Stylist: Sasha Seymour
Equipment: Canon 5Ds | Creative Director: Andrew Cloutier

39 BREAK TIME | Photographer: Laurie Frankel | Client: Sunbrella | Stylist: Hilary Robertson
Equipment: Hasselblad H5X with Phase One IQ3 100 back, Hasselblad 80mm Lens
Creative Director: Vivian Mize | Ad Agency: Wray Ward

Assignment: Sunbrella makes durable furniture coverings that have generally been used for outdoors. Still, many of their fabrics are both fashionable and comfortable. The objective was to appeal to international clients and interior designers to expand their market.

Approach: Identify beautiful and culturally compelling locations. Create environments and eye catching compositions with color combinations that show off both the fashion and flexibility of the fabrics.

40, 41 STACKED CHAIRS | Photographer: Laurie Frankel | Client: Sunbrella
Stylist: Hilary Robertson | Equipment: Hasselblad H5x with Phase One IQ3-100 back,
80mm Hasselblad Lens | Creative Director: Vivian Mize | Ad Agency: Wray Ward

Assignment: Sunbrella makes durable furniture coverings that have generally been used for outdoors. Still, many of their fabrics are both fashionable and comfortable. The objective was to appeal to international clients and interior designers to expand their market.

Approach: Identify beautiful and culturally compelling locations. Create environments and eye catching compositions with color combinations that show off both the fashion and flexibility of the fabrics.

42, 43 WHO IS THE REAL ANIMAL? | Production Company: Rabbit House Productions
Photographer: Claudio Napolitano | Client: PETA | Equipment: Hasselblad X1D, for Print and
Digital Advertising | Retouching: Rabbit House Post | Ad Agency: Archer Troy

Assignment: This PETA protest campaign needed to be loud and clear, the message was to raise awareness against animal cruelty.

Approach: This was a very interesting work for all the crew involved, it had to be daunting yet emotional. Technically it was a great challenge to solve this puzzle of separated images and bring them all together.

Results: It has been a shocking campaign with outstanding success for PETA which started as a local campaign and has been featured in the 200 best in Archive magazine in its first appearance.

44 SORONA CARPET | Photographer: RJ Muna | Client: DuPont
Equipment: Mamiya Leaf Credo | Associate Creative Director: Adrian Castillo
Account Director: Jessica Katz | Ad Agency: Brownstein Group

45 TOAST TO HOPE | Photographer: Mark Brautigam | Client: Iron Town Harley-Davidson/ALS Association Wisconsin Chapter | Producers: Ibro Gulamov, Christopher Dick
Photo Retoucher: Christopher Dick | Creative Director: Steve Drifka | Art Director: Steve Drifka
Account Executive: Whitney Marshall | Account Director: Shannon Egan
Executive Creative Director: Peter Bell | Equipment: Nikon D800E camera, 50mm lens

Assignment: Create promotional materials to drive attendance to the 16th Annual Toast To Hope, a fundraiser for the ALS Assn. WI Chapter.

Approach: Create a series of images featuring HOG Chapter members and associates of the H-D dealership, appropriately attired, to drive interest and attendance for the event.

Results: Attendance of HOG Chapter members and dealership staff was up year-over-year. The business partnerships associated with the event also grew year-over-year.

46, 47 F22 RAPTOR | Photographer: Patrick Molnar | Client: US Air Force
Equipment: Canon 5d Mk4

Assignment: Image library for the Air Force

48, 49 19 DUTCH GEZELLIG | Design Firm: IF Studio | Photographer: Athena Azevedo
Client: Carmel Partners | Equipment: Canon 5DS | Creative Directors: Toshiaki Ide, Hisa Ide

Assignment: Campaign and brochure photography for 19 Dutch, a luxury rental in the financial district of Manhattan.

Approach: Inspired by Dutch culture, we strove to evoke the concept of Gezelligheid, a word which, depending on context, can be translated as "conviviality" and "coziness," often used to describe a social situation.

Results: This playful and charming image of a woman "walking" barefoot on air across the couch encapsulates Gezelligheid in a single frame.

50, 51 A TOAST TO DUBAI | Photographer: Christopher Wilson
Client: FCB, Chicago | Equipment: Phase One Camera System

Assignment: The highest bar in Dubai. Photographed for FCB Chicago, as part of an extensive travel campaign for a credit card company that had us shooting in The Maldives, Dubai and all over England.

52 LIGHT IN A BOTTLE | Photographer: Jonathan Knowles | Client: Luxure Magazine
Equipment: Hasselblad H6D-100c with 120mm lens

Assignment: An editorial for the launch of JOY, the new Dior fragrance.

Approach: To tie in with some of the films made with Jennifer Lawrence, we decided to approach the project using liquids and flowers.

53 LOVE POTION | Photographer: Jan Kalish | Client: So...?Fragrance
Equipment: Profoto lighting, D2's | Lighting Design: Rob Driman | Retouching: Madeline Murray
Photo Retouching: Kathleen Gillis

Assignment: To produce an image to depict the new,' Miss...? perfume range, in time for an international launch. The marketing team required a youthful, lively, yet simply striking image; incorporating company colours.

Approach: The shooting project was complex and multi-faceted. We divided the concept into separate shooting assignments and components, requiring days of shooting in-studio splashes.

Results: The client released the imagery and new perfume during a recent world wide, international, online trade conference launch and reported a first-time 100% positive rating and excited response.

54 EL PASO | Photographer: John Schulz | Client: Pavement
Equipment: PhaseOne IQ180 | Photo Retouching: Daniel Fishel | Ad Agency: Pavement

Assignment: Studio Hero Photograph of El Paso Vodka Bottle. ■ Highlight the custom bottles facets.

Approach: Big camera and lots of lights.

Results: Happy Agency + Happy Client = Happy Photographer.

55 GREEN TREE PYTHON | Photographer: Lennette Newell | Client: PetSmart | Sr. Creative Service Director: Amy Rhodes | Creative Director: Maggie Parkhouse | Art Director: Paul Henson
Equipment: Canon EOS 5DS R + ProFoto lighting | Ad Agency: Spicefire

Assignment: Vivid reptile photography for PetSmart.

Approach: Worked with the creative team at PetSmart and Spicefire in pre-production, presenting the best reptile specimens for casting and approval on all reptiles. Photography of reptiles included the team from PetSmart directing and approving photography production. We worked closely with the reptile handler throughout the process to cast and shoot the reptiles safely. The colored background was added in post.

Results: Vivid photography for confidential brand to be launched in August. Photography was shot in December 2018.

56, 57 BULL ELEPHANTS | Photographer: Art Wolfe
Client: Earth Aware Editions | Publisher: Raoul Goff
Equipment: Canon EOS 5D Mark II, Canon EF 16-35mm f/2.8L II USM Lens

Assignment: This image is featured on the cover of Majestic: Elephants in the Age of Extinction (2019, Earth Aware Editions) ■ Legendary for their size and intelligence, elephants are one of the most charismatic of megafauna. That they are under siege from poachers is no secret, and the rapidity of their declining numbers is horrifying. However, amidst the steady stream of bad news, all is not lost. Ivory prices are declining, global education seems to be succeeding, and government crackdowns are beginning to stem the flow of illegal ivory. ■ While Silent Giants features my photographs of both African and Asian species, the emphasis is on the African savanna or bush elephant. Samuel Wasser's informative text focuses on his current groundbreaking research on the impacts of

the illegal trade in elephant ivory along with legal culling practices as a means of population control of this highly intelligent, tightly knit, social species. ■ Silent Giants is a celebration of these wondrous gentle giants, of the renewed efforts countries are taking to protect their natural heritage, and of what we can do to empower local populations to safeguard the survival of a magnificent species.

Approach: I set up by a shallow pond and was able to position the camera in a way to capture the width of the landscape with a wide angle. The elephants were moving with purpose, spraying water and flapping their ears.

Results: Using a wide angle lens I was able to capture the imposing stature and energy of these endangered animals.

58 ROOSTER, KEY WEST | Photographer: Darnell McCown | Client: Self-Initiated
Equipment: Canon 7D Mark II, EF 24-70mm 2.8 L II USM

59, 60 NEW YORK PIGEON FANCIERS | Photographer: Frankie Alduino
Client: Self-Initiated | Equipment: Canon 5d EOS Mark II

Assignment: Commonly disregarded as a pest by city dwellers pigeons have enamored a small group of enthusiasts who breed, exhibit, and love them wholeheartedly. This body of work examines themes of beauty, belonging, and community through the lens of an animal that is generally disregarded and disrespected. This selection of images comes from The 61st Annual Long Island Classic Open Show hosted by the Nassau Suffolk Pigeon Fanciers Club.

Approach: I approached this project with the goal of anthropomorphizing the pigeons. I photographed by utilizing classic portrait techniques that would be employed the exact same way were I shooting human sitters.

Results: The result is a body of beautiful and cohesive photographs depicting a generally disregarded creature in a elevated and dignified manner.

61 COCO | Photographer: Jill Greenberg | Client: mcgarrybowen/Fresh Step
Creative Director: Kevin Thomson | Art Director: Hannah Rand
Equipment: Phase One iQ280 with Hasselblad HC 100mm

Assignment: They wanted to have fun images of cats shot from below, through plexiglass so their paw pads would be front and center and the viewer could see how clean the paws were after the cats walked through their litter pan.

Approach: This cat litter campaign was meant to look very similar to my fine art animal series, which are shot on film. The hardest part was the frontal lighting since I was shooting the cats from below through plexiglass. It all turned out to be totally fine but we had to build quite an involved structure and the cats and their wranglers were about 10 feet up in the air and I was laying on my back on the studio floor. I tend to shoot with a long, flattering lens so they had to be high up. The cats were nonplussed. This is what it looked like with the platform and the lighting: https://bit.ly/2Q7Ndd9

Results: The clients and agency were thrilled. The images are exactly what they wanted and they ended up looking like just like my art. So, they decided to use the images for a cat adoption experiential event in Chelsea.

62 SAARINEN'S GATEWAY ARCH | Photographer: James Haefner
Client: Self-Initiated | Equipment: Canon 5DS, 17mm T/S

Approach: While on a road trip across the US I stopped at the Gateway Arch. I had never stood underneath it and the structure was magnificent!

63 NAVAL BASE MERCEDES | Photographer: Michael Mayo
Client: Michael Mayo Photography | Retouching: Imaginary Lines | Retoucher: Mary Brandt
Digital Artist: Chris Stoll | Equipment: Phase One XF

Assignment: Self promotion for Michael Mayo Photography

64, 65 BEAUTIFUL FRANKENSTEIN | Photographer: Christopher Wilson
Client: Road & Track | Equipment: Phase One Camera System

Assignment: Of all the crazy cool, held-together-with-gobs-of-spit-and-prayer contraptions I've had the pleasure of photographing during Speed Week at Bonneville Salt Flats, the belly tankers are my favorite. I think if Dr. Frankenstein were into car racing, these are the speed monsters he would have created. In their first life these belly tankers - or lakesters as they're often called - were fuel tanks on World War II fighter planes. ■ After the war, however, with hundreds of these fighters mothballed, resourceful hot-rodders - noting the aerodynamic potential of these fighters' fuel tanks - cut them in half and welded two lower-portions together, creating these utterly unique open-wheeled land torpedoes. The P-38 Lightening's fuel tanks were a particular favorite, being perfectly sized for an engine and drivetrain. ■ Part of an extensive library of imagery documenting Speed Week, and featured in Road & Track Magazine.

66, 67 CLASSIC CURVES | Photographer: Rick Kessinger
Client: Russell Maas Restoration | Equipment: Hasselblad H6D

Assignment: Create visual appealing images of a 1937 Hudson coupe for Bonhams auction catalog.

Approach: I wanted to highlight the great lines and curves that this classic car possess.

Results: The client fell in love with this image. Almost has an airbrushed quality to it, even though it was all done with light.

68 PORSCHE 911, GT3 RS | Photographer: Florin Gabor
Client: Loue la Vie | Equipment: 5D Mark III, EF 11-24 f/4

Assignment: The Porsche 911 GT3 RS was released to incite the hard core drivers and lovers of the motorsport fans. The photo assignment was to explore ways to reveal the car in a mysterious way, to intrigue the fans and encourage them to look out for more.

Approach: Shooting the new Porsche 911 GT3 RS took a minimalist approach: manipulate the light to be able to accentuate the unique shape of the car, keeping its personality and depict its DNA.

Results: A black and white photo that reveals the new Porsche 911 GT3 RS, seducing the eyes without giving away all the features.

69 GIRL IN RED MERCEDES | Photographer: Michael Mayo
Client: Michael Mayo Photography | Retouching: Imaginary Lines | Retoucher: Mary Brandt
Digital Artist: Chris Stoll | Equipment: Phase One XF

Assignment: Self promotion for Michael Mayo Photography

69 STORM CHASER | Photographer: Rick Kessinger
Client: Maxlider Brothers Customs | Equipment: Hasselblad H6D, Canon 7D

Assignment: Photograph the bronco in studio, then place it into a an engaging scene showing its use.

Approach: We wanted a background that could itself be the main subject. We photographed the bronco and the storm chaser separate in studio to match the light of the background scene. ■ With a little wind on the shirt and the drivers door open, added the right amount of action to reveal the extreme nature of the final composition.

Results: My dad, who is a photographer himself, was angry with me for taking such risks. Even he was fooled. Client was speechless.

70, 71 DIOR SHOW | Photographer: Jonathan Knowles | Client: Luxure Magazine
Equipment: Hasselblad | Model: Eve Deacon | Makeup: Jamie Coombes

72 MUSILEK-NIKE-NICOLE S. | Photographer: Stan Musilek
Client: Lui | Equipment: Phase One

Assignment: trainers Editorial
Approach: make the skin and the product look fresh
Results: my girlfriend kept those shoes

73 DIOR RETRO BEAUTY | Photographer: Jonathan Knowles
Client: Luxure Magazine | Equipment: Hasselblad

74 HEELING POWERS | Photographer: Bill Phelps | Client: Footwear Plus magazine
Editor-In-Chief: Greg Dutter | Creative Directors: Trevett McCandliss, Nancy Campbell
Equipment: Hasselblad, Phase One Back | Clothing Stylist: Barbara Ries

Assignment: This is an editorial fashion story featuring women's heels.
Approach: We shot this dreamy story in a romantic, smokey interior.
Results: Our readers loved this story.

75 MUSILEK-MARGAUX-LA-TREATS | Photographer: Stan Musilek
Client: Treats! | Equipment: Phase One

Assignment: Editorial w/stunning Margaux B.
Approach: mid-century modern goes well w/long legs
Results: turquoise and sexy

76, 77 THE 25TH FRAME | Photographer: Patrick Curtet
Client: GENLUX | Equipment: Canon

78 TOXIC OFFICE MASCULINITY | Photographer: Hadley Stambaugh
Client: Savannah College of Art and Design | Stylist: Jackson McCabe | Retoucher: Hadley Stambaugh | Producer: Hannah Malloy | Equipment: Canon 5d mark VI/Canon 70-200mm

Assignment: Photograph Jackson Wrenn McCabe's Senior fashion collection titled BusinessOnly sponsored by Swarovski. Imagery was used both for his senior portfolio as well as entered into the fashion competition sponsored by Moët Hennessy-Louis Vuitton (LVMH).

Approach: Collaborated with Jackson McCabe to visually represent the toxic environment of the "typical" corporate office mentality.

Results: Images were approved by the Fashion Dean Michael Fink to be sent to LVMH competition. Jackson McCabe adored the imagery and has used them on social media.

79 LIGHT + SHADOW | Photographer: Frank P. Wartenberg | Client: AMD Fashion Academy
Photo Retouching: Markus J. Reinhardt, Ben PPR | Hair & Makeup: Nina Krüger
Equipment: Canon 5 D Mark III | Lens: Canon 24 - 70 mm

Assignment: Workshop for Fashion students at the Munich Fashion Academy AMD: Light and Shadow.

Approach: For one week I worked together with the fashion students and taught them about lighting and shadow effects in fashion photography. The highlight of that workshop is the shooting at the end of the week. The students shall organize models, outfits, hair & makeup, and location. The students do their own pictures, but I do at the same time my shooting with their models, outfits and so on to show different approaches to the subject.

Results: I use the shadow effects a lot anyways and these fashion creations of the students inspired me to a sort of sixties-look of fashion photography.

80, 81 MUSILEK-OCTOBERFEST | Photographer: Stan Musilek
Client: Octoberfest Paris | Equipment: Phase One

Assignment: A promotion for Octoberfest in Paris, France that was sponsored by Löwenbräu Brewery.

Results: Very happy client, judging by the smiley faced emails we received after the shoot.

82 MUSILEK-FLAUNT-MIRANDA | Photographer: Stan Musilek
Client: Flaunt | Equipment: Phase One

Assignment: Editorial on location w/lovely Miranda
Approach: castle shenanigans
Results: Louis XIV never did that

82 BUTTERFLY STORY | Photographer: Jan Kalish | Client: Frascara
Assistant: Kathleen Gillis | Retoucher: Madeline Murray | Equipment: Profoto

Assignment: A client challenge to create a poster shot introducing this flowered dress within their spring 2019 fashion range.

Approach: The butterflies are real and secured from a butterfly sanctuary (usually reserved for education after they've expired.) Each butterfly was shot and combined in sequence with dress and background.

Results: The fashion design team was thrilled beyond expectation.

83 MUSILEK-JEANENE-VERA-SF | Photographer: Stan Musilek
Client: 7x7 | Equipment: Canon

Assignment: Swimsuit editorial in San Francisco with the lovelies Vera Jordanova and Jeanene Fox.

Approach: stay off the beach w/those swimsuits
Results: SF sights, and the background is not too bad either

84 BLACK IS BEAUTIFUL | Photographer: Christopher Wilson | Client: Amelia Island Tourism
Equipment: Phase One Camera System | Ad Agency: Paradise Advertising

Assignment: Outtakes from a project for Amelia Island Tourism with Paradise Advertising. We'd like to say thanks so much to Elie Rossetti-Serraino and Robbie Forrest for their impeccable styling and makeup, and to Sara Naomi, our beautiful model.

85 AMOR DA TERRA | Photographer: Christopher Wilson
Client: Amor Da Terra, Brazil | Equipment: Phase One Camera System

Assignment: A few new images from a shoot I did awhile ago for a Brazilian jewelry company, Amor da Terra - which means "Love of the Earth" in Portuguese. The jewelry has an organic, tribal sensibility to it (as it should, given the name). To compliment it, I looked to the body paintings of the tribes along the Omo Valley in Ethiopia for inspiration. Somehow putting Amor's tribal jewelry on the human form transformed into tribal art if you will made all the sense in the world. To further play off the jewelry's tribal sensibility, we built a black north-light tenting (as inspired by Irving Penn's method of photographing indigenous tribes), and I photographed our model, Priscilla Miranda, emerging out of the black into the sun. No lights were used other than God's light. Anyway, for what it's worth, this was the mad thinking that informed the imagery.

86 MUSILEK-YSL | Photographer: Stan Musilek
Client: YSL | Equipment: Phase One

Assignment: Lipsticks editorial.
Approach: 60's pop art approach was chosen
Results: Loose lips sink ships

86 MUSILEK-DIOR-ANNEMIEKE | Photographer: Stan Musilek
Client: Louis Vuitton | Equipment: Phase One

Assignment: Sunglasses editorial
Approach: we built an aquarium, naturally
Results: no models were harmed

87 THE DISRUPTERS! YOU ARE SO COOL! | Photographer: Amyn Nasser
Client: PRESTIGE INTERNATIONAL MAGAZINE | Photographer's Assistant: Bonnie Poole
Publisher: Marc Rougemond | Production: Neptune Communications | Photo Retouching: Proimage Experts | Photo Editor: Amyn Nasser | Models: James Goldstein, Taylor Bagley, Ilia Yordanov, Amanda Smith | Hair: Patrick Chai | Makeup: Maureen Burke | Hair & Makeup: Veronica Lane | Art Director: Amyn Nasser | Equipment: Nikon D810 D800 with 17-35mm 85mm 20-200mm IF-ED - All Nikon | Location: Sheats–Goldstein Residence James Goldstein House Los Angeles - Beverly Hills California

Assignment: This Fashion Issue was 90 pages of Editorial stories shot by me in Los Angeles. The Editorial stories shot at the James Goldstein House was conceptualized to have an Erotica edge against the stark contrast of concrete and architecture. The production and shoots took about 5 weeks between production, planning and getting the right talent and models for the Editorials. Depicting the balance between the softness of a woman, the sensuality and sexiness, yet the fragility and timelessness in contrast to the architecture was the challenge to capture. Grace, Moments and a Sculptural balance with a Steel Metallic Cinematic Light and an Organic feel.

Approach: FASHION EDITORIAL - FASHION EROTICA - The approach I used was a high level of direction and spontaneity with a command for the assertive look in the eyes. Careful attention so as not to represent the Editorial as sexist or opprobrious. Storytelling and in the moment yet Timeless. In some ways reminiscent of a movie scene, a drama, the 60s, 70s cinematic Technicolor metallic tones.

Results: The Fashion Issue was a Sell Out! The Cover and Editorials had many compliments and comments. Mostly it achieved the singular ability to tell a unique story through the skin of my eyes in a timeless aesthetic and visionary manner while respecting what Fashion is. Fast! Spontaneous! Empowering! Timeless & Fabulous. ■ BRIEF: The Disrupters! You Are So Cool! ■ Cover and Fashion Editorial. Fashion Erotica Edgy. A melange of 3 stories from the original Editorials that were shot at the

famous James Goldstein House in Los Angeles California. Story concept and directed by photographer Amyn Nasser with a 70s erotic sensation in subject, light and color tonality due to its hard raw concrete feeling and style that resembled an era of an exquisite voyeuristic and seductive taste gone by. This was further emphasized with the mix of cinematic Technicolor in warm subdued magenta color tones, and black and white page mix reminiscent of magazines and film storytelling which is a style representative of Amyn Nasser's style in his editorial stories. ■ The original story layout was the iconic Fashion Issue Cover with 32 Editorial Fashion pages of 2 stories: The Disrupters and You Are So Cool, and a 15-page Photo Profile on the Architecture at the James Goldstein House with an interview on James Goldstein and the application of a similar color tonality approach that delivered its raw sexy sensuality.

88 PERSONAL WORK | Photographer: Scott Redinger-Libolt
Client: Self-Initiated | Model: Regina Sil / NEXT | Hair & Makeup: Carrie LaMarca
Equipment: Canon 5D Mark II, 24-70mm, f2.8

89 SKIES CALLING SKIES FALLING | Photographer: RJ Muna | Client: Margaret Jenkins
Dance Company | Art Director: Margaret Jenkins | Equipment: Mamiya Leaf Credo

90 YASMIN + TESS | Photographer: Frank P. Wartenberg | Client: artistic project
Stylists: Anna Milena Balzer, Anais Näher | Photo Retouching: Nicole Fronzck
Hair & Makeup: Karo Loewe | Equipment: Canon 5D Mark III | Location: The Daylight Hamburg

Assignment: My daughter Tess is dancing since she was 3 years old. I knew Yasmin through my daughter's ballet class where Yasmin worked as a student teacher. I wanted to create pictures with dancers at different ages: child and young woman.

Approach: Both girls have a very genuine approach to movements and music. We've chosen different outfits with the help of the dance teacher Anais, who was at the shooting to choreograph and to take care of the correctness of movements and figures.

Results: Because of the close relationship between the little girl and the teacher - grown over years the atmosphere on set was very relaxed and full of energy at the same time. I felt that my daughter was so impressed by the older girl. She wanted to give her best in order to be an appropriate partner to the professional dancer.

91 THE DANCERS | Photographer: Tyler Stableford
Client: Self- Initiated | Model: The Dancers of the Aspen Santa Fe Ballet
Equipment: Canon EOS 5D Mark IV | Marketing: Canon USA

Assignment: This project was prompted by a desire to try something new. And not just to "try," but to really sink my teeth into a new discipline, and to master fine-art studio imagery. The ballet project gave me the opportunity to study, to practice, and refine my skills. Ten years ago I studied with the fine-art photographer Greg Gorman and the print-master Mac Holbert, and through them I gained a greater understanding of sculpting light, shadow and form. Over the years, I have tried to marry fine-art lighting techniques in my outdoor and adventure photo shoots. While I have not done a traditional studio shoot until now, I have been studying and working towards something of this nature for a long time. The ballet shoot was my first full-fledged studio project. ■ One of the most attractive elements of the project is the powerful combination of athleticism and grace. The Aspen Santa Fe Ballet dancers are truly world-class athletes as well as performance artists. I wanted to capture the essence of their athleticism as well as their incredible skill, in a single image.

Approach: Over the years I have been a huge fan of images from Herb Ritts, Bruce Weber, Greg Gorman and others who work in black-and-white with beautiful models and athletes. This style of imagery had been steadily percolating in my mind. ■ I told the dancers I wanted to capture something that was very special; a collection of images that would be a beautiful representation of their artistry. On the shoot day, my team and I had the lighting, lenses, and framing dialed in before they arrived—so that I could freely focus on collaborating with each dancer to find a range of poses and expressions that would be breathtaking.

Results: The project really did turn out as expected, at least in terms of the images created. However what was unexpected, and what is really resonating within me, are the powerful emotions created from collaborating with such talented artists and human beings. I was wowed by the time and generosity of the dancers, allowing me to come in and share in their craft. I feel so lucky to be a photographer and cinematographer — my job allows me to truly connect with, and to create memories with, special people like these dancers. ■ The artistic director said these images were a real treasure for the dancers. He mentioned as an aside that he danced professionally for 15 years, and had never received an image of himself like what the dancers were receiving today. ■ I really want to thank the dancers, and the artistic director Tom Mossbrucker, for allowing me to photograph with their dance company. They were incredibly generous with their time—and their passion for the project is the reason the images shine!

91 UNTITLED | Photographer: Parish Kohanim | Client: Parish KohanimFine Art LLC
Equipment: Canon 5 DSLR Broncolor Studio Strobe Equipment

Assignment: Fine Art

Approach: Using a studio setting to capture performers at their most spectacular moments and forms
Results: Achieved.

92, 93 PATRICIA | Photographer: Frank P. Wartenberg
Client: Picture Press | Equipment: Canon 5 D Mark III

Assignment: A portrait shooting with the actress Patricia Meeden.

Approach: Patricia mentioned that she was as a child already at a special dance school in Berlin. I asked her if we could some dance pictures beside the portraits. She agreed and we chose the impressive red dress for it.

Results: You can see her ability to have perfect body control. Many years of intense dance training plus the acting performance allowed me to shoot pictures of her full of strength with a certain magic.

94 DOWN THE DRAIN | Photographer: Cameron Davidson | Client: Personal Project with
Glotzl Retouching | Retoucher: Jeff Glotzl | Creative Director: Chris Nott | Equipment: Nikon

Assignment: Personal project on water usage and saving water. Outtake from a Virginia Tourism Campaign.

Approach: Aerial to show grand overview and longer reach of problem.

94 DOWN THE DRAIN | Photographer: Cameron Davidson
Client: Personal Project | Art Director: Chris Nott | Equipment: Alpa TC, Leaf Credo 60 back

Assignment: Personal project on water usage
Approach: Landscape photography to emphasize the message

95 REBIRTH | Photographer: Lennette Newell | Client: Self-Initiated
Equipment: Hasselblad, ProFoto, Hahnemühle Photo Rag Paper

Assignment: Artist Statement ■ Bird mythology has always intrigued me. In ancient mythology vultures ability to consume death and produce life was associated with rebirth. Many gods featured vulture wings or faces. Vultures were also associated with keeping life and death in order. As long as the vultures consumed the dead and were able to reproduce, the balance of life was in good order. ■ In the early Neolithic culture, the deceased were exposed in order to be excarnated by vultures and other carrion birds. The Neolithic period's highly prominent cult of the dead was focused around excarnation, and the use of the vulture as a symbol of both astral flight and the transmigration of the soul in death.

Approach: Composite: Cinereous vulture (Aegypius monachus) + Homo Sapiens Skull ■ The educational vulture was photographed in a large studio setting. The homo sapiens skull was photographed at the California Academy of Sciences with my location setup.

96 THE DEATH OF HERACLES | Photographer: P.J. Fugatze | Client: Self-Initiated
Models: Matthew Alan Brady, Tim Christian, Sam Schneider | Equipment: Hasselblad

Assignment: An exploration of the mythical story of the Death of Heracles.

Approach: The approach was to look at the master sculptors who created fantastic works of art around this mythology, and to apply a sculptural quality to portraits of the characters.

Results: Captured the light and emotion behind the Greek tragedy.

97 VIOLA BELLA PANTUSO | LONDON ABBY | Photographer: Michael Pantuso
Client: Acquisitions of Fine Art | Hinsdale Gallery | Equipment: Pentax K-3

Assignment: Fine Art

98 STILIFE NO. 01 | Photographer: Kristofer Dan-Bergman
Client: Self-Initiated | Equipment: DxO

Assignment: "stiLife" is a personal series triggered by the time I visited my old time friend painter/artist Peter in his apartment by Union Square in NYC. I've been to his apartment a million times but this time when I saw the empty canvas for the 100th time against the wall with no paint on it, it dawned on me that it was very symbolic of the situation. Peter had a stroke about eight years ago and haven't painted since, though he told me he has painted in his head. I asked to photograph him in front of the canvas with my iPhone and then I shot a few without him there. Once home I uploaded the images to my computer and I started playing and Voila! A new idea was born which worked well with my two series "S_PACE" and "allONE" which deal with time, space and consciousness.

Approach: The idea to 'stiLife' is to explore the concept of space, time and consciousness and what better way to do it through an empty canvas. The series is still in its infancy and who knows where it will end up. I am here photographing portraits, dancers, spiritual people, nudes... and each time something new happens. Right now the series is shot on the same location.

Results: So far I am very happy with the result and where my brain is taken me in this series. I have created thus far one definite final product and probably another 5-6. I expect the series to have somewhere between 15-20 in the end.

99 VIKTOR KEE STUDY I | Photographer: Parish Kohanim | Client: Parish KohanimFine Art
LLC | Equipment: Canon 5 dslr Mark III Broncolor strobe equipment

Assignment: Fine Art

Approach: To create an impactful image using design and vivid colors.
Results: Happy with the results.

100 VIKTOR KEE STUDY II | Photographer: Parish Kohanim
Client: Parish KohanimFine Art LLC | Equipment: Canon 5 DSLR Broncolor Strobe Equipment

Assignment: Fine Art

Approach: Using warm vivid colors for impact
Results: Happy with results

101 REFLECTION | Photographer: Saneun Hwang
Client: David Hocker | Equipment: Canon 70D

Assignment: David Hocker is my very first male model who is a prominent scientist and also a figure model. His face and body have been portrayed by many different painters, photographers, and other artists. And his main role is to stand in front of those creators, posing as a figure model and reflecting a different being. So he rarely have a chance to present himself. ■ He requested me to document his portrait that re-interpret his personality while capturing his own presence, leaving the substantial elements such as his name, and facial features as they are.
Approach: Through a viewfinder, one can reinterpret and reconstruct what's being seen through lens glass.
After a brief talk and study on his looks, I was reminded of the classical and historical traits of the figure, which gave me a glimpse of him in a different environment and era.
Results: Given the similarity of their names, I used a historical reference by the European painter, Jacques-Louis David. In the image I created, the surface where the backdrop touches the floor creates a reflection, giving a sense of illusion in a bathtub. I used a high-contrast lighting to enhance the dramatic quality of the scene. Accordingly, I focused on the drapery and textile of his own clothing, so the elements deliver a sense of historical atmosphere. None of this was planned in prior to the shooting. He laid out what he brought for the outfits and offered my book to play around. Clothings, props, and the set-up used for the creation was improvised.

102 LANY | Photographer: Jeffrey Milstein | Client: Thames & Hudson
Publisher: Thames & Hudson | Equipment: High resolution medium format digital photos, book was printed with a new stochastic process which eliminates the typical dot-pattern.

Assignment: I set out to create aerial photographs of Los Angeles and New York that would show the varieties and differences between each city in terms of social and architectural styles and features.
Approach: I used a comparative approach by photographing each city from a 90 degree angle straight down, as seen in an architectural plan view, and creating a typological study.
Results: The results turned into a highly regarded and well-reviewed book of the two densely populated, coastal American cities.

103 WALLPAPER FRUITS | Photographer: Beth Galton | Client: Self-Initiated
Food Stylist: Mariana Velasquez | Equipment: Sinar, IQ3 100 digital back

Assignment: Created in collaboration with food stylist Mariana Velazquez, this series explores the subtle patterns that result from the cooking process.

104 THE WICKANINNISH COOKBOOK | Photographer: Makito Inomata
Client: The Wickaninnish Inn | Equipment: Canon 5DS r

105, 106 WINTERLICIOUS | Photographer: Steve Krug | Client: City of Toronto
Company: Fuze Reps | Producer: Jessica Wong | Food Stylist: David Grenier
Retoucher: Evonne Bellefleur | Assistant: Brian McMillan
Equipment: Canon 5DS R, Canon 100mm f/2.8L | Agency: Fuze Reps

Assignment: We were selected by the City of Toronto to photograph a series of food images to promote 'Winterlicious 2019', a two-week culinary event designed to coax Torontonians out of hibernation and into some of more than 200 restaurants offering a prix fixe menu at a special price.
Approach: 'Pulse Blue', the City of Toronto's primary brand colour, was used as our overarching colour story complimented by bright hits of hot colours to make the food stand out. We highlighted various cooking elements such as fire, steam and smoke to capture rich, mouth-watering images of spectacular food.
Results: The agency and client were thrilled with the images, which have appeared in out-of-home, social media and online.

107 SOUP STORY | Photographer: Andrew Grinton | Client: Self-Initiated
Food Stylist: Noah Witenoff | Equipment: Sony A7RIII, 55mm 1.8, Profoto D1 Heads

Assignment: Highlight the change of seasons from summer to fall with a food series of colourful soups paired with seafood.
Approach: To do this, we combined a dark, rich background with neutral props to make the vibrant soups and fresh seafood pop.

107 SAVAGES | Photographer: SUECH AND BECK | Client: Self-Initiated
Food Stylist: Christopher St. Onge | Equipment: Canon 5D Mark iii, Profoto
Set Designer & Props: Andrea McCrindle

Assignment: The project was dreamed up by Food Stylist Christopher St. Onge. He was inspired by another photo of fruit he had seen from a friend. We wanted to create this series with beautiful color and food and the idea of this beauty so savagely consumed.
Approach: We wanted to transform ourselves and the viewer to this tropical place. We wanted the light to look like flash, but elevated, like you just stumbled across all these scenes and wondered who was here.
Results: Results of the series were very good and we were pleased that people responded so well to it. We had so much fun creating this story so it was nice to share that.

108 WELDER | Photographer: Lonnie Duka | Client: Fluor Corporation | Equipment: Canon 5DS

Assignment: Photography of recent infrastructure projects in America
Approach: Interpret construction activities
Results: A communications that reflects the dramatic hard work on heavy industrial projects.

109 WAVES OF FLAGS DISPLAY | Photographer: Craig Cutler
Client: Self-Initiated | Equipment: Leica SL

Assignment: Image captured at the "Waves of Flags" display honoring 9/11 victims at Pepperdine University.

110, 111 LANGUAGE IS SPEECHLESS | Photographer: Christopher Wilson
Client: Self-Initiated | Equipment: Phase One Camera System

Assignment: The Maritimes, Canada. Trying to describe this part of the world is like trying to describe god to a world without religion. They have the largest tidal shifts in the world (almost fifty feet in places), which makes the landscapes seem otherworldly at low tidal. Imagine Moses parting the Red Sea every twelve hours and you start to get a sense of how dramatic the tides are around the Bay of Fundy. Fantastic. Love Canada.

112, 113 1939 SPARKMAN & STEPHENS 12 METER SAILBOAT ,"VIM"
Photographer: Craig Cutler | Client: Self-Initiated | Equipment: Leica Monochrom

Assignment: Captured on a sailing trip in Denmark.

114 LAKE COMO | Photographer: Craig Cutler
Client: Self-Initiated | Equipment: Leica Monochrom

Assignment: personal travel work.

115 MOON KISSES | Photographer: Louis Raphael | Client: San Francisco Travel Association
Equipment: Nikon D810 80.0-400.0 mm f/4.5-5.6

Assignment: As the in-house photographer for the San Francisco Travel Association, I'm constantly challenged with taking unique photos of the city. It's not an easy task considering that the city is the subject of so many photographers and every conceivable angle has already been taken.
Approach: I've always had a fascination with the moon but especially the crescent moon. One particular evening as I was shooting the bridge I caught a glimpse of it crawling up the cables and decided to wait for the just the right moment to press the shutter.
Results: I ended up with a unique, classic shot of the bridge, which looks as if the moon is gently kissing its South tower.

116, 117 ALMSEE | Photographer: Staudinger+Franke | Client: Self-Initiated
Equipment: PhaseOne XF, Capture One Pro, Photoshop

118, 119 ALCHEMY | Photographer: Michel Leroy | Client: Self-Initiated
Equipment: Digital Photography, Canon EOS with custom Ludwig Meritar 50mm lens

Assignment: The Alchemy project started with a simple idea, photograph something in a creative and original way, stick to a single technical approach and let the self-imposed limitations drive the creative process. The result is a year-long collaboration between photographer Michel Leroy and a wide range of professional athletes with varying body types that explores the tension between physicality and sensuality. Each moment captured is a celebration of athletic confidence and vitality at its most pure. Moments of sculptural balance, anticipation and strength define the graceful lines and organic gestures of these vivid Black and White images. ■ In this figurative series the artist creates body-positive images that are exaggerated and explicit without sexual objectification. By emphasizing form over identity, Leroy seduces the viewer to reveal empathy for body acceptance and the freedom to be uplifted regarding their own self-image, challenge preconceptions about size and embracing a fresh perspective on the singular beauty of the human form.
Approach: The creative process is of great relevance and bears witness to the labor intensive technique reminiscent of a Daguerreotype in the pixel age. The photographic style was developed over months of experimentation with a mixture of analog and digital elements including camera, lens, lighting and post-production work flow to achieve the unrelenting clarity and unique dark metallic look. ■ The choice of dark bodies against a dark background focuses the viewer's attention on form and shape over the sexuality and eroticism of typical nude photography. The physical process of transmuting the skin metallic unites the constellation of skin tones to illuminate physical radiance and emphasize the physical similarity of all bodies.
Results: The goal of the Alchemy series is to create visually captivating, body positive images that celebrate the physicality of the human form and speak to the cultural relevance of body acceptance in the social media age. ■ The collaboration between Michel Leroy and the 75+ athletes he has photographed for the Alchemy series started in early 2017. The creative decision to keep the project discrete and hidden from public display for almost a year allowed for total creative freedom. ■ Images from the Alchemy series have been exhibited in solo and group shows in New York and nationally in 2018 with additional shows confirmed later this year and into 2019.

120 UNTITLED | Photographer: Terry Heffernan | Client: Self-Initiated

121 XUELI | Photographer: Jonathan Knowles | Client: Xueli | Model: Xueli Abbing
Hair: Robert Frampton | Art Director: Josie Gealer | Equipment: Hasselblad H6D-100c

Assignment: Xueli is an incredible teenager born visually impaired and with Albinism. Spending time with Xueli allowed us to capture the many facets of her personality. We aimed to pull her away from an identity defined by aesthetics, and reveal the dynamism of her inner conflicts.

Approach: We photographed Xueli in a cool, almost surreal and isolated environment. The contrast of her bright, white hair against the glowing blue background added a sense of fantasy. ■ The lighting was kept low and 'barely there' as Xueli's vision is sensitive, but this also added to the mood and tone of the images. ■ We talked to Xueli as we photographed, always keeping her engaged and capturing the raw elements of her expression.

Results: Vulnerable, Free and Confrontational; Xueli's collection shows her life journey so far, through her internal mind and through her identity.

122 MAASAI WARRIORS | Photographer: Christopher Wilson
Client: Smithsonian Magazine | Equipment: Phase One Camera System

Assignment: Maasai warriors, photographed in Tanzania for Smithsonian Magazine. The warriors are in charge of protecting livestock from predators and enemies. Since the Maasai is a cow culture, and wealth is based on the number of cows one has, being a warrior is a vital role within the community. To become a warrior, one must first be circumcised, the idea being if one can endure the excruciating pain of circumcision without flinching, one is brave enough to risk his life to protect their herds. Part of a new, larger campaign of portraits of indigenous tribes people in Tanzania for Smithsonian Magazine.

123 SLANDER | Photographer: Kristopher Burris | Client: Self-Initiated
Equipment: Canon 5D Mark III 24-105mm

Assignment: Portrait photography.

Approach: I wanted to make a portrait that was conceptually based around the idea of slanderous remarks that are embedded within communication.

Results: An eerie portrait that eludes to negative intent.

124 KEEP THE HISTORY ALIVE - WILLIAM BONELLI
Photographer: Michael Confer | Client: Self-Initiated
Equipment: Canon 5d Mark 4, Canon 24-70, Profoto B1x, Profoto 4 Foot Octabox

Assignment: This is a series about Mr. William Bonelli who is a WWII Veteran serving with the 773rd Bomb Squadron of the 463rd Bomb Group. Mr. Bonelli is a B17 mechanic, technician and a pilot. He was awarded the Distinguished Flying Cross and is also a survivor of Pearl Harbor attack. In the background of these images is the B17 the Memphis Belle. ■ My interest in the World War II era, the waning numbers of the veterans still alive and in decent health, as well my need to do some personal projects that will be meaningful, historic and on several levels were the main motivating factors for this project. ■ The goal of this assignment is to capture archival images of history, humanity and sacrifice while portraying these WWII Veterans as larger than life.

Approach: The plan was to contact the Veterans via telephone prior to the event. Arrive at the airshow Friday to make contact with potential veterans, scout the locations of each aircraft, do test shots, talk with the warbird owners, the museum owners and any other entity that needed to be cleared for photography. The difference for this assignment from years past, is the posing of veterans in front of warbirds with the addition of strobe lights on stands near aircrafts.

Results: The veterans, the warbird owners, Mr. William Bonelli and myself are all thrilled with the results of the larger than life portrayal of the WWII veterans bathed in a dramatic yet natural lighting situation in front of their chosen Warbirds as the main background element. ■ As a note, the veterans who were contacted prior to the event were not interested upon my arrival; the in-person, the cold calls were however 90% successful. These images will be used in up-coming direct mail and email blasts as well as portfolio prints.

124 TROG PORTRAITS - MRS. SHEETS | Photographer: Michael Confer
Client: Self-Initiated | Equipment: Canon 5d Mark 4, Canon 24-70, Profoto B1x

Assignment: I learned about The Race of Gentleman (TROG) in May. TROG is based on the old-school, beach drag racing from the 1940s & 50s. What is really cool about this event is that all motorcycles and Hot rod cars must be of the pre- and post-World War II eras, even the clothing, accessories and the bike clamps must look authentic. TROG was scheduled for June 2018 in Wildwood, New Jersey, and I wanted to do some personal projects that are meaningful on several levels. This assignments goal is to preserve a bygone era of machine vs machine, as well as the character of the TROG Racers which can be as important as their fast machines.

Approach: I showed up early on Sunday morning with a strobe light, a camera, and a smiling face. My approach was to wing it, just to see what I could make happen. The State Police were cracking down on media passes, so I decided to stand near the racers entrance and see what I could get. This worked out wonderfully as most racers were excited to have their portrait captured. I posed the subject as quickly as possible with various boardwalk elements, 3/4 back-lighting them with a strobe light and using

high-speed sync to add mood and drama. De-saturating the overall palette helped to convey the vintage feel.

Results: The racers and I are thrilled with the results. We are all particularly pleased with the vintage feel of the photos with a desaturated color palette. ■ I am using these images on my website, on an upcoming direct mail promotion, as well as in an email blast and portfolio prints.

125 NYA KONG | Photographer: Kah Poon | Client: Self-Initiated
Company: Supreme Model Management | Equipment: Sony A7R 3, Dracast Lights and Broncolor | Agency: Supreme Model Management | Website: www.kahpoon.com

Assignment: Self Promotion and Personal Project

Approach: This is part of an ongoing project called 'Black is Beautiful'. It is a study of the contrast and highlight in black men and women's portraiture. Like Yin and Yang, the shadows and highlights each have their own important role to play.

126 DANIEL AS VINCENT | Photographer: Paco Macías Velasco | Client: Self-Initiated
Equipment: Hasselblad, 150 mm. Lens

Assignment: My friend Daniel Groener looks like Vincent Van Gogh, I decided to make a portrait of him as Vincent, taking as reference one of the many self-portraits of Van Gogh, my wife, the painter Chantale Mazin, helped me by painting the background, the jacket and the hat, recreating Vincent's brush strokes, a makeup artist (I do not remember her name, sorry!), she paints Daniel's face in the same mood of Vincent's brush strokes. The first session was in Fuji-chrome film back in 1999.

Approach: After 20 years, I took the slide, digitized it and using Photoshop, I did an intervention of my own work, this portrait combining two important ages in the history of photography, analog and digital.

Results: I could say that took me 20 years to finish this photo.

127 SENIOR BEAUTY | Photographer: Jonathan Knowles | Client: Getty Images | Hair: Stefano
Mazzoleni | Makeup: Ellie Tobin | Art Director: Josie Gealer | Equipment: Hasselblad

128 JUDITH'S HOUSE PARTY | Photographer: Krug Studios | Client: Fuze Reps
Company: Fuze Reps | Model: Judith Bradley | Producer: Jessica Wong | Hair & Makeup:
Andrew Elek | Retoucher: Kevin Luc | Assistants: Brian McMillan, Hugh Read | Creative Director:
Weaymouth Creative | Equipment: Canon 5DS R, Canon 24-70mm f/2.8L II | Clothing Stylist:
Caprice Conners | Set Designer & Props: Catherine Doherty | Agency: Fuze Reps

Assignment: In an effort to increase awareness of the photographers on their roster, Fuze Reps holds a biennial industry event centered around a specific theme. Each photographer creates a self-directed image based on the year's theme and shows their work at the event. The theme for the 2018 event was "House Party."

Approach: We thought about the kind of 'House Party' we'd want to attend and knew it would be one in which Canada's legalization of cannabis was being celebrated. From there we created an unforgettable character portrait featuring 'Judith,' the most gracious hostess. We built a set that would invoke nostalgia, including an environment rich in tone and texture.

Results: The image received praise among clients and industry-insiders at the event and was shared heavily on social media in the days following.

128 DRIZELLA | Photographer: Susan J Chen | Client: Self-Initiated | Model: Aussie Guevara
Production Specialists: Neil Kelly, Elizabeth Young at Palomacy Pigeon, John South, Tyler
Duchanel, Troy Thompson | Production Artist: Krista Rojas | Producer: Alfred Yan
Director: Susan J Chen | Director of Photography: Andrew Eckmann | Stylist: Andrea Guindi
Hair & Makeup: Jacqueline Wray | Photo Corrector: Chris Tipton King | Editor: Susan J Chen
Equipment: Sony, Adobe Premiere Pro | Set Designer & Props: Damian Alvarado
Music & Sound: Drew Joy | Studio: Sandbox Studio | Video Link: https://vimeo.com/253086143

Assignment: I wanted to tell the lesser known, original stories of classic fairy tales that are decidedly darker than the well-known Disney versions.

Approach: "Drizella" is a modern re-interpretation of the classic fairy tale Cinderella, portrayed from the evil step sister's perspective. My creative team shot a video short of one scene in the story that shows that perhaps the "evil" character Drizella may just be a bit misunderstood as she faces a very dark decision.

Results: In the original version of the story, Drizella cuts off her toes to jam her feet into the golden (not glass) shoe. Symbolic visuals in this video brood the tension and forces surrounding her desperate decision. The shadow of the swaying tree is Cinderella's mother, haunting Drizella. The birds in the original story peck out Drizella's eyes. This video short "Drizella" is part of a larger body of work "Modern Fairy Tales", a modern re-interpretation in narrative, style, and dark humour.

129 MICHAEL SCHOENFELD MARKETING 2018 BLACK AND WHITE
Photographer: Michael Schoenfeld | Client: Michael Schoenfeld Studio
Equipment: Sony A7rII & A7rIII 50mm lens

Assignment: Various Black and white environmental portraits

Approach: I believe all creativity centers around the subject of intimacy that the artist experiences in the dance with their subject. It's very personal, and says more about the artist than the subjects of the work.

Results: Numerous editorial and advertising inquiries

130 EYECORPS BOSTON WORK IN MOSHI TANZANIA | Photographer: Michael Schoenfeld
Client: EyeCorps | Equipment: A7rIII, 35mm and 50mm Sony lenses

Assignment: Marketing work created for EyeCorps Boston Work in Moshi Tanzania, October 2018

Approach: I believe all creativity centers around the subject of intimacy

that the artist experiences in the dance with their subject. It's very personal, and says more about the artist than the subjects of the work.
Results: I will be returning to Tanzania in 2019 for two more assignments.

131 JOÃO MACDOWELL AS JOFF | Photographer: Athena Azevedo
Client: Epic Litho | Equipment: Canon 5DS | Design Firm: IF Studio
Assignment: Create a unique portrait of composer João MacDowell to lead an article in Epic Eye magazine about his recently completed composition, "The Seventh Seal" opera, with original text from Ingmar Bergman.
Approach: Being that the composer, a lifetime artist, most identified with the character Jof, a traveling actor, we literally made look like the clown.
Results: A surprised MacDowell, holding a rose in his mouth, is rendered speechless; however, we still feel as if music is richly pouring out of him.

132 RIC POWELL SOUTH BEACH | Photographer: Neil Malcolm Roberts
Client: Self-Initiated | Company: Neil Malcolm RobertsDate: 2004 | Other: Leslielohman.org

133 MICHAEL SCHOENFELD STUDIO 2018 PORTRAIT MARKETING
Photographer: Michael Schoenfeld | Client: Self-Initiated | Equipment: Sony Cameras and lenses
Assignment: Michael Schoenfeld Studio 2018 Portrait Marketing
Approach: I believe all creativity centers around the subject of intimacy that the artist experiences in the dance with their subject. It's very personal, and says more about the artist than the subjects of the work.
Results: Increased inquiries for national and international assignments.

134 HAZE | Photographer: Staudinger+Franke | Client: Self-Initiated
Equipment: PhaseOne XF, CaptureOne Pro, Broncolor, Tether Tools, Photoshop

135 THE ACTORS | Photographer: Todd Houser | Client: Individuals
Producer: Anthony Reynolds | Equipment: Pentax 645D, Pentax 80-160mm f/4.5
Assignment: A portrait series of actors.
Approach: I wanted to create a new and memorable version of a portrait for these "young" actors. So, we went through the ranges of emotion that seemed to fit each subject and created a version depending on how they wanted to be portrayed.
Results: The results are based on the large volume of feed back I have received on the images. Most of the thoughts were how 'deep' and 'rich' the images are, but my favorite comments were: "I just spend time trying to figure out the story behind each image, I want to learn more." That, is enrolling in my book.

136 HOT ROD! | Photographer: Christopher Wilson
Client: Road & Track | Equipment: Phase One Camera System
Assignment: Images featured in the January issue of Road & Track, in an article titled "Go," about racing at the Bonneville Salt Flats. I've photographed there many times, and never get tired of it. The landscape is simple and graphic. The light is always wonderful due to the natural bounce coming from the whiteness of the salt. And the race car? Well, what can I say? I'm completely mesmerized by these crude, crazy cool, held-together-with-gobs-of-spit-and-prayers contraptions. If Dr. Frankenstein was into car racing, these are the speed monsters he would have created I'm certain.

137 FRESH PERSPECTIVE | Photographer: Joseph Saraceno
Client: Sylvanus Urban | Creative Director: Wilson Wong @P1M
Sylist: Wilson Wong @P1M | Equipment: canon 1DS MarkIII
Assignment: feature men's fragrance
Approach: using graphic elements to create images for men's editorial
Results: A four page editorial, featuring men's grooming and accessories

138 STATIONARY STUDIO | Photographer: Joseph Saraceno
Client: Self-Initiated | Creative Director: Wilson Wong @P1M
Sylist: Wilson Wong @P1M | Equipment: canon 1DS MarkIII
Assignment: personal project using stationary
Approach: using elements to create graphic images
Results: graphic images for personal promotion

139 FORGIVENESS | Photographer: Adam Voorhes | Client: MetaLeap Creative | Associate
Creative Director: Eric Capossela | Stylist: Robin Finlay | Equipment: Hasselblad 500CM
Assignment: Eric Capossela from MetaLeap Creative came to us with four various stories about the act of forgiveness from different personal accounts, and needed a way to unite them visually.
Approach: After reading these stories, we were able to pinpoint a clear subject in each story that we could center our image around, and by using a cohesive color palette and lighting we were able to create a central mood to unite these random subjects together into a series that flows. The colors and subject matter work together to bring a slightly surreal quality, making the viewer take a second or third look at a seemingly simple subject.
Results: The final series of images conveys the mood we were striving for, and most importantly made Eric and the MetaLeap team happy!

140 TOM FORD | BEAUTY | Photographer: Nicholas Duers | Client: Tom Ford
Stylist: Elizabeth Serwin | Equipment: PhaseOne XF, IQ3
Assignment: Tom Ford | Beauty
Approach: Tom Ford | Beauty
Results: Tom Ford | Beauty

141, 142 DIPPED SERIES | Photographer: Robert Tardio | Client: Self- Initiated
Stylist: Jessica Agullo | Equipment: Phase One XF IQ3 Digital Camera/Elinchrom Lighting
Assignment: Dipped is a continuing personal project based on color idiom wordplay. It was undertaken in conjunction with prop stylist Jessica Agullo.
Approach: Graphic, clean lighting and composition to highlight the concept in a straightforward and dramatic way
Results: We were asked to do a show of the Dipped series at the Fifth Hammer Brewery in Long Island City. Several of the images were used on the beer labels.

143-145 FUTURE TRAVEL | Photographer: Adam Voorhes | Client: AFAR Magazine
Director of Photography: Tara Guertin | Stylist: Robin Finlay | Equipment: Hasselblad 500CM
Assignment: The word "travel" always makes one think of where they're going, but in the November/December 2018 issue of Afar they wanted to ask "Where is travel going in the future?"
Approach: Since we were working on images for multiple stories, including the cover, we wanted to keep a consistent color palette and style. Bright, poppy primary colors provide the zip, and mixing some slight vintage elements in props and wardrobe in with glints of silver and white help push the future angle without it looking like a sci-fi movie from the 1950s. We wanted the images to be a quick read conceptually but with a beautiful look and feel to keep the reader on the page a little longer.
Results: In the world we created, the future is truly so bright you gotta wear shades! Tara and the rest of the Afar team were thrilled with the final images, and they have made a colorful splash on the newsstand.

146 FILOTIMO | Photographer: Joseph Saraceno | Client: Filo Timo | Creative Director: Wilson
Wong @P1M | Stylist: Wilson Wong @P1M | Equipment: Canon 1DS Mark III
Assignment: Using hardware from Filo Timo to create look-book images
Approach: By using graphic lines and hardware, we wanted to create a series of poster inspired images
Results: Look-book images for Filo Timo

147 PLASTER AND BONE | Photographer: Adam Voorhes | Client: Self-Initiated
Stylist: Robin Finlay | Equipment: Hasselblad 500CM
Assignment: Plaster & Bone began as a meditation on addiction. We all have our vices. Some are innocent and some are brutally self-destructive. But as a society, a global society, we are raging addicts with no concept of control or consequence. Much like the way tobacco creates a body that can't sustain life, humanity's addictions to oil and coal compounded with the rapidly growing human population seems doomed to destroy itself. It sounds dramatic, but can you deny it? We are living in a glimmering golden age, yet we can all see what's on the horizon.
Approach: This project has been an outlet to express themes of anxiety, decay, famine and hopelessness. But also, it has been a venue to explore more traditional imagery at a time when we spend so much of our energy on contemporary visuals. I was able to explore and play. I could re-shoot an image again and again on my own time line, or abandon a direction if it wasn't working. That is a luxury I'm not used to. This was the first time in years that I put so much energy into not just testing an idea, or technique or exploring something for a project or portfolio development.
Results: This body of work exists for no reason other than to exist. Yet, I'm so happy to have put the energy into creating this body of work, and I look forward to developing it in the future. Or maybe not! That's the freedom of the personal project.

148 AMBER CRYSTAL BOWL | Photographer: Jim Brennan | Client: Self-Initiated
Stylist: Jim Brennan | Equipment: Hasselblad | Retouching: Jim Brennan
Assignment: I chose to photograph this flawless, hand cut, crystal bowl with as much integrity as possible. I wanted to accentuate the artistic quality, and master craftsmanship of such a wonderful work of glass.
Approach: My approach was to portray the object in the cleanest form with lighting, and composition done completely in camera, and post production for minimal dust spotting. To achieve this I bounced highly diffused lighting off of the surface to create the glow from underneath. ■ The design of the bowl is perfectly symmetrical. I specifically chose to use a dynamic symmetrical composition with the object. I paralleled diagonals, and locked key features into the 90 degree reciprocals. This allowed me to lock the cut work in the bowl onto the sinister diagonal.
Results: It created a captivating image that is pleasurable to view.

149 SEED | Photographer: Adam Voorhes | Client: Popular Science Magazine
Photo Director: Thomas Payne | Stylist: Robin Finlay | Equipment: Hasselblad 500CM
Assignment: Popular Science came to us to with multiple ideas for their Summer 2018 "Life and Death" issue, or more like "The Cycle of Life" issue. Once again we were honored to be able to collaborate with Thomas Payne and the whole Popular Science team to dream up ideas for various parts of the issue, one of them being section openers. We needed to show how life begins and ends: a seed being a natural choice for a beginning.
Approach: Following a plant from seed to germination, growth, death, and then rebirth became our metaphor. Thank you to Adam's kindergarten teacher who taught him to sprout seeds 30+ years ago. He still

remembers the instructions and they worked out beautifully.
Results: We were able to produce a series of images that brings the stages of a growing plant up close, providing a lush and intriguing view to it.

150 MUSILEK-WIRED-LEGO | Photographer: Stan Musilek
Client: Wired | Equipment: Phase One
Assignment: Editorial about perception of reality
Approach: Kind of like Rubik's cube, but with lunch break.
Results: Anybody wants 3 boxes of Legos?

151 SLIME | Photographer: Jonathan Knowles | Client: Self-Initiated
Art Director: Lauren Catten | Equipment: Hasselblad | Set Designer & Props: Jaina Minton

152, 153 MUSILEK-TEUFFEL | Photographer: Stan Musilek
Client: Teuffel | Equipment: Phase One
Assignment: Teuffel guitar ad
Approach: objects of desire approach
Results: shiny and new, like.....

154 NUTS & BOLTS OF CREATIVITY | Photographer: John Surace
Client: Self-Initiated | Equipment: Sinar P2, Schneider APO 210mm, Phase One P25
Assignment: Graphic examination of color, shape, line, light and shadow.
Approach: I sourced the nuts, bolts and background to ensure proportions and texture were consistent throughout the composition. I also painted and graphically arranged the hardware on a 45 degree angle to introduce pattern and depth. ∎ A tilt of the lens standard on the camera ensured the entire image was in sharp focus to further emphasize the angular shapes.
Results: Soft colors applied to rigid shapes creates a pleasing tension that highlights the distinct beauty of geometric forms. The light and shadow play on the background creates a tactile surface that reinforces the interplay of light and shadow.

155 A MURMURATION OF FOG | Photographer: Christopher Wilson
Client: Euro Motors | Equipment: Phase One Camera System
Assignment: Paris has Notre Dame, Florence the Santa Maria Del Fiore and Barcelona the Sagrada Familia. But for me the most beautiful cathedral in the world isn't a building at all. It's these mountains on the Isle of Skye in Scotland. There's something about this ancient foggy land that pulls me in like gravity and makes me feel closer to spirit than I ever do in a church, no matter how stunning the architecture. There are over 6,500 languages in the world, and I don't think any one of them has a word to describe this sacred place. My eldest daughter, Celia, stand on the Defender 110. Photographed for Euro Motors.

155 1930 HARLEY BOARD TRACK RACER | Photographer: Christopher Wilson
Client: Wheels Through Time, 1903 Magazine | Equipment: Phase One Camera System
Assignment: This is a renovated 1930 Harley-Davidson CA Board Track Racer. Photographed at Wheels Through Time in North Carolina as part of a story on the history of Harley race bikes. A huge thank you to Dale Walklser for opening up his motorcycle museum, and letting us photograph a few of the hundreds and hundreds of bikes there. I think I could shoot there every day for a year and not even come close to documenting all that he's collected there. The place is both overwhelming and magical.

SILVER WINNERS:
157 QUIXOTE | WRITERS THEATRE | PREPRODUCTION POSTER IMAGE | 2018 SEASON | Photographer: Joe Mazza | Client: Writers Theatre, Glencoe, IL
Marketing Manager: Chad Peterson | Clothing Designer: Sanja Manakoski
Assistants: Leroy Sheridan, Susan Ask | Equipment: Canon 5div, Chimera, Norman Flash

157 JEWELRY IN THE JUNGLE | Photographer: Darnell McCown | Client: Heritage Auctions
Digital Artist: James Harris | Art Director: Jill Burgum, Sr. Director of Fine Jewelry
Equipment: Horseman LD Pro, Phase One IQ 180, Schneider 210 APO-Digitar,Dynalites

157 K-CUP BREAKAWAY | Photographer: David Butler
Client: Kuerig | Equipment: Sony A7R II

158 "FRANKENSTEIN" PREPRODUCTION CAMPAIGN | Photographer: joe mazza
Client: Remy Bumppo Theatre - Chicago | Models: Greg Matthew Anderson, Nick Sandys (also the Artistic Director of Remy Bumppo) | Director of Brand Marketing: Mackenzie Nilsen
Makeup: Kristy Hall | Equipment: Canon 5d IV, Canon 35mm 1.4, Canon 24-70mm 2.8, Canon 85mm 1.2 II, Speedtron zoom spot, various Mole Richardson fresnels with barn doors, various reflectors

158 DECATUR FIREFIGHTER | Photographer: Todd Burandt | Client: Ford
Art Director: Patrick Miller | Equipment: Nikon D800 | Ad Agency: GTB

159 PATAGONIA WORKWEAR CAMPAIGN | Photographer: Tyler Stableford
Client: Patagonia | Assistant: Ethan Harrison | Equipment: Canon EOS 1DX Mark II, Canon EF50mm f/1.2L USM, Canon EF70-200mm 2.8L II USM, Canon EF100mm f/2.8L Macro IS USM, CANON EF24-70mm f/2.8L USM

159 THE BRYANT | Company: IF Studio | Photographer: Athena Azevedo
Client: HFZ Capital Group | Creative Directors: Toshiaki Ide, Hisa Ide
Equipment: Canon 5DS | Design Firm: IF Studio

159 POMEGRANATE INGREDIENTS | Photographer: Laurie Frankel | Client: MDSolarSciences | Company: Neue Amsterdam | Producer: Proof Films | Creative Director: Robert Valentine | Stylist: Ryan Renick | Food Stylist: Robyn Valarik | Equipment: Hasselblad H5X with Phase One IQ260 Digital Back, Hasselblad 120mm lens | Design Firm: Neue Amesterdam

160 CANON EOS R MIRRORLESS CAMERA LAUNCH CAMPAIGN | Photographer: Tyler Stableford | Client: Canon USA | Equipment: Canon EOS R Mirrorless Camera And RF Lenses

160 FAMILY #3 | Photographer: Patrick Molnar
Client: Self-Initiated | Equipment: Canon 5d Mk4

161 SOFA DELIVERY | Photographer: Laurie Frankel | Client: Sunbrella
Stylist: Hilary Robertson | Creative Director: Vivian Mize | Equipment: Hasselblad H5X with Phase One IQ3-100 back, Hasselblad Lens | Ad Agency: Wray Ward

161 BALLET DUO | Photographer: Tyler Stableford | Client: Canon USA | Dancers: Seia Rassenti Watson, Joseph Watson II | Equipment: Canon EOS 5D Mark IV, Canon EF 85mm f/1.4L

161 ESPN #2 | Photographer: Patrick Molnar | Client: ESPN | Equipment: Canon 5d Mk4

162 STRENGTH & GRACE | Photographer: Tyler Stableford | Client: Canon USA
Dancer: Anthony Tiedeman | Equipment: Canon EOS 5D Mark IV, Canon 85mm 1.4 L

162 EXPANDED SPACES | Photographer: Lindsay Siu | Client: Vancouver Public Library
Company: One Twenty Three West | Art Director: Jeff Harrison | Copywriter: Danielle Haythorne
Equipment: Contax 645/ Phase One P45+ | Ad Agency: One Twenty Three West

162 STAR WARS FORCE BAND CAMPAIGN | Photographer: Bryan Rowe
Client: Sphero | Equipment: Canon 5DSR

163 THE PARTY IS ALWAYS IN THE KITCHEN | Photographer: Craig Bromley
Client: Farm Rich | Equipment: Canon | Ad Agency: SCOUT

163 EVAN WILLIAMS 0615714 | Photographer: Scott Lowden | Client: Evan Williams | Project Manager: Aftab Ahmad | Production Designer: Jessica Pinkstone | Producers: Jason Goldman, Helen Urriola | Executive Producer: Judd Cherry | Creative Director: David Muldoon | Stylist: Casey Jordan | Hair & Makeup: Jacque Carder | Equipment: Canon 5DM4, 70-200 2.8 IS II USM

164 AN ATHLETA MORNING | Photographer: Dylan H Brown
Client: Athleta | Equipment: Sony A9, Sony 35mm

164 DEER OF MIYAJIMA | Photographer: Clarence Lin
Client: Self-Initiated | Artist: Clarence Lin | Equipment: Nikon

165 PRAGUE | BIRDS IN FLIGHT | Photographer: Rosanne Olson | Client: Self-Initiated
Equipment: Sony A7II, Fe 28-70mm, Epson archival paper and pigment

165 PINK-TOED TARANTULA | Photographer: Lennette Newell | Client: PetSmart | Sr. Creative Service Director: Amy Rhodes | Creative Director: Maggie Parkhouse | Art Director: Paul Henson | Equipment: Canon EOS 5DS R + ProFoto lighting | Ad Agency: Spicefire

165 VULTURES | Photographer: Rosanna U
Client: Self-Initiated | Equipment: Nikon D750

166 ART SUBWAYS IN STOCKHOLM | Photographer: A. Tamboly
Client: Self-Initiated | Equipment: Sony A7RII, canon 17-40mm

166 DON'T FORGET TO LOOK UP. | Photographer: Bill Hornstein
Client: Hornstein Creative | Equipment: Fuji x100t

167 MY19 AUDI A7 BROCHURE COVER | Photographer: Roberto Kai Hegeler
Client: Audi of America | Equipment: CGI

167 URBAN MERCEDES | Photographer: Michael Mayo
Client: Michael Mayo Photography | Digital Artist: Chris Stoll | Retouching: Imaginary Lines
Retoucher: Mary Brandt | Equipment: Phase One XF

168 1948 ALFA ROMEO 6C 2500 COMPETIZIONE | Photographer: Craig Cutler
Client: Bonhams Auction House | Equipment: Leica SL

168 MY19 AUDI A6 BROCHURE COVER | Photographer: Roberto Kai Hegeler
Client: Audi of America | Equipment: CGI

169 MY19 AUDI Q7 BROCHURE COVER | Photographer: Roberto Kai Hegeler
Client: Audi of America | Equipment: CGI

169 EL MIRAGE DRY LAKE BED RACES | Photographer: Aaron Cobb
Client: SCTA | Equipment: Canon 5DSR 24-70mm

170 TO INFINITI AND BEYOND | Photographer: Christopher Wilson
Client: Infiniti | Equipment: Phase One Camera System | Ad Agency: TBWA Hong Kong

170 MY19 AUDI TT BROCHURE COVER | Photographer: Roberto Kai Hegeler
Client: Audi of America | Equipment: CGI

171 RAM SNOW | Photographer: Michael Mayo | Client: Michael Mayo Photography
Retouching: Imaginary Lines | Retoucher: Mary Brandt | Equipment: Phase One XF

171 MUD BATH | Photographer: Christopher Wilson
Client: Self-Initiated | Equipment: Phase One Camera System

172 MARIANA CASTILLO DEBALL | Photographer: Dylan Wilson | Client: Savannah College of Art and Design | Retoucher: Scott Newman | Equipment: Canon 5d MkIII

172 YES GIRL | Photographer: Hadley Stambaugh
Client: Savannah College of Art and Design | Producer: Hannah Malloy
Stylist: Ashley Romasko | Equipment: Canon 5d mark VI / Canon 70-200mm

172 MUSILEK-CHANEL-PURSE | Photographer: Stan Musilek
Client: Chanel | Equipment: Phase One

173 BLISS RELAUNCH 2018 | Photographer: Sarah Silver | Client: Bliss, Bliss Spa | Creative Director: Kim Biggs, Alli Truch / Biggs&Co. | Wardrobe: Julie Brooke Williams | Manicurist: Gina Edwards | Hair: Zaiya | Makeup: Anastasia | Equipment: Camera: Hasselblad H4X with PhaseOne IQ250 digital back, Canon EOS 1DX MK II / LENS: Hasselblad HC 80MM F/2.8, Hasselblad HC 100MM F/2.2, Canon LENS EF 85mm f 1.8 USM

173 LAKE #1 | Photographer: Patrick Molnar
Client: Self-Initiated | Equipment: Canon 1dx Mk2

174 ZEN PALETTE | Photographer: Trevett McCandliss | Client: Footwear Plus magazine
Creative Directors: Trevett McCandliss, Nancy Campbell | Editor-In-Chief: Greg Dutter
Clothing Stylist: Dani Morales | Hair & Makeup: Nevio Ragazzini | Equipment: Canon 5D

174 MUSILEK-MARGAUX-NEED-TO-TALK | Photographer: Stan Musilek
Client: Treats! | Equipment: Phase One

174 ORANGE AND RED AND GOLD | Photographer: Michael Winokur | Client: Self-Initiated
Model: Jerusha Krebs | Hair & Makeup: Audra Langley | Equipment: Canon EOS, Hensel, Westcott, Rosco Labs

174 MUSILEK-FONTAINEBLEAU-INCA-MARIA-DIOR | Photographer: Stan Musilek
Client: Dior | Equipment: Phase One

175 MUSILEK-TEEN DRIVER | Photographer: Stan Musilek
Client: Lui | Equipment: Phase One

175 GRANITE CHIEF ALBUM ART | Photographer: James Exley
Client: Granite Chief | Equipment: Canon 5D Mark III, Broncolor MOVE

176 MUSILEK-WOLFORD20 | Photographer: Stan Musilek
Client: Wolford | Equipment: Phase One

176 EARTH ANGELS | Photographer: Vika Pobeda | Client: Earnshaw's magazine
Creative Directors: Trevett McCandliss, Nancy Campbell | Fashion Director: Mariah Walker
Editor: Emily Beckman | Hair & Makeup: Martin Lane | Equipment: Canon 5D

176 MUSILEK-IRINA-YSL | Photographer: Stan Musilek
Client: YSL | Equipment: Phase One

177 I LOVE THE FLOWER GIRL | Photographer: Christopher Wilson
Client: Natura Brazil | Equipment: Phase One Camera System | Ad Agency: Strawberry Frog

177 PUBLIC TRANSIT, 1957 AND 2017 | Photographer: Lindsay Siu | Client: Lindsay Siu
Photographer | Stylists: Anya Ellis, Lindsay Siu | Retoucher: Istvan (Steve)Pinter
Hair & Makeup: Anya Ellis | Equipment: Contax 645/ Phase One P45+ / Nikon D810

178 LAKE #2 | Photographer: Patrick Molnar
Client: Self-Initiated | Equipment: Canon 1dx Mk2

178 BODY TREATMENTS | Photographer: Terry Vine
Client: Bergamos Spa | Equipment: Canon

179 FOUR PILLARS GIN SUMMER CAMPAIGN | Photographer: Jack Hawkins
Client: Four Pillars Gin | Creative Director: Daniel Cookson | Art Director: Darren Song
Equipment: Sony Alpha 7S SLR | Agency: Interweave Group

179 HOUSE OF COCKTAILS | Photographer: SUECH AND BECK
Client: Self-Initiated | Food Stylist: Ian Muggridge
Set Designer & Props: Franny Alder | Equipment: Canon 5d Mark iii, Profoto

179 POWERS | Photographer: Jonathan Knowles | Client: Irish Distillers | Company: ROTHCO
Creative Director: Ray Swan | Equipment: Hasselblad | Ad Agency: ROTHCO

180 MANHATTEN | Photographer: Jim Norton | Client: Self-Initiated
Stylist: Nicolino De Francesco | Food Stylist: Julie Zambonelli | Equipment: Hasselblad H Series

180 MAD MEN | Photographer: Jonathan Knowles | Client: Self-Initiated
Retoucher: Gareth Pritchard | Equipment: Hasselblad

180 PARTY TIME | Photographer: Jim Norton
Client: Jim Norton/Fuze Reps | Equipment: Canon 5DsR

181 BALLERINA STUDY I, II & III | Photographer: Parish Kohanim
Client: Parish KohanimFine Art LLC | Equipment: Canon 5 DSLR 16-35 lens

181 I DON'T KNOW AND NEVER WILL | Photographer: RJ Muna | Client: Liss Fain Dance
Art Director: Liss Fain | Equipment: Canon EOS 5DS

182 MAGIC TREE | Photographer: Frank P. Wartenberg | Client: Self-Initiated
Photo Retouching: Christiane Wartenberg | Equipment: Canon 5 D Mark III

182 I DON'T KNOW AND NEVER WILL | Photographer: RJ Muna
Client: Liss Fain Dance | Art Director: Liss Fain | Equipment: Canon EOS 5DS

183 2017 SEASON | Photographer: RJ Muna | Client: Alonzo King LINES Ballet
Art Director: Robert Rosenwasser | Equipment: Mamiya Leaf Credo

183 ANNA BEDERKE | Photographer: Frank P. Wartenberg | Client: EMOTION
Fashion Director: Birgit Tyszkiewicz | Hair & Makeup: Karo Loewe
Photo Retouching: Christiane Wartenberg | Equipment: Canon 5 D Mark III
Lens: Canon 80 mm | Location: The Daylight Hamburg

183 MCMAFIA | Photographer: Todd Antony
Client: BBC | Equipment: Canon 5Ds

183 MEGALYN ECHIKUNWOKE | Photographer: Stephanie Diani
Client: ID PR | Hair: Eric Williams | Makeup: Nick Barose | Equipment: Mamiya RZ67

184 WE ARE THE CHOSEN... ACKNOWLEDGE IT. | Photographer: P.J. Fugatze
Client: Self-Initiated | Photographer's Assistant: Anthony Mehlhaff | Model: Hyro the Hero
(Matty Maac, Guitarist) | Equipment: Sony Alpha A7r2 - Profoto - Epson Bartya

184 JANNIS NIEWÖHNER | Photographer: Frank P. Wartenberg | Client: Place to B
Photo Retouching: Markus J. Reinhardt Fine Post | Stylist: Violetta Styling
Equipment: Canon 5 D Mark III | Lens: 24-70 mm Canon EF | Location: Place to B Berlin

184 GIDEON AT THE ROCK OF OREB | Photographer: Brian Neel Parks
Client: Self-Initiated | Models: Noah Norooz, Ed Worden | Makeup: Karina Cohrs
Clothing Designer: Karina Cohrs | Equipment: Canon 5D2, 70-200, f/5, 1/60th

185 THE PAIN THAT SCREAMS | Photographer: Jackson Carvalho
Client: Phabrica Models | Equipment: Hasselblad H4D 40

185 FORM IN NATURE | Photographer: Tatsuro Nishimura | Client: Self-Initiated
Equipment: Nikon FM2, Nikkor 50mm, Nikkor 200mm, Ilford FP4 Film

185 METAMORPHOSIS | Photographer: Jan Kalish | Client: Self-Initiated
Retoucher: Madeline Murray | Equipment: Profoto lighting

186 TRAFFIC | Photographer: Clarence Lin | Client: Self-Initiated
Artist: Clarence Lin | Equipment: Nikon

186 HEAVENLY BLOSSOM | Photographer: SAZELI JALAL
Client: Self-Initiated | Equipment: NIKON

186 DARK FAIRY | Photographer: Barry Barnes | Client: Portfolio - used in 3 x 3 Illustration
Directory | Model: Emma Anne | Equipment: Canon EOS 7D, EFS 18-135 Lens

187 THE MAGIC WORLD OF PAPER | Photographer: Carlos Caicedo
Client: Self-Initiated | Equipment: Nikon D810 / Nikkor 24-85

187 EYE OF THE STORM | Photographer: Jan Kalish
Client: Self-Initiated | Equipment: Profoto lighting

187 SCORCHED. | Photographer: Bill Hornstein
Client: Hornstein Creative | Equipment: Fuji x100t

187 BABY'S BREATH | Photographer: P.J. Fugatze | Client: Self-Initiated
Photographer's Assistant: Anthony Mehlhaff | Model: Hyro the Hero (Troy Wageman, Percussion)
Equipment: Sony Alpha A7r2 - Profoto - Epson Bartya

187 KILLAS ARE COMIN | Photographer: P.J. Fugatze | Client: Self-Initiated
Photographer's Assistant: Anthony Mehlhaff | Model: Hyro the Hero (Matty Maac, Guitarist)
Equipment: Sony Alpha A7r2 - Profoto - Epson Bartya

187 LET YOUR SNAKE SHOW | Photographer: P.J. Fugatze
Client: Self-Initiated | Model: Hyro the Hero (Troy Wageman, Percussion)
Equipment: Sony Alpha A7r2 - Profoto - Epson Bartya

188 FLOWER STUDY | Photographer: Craig Cutler
Client: Self-Initiated | Equipment: Leica SL

188 8 X 10 VIEW CAMERA FLOWER STUDY | Photographer: Craig Cutler
Client:Self-Initiated | Equipment: Toyo 8x10 view camera

188 COCONUT | Photographer: Laurie Frankel | Client: Self-Initiated
Equipment: Hasselblad H5X with Phase One IQ260, Hasselblad 80mm Lens

189 CHARCUTERIE BOARD | Photographer: Makito Inomata | Client: The Parlour
Equipment: Canon 5Ds-r, 24-70

189 EAT MORE FISH | Photographer: Stacey Brandford | Client: Longo's | Creative Director:
David Taylor | Food Stylist: David Grenier | Stylist: Catherine Doherty | Equipment: Canon 5Ds

189 JAGGERY | Photographer: Stacey Brandford | Client:Self-Initiated
Stylist: Renee Drexler | Food Stylist: Michael Elliott | Equipment: Canon 5Ds

190 KRUG SESSIONS | Photographer: Steve Krug | Client: 99th Floor | Company: Fuze Reps
Producers: Jessica Wong, Sally McConnell | Creative Director: Weaymouth Creative
Assistant: Brian McMillan | Food Stylist: David Grenier | Retoucher: Kevin Luc
Equipment: Canon 5DS R, Canon 100mm f/2.8L, Canon 24-70mm f/2.8L II
Set Designer & Props: Catherine Doherty | Agency: Fuze Reps

190 BREAKFAST | Photographer: Tatsuro Nishimura | Client: Self-Initiated
Equipment: Sinar P2, Rodenstock Lens, Mamiya Digital Back

190 KRUG SESSIONS | Photographer: Steve Krug | Client: 99th Floor | Company: Fuze Reps
Producers: Sally McConnell, Jessica Wong | Creative Director: Jennifer Weaymouth
Assistant: Brian McMillan | Food Stylist: David Grenier | Retoucher: Kevin Luc
Equipment: Canon 5DS R, Canon 100mm f/2.8L, Canon 24-70mm f/2.8L II
Set Designer & Props: Catherine Doherty | Agency: Fuze Reps

191 BLACK SESAME | Photographer: Andrew Grinton | Client: Self-Initiated
Food Stylist: Michael Elliott | Equipment: Sony A7RIII, 55mm 1.8, Profoto D1 Heads

191 MAD ABOUT MARBLE | Photographer: SUECH AND BECK
Client: Nuevo Living | Equipment: Canon 5D Mk3

191 SURFBOARD SHAPER | Photographer: Wray Sinclair
Client: Self-Initiated | Equipment: Canon

191 PRE RENOVATION PHOTOGRAPHY OF FORD'S MICHIGAN CENTRAL STATION
Photographer: James Haefner | Client: Ford | Equipment: Canon 5DS, 17mm T/S

192 REDEFINING ACTIVE SENIORS | Photographer: Steve Greer
Client: Self-Initiated | Equipment: Canon 5Ds, 5Dmk3, variety of lens

192 REBEL AMERICANA, CUSTOM SHOP | Photographer: Scott Lowden
Client: Rebel Americana | Director of Photography: Jimmy Gilmore
Art Director: Rick Bryson | Copywriter: John Spalding | Hair & Makeup: Katie Eidecker
Wardrobe: Tamara Conner | Equipment: Canon 5DSR, various lenses | Location: Fuller Moto

193 DEKOTORA | Photographer: Todd Antony
Client: Self-Initiated | Equipment: Phase One XF100

193 "BANKING ON AN AFTERLIFE" | Photographer: Warren Eakins
Client: Warren Eakins Inc | Equipment: Canon Powershot Elph 530 HS

194 DON'T LOOK TOO CLOSE. | Photographer: Jesse Reed
Equipment: Yashica T2, Kodak Portra 400 35mm. | Client: Self-Initiated

194 TWILIGHT ON LAKE COLUMBINE | Photographer: David Westphal
Client: Self-Initiated | Equipment: Nikon D810

195 SANDS OF TIME | Photographer: Alina Holodov
Client: Alina Holodov Photography | Equipment: Canon EOS 5DS R

195 RECEDING STORM AT ARNARFJORDUR | Photographer: Jim Norton
Client: Self-Initiated | Equipment: Canon 5DsR

196 PERSONAL LANDSCAPES | Photographer: Michael Schoenfeld
Client: Michael Schoenfeld Studio | Equipment: Various Sony and Canon cameras and Lenses

196 FAIRMED "JUNGLE" | Photographer: Staudinger+Franke | Client: FairMed
Company: Spinas Civil Voices | Equipment: Hasselblad H2, Phase One IQ260, CaptureOne Pro,
Photoshop | Agency: Spinas Civil Voices

197 UKA | Photographer: Rosanna U | Client: Self-Initiated | Equipment: Nikon D750 28mm 1.8

197 DULUTH, MN | Photographer: John Haynes
Client: Self-Initiated | Equipment: Nikon D850

197 SKY MEETS WATER | Photographer: Stephen Guenther
Client: Self-Initiated | Equipment: Sony A7

197 VIRGINIA COASTAL RESERVE | Photographer: Cameron Davidson
Client: Self-Initiated | Equipment: Inspire 2 Drone, X5s Gimball, 15mm lens

197 SKEIÐARÁRSANDUR SANDSTORM | Photographer: Jim Norton
Client: Self-Initiated | Equipment: Canon 5DsR

198 VIRGINIA COAST RESERVE | Photographer: Cameron Davidson
Client: Self-Initiated | Equipment: DJI Inspire 2 drone with X5s gimball, 15mm lens

198 DANCING ON THE MOON | Photographer: Dylan H Brown
Client: Self-Initiated | Equipment: Nikon D600, Nikkor 24-70 f/2.8

199 COWBOY WORK | Photographer: Wray Sinclair
Client: Self-Initiated | Equipment: Canon

199 JOAQUIN SALIM | Photographer: Hadley Stambaugh
Client: Savannah College of Art and Design | Equipment: Canon 5d mark IV/Canon 24-70mm

199 PORTRAIT OF FINN MCCORMACK | Photographer: Emily Neumann
Client: Self-Initiated | Equipment: Canon 5D ii, 24-70mm lens, strobe lights, Adobe Photoshop

200 ALAN CUMMING | Photographer: Hadley Stambaugh | Client: Savannah College of Art and Design | Retoucher: Scott Newman | Equipment: Canon 5d mark VI/Canon 70-200mm

200 IN A PUFF OF SMOKE | Photographer: Michael Winokur
Client: Winokur Photography | Equipment: Canon Eos, Hensel, Westcott

200 R.I.P. | Photographer: Christopher Wilson
Client: Nokota Horse Conservancy | Equipment: Phase One Camera System

201 OH, WHAT A DAY! | Photographer: Tom Barnes | Client: Self-Initiated
Assistant: Morgan | Equipment: Phase One XF & IQ150

201 KEEP THE HISTORY ALIVE - GERMAN WEHRMACHT | Photographer: Michael Confer
Client: Self-Initiated | Equipment: Canon 5d Mark 4, Canon 24-70, Profoto B1x,4 Foot Octabox

202 JUNGLE CAMP | Photographer: James Martin
Client: CBS Interactive | Equipment: Canon 5D MKIV, 24-70mm lens

202 KEEP THE HISTORY ALIVE - NORRIS JERNIGAN
Photographer: Michael Confer | Client: Self-Initiated
Equipment: Canon 5d Mark 4, Canon 24-70, Profoto B1x, Profoto 4 Foot Octabox

202 CHERISH | Photographer: Howard Rosenberg
Client: Self-Initiated | Equipment: Canon 5dlll

202 MOM TIME BATHTUB | Photographer: Callie Lipkin
Client: Self-Initiated | Equipment: Canon MKIV, 24-70mm

203 KENG #1 | Photographer: Patrick Molnar
Client: Self-Initiated | Equipment: Canon 5d Mk4

203 TROG PORTRAIT - THELMA | Photographer: Michael Confer
Client: Self-Initiated | Equipment: Canon 5d Mark 4, Canon 24-70, Profoto B1x

203 KAT | Photographer: Howard Rosenberg
Client: Self-Initiated | Equipment: Hasselblad

204 NYOTEE | Photographer: Christopher Wilson
Client: Smithsonian Magazine | Equipment: Phase One Camera System

204 RECHO OMONDI 1 | Photographer: Dylan Wilson
Client: Savannah College of Art and Design | Equipment: Canon 5d MkIII

204 SARA | Photographer: Howard Rosenberg
Client: Self-Initiated | Equipment: Canon 5D3

205 KAT | Photographer: Howard Rosenberg
Client: Self-Initiated | Equipment: Canon 5D3

205 "WHO IS?" (THE NEXT GAME WILL TELL US.) | Photographer: Lindsay Siu
Client: BC Lions | Creative Director: Matt Bielby | Art Director: Chris Raedcher
Copywriter: Matt Bielby | Retoucher: Istvan (Steve) Pinter | Hair & Makeup: Anya Ellis
Equipment: Contax 645/ Phase One P45+ | Ad Agency: Here Be Monsters

205 KEEP THE HISTORY ALIVE - SGT. FRANCIS RYAN | Photographer: Michael Confer
Client: Self-Initiated | Equipment: Canon 5d Mark 4, Canon 24-70

206 TROG PORTRAIT #141 | Photographer: Michael Confer
Client: Self-Initiated | Equipment: Canon 5d Mark 4, Canon 24-70, Profoto B1x

206 MOM TIME JENNIFER | Photographer: Callie Lipkin
Client: Self-Initiated | Equipment: Canon MKIV, 85mm

206 ROYALTY | Photographer: Kristopher Burris
Client: Self-Initiated | Equipment: Sony a7 III 28-70mm Lens

206 VIGNETTES - ILENE #0196 | Photographer: Dave Moser
Client: Self-Initiated | Assistant: Justin Chiu | Equipment: Nikon

206 MUSILEK-EGGED-MAN-BUN | Photographer: Stan Musilek
Client: Zebule | Equipment: Phase One

207 SPRING PORTRAITS | Photographer: Lindsay Siu
Client: Lindsay Siu Photographer | Retoucher: Kathleen Loski | Hair & Makeup: Katie Elwood
Equipment: Contax 645 / Phase One P45+

207 DAKOTA | Photographer: Tony Kemp | Client: Self-Initiated
Equipment: Nikon D3300, Stock 35mm Lens

207 DANCER PORTRAITS | Photographer: RJ Muna
Client: Alonzo King LINES Ballet | Equipment: Mamiya Leaf Credo

207 EMPLOYEE RECOGNITION PORTRAIT | Photographer: Mark Battrell
Client: CDW | Communications: Jaime Zaugra
Photo Editor: Wendy Morris | Equipment: Canon 5D Mark IV 24-205mm lens

208 MOHAMMED MASSAQUOI | Photographer: Todd Burandt
Client: Mohammed Massaquoi | Equipment: Nikon D800

208 ANNUAL REPORT PORTRAIT | Photographer: Mark Battrell
Client: Alliance Francaise Chicago | Company: Watel Davis Design | Art Director: Bruno Watel
Equipment: Canon 5D Mark IV | Design Firm: Watel Davis Design

208 TRAIN OF THOUGHT | Photographer: Craig Bromley | Client: Self-Initiated
Model: Carrie Anne Hunt | Equipment: Canon

208 CAM NEWTON | Photographer: Matt hawthorne
Client: Gatorade | Equipment: Canon

209 MUSILEK-AMERICAN APPAREL-MIRANDA | Photographer: Stan Musilek
Client: American Apparel | Equipment: Phase One

209 BOXER | Photographer: Steve Krug | Client: Dave McGregor
Producer: Jessica Wong | Photographer's Assistant: Brian McMillan | Retoucher: Kevin Luc
Equipment: Canon 5DS R, Canon 24-70mm f/2.8L II | Agency: Fuze Reps

210 SWIMMER | Photographer: Terry Vine
Client: The Preserve | Equipment: Canon

210 HARLEY BLUE GOOSE | Photographer: Christopher Wilson
Client: Wheels Through Time, 1903 Magazine | Equipment: Phase One Camera System

211 ANACHRONISM_003 | Photographer: Joseph Saraceno
Client: DLTD Magazine | Creative Director: Wilson Wong @P1M
Stylist: Wilson Wong @P1M | Equipment: Canon 1DS MarkIII

211 EDGE | Photographer: Joseph Saraceno | Client: Sylvanus Urban
Creative Director: Wilson Wong @P1M | Stylist: Wilson Wong @P1M
Equipment: canon 1DS MarkIII | Set Designer & Props: Suzanne Campos @P1M

211 MUST HAVES | Photographer: Stacey Brandford
Creative Director: Lionel Bebbington | Client: re:porter | Equipment: Canon 5Ds

212 ANACHRONISM_001 | Photographer: Joseph Saraceno
Client: DLTD Magazine | Creative Director: Wilson Wong @P1M
Stylist: Wilson Wong @P1M | Equipment: Canon 1DS MarkIII

212 PURPLE CANNABIS PLANTS ON BLACK | Company: Fuze Reps | Photographer:
Steve Krug | Client: Up Cannabis | Producer: Jessica Wong | Assistant: Brian McMillan
Retoucher: Kevin Luc | Equipment: Canon 5DS R, Canon 24-70mm f/2.8L II | Agency: Fuze Reps

212 SPACE | Photographer: Joseph Saraceno | Client: Sylvanus Urban Magazine | Creative
Director: Wilson Wong @P1M | Stylist: Wilson Wong @P1M | Equipment: canon 1DS MarkIII

213 HI THANKS BYE, COLLECTION 0 | Photographer: Brandon Titaro
Client: Hi Thanks Bye Studio | Equipment: Canon EOS 5D mark iv, Profoto
Furniture Design: Stein Wang, Topher Kong

213 KRUG SESSIONS | Photographer: Steve Krug | Client: 99th Floor | Company: Fuze Reps
Producer: Jessica Wong | Assistant: Brian McMillan | Retoucher: Kevin Luc
Equipment: Canon 5DS R, Canon 100mm f/2.8L Macro | Agency: Fuze Reps

213 NATURE STILL LIFE | Photographer: Tatsuro Nishimura
Client: Self-Initiated | Equipment: Sinar P2, Rodenstock Lens, Mamiya Digital Back

213 MASCULINITY | Photographer: Adam Voorhes | Client: GLAMOUR Magazine
Photo Editor: Michelle Sulcov | Stylist: Robin Finlay | Equipment: Hasselblad 500CM

214 FW18 ACCESSORIES | Photographer: Nicholas Duers
Client: Elite Traveler | Stylist: Kristen Shirley | Equipment: PhaseOne XF, IQ3

214 2018 SPIRITS | Photographer: Nicholas Duers
Client: Elite Traveler | Stylist: Kristen Shirley | Equipment: PhaseOne XF, IQ3

214 ELITE TRAVELER FW18 | Photographer: Nicholas Duers
Client: Elite Traveler | Stylist: Kristen Shirley | Equipment: PhaseOne XF

214 UBER 2018 | Photographer: Nicholas Duers
Client: Uber | Stylist: Betim Balaman | Equipment: PhaseOne XF

214 UNDER ARMOUR AFC-NFC PRO BOWL CLEATS | Photographer: Fj Hughes
Client: Under Armour | Producer: Brenna Bourie | Creative Director: Kirk Roush
Art Director: Gustavo Uriarte | Stylist: Michael Fusco | Photo Retouching: John Flynn/*Post
Equipment: Canon 5dsr, Canon 90mm f 2.8 Tilt-shift

214 TOM FORD | BEAUTY | Photographer: Nicholas Duers
Client: Tom Ford | Stylist: Elizabeth Serwin | Equipment: PhaseOne XF, IQ3

215 DIOR SAUVAGE | Photographer: Jonathan Knowles | Client: Luxure Magazine
Equipment: Hasselblad | Set Designer & Props: Alice Andrews

215 SIFIMD (SH*T I FOUND IN MY DRIVEWAY) | Photographer: Bruce Peterson
Client: Self-Initiated | Equipment: Hasselblad

215 GEAR ABSTRACTS | Photographer: Craig Cutler
Client: Self-Initiated | Equipment: Leica SL

216 PAINT ROLLER | Photographer: Bruce Peterson | Client: Architect Magazine
Art Director: Rob Ogle | Equipment: Hasselblad

216 OTTO | Photographer: Joseph Saraceno
Client: Yabu Pushelberg | Creative Director: Wilson Wong @P1M
Stylist: Wilson Wong @P1M | Equipment: canon 1DS MarkIII

216 COSMIC BUBBLES | Photographer: Jonathan Knowles
Equipment: Hasselblad | Client: Self-Initiated

216 SPEAKER SPLASH | Photographer: Robert Tardio
Client: Bose | Equipment: Phase One XF IQ3 Digital Camera/Elinchrom Lighting

217 DIRTY SPONGES | Photographer: Bruce Peterson
Client: Self-Initiated | Equipment: Hasselblad

217 SPERM UND DRANG | Photographer: Gregory Reid
Client: Newsweek | Equipment: Phaseone XF+, Leaf Credo 60 DB

217 PAPER & SHADOW | Photographer: Adam Voorhes
Client: Self-Initiated | Stylist: Robin Finlay | Equipment: Hasselblad 500CM

218 ICONIC GROOVES | Photographer: Takahiro Igarashi
Client: Rimowa | Equipment: Mamiya 645 DF+, Leaf Credo 40, Schneider Kreuznach 80mm

218 COLOUR EXPLOSION | Photographer: Jonathan Knowles
Client: Graff Diamonds | Company: Brave New World | Equipment: Hasselblad
Set Designer & Props: Annette Masterman | Agency: Brave New World

218 TOM FORD | MEN'S ACCESSORIES | Photographer: Nicholas Duers
Client: Tom Ford | Stylist: Elizabeth Serwin | Equipment: PhaseOne XF, IQ3

218 COSMETICS | Photographer: Nicholas Duers | Client: Lash Star Beauty
Stylist: Michele Faro | Equipment: PhaseOne XF

218 RANGE | Photographer: William Bartlett | Client: Self-Initiated | Equipment: Phase One H25

219 HEAVEN IS IN THE CLOUDS | Photographer: Christopher Wilson
Client: Euro Motors | Equipment: Phase One Camera System

219 JIMMY BURNOUTS | Photographer: James Exley | Client: Self-Initiated
Equipment: Canon 5D Mark III, Broncolor MOVE

220 LOVEJOY SPEEDSTER | Photographer: Christopher Wilson
Client: Amelia Island Tourism | Equipment: Phase One Camera System
Ad Agency: Paradise Advertising

PHOTOGRAPHERS

Alduino, Frankie 59, 60
Antony, Todd 183, 193
Azevedo, Athena 24, 37,
........................... 48, 49, 131, 159
Barnes, Barry 186
Barnes, Tom 201
Bartlett, William 218
Battrell, Mark 207, 208
Brandford, Stacey 38, 189, 211
Brennan, Jim 148
Bromley, Craig 163, 208
Brown, Dylan H 164, 198
Brautigam, Mark 45
Burandt, Todd 158, 208
Burris, Kristopher 123, 206
Butler, David 157
Caicedo, Carlos 187
Carvalho, Jackson 185
Chen, Susan J 128
Cobb, Aaron 169
Confer, Michael 124, 201,
........................... 202, 203, 205, 206
Cruz Durán, Juan 25
Curtet, Patrick 76, 77
Cutler, Craig 109, 112, 113, 114,
........................... 168, 188, 215
Dan-Bergman, Kristofer 98
Davidson, Cameron 94, 197, 198
Diani, Stephanie 183
Duers, Nicholas 140, 214, 218
Duka, Lonnie 108
Eakins, Warren 193
Exley, James 175, 219
Frankel, Laurie ... 39, 40, 41, 159, 161, 188

Fugatze, P.J. 96, 183, 184, 187
Gabor, Florin 68
Galton, Beth 103
Greenberg, Jill 61
Greer, Steve 191
Grinton, Andrew 107, 191
Guenther, Stephen 197
Haefner, James 62, 191
Hawkins, Jack 179
Hawthorne, Matt 208
Haynes, John 197
Heffernan, Terry 120
Holodov, Alina 195
Hornstein, Bill 166, 187
Houser, todd 135
Humphreys, Dan 23
Hughes, Fj 214
Hwang, Saneun 101
Igarashi, Takahiro 218
Inomata, Makito 104, 189
Jalal, Sazeli 186
Kai Hegeler, Roberto 167, 168,
........................... 169, 170
Kalish, Jan 53, 82, 185, 187
Kemp, Tony 207
Kessinger, Rick 66, 67, 69
Knowles, Jonathan 22, 30,
........................... 52, 70, 71, 73, 121, 127,
........................... 151, 179, 215, 216, 218
Kohanim, Parish 33, 91, 99, 100
Krug, Steve 105, 106, 190,
........................... 209, 212, 213
Krug Studios 128
Leroy, Michel 118, 119

Lin, Clarence 164
Lipkin, Callie 202, 206
Lowden, Scott 163, 192
Macías Velasco, Paco 126
Malcolm Roberts, Neil 132
Martin, James 202
Mayo, Michael 63, 69, 167, 171
Mazza, Joe 157, 158
McCandliss, Trevett 174
McCown, Darnell 58, 157
Milstein, Jeffrey 102
Molnar, Patrick 46, 47,
........................... 160, 161, 173, 178, 203
Moser, Dave 206
Muna, RJ 44, 89, 181, 182, 183, 207
Musilek, Stan 29, 72, 75,
........................... 80, 81, 82, 83, 86, 150,
........................... 172, 174, 175, 176, 206, 208
Napolitano, Claudio 42, 43
Nasser, Amyn 87
Neel Parks, Brian 184
Neumann, Emily 199
Newell, Lennette 55, 95, 165
Nishimura, Tatsuro 185, 190, 213
Norton, Jim 180, 195, 197
Olson, Rosanne 165
Pantuso, Michael 97
Peterson, Bruce 215 , 216, 217
Phelps, Bill 74
Pobeda, Vika 176
Poon, Kah 125
Raphael, Louis 115
Redinger-Libolt, Scott 88
Reed, Jesse 194

Reid, Gregory 217
Rosenburg, Howard ... 202, 203, 204, 205
Rowe, Bryan 162
Saraceno, Joseph 34, 35, 137, 146,
........................... 211, 212, 216
Schoenfeld, Michael 26-28,
........................... 129, 130, 133, 196
Schulz, John 54
Silver, Sarah 173
Sinclair, Wray 191, 197
Siu, Lindsay 162, 177, 205, 207
Stableford, Tyler 91, 159,
........................... 160, 161, 162
Stambaugh, Hadley 78, 172
Staudinger+Franke 32,
........................... 116, 117, 134, 196
SUECH AND BECK 107, 179, 191
Surace, John 154
Tamboly, A 166
Tardio, Robert 141, 142, 216
Titaro, Brandon 213
U, Rosanna 165, 197
Vine, Terry 178, 210
Voorhes, Adam 139, 143-145,
........................... 147, 149, 213, 217
Wartenberg, Frank P 79, 90, 92, 93,
........................... 182, 184
Westphal, David 194
Wilson, Christopher 50, 51, 64, 65,
........................... 84, 85, 110, 111, 122, 136, 155,
........................... 170, 171, 177, 200, 204, 210, 220
Wilson, Dylan 172, 204
Winokur, Michael 174, 200
Wolfe, Art 56, 57

CLIENTS

Adcos ... 31
AFAR Magazine 143-145
Alliance Francaise Chicago 208
Alina Holodov Photography 195
Alonzo King LINES Ballet 183, 207
AMD Fashion Academy 79
Amelia Island Tourism 84, 220
Amor Da Terra, Brazil 85
Architect Magazine 216
artistic project 89
Athleta ... 164
Atomic .. 29
Audi of America 167, 168, 169, 170
BBC ... 183
BC Lions .. 205
Bergamos Spa 178
Bonhams Auction House 168
Bose ... 216
Canon USA 160, 161, 162
Carmel Partners 24, 37, 48, 49
CBS Interactive 202
CDW ... 207
City of Toronto 105, 106
David Hocker 101
Dior ... 174
DLTD Magazine 211, 212
DuPont ... 44
Earnshaw's magazine 176
Earth Aware Editions 56, 57
Elite Traveler 214
Elte ... 38
EMOTION .. 183
Epic Litho 131
ESPN .. 161
Euro Motors 219
EyeCorps .. 130

FairMed .. 196
Farm Rich 163
FCB, Chicago 50, 51
Filo Timo .. 146
Flaunt .. 83
Fluor Corporation 108
Footwear Plus magazine 74, 174
Ford .. 158, 191
Four Pillars Gin 179
Frascara ... 82
Fuze Reps 128, 180
Gatorade ... 208
GENLUX 76, 77
Getty Images 127
GLAMOUR Magazine 213
Glotzl Retouching 94
Graff Diamonds 218
Granite Chief 175
Heritage Auctions 157
HFZ Capital Group 159
Hi Thanks Bye Studio 213
Hornstein Creative 166, 187
Individuals 135
Infiniti .. 170
Irish Distillers 179
Iron Town Harley-Davidson/ALS
Association Wisconsin Chapter 45
James Purdey & Sons 23
Kuerig .. 157
Lash Star Beauty 218
Lindsay Siu Photographer 177, 206
Liss Fain Dance 181, 182
Longo's .. 189
Loue la Vie 68
Louis Vuitton 86
Lui ... 72, 175

Luxure Magazine 30, 52,
........................... 70, 71, 73, 215
Margaret Jenkins Dance Company 89
Massaquoi, Mohammed 208
Maxlider Brothers Customs 69
mcgarrybowen/Fresh Step 61
McGregor, Dave 209
MDSolarSciences 159
MetaLeap Creative 139
Michael Mayo Photography 63, 69,
........................... 167, 171
Michael Schoenfeld Studio 129, 196
Natura Brazil 177
Newsweek 217
Nokota Horse Conservancy 200
Nuevo Living 191
Octoberfest Paris 80, 81
Parish KohanimFine Art LLC 91, 99,
........................... 100, 181
Parker Pens / Newell Brands 22
The Parlour 189
Patagonia 159
Pavement ... 54
PETA .. 42, 43
PetSmart 55, 165
Phabrica Models 185
Picture Press 92, 93
Place to B 184
Popular Science Magazine 149
Portfolio - used in 3 x 3 Illustration
Directory 186
The Preserve 210
PRESTIGE INTERNATIONAL MAGAZINE
.. 87
Rebel Americana 192
Remy Bumppo Theatre - Chicago 158

Re:porter .. 211
Rimowa ... 218
Road & Track 64, 65, 136
Russell Maas Restoration 66, 67
San Francisco Travel Association 115
Savannah College of Art and Design 78,
........................... 172, 199, 200, 204
Schon Magazine 34, 35
SCTA ... 169
Smithsonian Magazine 122, 204
Sphero ... 162
So...?Fragrance 53
Sonrisas de Bombay/Mumbai Smiles .. 25
Sunbrella 39, 40, 41, 161
Sylvanus Urban 137
Sylvanus Urban Magazine 212
Teuffel 152, 153
Thames & Hudson 102
Treats! 75, 174
Uber ... 214
Under Armour 214
US Air Force 46, 47
Vancouver Public Library 162
Warren Eakins Inc 193
Wheels Through Time, 1903 Magazine
........................... 155, 210
The Wickaninnish Inn 104
Williams, Evan 163
Winokur Photography 200
Wired ... 150
Writers Theatre, Glencoe, IL 157
Xueli .. 121
YSL .. 86, 176
Zebule .. 206
7x7 ... 83
99th Floor 190, 213

AD AGENCY / DESIGN FIRM / STUDIO

Archer Troy 42, 43
Brave New World 218
Brownstein Group 44
Caldas Naya 25
Fuze Reps .. 105, 106, 128, 190, 209, 212, 213
GTB ... 158

Here Be Monsters 205
IF Studio 24, 37, 48, 49, 131, 159
Interweave Group 179
Neue Amsterdam 159
One Twenty Three West 162
Paradise Advertising 84, 220

Pavement ... 54
ROTHCO .. 179
Sandbox Studio 128
SCOUT .. 163
Spicefire 55, 165
Spinas Civil Voices 196

Splash Worldwide 22
Strawberry Frog 177
Supreme Model Management 125
TBWA Hong Kong 170
Watel Davis Design 208
Wray Ward 39, 40, 41, 161

EXECUTIVE CREATIVE DIRECTORS / CREATIVE DIRECTORS / ASSOCIATE CREATIVE DIRECTORS

Bebbington, Lionel ... 211
Bell, Peter ... 45
Bielby, Matt ... 205
Biggs, Kim ... 173
Caldas, Gustavo ... 25
Campbell, Nancy ... 74, 174, 176
Capossela, Eric ... 139
Castillo, Adrian ... 44
Chen, Susan J ... 128
Cloutier, Andrew ... 38
Cookson, Daniel ... 179
Doherty, Catherine ... 190
Drifka, Steve ... 45
Eckmann, Andrew ... 128
Fairley, John ... 22, 23
Gilmore, Jimmy ... 192
Guertin, Tara ... 143-145
Ide, Hisa ... 24, 37, 48, 49, 159
Ide, Toshiaki ... 24, 37, 48, 49, 159
McCandliss, Trevett ... 74, 174, 176
Mize, Vivian ... 39, 40, 41, 161
Muldoon, David ... 163
Nott, Chris ... 94
Parkhouse, Maggie ... 55, 165
Payne, Thomas ... 149
Rhodes, Amy ... 165
Roush, Kirk ... 214
Swan, Ray ... 179
Taylor, David ... 189
Thomson, Kevin ... 61
Truch, Alli ... 173
Tyszkiewicz, Birgit ... 183
Valentine, Robert ... 159
Weaymouth Creative ... 128, 190
Wong, Wilson ... 34, 35, 137, 146, 211, 212, 216

ART DIRECTORS

Bryson, Rick ... 192
Burgum, Jill ... 157
Drifka, Steve ... 45
Catten, Lauren ... 151
Fain, Liss ... 181, 182
Fairley, John ... 23
Gealer, Josie ... 121, 127
Harrison, Jeff ... 162
Henson, Paul ... 55, 165
Jenkins, Margaret ... 89
Lin, Clarence ... 164, 186
Miller, Patrick ... 158
Nott, Chris ... 94
Ogle, Rob ... 216
Raedcher, Chris ... 205
Rand, Hannah ... 61
Rosenwasser, Robert ... 183
Song, Darren ... 179
Uriarte, Gustavo ... 214
Watel, Bruno ... 208

PHOTOGRAPHER'S ASSISTANTS / ASSISTANTS

Ask, Susan ... 157
Chiu, Justin ... 206
Gillis, Kathleen ... 83
Harrison, Ethan ... 159
McMillan, Brian ... 105, 106, 128, 190, 209, 212, 213
Mehlhaff, Anthony ... 184, 187
Morgan ... 201
Poole, Bonnie ... 87
Read, Hugh ... 128
Sheridan, Leroy ... 157

PHOTO EDITORS

Beckman, Emily ... 176
Chen, Susan J ... 128
Dutter, Greg ... 74, 171
Morris, Wendy ... 207
Nasser, Amyn ... 87
Sulcov, Michelle ... 213

RETOUCHERS

Bellefleur, Evonne ... 105, 106
BenPPR ... 79
Brandt, Mary ... 63, 69, 167, 171
Brennan, Jim ... 148
Dick, Christopher ... 45
Flynn, John ... 214
Fronzek, Nicole ... 90
Gillis, Kathleen ... 52
Glotzl, Jeff ... 94
Lanario, Rob ... 23
Loski, Kathleen ... 207
Luc, Kevin ... 128, 190, 209, 212, 213
Murray, Madeline ... 52, 83, 185
Newman, Scott ... 172, 200
Pinter, Istvan (Steve) ... 177, 205
Pritchard, Gareth ... 180
Reinhardt, Markus J ... 79, 184
Stambaugh, Hadley ... 78, 199, 200
Tipton King, Chris ... 128
Wartenberg, Christiane ... 182, 183
Proimage Experts ... 87
Imaginary Lines ... 63, 69, 167, 171
Rabbit House Post ... 42, 43

HAIR / MAKEUP

Anastasia ... 173
Barose, Nick ... 183
Burke, Maureen ... 87
Carder, Jacque ... 163
Chai, Patrick ... 87
Cohrs, Karina ... 184
Coombes, Jamie ... 70, 71
Edwards, Gina ... 173
Eidecker, Katie ... 192
Elek, Andrew ... 128
Ellis, Anya ... 177, 205
Elwood, Katie ... 207
Frampton, Robert ... 121
Krüger, Nina ... 79
LaMarca, Carrie ... 88
Lane, Martin ... 176
Lane, Veronica ... 87
Langley, Audra ... 174
Loewe, Karo ... 90, 183
Mazzoleni, Stefano ... 127
Nasser, Amyn ... 87
Ragazzini, Nevio ... 174
Tobin, Ellie ... 127
Varland, Virginia ... 158
Williams, Eric ... 183
Wray, Jacqueline ... 128
Zaiya ... 173

STYLISTS / FOOD STYLISTS / CLOTHING DESIGNERS / LIGHTING DESIGNERS / SET DESIGNER & PROPS

Agullo, Jessica ... 141, 142
Alder, Franny ... 179
Alvarado, Damian ... 128
Andrews, Alice ... 215
Balaman, Betim ... 214
Balzer, Anna Milena ... 90
Brennan, Jim ... 148
Campos, Suzanne ... 211
Cohrs, Karina ... 184
Conner, Tamara ... 192
Conners, Caprice ... 128
De Francesco, Nicolino ... 180
Driman, Rob ... 52
Drexler, Renee ... 189
Doherty, Catherine ... 128, 189
Elliott, Michael ... 189, 191
Ellis, Anya ... 177
Faro, Michele ... 218
Finlay, Robin ... 139, 143-145, 147, 149, 213, 217
Fusco, Michael ... 214
Grenier, David ... 105, 106, 189, 190
Jordan, Casey ... 163
Kong, Topher ... 213
Manakoski, Sanja ... 157
Masterman, Annette ... 218
McCabe, Jackson ... 78
McCrindle, Andrea ... 107
Minton, Jaina ... 151
Morales, Dani ... 174
Muggridge, Ian ... 179
Näher, Anais ... 90
Renick, Ryan ... 159
Ries, Barbara ... 74
Romasko, Ashley ... 172
Serwin, Elizabeth ... 140, 214, 218
Seymour, Sasha ... 38
Shirley, Kristen ... 214
Siu, Lindsay ... 177
St. Onge, Christopher ... 107
Styling, Violetta ... 184
Valarik, Robyn ... 159
Velasquez, Mariana ... 103
Walker, Mariah ... 176
Wang, Stein ... 213
Williams, Julie Brooke ... 173
Witenoff, Noah ... 107
Wong, Wilson ... 34, 35, 137, 146, 211, 212, 216
Zambonelli, Julie ... 180

MODELS / DANCERS

Abbing, Xueli ... 121
Anderson, Greg Matthew ... 158
Anne, Emma ... 186
Bagley, Taylor ... 87
Bradley, Judith ... 28
Brady, Matthew Alan ... 96
Christian, Tim ... 96
The Dancers of the Aspen Santa Fe Ballet .. 91
Deacon, Eve ... 70, 71
Goldstein, James ... 87
Guevara, Aussie ... 128
Hunt, Carrie Anne ... 208
Hyro the Hero (Matty Maac, Guitarist) ... 184, 187
Hyro the Hero (Troy Wageman, Percussion) ... 187
Krebs, Jerusha ... 174
Noah, Norooz ... 184
Sandys, Nick ... 158
Schneider, Sam ... 96
Sil, Regina / NEXT ... 88
Smith, Amanda ... 87
Tiedeman, Anthony ... 162
Watson, Seia Rassenti ... 161
Watson II, Joseph ... 161
Worden, Ed ... 184
Yordanov, Ilia ... 87

PLATINUM

Athena Azevedo
www.athenaazevedo.carbonmade.com
34 W. 27th St., Suite 501
New York, NY 10001
United States
Tel +1 203 550 1432
athena.azevedo@gmail.com

Caldas Naya
www.caldasnaya.com
taulat 93
Barcelona, 08005
Spain
Tel +34 686988571
info@caldasnaya.com

Curious Productions
www.curious-productions.co.uk
3-4 Bakers Yard
London, EC1R 3DD
United Kingdom
Tel +44 (0)785 222 9751
jfairley@curious-productions.co.uk

Jonathan Knowles
www.jknowles.com
48A Chancellors Road
London W6 9RS GB
United Kingdom
Tel +44 (0)20 8741 7577
jk@jknowles.co.uk

Parish Kohanim
www.parishkohanim.com
425 Peachtree Hills Ave. NE
Building 1, Suite 2
Atlanta, GA 30305
United States
Tel +1 404 892 0099
pk@parishkohanim.com

Stan Musilek
www.musilek.com
1224 Mariposa St.
San Francisco CA 94107
United States
Tel +1 415 621 5336
studio@musilek.com

Joseph Saraceno
www.josephsaraceno.com
26 Wolverton Ave.
Toronto, ON M4J 3H8
Canada
Tel +1 416 908 1598
joe@josephsaraceno.com

Michael Schoenfeld
www.michaelschoenfeld.com
560 West 200 South
Salt Lake City, UT 84101
United States
Tel +1 801 560 3305
michael@michaelschoenfeld.com

Staudinger + Franke
www.staudinger-franke.com
Josef-Endlweber-Gasse 2a
Vienna, 1230
Austria
Tel +43 1 597 01 24
sf@staudinger-franke.com

GOLD

Frankie Alduino
www.frankiealduino.com
64 Morton St., 1C
New York, NY 10014
United States
Tel +1 407 575 0002
studio@frankiealduino.com

Athena Azevedo
www.athenaazevedo.carbonmade.com
34 W. 27th St., Suite 501
New York, NY 10001
United States
Tel +1 203 550 1432
athena.azevedo@gmail.com

Stacey Brandford
www.staceybrandford.com
9 Davies Ave., Studio 103
Toronto, ON M4M 2A6
Canada
Tel +1 416 463 8877
studio@staceybrandford.com

Mark Brautigam
www.markbrautigam.net
233 N. Milwaukee St.
Milwaukee, WI 53202
United States
Tel +1 414 273 7311

Jim Brennan
www.JimBrennanPhotography.com
1657 Bonita Bluff Court
Ruskin, FL 33570
United States
Tel +1 813 610 2756
JimBrennanPhotography@gmail.com

Kristopher Burris
Atlanta, GA 30316
United States
tbareford@gmail.com

Susan J. Chen
www.susanjchen.com
United States
Tel +1 646 594 7686
susan@susanjchen.com

Michael Confer
www.mconferphoto.com
2949 Berkley Road
Ardmore, PA 19003
United States
Tel +1 610 299 0341
mike@mconferphoto.com

Patrick Curtet
www.curtet.com
740 Swaorthmore Ave.
Pacific Palisades, CA 90272
United States
Tel +1 424 316 9044
patrick@curtet.com

Craig Cutler
www.craigcutler.com
197 Grand St. 5N
New York, NY 10013
United States
Tel +1 212 779 9755
cc@craigcutler.com

Kristofer Dan-Bergman
www.KristoferDanBergman.com
46 Rivington St., Apt. 5D
New York, NY 10002
United States
Tel +1 646 295 4663
kdb@kristoferdanbergman.com

Cameron Davidson
www.camerondavidson.com
399 Tennessee Ave.
Alexandria, VA 22305
United States
Tel +1 703 845 0547
cameron@camerondavidson.com

Nicholas Duers
www.nicholasduers.com
255 W. 36th St., Suite 1102
New York, NY 10018
United States
Tel +1 917 574 2636
nd@nicholasduers.com

Lonnie Duka
www.dukamedia.com
105 Norfolk St., Tower 15
New York, NY 10002
United States
Tel +1 949 280 2676
lonnie@dukamedia.com

Laurie Frankel
www.lauriefrankel.com
697 Douglass St.
San Francisco, CA 94114
United States
Tel +1 415 282 7345
lga@lauriefrankel.com

P.J. Fugatze
Culver City, CA 90230
United States
fugatze@blingimaging.com

Florin Gabor
www.floringaborphotography.com
7882 de l'Aurore
Laval, Quebec H7A0C8
Canada
Tel 514 206 3883

Beth Galton
www.bethgalton.com
109 W. 27th St. 6A
New York, NY 10001
United States
Tel +1 212 242 2266
studio@bethgalton.com

Jill Greenberg
www.jillgreenberg.com
253 W. 28th St., Floor 5
New York, NY 10001
United States
Tel +1 212 594 5624

Andrew Grinton
www.grintonphotography.com
136 Geary Ave., Unit 212
Toronto, Ontario M6H4H1
Canada
Tel +1 416 354 2612
andrew@grintonphotography.com

James Haefner
www.jameshaefner.com
6740 Birmingham Club Drive
Bloomfield Hills, MI 48301
United States
Tel +1 248 588 6850
jim@haefnerphoto.com

Terry Heffernan
www.heffernanfilms.com
991 Tennessee St.
San Francisco, CA 94107
United States
Tel +1 707 252 3505
terry@heffernanfilms.com

Todd Houser
www.houserphoto.com
113 Barcliff Terrace
Cary, NC 27518
United States
Tel +1 919 924 6263
todd@houserphoto.com

Saneun Hwang
www.studiosaneun.com
89 Wyckoff 2F
Brooklyn, NY 11237
United States
Tel +1 646 784 6370
hi.saneun@gmail.com

Makito Inomata
www.makito.ca
315 - 555 E. Sixth Ave.
Vancouver, BC V5T 1K9
Canada
Tel +1 778 999 8896
info@makito.ca

Jan Kalish
www.Jankalish.com
17 Tresillian Road
Toronto, Ontario M3H1L5
Canada
Tel +1 416 823 2600
info@jankalish.com

Rick Kessinger
www.kessingerstudio.com
10 Finance Drive
Bloomington, IL 61704
United States
Tel +1 309 664 1918
rick@kessingerstudio.com

Jonathan Knowles
www.jknowles.com
48A Chancellors Road
London W6 9RS
United Kingdom
Tel +44 (0)20 8741 7577
jk@jknowles.co.uk

Parish Kohanim
www.parishkohanim.com
425 Peachtree Hills Ave. NE
Building 1, Suite 2
Atlanta, GA 30305
United States
Tel +1 404 892 0099
pk@parishkohanim.com

Steve Krug
www.krugstudios.com
69 Pelham Ave., Second Floor
Toronto, Ontario M6N1A5
Canada
Tel +1 416 658 4320
steve@krugstudios.com

Krug Studios
www.krugstudios.com
69 Pelham Ave., Second Floor
Toronto, Ontario M6N1A5
Canada
Tel +1 416 658 4320
steve@krugstudios.com

Michel Leroy
www.michelleroyphoto.com
115 West 30th St. #200
New York, NY 10001
United States
Tel +1 212 475 4110
studio@michelleroyphoto.com

Michael Mayo
www.michaelmayo.com
1389 Crampton St.
Dallas, Texas 75207
United States
Tel +1 214 406 8757
studio@michaelmayo.com

Darnell McCown
2007 S. Ervay St.
Dallas, TX 75215
United States
Tel +1 214 421 9333
darnellmc@sbcglobal.net

Jeffrey Milstein
www.jeffreymilstein.com
331 Wall St.
Kingston, NY 12401
United States
Tel +1 845 331 3111
jmilstein.studio331@gmail.com

Patrick Molnar
www.patmolnar.com
443 Lakeshore Drive, NE
Atlanta, GA 30307
United States
patmolnar@mac.com

RJ Muna
www.rjmuna.com
2055 Bryant St.
San Francisco, CA 94110
United States
Tel +1 415 285 8300
studio@rjmuna.com

Stan Musilek
www.musilek.com
1224 Mariposa St.
San Francisco CA 94107
United States
Tel +1 415 621 5336
studio@musilek.com

Claudio Napolitano
www.napolitano.photo
57 E 95 St., Apt. 8
New York, NY 10128
United States
Tel +1 917 250 0503
claudionapolitano@mac.com

Amyn Nasser
AmynNasser.com
Worldwide
Tel +1 310 494 6848
Studio@AmynNasser.com

Lennette Newell
www.lennettenewell.com
2340 Pimlico Lane
Placerville, CA 95667
United States
Tel +1 925 930 9229
lennette@lennettenewell.com

Michael Pantuso
www.pantusodesign.com
820 S. Thurlow St.
Hinsdale, IL 60521
United States
Tel 312 318 1800
michaelpantuso@me.com

Bill Phelps
www.mccandlissandcampbell.com
433 N. Windsor Ave.
Brightwaters, NY 11718
United States
Tel +1 631 252 3527
mcandcstudio@gmail.com

Kah Poon
www.kahpoon.com
433 W. 34th St. #8G
New York, NY 10001
United States
Tel +1 917 374 1129
kah@kahpoon.com

Louis Raphael
www.louisraphaelphotography.com
32 Sutro Heights Ave.
San Francisco, CA 94111
United States
Tel +1 323 244 0619
raphlo2@yahoo.com

Scott Redinger-Libolt
www.redphoto.com
Rondorfer Hauptstrasse 45
Köln, 50997
Germany
Tel +49 (0) 2233 979 4699

Neil Malcolm Roberts
United States
lightmotives@gmail.com

Joseph Saraceno
www.josephsaraceno.com
26 Wolverton Ave.
Toronto, ON M4J 3H8
Canada
Tel +1 416 908 1598
joe@josephsaraceno.com

Michael Schoenfeld
www.michaelschoenfeld.com
560 West 200 South
Salt Lake City, UT 84101
United States
Tel +1 801 560 3305
michael@michaelschoenfeld.com

John Schulz
www.studioschulz.com
6790 Top Gun St., Suite 11
San Diego, CA 92121
United States
Tel +1 888 447 8862
info@studioschulz.com

Tyler Stableford
www.tylerstableford.com
46 Weant Blvd.
Carbondale, CO 81623
United States
Tel +1 970 963 2462
tyler@tylerstableford.com

Hadley Stambaugh
www.scad.edu
115 E. York St.
Savannah, GA 31402
United States
sward@scad.edu

Staudinger + Franke
www.staudinger-franke.com
Josef-Endlweber-Gasse 2a
Vienna, 1230
Austria
Tel +43 1 597 01 24
sf@staudinger-franke.com

SUECH AND BECK
www.suechandbeck.com
Toronto, Ontario M6E 4P3
Canada
Tel +1 647 456 8296
info@suechandbeck.com

John Surace
www.johnsurace.com
102 Hillcrest St.
Staten Island, NY 10308
United States
Tel +1 212 203 3183
espending@gmail.com

Robert Tardio
www.roberttardio.com
118 E. 25th St., FL 6
New York, NY 10010
United States
Tel +1 212 254 5413
robert@roberttardio.com

GOLD

Paco Macías Velasco
www.pacomaciasvelasco.mx
Leopoldo Romano No. 6-1
Mexico, city., D.F. 05280
Mexico
Tel +52 55 1498 5864
pacomaciasvelasco@yahoo.com.mx

Adam Voorhes
www.voorhes.com
4321 Gillis St.
Austin, TX 78745
United States
Tel +1 512 386 7417
adam@voorhes.com

Frank P. Wartenberg
www.frank-wartenberg.com
Holstenkamp 46 a Hamburg
22525
Germany
Tel +49 40 850 8331
mail@wartenberg-photo.com

Christopher Wilson
christopherwilsonphotography.com
512 Peebles St.
Raleigh, NC 27608
United States
Tel +1 919 247 9956

Art Wolfe
www.artwolfe.com
6523 California Ave. SW, #343
Seattle, WA 98104
United States
Tel +1 206 332 0993
info@artwolfe.com

SILVER

Todd Antony
www.toddantony.com
99 Mercers Road
London, N19 4PS
United Kingdom
Tel +44 7879 443 587
todd@toddantony.com

Athena Azevedo
www.athenaazevedo.carbonmade.com
34 W. 27th St., Suite 501
New York, NY 10001
United States
Tel +1 203 550 1432
athena.azevedo@gmail.com

Barry Barnes
www.trainedeyegraphics.com
P.O. Box 460
Emmett, ID 83617
United States
Tel +1 208 365 4896
bb@trainedeyegraphics.com

Tom Barnes
www.tombarnes.co
Unit #131, 14 London Road
Guildford, Surrey GU1 2AG
United Kingdom
Tel +44 7515 898 999
tom.barnes@tombarnesphoto.com

William Bartlett
gamut1studios.com
5249 W. 73rd St.
Minneapolis, MN 55439
United States
Tel +1 952 835 1811
bill@gamut1studios.com

Mark Battrell
www.battrellphotography.com
1119B Greenleaf Ave.
Wilmette, IL 60091
United States
Tel +1 312 420 5646
mark@battrell.com

Stacey Brandford
www.staceybrandford.com
9 Davies Ave., Studio 103
Toronto, ON M4M 2A6
Canada
Tel +1 416 463 8877
studio@staceybrandford.com

Craig Bromley
www.craigbromley.com
1136 Briarcliff Road, NE #2
Atlanta, GA 30306
United States
+1 404 229 7279
craig@cbromley.com

Dylan H Brown
www.dhbrownphotography.com
Carbondale, Colorado
United States
Tel +1 435 263 1441
dylan@dhbrownphoto.com

Todd Burandt
www.toddburandt.com
1430 Magnolia Park Circle
Cumming, GA 30040
United States
Tel +1 770 598 7322
toddburandt@mac.com

Kristopher Burris
Atlanta, GA 30316
United States
tbareford@gmail.com

David Butler
www.davidbutlerstudios.com
2 Constitution Drive
Westbrook, ME 04092
United States
Tel +1 620 960 1901
studio@davidbutlerstudios.com

Carlos Caicedo
31 Ormont Road
Chatham, NJ 07928
United States
Tel +1 973 457 7709
carloscedo@yahoo.com

Jackson Carvalho
www.jacksoncarvalho.com
1071 Pape Ave.
Toronto, Ontario M4K3W4
Canada
Tel +55 81 3722 2923
jackson@intertotal.com.br

Aaron Cobb
aaroncobb.com
Toronto, Ontario
Canada
Tel + 416 460 8636
nfo@aaroncobb.com

Michael Confer
www.mconferphoto.com
2949 Berkley Road
Ardmore, PA 19003
United States
Tel +1 610 299 0341
mike@mconferphoto.com

Craig Cutler
www.craigcutler.com
197 Grand St. 5N
New York, NY 10013
United States
Tel +1 212 779 9755
cc@craigcutler.com

Cameron Davidson
www.camerondavidson.com
399 Tennessee Ave.
Alexandria, VA 22305
United States
Tel +1 703 845 0547
cameron@camerondavidson.com

Stephanie Diani
www.stephaniediani.com
122 W. 80th St. Apt. BF
New York, NY 10024
United States
Tel +1 323 697 6441
stephanie@stephaniediani.com

Nicholas Duers
www.nicholasduers.com
255 W. 36th St., Suite 1102
New York, NY 10018
United States
Tel +1 917 574 2636
nd@nicholasduers.com

Warren Eakins
warreneakins.com
65 Pike St., 11 D
New York, NY 10002
United States
Tel +1 646 321 3298
warren.eakins@gmail.com

James Exley
www.thejamesexley.com
4105 S. Carolina Place
San Pedro, CA 90731
United States
Tel +1 310 418 6365
holler@thejamesexley.com

Laurie Frankel
www.lauriefrankel.com
697 Douglass St.
San Francisco, CA 94114
United States
Tel +1 415 282 7345
lga@lauriefrankel.com

P.J. Fugatze
Culver City, CA 90230
United States
fugatze@blingimaging.com

Steve Greer
www.SteveGreerPhotography.com
PO Box 641
Lumberton, NJ 08048
United States
Tel +1 609 257 7000
steve@stevegreerphotography.com

Andrew Grinton
www.grintonphotography.com
136 Geary Ave., Unit 212
Toronto, Ontario M6H4H1
Canada
Tel +1 416 354 2612
andrew@grintonphotography.com

Stephen Guenther
stephenguenther.com
1414 Hinman, 1b
Evanston, IL 60201
United States
Tel +1 847 732 2291
stephen.guenther@gmail.com

James Haefner
www.jameshaefner.com
6740 Birmingham Club Drive
Bloomfield Hills, MI 48301
United States
Tel +248 588 6850
jim@haefnerphoto.com

Jack Hawkins
www.jackhawkinsphoto.com
Melbourne, Victoria
Australia
Tel +1 049 013 4830
just.say.jack@gmail.com

Matt Hawthorne
www.matthawthorne.com
1176 Mississippi Ave.
Dallas, TX 75207
United States
matt@matthawthorne.com

John Haynes
www.johnhaynesphoto.com
3151 Johnson St. NE
Minneapolis, MN 55418
United States
Tel +1 320 420 8361
john@johnhaynesphoto.com

Roberto Kai Hegeler
211 East Ocean Blvd., Suite 100
Long Beach, CA 90802
United States
jennifer.holmes@designory.com

Alina Holodov
www.alinaholodov.com
268 Campbell Ave.
Toronto On M6P 3V6
Canada
Tel +1 416 830 1987
alina@alinaholodov.com

Bill Hornstein
www.billhornstein.com
26070 Potter Place
Stevenson Ranch, CA 91381
United States
Tel +1 310 283 5059
hornstein@mac.com

Fj Hughes
fjhughesphoto.com
809 S. Montford Ave.
Baltimore, MD 21224
United States
Tel +1 443 631 6760
fhughes@underarmour.com

Takahiro Igarashi
igarashiphoto.com
1611 Norman St.
Ridgewood, NY 11385
United States
Tel +1 860 519 3215
igarashi@igarashiphoto.com

Makito Inomata
www.makito.ca
315 - 555 E. Sixth Ave.
Vancouver, BC V5T 1K9
Canada
Tel +1 778 999 8896
info@makito.ca

Sazeli Jalal
www.sazelijalal.com
93 JLN Sendudok #05-24
The Nautical
769472
Singapore
Tel 65 9107 0279
saz@sazelijalal.com

Jan Kalish
www.Jankalish.com
17 Tresillian Road
Toronto, Ontario M3H1L5
Canada
Tel +1 416 823 2600
info@jankalish.com

Tony Kemp
www.xiphosdesign.com
0623 Oquirrh Lake Road
South Jordan, Utah 84009
United States
Tel + 385 202 9787
tonykemp@xiphosdesign.com

Jonathan Knowles
www.jknowles.com
48A Chancellors Road
London W6 9RS
United Kingdom
Tel +44 (0)20 8741 7577
jk@jknowles.co.uk

Parish Kohanim
www.parishkohanim.com
425 Peachtree Hills Ave. NE
Building 1, Suite 2
Atlanta, GA 30305
United States
Tel +1 404 892 0099
pk@parishkohanim.com

Steve Krug
www.krugstudios.com
69 Pelham Ave., 2nd Fl.
Toronto, Ontario M6N1A5
Canada
Tel +1 416 658 4320
steve@krugstudios.com

Clarence Lin
www.clarencelin.com
United States
reroutedoutfordelivery@gmail.com

Callie Lipkin
www.callielipkin.com
Chicago, IL 60641
United States
Tel +1 773 919 6182
callie@callielipkin.com

Scott Lowden
www.scottlowden.com
634 N. Highland Ave. NE
Atlanta, GA 30306
United States
Tel +1 404 291 2621
scott@scottlowden.com

James Martin
Remaininlight.com
235 Second St.
San Francisco, CA 94105
United States
Tel +1 415 894 5256
james.martin@cbsinteractive.com

Michael Mayo
www.michaelmayo.com
1389 Crampton St.
Dallas, Texas 75207
United States
Tel +1 214 406 8757
studio@michaelmayo.com

Joe Mazza
www.bravelux.com
1770 W. Berteau Ave., 404
Chicago, IL 60613
United States
Tel +1 312 752 8005
joe@bravelux.com

Trevett McCandliss
www.mccandlissandcampbell.com
433 N. Windsor Ave.
Brightwaters, NY 11718
United States
Tel +1 631 252 3527
mcandcstudio@gmail.com

Darnell McCown
2007 S. Ervay St.
Dallas, TX 75215
United States
Tel +1 214 421 9333
darnellmc@sbcglobal.net

Patrick Molnar
www.patmolnar.com
443 Lakeshore Drive N.E.
Atlanta, GA 30307
United States
patmolnar@mac.com

Dave Moser
www.davemoser.com
853 N. 25th St.
Philadelphia, PA 19130
United States
Tel +1 215 769 1777
dave@davemoser.com

RJ Muna
www.rjmuna.com
2055 Bryant St.
San Francisco, CA 94110
United States
Tel +1 415 285 8300
studio@rjmuna.com

Stan Musilek
www.musilek.com
1224 Mariposa St.
San Francisco, CA 94107
United States
Tel +1 415 621 5336
studio@musilek.com

Tatsuro Nishimura
www.tatsuronishimura.com
150 Bay St. 804
Jersey City, NJ 07302
United States
Tel +1 646 713 9612
tatsuro.pc@mac.com

Emily Neumann
37 Elm St.
Canton, MA 02021
United States
Tel +1 617 833 5921
emilycarolneumann@gmail.com

Lennette Newell
www.lennettenewell.com
2340 Pimlico Lane
Placerville, CA 95667
United States
Tel +1 925 930 9229

Jim Norton
www.jimnortonphoto.com
69 Pelham Ave., Studio B
Toronto, ON M6N 1A5
Canada
Tel +1 416 777 1771
studio@jimnortonphoto.com

Rosanne Olson
www.rosanneolson.com
5200 Latona Ave. NE
Seattle, WA 98105
United States
Tel +1 206 633 3775
rosanne@rosanneolson.com

Brian Neel Parks
www.ForgedByFaithArt.com
16011 SE 16th St,
Bellevue, WA 98008
United States
Tel +1 425 562 0816
brian@parkscreative.com

Bruce Peterson
www.brucepeterson.com
21 Wormwood St. #209
Boston, MA 02210
United States
Tel +1 617 292 9922
bruce@brucepeterson.com

Vika Pobeda
www.mccandlissandcampbell.com
433 N. Windsor Ave.
Brightwaters, NY 11718
United States
Tel +1 631 252 3527
mcandcstudio@gmail.com

Jesse Reed
www.jessereedfromohio.com
726 Lorimer St., 2R
Brooklyn, NY 11211
United States
Tel +1 330 507 2567
jesse.middle.reed@gmail.com

Gregory Reid
www.gregoryreidphoto.com
61 Greenpoint Ave. #220
Brooklyn, NY 11222
United States
Tel +1 631 428 8816
gregory@gregoryreidphoto.com

Howard Rosenberg
www.hrphoto.com
2520 Sunset Boulevard
Los Angeles, CA 90026
United States
howard@hrphoto.com

Bryan Rowe
www.bryanrowephoto.com
4084 Greenbriar Blvd.
Boulder, CO 80305
United States
Tel +1 970 401 1796
bryan@bryanrowephoto.com

Joseph Saraceno
www.josephsaraceno.com
26 Wolverton Ave.
Toronto, ON M4J 3H8
Canada
Tel +1 416 908 1598
joe@josephsaraceno.com

Michael Schoenfeld
www.michaelschoenfeld.com
560 W. 200 South
Salt Lake City, UT 84101
United States
Tel +1 801 560 3305
michael@michaelschoenfeld.com

Sarah Silver
www.biggsandco.net
154 Grand St.
New York, NY 10013
United States
Tel +1 646 217 4165
alli@biggsandco.net

Wray Sinclair
www.wraysinclair.com
3053 South Robertson Blvd., Apt. #1
Los Angeles, CA 90034
United States
Tel +1 703 967 6409
wcsinclair@msn.com

Lindsay Siu
lindsaysiu.com
3628 St. George St.
Vancouver, BC V5V 3Z7
Canada
Tel +1 604 780 4755
lindsay@lindsaysiu.com

Tyler Stableford
www.tylerstableford.com
46 Weant Blvd.
Carbondale, CO 81623
United States
Tel +1 970 963 2462
tyler@tylerstableford.com

Hadley Stambaugh
www.scad.edu
115 E. York St.
Savannah, GA 31402
United States
sward@scad.edu

Staudinger + Franke
www.staudinger-franke.com
Josef-Endlweber-Gasse 2a
Vienna, 1230
Austria
Tel +43 1 597 01 24
sf@staudinger-franke.com

SUECH AND BECK
www.suechandbeck.com
Toronto, Ontario M6E 4P3
Canada
Tel +1 647 456 8296
info@suechandbeck.com

A. Tamboly
www.tambolydesign.com
Linienstraße
Berlin, 10178
Germany
Tel +49 1522 934 4899
info@tambolydesign.com

Robert Tardio
www.roberttardio.com
118 E. 25th St., FL 6
New York, NY 10010
United States
Tel +1 212 254 5413
robert@roberttardio.com

Brandon Titaro
www.brandontitaro.com
75 Portland St., Unit 413
Toronto, Ontario M5V 2M9
Canada
Tel +1 905 616 6671
btitaro@gmail.com

Rosanna U
www.rosannau.com
Toronto Ontario
Canada
Tel +1 416 704 7198
youare@rosannau.com

Terry Vine
www.terryvine.com
2417 Bartlett St.
Houston, TX 77098
United States
Tel +1 713 528 6788
terry@terryvine.com

Adam Voorhes
www.voorhes.com
4321 Gillis St.
Austin, TX 78745
United States
Tel +1 512 386 7417
adam@voorhes.com

Frank P. Wartenberg
www.frank-wartenberg.com
Holstenkamp 46 a Hamburg
22525
Germany
Tel +49 40 850 8331
mail@wartenberg-photo.com

David Westphal
www.westphalphotography.com
827 Cresthaven Drive
Los Angeles, CA 90042
United States
Tel +1 323 377 7061
david@westphalphotography.com

Christopher Wilson
christopherwilsonphotography.com
512 Peebles St.
Raleigh, NC 27608
United States
Tel +1 919 247 9956

Dylan Wilson
www.dylanwilsonphotography.com
Savannah, GA
United States
Tel +1 706 424 0699
dylan@dylanwilsonphotography.com

Michael Winokur
www.winokurphotography.com/blog
650 Alabama St., 302
San Francisco, CA 94110
United States
Tel +1 415 874 9909
winokur@gmail.com

249 WINNERS BY COUNTRY

Visit Graphis.com to view the work within each Country, State or Province.

BEST IN THE AMERICAS

CANADA 🍁

Brandford, Stacey 38, 189, 211
Carvalho, Jackson 185
Cobb, Aaron 169
Gabor, Florin 68
Grinton, Andrew 107, 191
Guenther, Stephen 197
Haefner, James 62, 191
Holodov, Alina 195
Inomata, Makito 104, 189
Kalish, Jan 53, 82, 185, 187
Krug, Steve 105, 106, 190,
............. 209, 212, 213
Krug Studios 128
Norton, Jim 180, 195, 197
Saraceno, Joseph 34, 35, 137,
............. 146, 211, 212, 216
Siu, Lindsay 162, 177, 205, 207
SUECH AND BECK 107, 179, 191
Titaro, Brandon 213
U, Rosanna 165,197

MEXICO 🇲🇽

Macías Velasco, Paco 126

UNITED STATES 🇺🇸

Alduino, Frankie 59, 60
Azevedo, Athena 24, 37,
............. 48, 49, 131, 159
Barnes, Barry 186
Bartlett, William 218
Battrell, Mark 207, 208
Brennan, Jim 148
Bromley, Craig 163, 208
Brown, Dylan H 164, 198
Brautigam, Mark 45
Burandt, Todd 158, 208
Burris, Kristopher 123, 206
Butler, David 157
Caicedo, Carlos 187

Chen, Susan J 128
Confer, Michael 124,
............. 201, 202, 203, 205, 206
Curtet, Patrick 76, 77
Cutler, Craig 109, 112, 113, 114,
............. 168, 188, 215
Dan-Bergman, Kristofer 98
Davidson, Cameron 94, 197, 198
Diani, Stephanie 183
Duers, Nicholas 140, 214, 218
Duka, Lonnie 108
Eakins, Warren 193
Exley, James 175, 219
Frankel, Laurie 39, 40, 41, 159, 161, 188
Fugatze, P.J. 96, 183, 184, 187
Galton, Beth 103
Greenberg, Jill 61
Greer, Steve 191
Hawthorne, Matt 208
Haynes, John 197
Heffernan, Terry 120
Hornstein, Bill 166, 187
Houser, todd 135
Hughes, Fj 214
Hwang, Saneun 101
Igarashi, Takahiro 218
Kai Hegeler, Roberto 167, 168, 169, 170
Kemp, Tony 207
Kessinger, Rick 66, 67, 69
Kohanim, Parish 33, 91, 99, 100
Leroy, Michel 118,119
Lin, Clarence 164
Lipkin, Callie 202, 206
Lowden, Scott 163, 192
Malcolm Roberts, Neil 132
Martin, James 202
Mayo, Michael 63, 69, 167, 171
Mazza, Joe 157, 158
McCandliss, Trevett 174
McCown, Darnell 58, 157
Milstein, Jeffrey 102
Molnar, Patrick 46, 47,
............. 160, 161, 173, 178, 203

Moser, Dave 206
Muna, RJ 44, 89, 181, 182, 183, 207
Musilek, Stan 29, 72, 75, 80, 81, 82, 83,
............. 86, 150, 172, 174, 175, 176, 206, 208
Napolitano, Claudio 42, 43
Nasser, Amyn 87
Neel Parks, Brian 184
Neumann, Emily 199
Newell, Lennette 55, 95, 165
Nishimura, Tatsuro 185, 190, 213
Olson, Rosanne 165
Pantuso, Michael 97
Peterson, Bruce 215 , 216, 217
Phelps, Bill 74
Pobeda, Vika 176
Poon, Kah 125
Raphael, Louis 115
Reed, Jesse 194
Reid, Gregory 217
Rosenburg, Howard 202, 203, 204, 205
Rowe, Bryan 162
Schoenfeld, Michael 26-28, 129,
............. 130, 133, 196
Schulz, John 54
Silver, Sarah 173
Sinclair, Wray 191, 197
Stableford, Tyler 91, 159,
............. 160, 161, 162
Stambaugh, Hadley 78, 172
Surace, John 154
Tardio, Robert 141, 142, 216
Vine, Terry 178, 210
Voorhes, Adam 139,
............. 143-145, 147, 149, 213, 217
Westphal, David 194
Wilson, Christopher 50, 51, 64, 65,
............. 84, 85, 110, 111, 122, 136, 155,
............. 170,171, 177, 200, 204, 210, 220
Wilson, Dylan 172, 204
Winokur, Michael 174, 200
Wolfe, Art 56, 57

BEST IN EUROPE & AFRICA

AUSTRIA ▬

Staudinger+Franke 32,
............. 116,117, 134, 196

GERMANY 🇩🇪

Redinger-Libolt, Scott 88
Wartenberg, Frank P 79, 90, 92, 93,
............. 82, 184

SPAIN 🇪🇸

Cruz Durán, Juan 25

UNITED KINGDOM 🇬🇧

Antony, Todd 183, 193
Barnes, Tom 201
Humphreys, Dan 23
Knowles, Jonathan 22, 30, 52, 70, 71, 73,
............. 121, 127, 151, 179, 215, 216, 218
Tamboly, A 166

BEST IN ASIA & OCEANIA

AUSTRALIA 🇦🇺

Hawkins, Jack 179

SINGAPORE 🇸🇬

Jalal, Sazeli 186

For the image we entered, we used the Hasselblad H6D-100c, with their selection of beautifully sharp lenses and close-up adapters. The dynamic range of these files provided the perfect captures on which we could build the luxurious feel of the product, and bring out all its amazing details.

Jonathan Knowles, *Photographer*

I've used PhaseOne equipment since their first digital back, including their scanning back, circa Y2K. The image quality is superior to any other existing system.

Stan Musilek, *Photographer*

Canon is once again the most popular camera brand for the Photographers featured in this Annual, followed by Hasselblad, Nikon, and Phase One, among others. Below are the models for each of the brands, which are listed in order of most to least frequently used.

CAMERAS

1. CANON (43%)
Canon 1DS Mark III
Canon 5D
Canon 7D
Canon 5D Mark III
Canon 7D Mark II
Canon EOS
Canon EOS R
Canon EOS 1DX
 Mark II
Canon EOS 5D Mark II
Canon EOS 5D Mark IV
Canon EOS 5DS
Canon EOS 5DSR
Canon EOS 7D
Canon EOS 70D
Canon Powershot
 Elph 530 HS

2. PHASE ONE (21%)
Phase One H25
Phase One IQ 150
Phase One IQ 180
Phase One IQ 280
Phase One P25
Phase One P45
Phase One XF
Phase One XF, IQ3
Phase One XF 100MP

3. HASSELBLAD (13%)
Hasselblad 500CM
Hasselblad H Series
Hasselblad H4D 40
Hasselblad H6D- 100c
Hasselblad H6D
Hasselblad H4X with
 Phase One IQ250
Hasselblad H5X with
 Phase One IQ260
Hasselblad H5X with
 Phase One IQ3-100
Hasselblad X1D- 50c
Hasselblad Phase
 One Back

4. SONY (7%)
Sony Alpha 7
Sony Alpha 9
Sony Alpha 7R II
Sony Alpha 7R III
Sony Alpha 7S SLR

4. NIKON (6%)
Nikon D600
Nikon D750
Nikon D800
Nikon D800E
Nikon D810
Nikon D850
Nikon D3300

Other (14%)
Alpa TC, Leaf Credo
60 back
Contax 645
Contax 645/ Phase
 One P45+
Contax 645/ Phase
 One P45+ Mamiya
 Digital Back
DJI Inspire 2 Drone,
 X5s Gimball
Fuji x100t
Horseman LD Pro,
 Phase One IQ 180
Leica Monochrom
Leica SL
Mamiya Leaf Credo
Mamiya Leaf Credo 40
Mamiya Leaf Credo
 60 DB
Mamiya Leaf RZ67
Mamiya 645DF
Pentax 645D
Sinar P2
Sinar, IQ3 100
 digital back
Pentax K-3
Toyo-View 810GII
 8x10 view camera
Yashica T2

"Canon EOS 5D Mark III" by decltype, licensed under CC BY 2.0 | Image found on Wikimedia Commons

Camera: *"Nikon D800E"* by Marie-Lan Nguyen | Image: *"Green Tree Python"* by Lennette Newell

LENSES

1. CANON (54%)
Canon 24-70mm
 f/2.8L II
Canon 24-205mm
Canon 70-200mm
Canon 85mm 1.2
Canon 85mm 1.4 L
Canon 90mm f 2.8
 Tilt-shift
Canon 100mm f/2.8L
 Macro IS USM
Canon EF 11-24mm
 f/4L USM
Canon EF 17-40 mm
 f/4L USM
Canon EF 24-70mm
Canon EF 24-70mm
 f/2.8L USM
Canon EF 70-200mm
 2.8L II USM
Canon EF 100mm
 f/2.8L Macro IS USM

2. HASSELBLAD (10%)
Hasselblad 80mm
Hasselblad 150mm
Hasselblad 120mm
Hasselblad HC 80MM
 F/2.8
Hasselblad HC 100mm
Hasselblad HC 100MM
 F/2.2

3. NIKON (8%)
Nikon FM2
Nikon 17-35mm
Nikon 20-200mm IF-ED
Nikon 35mm
Nikon 50mm
Nikon 80.0-400.0 mm
 f/4.5-5.6
Nikon 85mm

4. NIKKOR (4%)
Nikkor 24-85
Nikkor 24-70 f/2.8
Nikkor 200mm

Other (11%)
DJI 15mm lens
Kodak Portra 400
 35mm.
Ludwig Meritar 50mm
Pentax 80-100mm f/4.5
Schneider Krueznach
 80mm
Schneider APO 210mm
Schneider 210
 APO-Digitar
Sinar P2, Rodenstock

LIGHTING
Broncolor (5%)
Broncolor MOVE (3%)
Broncolor Studio
 Strobe (3%)
Chimera (2%)
Profoto (33%)
Dracast Lights (3%)
Profoto B1x (14%)
Profoto D1 (5%)
Elinchrom (5%)
Dynalites (3%)
Profoto 4 Foot
 Octabox (7%)
Rosco Labs (3%)
Hensel (5%)
Westcott (5%)
Norman Flash (3%)

PRINTERS
Epson Bartya (100%)

PAPER
Hahnemühle Photo
 Rag Paper (50%)
Epson Archival
 Paper (50%)

252 GRAPHIS MASTERS

Visit Graphis.com/masters to see our Graphis Photogrphy Masters.

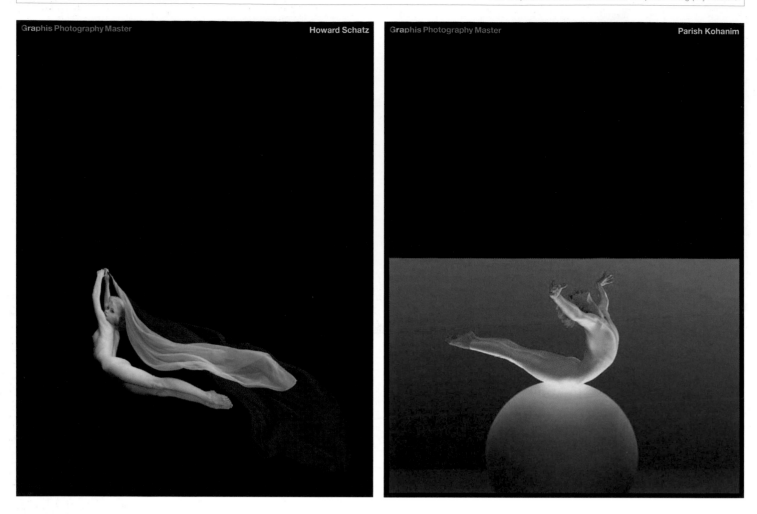

Graphis Photography Master — Howard Schatz

Graphis Photography Master — Parish Kohanim

Graphis Masters Inspire!

These Masters have been consistently submitting to our competitions, and started winning Silver, Gold and Platinum awards, and therefore have earned the status of a Graphis Master.

We are continuously building our Master collection of these very special talents and we are aware that there are more in our archives for consideration. This is a continuous process.

To be considered for an article in our Journal, we need to see your work. Generally, our loyalty remains with the consistent winners in our Annuals, most of which become Masters.

What makes Graphis Annuals and *Journals* visually inspiring is the work that we receive and present on our pages.

The Masters shown below have been Platinum & Gold winners who set the standard of excellence in their professions.

ADVERTISING MASTERS

VIEW ALL 16 ADVERTISING MASTERS

Doug Lloyd

Lewis Communications

Zulu Alpha Kilo

The Richards Group

DESIGN MASTERS

VIEW ALL 80 DESIGN MASTER

Atlas (Astrid Stavro & Pablo Martín)

KMS TEAM GmbH

Ikko Tanaka

ARSONAL

ART / ILLUSTRATION MASTERS

VIEW ALL 24 ART / ILLUSTRATION MASTER

Peter Kraemer

Guy Billout

Michael Pantuso

Craig Frazier

PHOTOGRAPHY MASTERS

VIEW ALL 44 PHOTOGRAPHY MASTERS

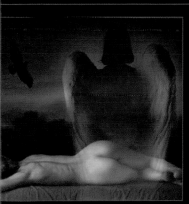
Phil Marco

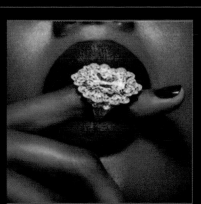
Jonathan Knowles

Adam Voorhes

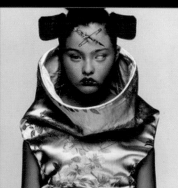
Nick Knight

New Talent Annual 2019

GraphisNewTalentAnnual2019

Some of the ideas were so well executed, they even inspired a seasoned creative director like myself. It made me a little envious too.

Michael Schilling, Creative Director FTK

2019 *Trim: 8.5 x 11.75"*
Hardcover: 256 pages *ISBN: 978-1-931241-77-9*
200-plus color illustrations *US $90*

This Annual presents award-winning Instructors and students.
Platinum: Advertising: Frank Anselmo, Josh Ege, Larry Gordon, Seung-Min Han, Patrick Hartmann, Kevin O'Neill, Dong-Joo Park, Hank Richardson, Eileen Hedy Schultz, and Mel White. Design: Brad Bartlett, Devan Carter, Eszter Clark, Carin Goldberg, Seung-Min Han, Marvin Mattelson, Kevin O'Callaghan, Dong-Joo Park, Adrian Pulfer, Ryan Russell, and Kristin Sommese. **Gold:** Advertising: 88; Design: 85; Photography: 5; Film: 36. **Silver:** Advertising: 95; Design: 185; Photography: 9; Film: 40. We award up to 500 Honorable Mentions, encouraging new talent to submit. All winners are equally presented and archived on our website. This book is a tool for teachers to raise their students' standards and gauge how their school stacks up.

Advertising 2019

GraphisAdvertisingAnnual2019

Don't tell me how good you make it; tell me how good it makes me when I use it.

Leo Burnett, Advertising Executive and Founder of the Leo Burnett Company

2018 *Trim: 8.5 x 11.75"*
Hardcover: 240 pages *ISBN: 978-1-931241-74-8*
200-plus color illustrations *US $90*

Awards: 16 Platinum, 122 Gold, and 310 Silver Awards, totaling more than 600 Winners, along with 197 Honorable Mentions.
Platinum Winners: 21X Design, Earnshaw's Magazine, Entro, Fred Woodward, hufax arts, IF Studio & Magnus Gjoen, Ken-tsai Lee Design Lab/Taiwan Tech, Michael Pantuso Design, Morla Design, Shadia Design, Steiner Graphics, Stranger & Stranger, Studio 5 Designs Inc., Toppan Printing Co., Ltd., and Traction Factory.
Judges: Ronald Burrage of PepsiCo Design & Innovation, Randy Clark, John Ewles, William J. Gicker, Matthias Hofmann, John Krull, and Carin Stanford.
Content: Designs by the Judges and award-winning student work.

Branding 7

GraphisBranding7

PLATINUM WINNERS:

Ventress Design Works
cosmos
SVIDesign
Commission Studio
Karousel
COLLINS
Ginger Brand
Tiny Hunter
STUDIO INTERNATIONAL

2018 *Trim: 8.5 x 11.75"*
Hardcover: 240 pages *ISBN: 978-1-931241-73-1*
200-plus color illustrations *US $90*

Awards: 10 Platinum, 73 Gold, and 194 Silver Awards, totaling nearly 500 winners, along with 124 Honorable Mentions.
Platinum Winners: Tiny Hunter, COLLINS, cosmos, Ventress Design Works, Karousel, SVIDesign, Ginger Brand, Commission Studio, and STUDIO INTERNATIONAL.
Judges: All entries were judged by a panel of highly accomplished, award-winning Branding Designers: Adam Brodsley of Volume Inc., Cristian "Kit" Paul of Brandient, and Sasha Vidakovic of SVIDesign.
Content: Branding designs from New Talent Annual 2018, award-winning designs by the Judges, and Q&As with this year's Platinum Winners, along with some of their additional work.

Design 2019

GraphisDesignAnnual2019

PLATINUM WINNERS:

Studio 5 Designs Inc.
Toppan Printing Co., Ltd.
GQ
McCandliss and Campbell
hufax arts Co., Ltd.
Entro
Michael Pantuso Design
Morla Design
21xdesign
IF Studio
Magnus Gjoen
Steiner Graphics
Traction Factory
Ken-Tsai Lee Design Lab /Taiwan Tech
Shadia Design
Stranger & Stranger

2018 *Trim: 8.5 x 11.75"*
Hardcover: 256 pages *ISBN: 978-1-931241-71-7*
200-plus color illustrations *US $90*

Awards: 16 Platinum, 122 Gold, and 310 Silver Awards, totaling nearly 500 winners, along with 197 Honorable Mentions.
Platinum Winners: 21X Design, Earnshaw's Magazine, Entro, Fred Woodward, hufax arts, IF Studio & Magnus Gjoen, Ken-tsai Lee Design Lab/Taiwan Tech, Michael Pantuso Design, Morla Design, Shadia Design, Steiner Graphics, Stranger & Stranger, Studio 5 Designs Inc., Toppan Printing Co., Ltd., and Traction Factory.
Judges: Ronald Burrage of PepsiCo Design & Innovation, Randy Clark, John Ewles of Jones Knowles Ritchie, William J. Gicker of The United States Postal Service, Matthias Hofmann of hofmann.to, John Krull of Shine United, and Carin Standford of Shotopop.
Content: Designs by the Judges and award-winning student work.

Poster 2019

GraphisPosterAnnual2019

PLATINUM WINNERS:

COLLINS
Rikke Hansen
Bond/P+A/ Ignition/Iconisus
hofmann.to
hufax arts Co., Ltd./ CUTe
Gunter Rambow
Traction Factory
21xdesign
Takashi Akiyama Studio

2018 *Trim: 8.5 x 11.75"*
Hardcover: 240 pages *ISBN: 978-1-931241-69-4*
200-plus color illustrations *US $90*

Awards: This year, Graphis awarded 10 Platinum, 110 Gold, and 162 Silver Awards, along with 241 Honorable Mentions, totaling over 500 winners, all equally presented and archived on Graphis.com.
Platinum Winners: 21X Design, Takashi Akiyama, Peter Bell, Rikke Hansen, Matthias Hofmann, Fa-Hsiang Hu, Gunter Rambow, COLLINS, and FX Networks/Bond/P+A/Ignition/Iconisus.
Judges: All entries were judged by a panel of highly accomplished Poster Designers: Fons Hickmann, Andrew Hoyne, Zach Minnich, Daeki Shim, Hyojun Shim, and Rick Valicenti.
Content: Included are Professor and student posters from New Talent Annual 2018. Also featured are award-winning posters by this year's Judges. A poster museum directory is also presented.

Type 4

GraphisTypography4

2018 *Trim: 8.5 x 11.75"*
Hardcover: 256 pages *ISBN: 978-1-931241-68-7*
200-plus color illustrations *US $90*

Awards: This year, Graphis awarded 18 Platinum, 150 Gold, 219 Silver, and 116 Merit Awards, totaling over 500 winners.
Platinum Winners: ARSONAL, Chemi Montes, DAEKI & JUN, Hufax Arts, Jones Knowles Ritchie, McCandliss & Campbell, Ron Taft Design, SCAD, Selman Design, Studio 32 North, Traction Factory, Umut Altintas, Atlas, Jamie Clarke Type, Jones Knowles Ritchie, Linotype, SVA, and Söderhavet.
Judges: Entries were judged by highly accomplished Type Designers: Nadine Chahine (LB), Akira Kobayashi (JP), and Dan Rhatigan (US).
Content: A documentation of the history of typeface design from the 5th Century B.C. to 2018, as well as informative articles on Typeface Design Masters Matthew Carter and Ed Benguiat.